THE NELSON-ATKINS MUSEUM OF ART

A Handbook of the Collection

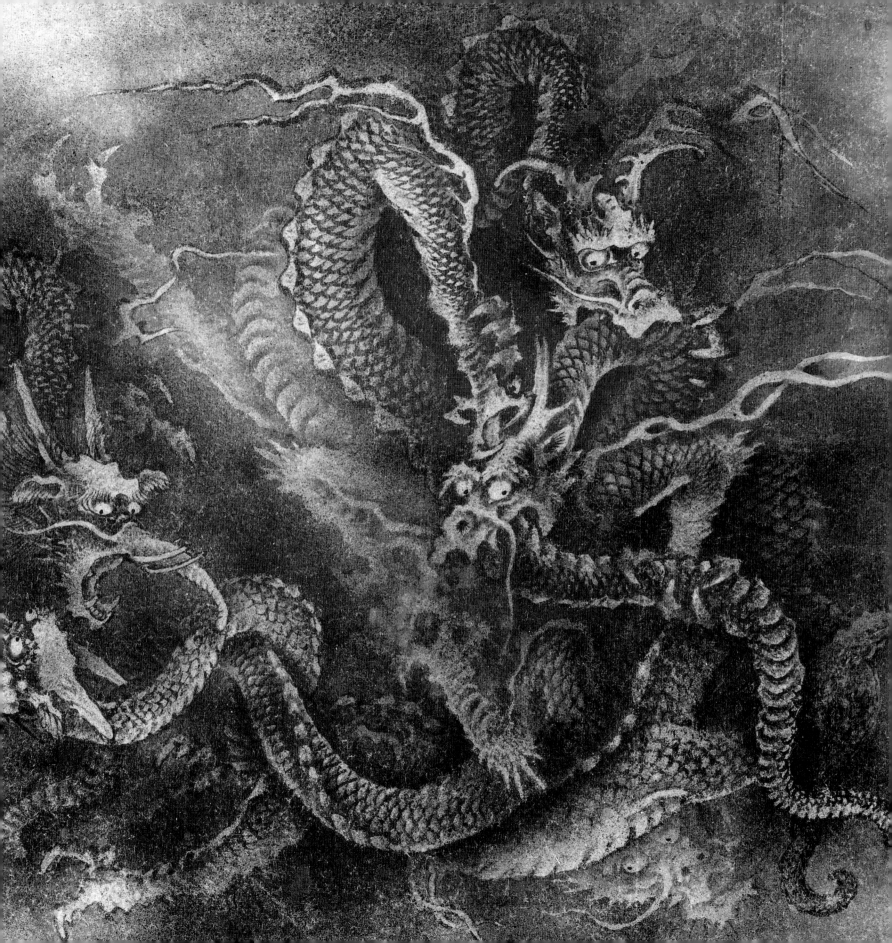

THE NELSON-ATKINS MUSEUM OF ART

A Handbook of the Collection

Compiled and Edited for Publication by

ROGER WARD AND PATRICIA J. FIDLER

HUDSON HILLS PRESS, NEW YORK

in association with the Nelson-Atkins Museum of Art

FIRST EDITION

© 1993 by the Nelson Gallery Foundation

All rights reserved under International and Pan-American Copyright Conventions.

Published in the United States by Hudson Hills Press, Inc., Suite

1308, 230 Fifth Avenue, New York, NY 10001-7704.

Distributed in the United States, its territories and possessions,

Canada, Mexico, and Central and South America by National Book Network, Inc.

Distributed in the United Kingdom and Eire by Art Books International Ltd.

Distributed in Japan by Yohan (Western Publications Distribution Agency).

Editor and Publisher: Paul Anbinder

Copy Editor: Virginia Wageman

Proofreader: Lydia Edwards

Designer: Bruce Campbell

Composition: U.S. Lithograph, typographers

Manufactured in Japan by Toppan Printing Company.

**This publication has been made possible through the generosity of
Margaret Garner Gustin in memory of Hester Milligan Gustin.**

LIBRARY OF CONGRESS CATALOGUING-IN-PUBLICATION DATA

Nelson-Atkins Museum of Art.

The Nelson-Atkins Museum of Art : a handbook of the collection /

compiled and edited for publication by Roger Ward and Patricia J. Fidler. — 1st ed.

p. cm.

Includes bibliographical references and index.

ISBN 1-55595-090-6

1. Art—Missouri—Kansas City—Catalogues. 2. Nelson-Atkins Museum

of Art—Catalogues. I. Ward, Roger B. II. Fidler, Patricia J.

III. Title.

N582.K3N42 1993 708.178'411—dc20

93-17549

CIP

CONTENTS

FOREWORD

One can tell much about an art museum's view of itself and its public by perusing a handbook of its collections. Some publications illustrate relatively few works. The selection might accurately characterize the museum's collections, or it might "editorialize," perhaps in order to conform as nearly as possible to some interpretation of art history. In either case, the illustrations are usually accompanied by rather longish captions that offer the reader a mix of art appreciation and art-historical reference. At the other end of the spectrum is the handbook that makes no attempt to present a potted version of the history of art, but that does seek to characterize the museum's collections as fully and objectively as possible.

In this, the sixth *Handbook* published by the Nelson, we have taken the latter approach. Gone are the inadequately brief art-historical prologues that preceded each section of the former editions and the short captions that tried to explain in a sentence or two something of significance about a particular art work. We have recast the selection to reflect current thinking of the curatorial staff about the collections and the relative merits of subcollections and individual works, too. Confident that the reader's education in art history and art appreciation can be better served by other means, we have replaced the former prologues with something the reader cannot readily find elsewhere, namely thumbnail sketches of five individual sections of the overall collection. These divisions have been determined by geography. We have tried to impart not only a sense of collection growth through time but also something of the comings and goings of the people who have played instru-

mental roles in that growth: their names add the human dimension to an institutional resume.

Roger Ward, Curator of European Art, wrote the Introduction, which is a survey of the early history and subsequent development of the museum, and each of the section prefaces. Even more, he led and managed the entire project. The organization of such masses of disparate material is an immense task. Chaos threatens at a thousand points as questions of selection, photography, format, consistency, design, and the like need to be discussed, determined, and accomplished. All who use this volume will surely join me in extending our sincerest thanks to Dr. Ward. He was ably assisted in this project by Patricia Fidler, Curatorial Assistant, who bore so much of the responsibility for organizing photography, ensuring consistency, working with designs, and helping with proofreading. All these assignments she completed with exemplary reliability and efficiency.

This enterprise could not have come to fruition without the extraordinarily generous support of Mrs. Albert L. Guston III. Hers is a commitment of rare understanding.

In the end, this new *Handbook* presents a self-portrait of the Nelson-Atkins Museum of Art drawn by the generation charged with its welfare as the institution marks its sixtieth anniversary. This self-portrait differs from those of our predecessors. The future will create yet a different picture. There will be change, and we look forward to it.

Marc F. Wilson
Director

6

ACKNOWLEDGMENTS

We wish to thank the numerous persons who assisted in the compilation and publication of this sixtieth-anniversary edition of the Nelson-Atkins *Handbook*. Many individuals on the museum's staff facilitated the seemingly endless task of accumulating and revising information; gathering and making photographs; checking, correcting, and in some cases composing credit lines. Our curatorial colleagues reviewed the original selection of objects and continued up to the very last minute to make thoughtful additions or substitutions and to update the cataloguing data. For their essential participation we are grateful to Marc Wilson, Wai-kam Ho, Dorothy Fickle, George McKenna, David Binkley, Robert Cohon, Christina Nelson, Scott Erbes, Deborah Emont Scott, Deni McIntosh-McHenry, Henry Adams, Margaret Conrads, and Eliot Rowlands. With her usual efficiency and dispatch, Jean Drotts, Curatorial Secretary, made short work of myriad small tasks that otherwise would have driven us to distraction: we wish to express our thanks for her conscientious assistance over many months.

Without the cheerful cooperation of Ann Erbacher, Registrar, it is unlikely that we would have got very far with this project. She and members of her staff, including Tirrell Hellyer and the late Jane Miller, responded promptly and with enthusiasm to a million questions about everything from ancient Egyptian cosmetics to Laura Nelson Kirkwood's sable coats. Sifting through the collection, we unearthed a number of lesser-known objects, and this process of encounter of course raised other issues having to do with missing objects, deaccessioned objects,

methods of reporting and description, and lines of curatorial jurisdiction. For patiently disentangling many of these knots, the registrar's office merits our respect and gratitude.

One of the primary challenges of this sort of project is the assembly of more than a thousand photographs and color transparencies. In the present case, hundreds of new prints were made from existing black-and-white negatives, while scores of objects were photographed either anew or for the first time. These recent photographs, and virtually all the excellent color transparencies, were made by Melville McLean and Rob Newcombe, past and present staff photographers. With characteristic calm and intelligence, Marla Cling and Diane Treff—the successive Coordinators of Collection Photography—organized the enterprise and kept the "production line" moving at a reasonable pace. Art handlers Bobby Hornaday, Craig Burns, and Dan Gude worked with quiet efficiency to insure that deadlines were met without panic. We are pleased to have the opportunity to thank all these coworkers for their contributions to a protracted effort.

The production of this new and greatly revised edition of the Handbook was entrusted to Paul Anbinder and Hudson Hills Press. Paul's consummate patience and expertise made our jobs easier by far, as we gratefully relied on him for guidance in dealing with many issues—both large and small—that arose during preparation and publication of the manuscript. It would be hard to overestimate the contribution made by the editor, Virginia Wageman, for there is nothing more vital to an effort such as this than

the insistence on precision and consistency. We feel that the quality (and clarity) of the information presented has been much enhanced by her thoughtful participation in the project. Bruce Campbell's elegant design of the book is a source of great joy, for this selection of the best and the favorite from the museum's permanent collection has been made to seem even more distinguished than we had imagined. Our thanks are extended in large, equal measures to each of these individuals.

It is, finally, a distinct privilege to acknowledge those individuals and entities whose financial support made it possible to finish the book in a timely way and in a style that does justice to the quality of the museum's collection. Foremost is Mrs. Albert L. Gustin III, whose personal generosity in the interest of a publication is unprecedented in the history of this institution. Steady cash contributions from the Mellon-Frick-Rothschild-Sprint Publications Fund likewise helped to advance the project from preparation to completion. For these magnificent benefactions and expressions of confidence, we are profoundly grateful.

Roger Ward
Patricia J. Fidler

INTRODUCTION

A brief account of the origins of the museum and its subsequent development

The creation of the Nelson-Atkins Museum of Art is a peculiarly American saga whose principal themes are vision, luck, generosity, and hard work. The story has been partially told in other publications and could be expanded upon at great length—such was the complexity of events that preceded the opening to the public on December 11, 1933. From both archival sources and the firsthand reports of some who witnessed the earliest days of the museum, there emerges an account of the manner in which one man's remarkable dream became reality; that account is rather differently inflected than the one usually regarded as authoritative. My present purpose is not to quibble with any other author, but simply to review the history in a synoptic fashion for those not familiar with it as well as for those who wish to be reminded of the main story line.

It is well known that William Rockhill Nelson (1841–1915), newspaper publisher and philanthropist, in his will determined to provide an art collection for Kansas City as a legacy to himself and his immediate family. An art museum, he thought, was essential to the life of any modern metropolis, and he saw in his fortune and commercial empire a means of providing one for Kansas City. An accelerating train of events was set in motion by the premature death of his daughter and sole heir, Laura (Mrs. Irwin R. Kirkwood), on February 27, 1926, at age forty-two. Exactly according to Nelson's wishes, the death of the last member of his immediate family empowered the presidents of the state universities of Missouri, Kansas, and Oklahoma to appoint three trustees, designated as the University Trustees of the William Rockhill Nelson Trust. Their job was to dispose of all worldly possessions of the Nelson family in order to furnish capital for the Trust, whose income would then be used, at the discretion of the University Trustees, for buying works of art. The Trustees, in Nelson's words, "would administer the estate and provide means for collecting and caring for works of art." Consisting of J. C. Nichols (chairman), William Volker, and Herbert V. Jones, the University Trustees held their first meeting on March 4, one week after Mrs. Kirkwood's death. Almost immediately they tackled the enormous task of liquidating Nelson's business assets, which included not just his newspapers—the *Kansas City Star* and the *Times*—but stocks, bonds, agricultural properties and livestock in eastern Jackson County, and commercial real-estate property in downtown Kansas City, Missouri. In all nearly $12 million was amassed from the sale of these assets during the years 1926 to 1930.

The work of establishing the Trust got underway soon enough with the sale of the Kansas City Star Company on July 13, 1926. While bids from potential buyers had been widely solicited and received, no one was too surprised when it was announced that the successful bid had been tendered by none other than Irwin R. Kirkwood, Nelson's son-in-law, who happened also to be the president of the company and editor of its newspapers. In this capacity he was acting on behalf of not just himself but a large ma-

jority of the newspaper's employees, who then became shareholders in the business for which they worked. Almost immediately the sale was decried as a fraud by the Dickey family, owners of the rival *Kansas City Journal-Post,* who quite naturally had hoped to acquire the very profitable *Star* for themselves and thereby eliminate their principal competitors. The lawsuit brought against the University Trustees meant that the sale of the *Star* could not be considered final until adjudicated by the courts, temporarily preventing J. C. Nichols and his colleagues from collecting works of art per the terms of Nelson's will. But those directives had long been public, and the Trustees' potential spending power was an open secret. Virtually from the moment of Laura Kirkwood's death they had been obliged to shoo away swarms of dealers and collectors' agents who longed "to swirl their toes in the new honey-pot of the West," as the situation was appraised by one observer in London.

Meanwhile thought had to be given to plans for the museum building itself, for the Trustees never doubted that the nettlesome suit would be settled in their favor, or that Nelson's estate would generate income sufficient to enable them to collect widely and rapidly. They were hopeful, too, that a building of imposing size and distinction would attract the donations of private collections. For a site they originally favored the attenuated, rectangular mall immediately to the south of Kansas City's most important public monument, the Liberty Memorial, to which the finishing touches were applied early in 1926. It was imagined that the art museum and the Kansas City Art Institute would be housed separately on opposite long sides of the dramatic promontory, with its spectacular views to the north, east, and west. Adorned with modern temples, dedicated to immortality and freedom, its steep sides shaded by woods, the site would have been something of a midwestern Acrop-

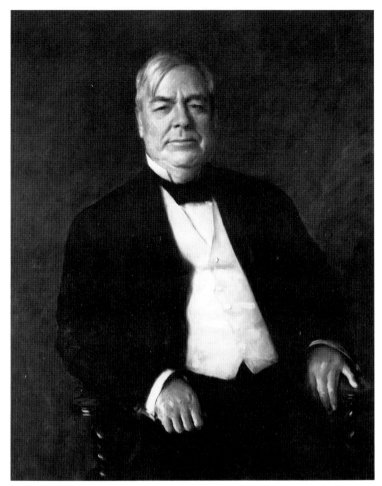

William Merritt Chase, American, 1849–1916
Portrait of William Rockhill Nelson, 1907
Oil on canvas
60 x 50¼ inches (152.4 x 127.6 cm)
Gift of William Rockhill Nelson [34-316]

olis. But the question of where to build "Nelson's art gallery" was answered differently in January 1927 when Irwin Kirkwood volunteered to surrender Oak Hall—the Nelsons' baronial mansion at Forty-fifth Street and Rockhill Road—so the house might be demolished, the land ceded to the city, and the art museum erected on the crest of another of Kansas City's imposing hillsides. The minutes of the Nelson Trustees' meeting on January 29, 1927, record their pleasure at and approval of Kirkwood's

Portrait of Mary McAfee Atkins
Black and white photograph
Museum archives

proposal, which was forwarded to City Hall for ratification.

On July 11 of the same year the executors of the estate of Mary McAfee Atkins (1836–1911), who had left money in trust "for the erection of a building to be maintained and used as a Museum of Fine Arts," informed the Nelson Trust that they wished to join forces. It was their desire, they said, that the Mary Atkins Museum of Fine Arts be built alongside the William Rockhill Nelson Gallery of Art on the Oak Hall site that had been dedicated to that purpose. The University Trustees' ready acceptance of this plan was faciliated not a little, one assumes, by the fact that Herbert V. Jones was a member of both boards: he was one of two Atkins Trustees, and one of three of Nelson's University Trustees. Surely neither Jones's dual trusteeship nor the merger of interests was accidental, but had been settled upon long before Mrs. Kirkwood's death. The exact circumstances of this arrangement may never be known. In any event, it was obvious to all that Kansas City should have but one art museum and thereby avoid the crosstown rivalry of competing institutions, like that which alienated the two museums of San Francisco for so many years.

A few weeks later, on August 29, 1927, Irwin Kirkwood died unexpectedly while vacationing in Saratoga Springs, New York. His death seems to have galvanized the Trustees' determination to move forward with plans for the building, for Mrs. Kirkwood's will instructed that upon the death of her husband the entire contents of Oak Hall were to be dispersed and the proceeds added to the "building fund." This endowment, distinct from the Nelson Trust, had been established by William Rockhill Nelson's widow, Ida, and his lawyer, Frank Rozzelle, who by their last testaments directed that all their personal goods, effects, and properties were to be liquidated and nearly all the proceeds set aside for the construction and furbishment of a museum that would house the collection one day formed by the Nelson Trust. And by the terms of Irwin Kirkwood's will, he too would add $250,000 to the building fund from the sale of property and possessions and the simple transfer of bank funds.

By the end of 1927 the Trustees thus found themselves deeply engaged in the business of selling off everything from bulls to diamond brooches as the multifarious holdings and investments of the Nelsons and Kirkwoods were

converted to cash. From the contents of Oak Hall the Trustees selected, in January 1928, a few works which they had been advised would be suitable for the collection of the museum-to-be. It is alarming that these selections did not include Claude Monet's *View of Argenteuil, Snow* or Camille Pissarro's *Poplars, Sunset at Eragny,* modern works that were, in the end, retained for the collection. Everything else was sold to the Los Angeles–based Loews' Cinema Company and resold by them to the Woolf/ Lighton family of Kansas City for exactly one dollar, for use in the decoration of the lobbies of one of Loews' newest movie palaces, the Midland Theater at 1228 Main Street. The material deemed appropriate for such a purpose— chandeliers, huge pieces of Louis XV–style furniture, reproduction Boulle clocks, and dreadful late-nineteenth-century French salon paintings—can still be seen there today. The remainder, comprising household furnishings and goods of every conceivable description, was sold to the public over a period of several days in the spring of 1928. This open-air bazaar on the sweeping lawns of Oak Hall, supervised by the Junior League, must have been the greatest "garage sale" in local history.

Finally in October 1928 the Supreme Court of the State of Missouri handed down a decision in favor of the University Trustees in the case brought against them by the owners of the *Kansas City Journal-Post.* At last they could proceed with the formation of an art collection. Announcement of the settlement simply exacerbated the flood of correspondence and telephone calls from individuals and businesses alike who wished either to be employed by, represent, or sell works of art to the Nelson Trust. All were turned away with the explanation that plans for the building had not yet been finalized, and that the Trustees were not ready to consider the acquisition of artworks. At their meeting of October 31 the Trustees discussed but de-cided against the imminent hiring of a director. There seemed to be no need for one "until he could function," which is to say not until some sort of building and collect-ing were underway. Eventually construction did com-mence, on July 16, 1930, nine months after the great crash of the Wall Street stock market. Designed by the Kansas City firm of Wight and Wight, the classical building of Indiana limestone—seamlessly integrating the Nelson Gallery with the Atkins Museum—rose swiftly through-out the early years of the Depression and was virtually complete by the spring of 1932, though much remained to be done by way of finishing and fitting out the public areas of the interior. Today the exterior aspect is more or less identical to the original, for there have been neither changes to the structure per se nor the addition of any sort of wing.

The business of buying art had begun in April 1930 when the Trustees voted to purchase a batch of run-of-the-mill British portraits from the Yunt Art Galleries (now defunct) of Kansas City. Taking as their model an all-around museum such as the Museum of Fine Arts, Boston, the Trustees declared that the scope of the collection should not be limited to any specific phase or period of art. Articulating at least a theoretical belief in the equal validity of the arts of all people and times, they intended to spread their nets wide and draw in a bounty from around the world. To their very great credit, they earlier had realized that in the absence of a professional staff, advisers would be needed to help them make some sense of the interna-tional art market—disrupted by the onset of international economic contraction—and to analyze the flood of ma-terial being offered for sale from the four quarters of the globe. First to be engaged was Harold Woodbury Parsons, an adviser to the trustees of the Cleveland Museum of Art on the purchase of European works of art. He was retained

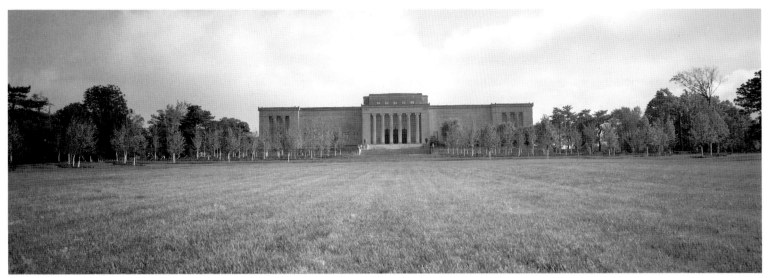

The Nelson-Atkins Museum of Art: View from the South Lawn

for the same purpose by the Nelson Trust, and his influence was almost immediately felt with the dispatch to Kansas City of paintings by such artists as Titian, Jean-François Millet, Goya, Bartolomé Estebán Murillo, and Rembrandt, from the London and New York dealers Agnew's, Knoedler, Durlacher, Sabin, and Duveen, among others.

In January 1931 the University Trustees appointed Langdon Warner, of the Fogg Art Museum, as "Oriental adviser," thus bringing on board expertise in Asian art, and in 1932 another Bostonian, Paul Gardner, was hired as the first director. To him fell the great responsibility of bringing some order to the rapidly growing collections and preparing the finished building for opening to the public. By that day, December 11, 1933, more than $4 million had been spent on 4,539 works of art. These were displayed in thirty-six exhibition galleries and period rooms on both floors of the east wing of the building. Because the structure was very much larger than the immediate needs of the collection, the west wing—all those spaces, on both floors, enclosing Rozzelle Court—was left unfinished for

future growth. The gallery spaces of the first floor of the west wing were eventually finished in 1949, while the remainder of the more capacious second-floor spaces was not finished as galleries and filled with artworks until 1976.

Though interrupted by World War II, Gardner's directorship, which continued until 1953, witnessed spectacular growth in the collection. The bulk of Kansas City's fabled Asian collections was amassed during that period thanks to the scholarship, acumen, and reputation of Laurence Sickman. His association with the Nelson Trust had begun somewhat accidentally in 1931. Then, as a protégé of Langdon Warner, living in Peking on a Harvard-Yenching Fellowship, Sickman made his first rounds of the city's dealers as Warner sought works of every description for Kansas City. When Warner returned to the United States, his brilliant young friend was recommended to the University Trustees as someone who might conveniently carry on the work already begun. At first the board was attracted by the fact that Sickman's services were available to them at very little expense. Within a short while they realized

that fate had smiled on them in a most extraordinary way. As the galleries began to swell with the splendid works being forwarded from Peking to Kansas City, they determined that Sickman should join the museum's staff in a formal manner at the conclusion of his Harvard fellowship. In 1935 he became the first Curator of Oriental Art. By the end of the 1930s the collection contained many of the masterpieces of Chinese as well as Indian and Japanese art for which it is best known.

By the time Sickman himself became the director, in 1953, the Nelson-Atkins was well established as one of the major institutions of the country, with the foundations laid for practically all the different components of its wide-ranging collection. During Sickman's administration, emphasis continued to be put on acquisitions and exhibitions, rather than publications or conservation, for the staff remained small while the collection continued to grow with some rapidity. In 1977, when Sickman retired from the directorship, he was succeeded by Ralph T. Coe, since 1959 Curator of Painting and Sculpture. Coe's very wide range of interests had done much to inspire the activity of local collectors in a multiplicity of fields, and he had been responsible for acquisitions and exhibitions of all sorts. Surely the most important legacy of his curatorship and directorship is the addition of a number of Impressionist masterpieces to the collection—Monet's *Boulevard des Capucines* (colorplate, page 44), for example, or two splendid pastels by Edgar Degas (*Rehearsal of the Ballet* and *Little Milliners)*, both formerly part of the renowned Havemeyer collection.

In 1982 Marc Wilson, Curator of Oriental Art, followed Coe as director. Under Wilson's leadership the museum has developed dramatically into a modern institution that recognizes its civic obligations to an ever more diverse constituency. When the first edition of the *Handbook* was offered to the public on opening day, the staff roster had thirteen names (and three of these individuals—the art advisers—were not residents). Today there are 154 full-time and 381 part-time employees, including a curatorial staff of twenty-one and a conservation staff of ten (up from a grand total of one since 1973, when the *Handbook* was last published). Historic changes in the museum's administrative structure and general outlook are manifest in a distinguished agenda of research and publication, the origination of more exhibitions, a more prominent Education Department, phenomenal growth in general and corporate membership, and the invigoration of public services such as the bookstore and restaurant. In all sorts of ways the museum is now more directly engaged with its local community, the wider audience of several neighboring states, and the international world of scholarship.

The collection, too, has evolved notably during the Wilson administration, as will be evident to anyone who compares the present edition of the *Handbook* to the one published in 1973. Like that two-volume edition, this single-volume compendium illustrates only about 1,200 objects from the permanent collection of nearly 30,000 works. In each there appear many of the same works of art, of course, for a handbook is a cumulative record of experience, choices, and accomplishment. The masterpieces, like the beautiful and the simply worthy objects, have a staying power over time, but developments in scholarship and taste may bring previously neglected or underrated artworks to the fore while eliminating others from a publication like the present one. A quick survey of accession numbers, whose first two digits indicate the year of acquisition, will reveal that certain aspects of the collection have been augmented considerably during the last twenty years. Most conspicuous, perhaps, is the addition of many European paintings of the first order by such now-rare artists as Joachim Anthonisz. Wtewael, Jusepe

de Ribera, Jean-Baptiste-Siméon Chardin, J.-L.-A. Théodore Géricault, and Gustave Caillebotte. Still more numerous are the recently acquired American masterworks of the nineteenth and twentieth centuries, from those of Severin Roesen, Frederic Edwin Church, and John Singer Sargent to major canvases by Thomas Hart Benton, Robert Rauschenberg, and Philip Pearlstein. Surprising, too, for their variety and fine quality are the many objects purchased for and given to the department responsible for the arts of Africa, Oceania, and the Americas. The famous array of Asian art has gained scope and depth through bequests of much-needed Japanese art and through the selective purchase of objects in those categories of Chinese art that already were the best represented: painting, sculpture, ceramics, and furniture. The representation of Western decorative arts has been enhanced mainly through the acquisition of exceptionally fine eighteenth-century Continental ceramics, and has grown in dimension with a sampling of late-nineteenth- and early-twentieth-century furniture, glass, and metalwork. Scores of prints have been acquired, from superb examples of old masters such as Lucas van Leyden to those of contemporary artists such as Roger Shimomura. Thus the collection continues to expand in all directions, much as William Rockhill Nelson would have wanted it to do. At age sixty, the Nelson-Atkins Museum of Art does credit to the range of his vision and the depth of his respect for beautiful things.

Roger Ward
Curator of European Art

Notes for Use

This sixth and extensively revised edition of the *Handbook* makes free and unacknowledged use of all previous editions and of other museum publications, as cited on page 410.

The color reproductions in this *Handbook* do not illustrate only the museum's best-known treasures; rather, they are intended to supplement those in Ellen Goheen's popular book, *The Collections of the Nelson-Atkins Museum of Art* (1988). When published, that book was widely distributed, and in 1993 it was still available in the museum's bookstore. Forthcoming catalogues of various subcollections—the Italian paintings, for example—will feature full-color plates of all artworks in the museum's permanent collection.

Dimensions are rendered in both inches and centimeters. The measurement of the diameter only is recorded for some circular objects such as jade discs, tondo-shape reliefs, metal and ceramic bowls, plates, etc. Artworks of essentially two-dimensional format (paintings and scrolls, drawings, prints, textiles, screens, relief sculptures, metal and ivory plaquettes, enamels, stained-glass windows, etc.) are described in terms of height followed by width, with measurements taken down the left vertical edge and along the bottom. For three-dimensional objects of irregular height or width (freestanding sculptures, ceramic figures and many wares, figural and ornamental bronzes, etc.), only the greatest dimension is given. Height, width, and depth are recorded for all pieces of freestanding furniture and for those objects whose regular shapes are meaningfully described in three dimensions (sarcophagi, reliquaries, and boxes, for example).

The museum has no standardized style or method of assigning dates to works of art. For their information the compilers have relied on the records, practices, and opinions of the museum's individual curatorial departments; while the more eccentric forms of reporting have been eliminated, the present publication nonetheless includes a surprising variety of renderings. The following explanations are offered with the knowledge that similar designations may be differently used in other institutions:

★ Egyptian and many Asian artworks are characterized as products of a dynasty or dynastic-type period, and whenever possible are also assigned approximate or specific dates. The abbreviations "B.C." and "A.D." are used only in sections that include objects made both before and after the birth of Christ. While B.C. is used in connection with every object made at that time, A.D. is used with dates before the year 1000 in order to avoid ambiguity.

★ "Dated 1330," for example, indicates that there appears on the artwork itself a date (written, printed, painted, stamped, or inscribed) that is accepted as original to the artwork and therefore authoritative.

★ "1889," for example, indicates that while the artwork itself bears no date, documentation or some other form of external evidence confirms that it was accomplished in the stated year.

★ "1635–36," for example, indicates that while the artwork itself bears no date, documentation or some other form of external evidence confirms that it was begun in the earlier year and completed in the later year.

★ "Bears date 1649," for example, indicates that while the authenticity of the artwork itself is unquestioned, the date it carries was not necessarily applied by the artist to whom the work is attributed, nor, indeed, is it necessarily of comparable age.

★ "Dated to the reign of Kuang-shun (A.D. 951–53)," for example, indicates that while the artwork itself bears no date, documentation or some other form of external evidence confirms that it was accomplished during the reign of a particular ruler.

★ The use of "c." standing for *circa* (whose translation into English of "around" or "about" is ambivalent) varies from one department to the next. With reference to objects of some antiquity it is most often used to mean "approximately," whereas for artworks of more recent origin its use is much more restrictive. Degas's *Rehearsal of the Ballet,* for example, is dated "c. 1876,"

meaning that it can be assigned confidently to the stated year—plus or minus a year or so—on the basis of circumstantial evidence or stylistic comparison with other works documented to the same year.

★ The use of a slash indicates that while the exact date of execution is unknown, the artwork can be assigned confidently to the time frame that is more or less well defined by the stated years or even centuries. This time frame may be quite broad, as in "4th/5th century A.D.," or narrowed to a single decade, as in "1160/70." For Monet's *Boulevard des Capucines,* which bears no date, the date "1873/74" signifies that documentation or some other form of external evidence confirms that the painting was accomplished at some point during the two consecutive years of 1873 and 1874, but whether wholly in one or the other, or over an extended period comprising parts of both years, is unknown. Any designation incorporating a slash may be further qualified by combination with a "c." for *circa.*

★ The absence of a date indicates that the relevant curatorial department offers none for the object beyond general period dates, life dates of an artist, etc.

COLORPLATES

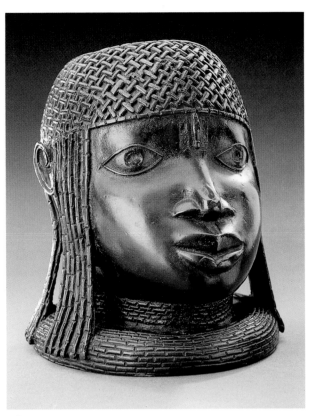

African
Memorial Head of an Oba [87-7]
[see p. 84]

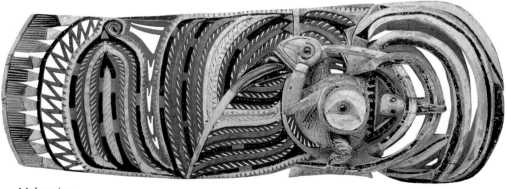

Melanesian
Bird Frieze [F92-8]
[see p. 89]

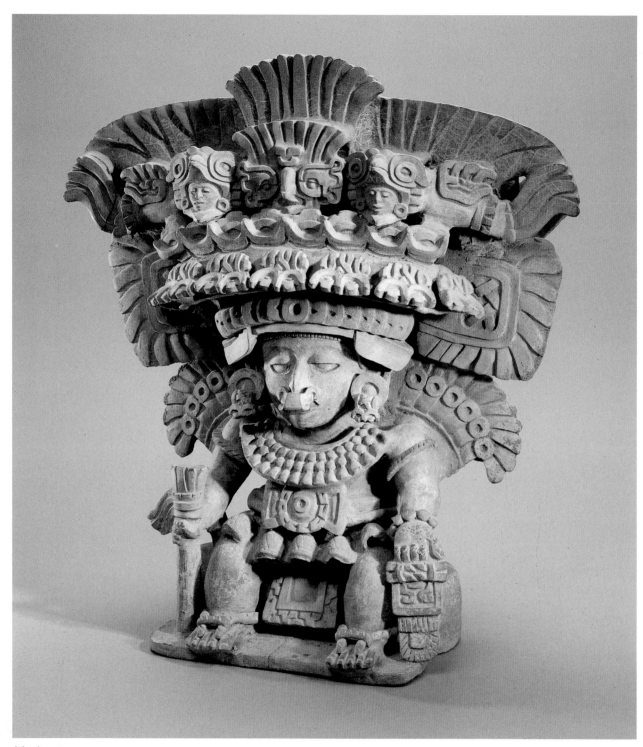

Mexican
Figural Urn [61-16]
[see p. 90]

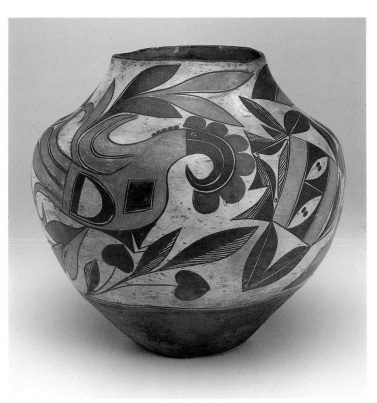

Native American
Olla (Storage Jar) [50-73/8]
[see p. 98]

Native American
Parfleche (Storage Bag) [31-125/4]
[see p. 101]

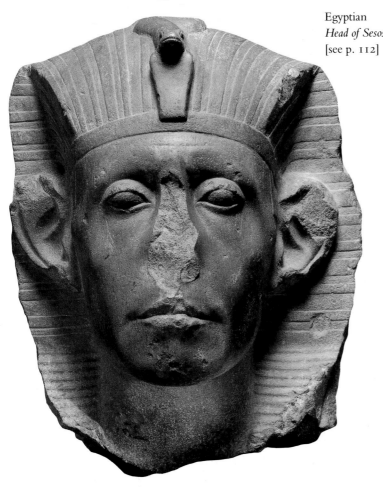

Egyptian
Head of Sesostris III [62-11]
[see p. 112]

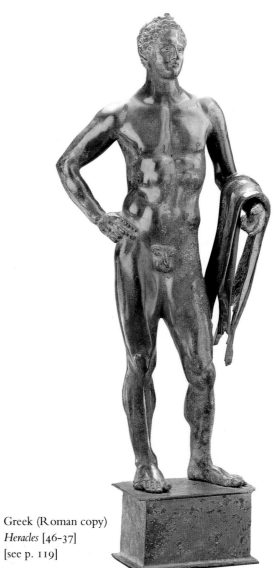

Greek (Roman copy)
Heracles [46-37]
[see p. 119]

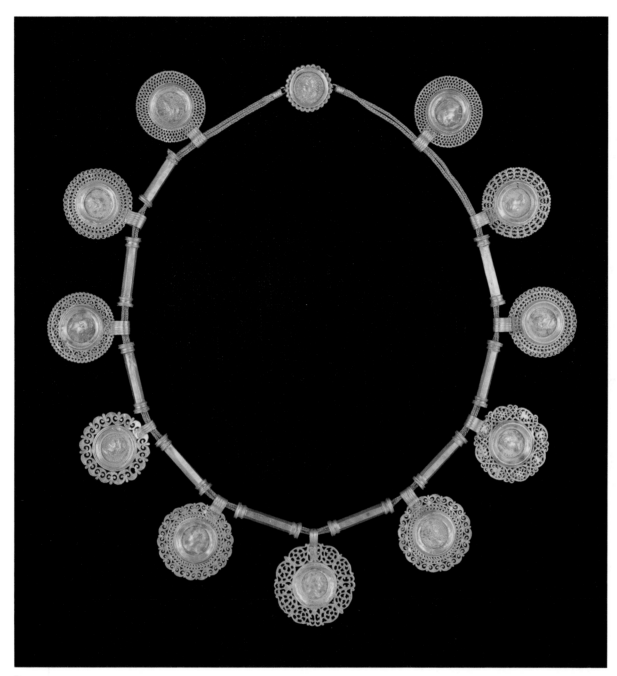

Roman
Necklace of Coins Bearing Imperial Portraits [56-77]
[see p. 123]

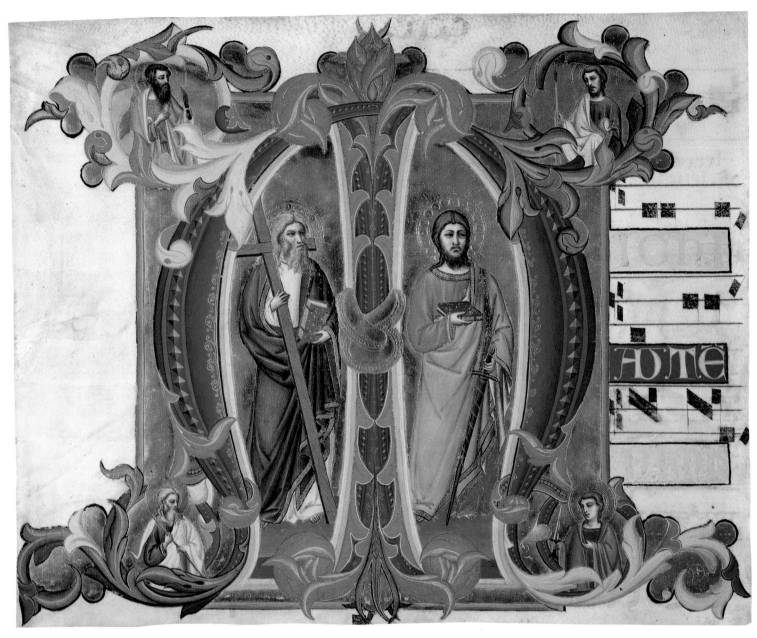

Attributed to Don Silvestro dei Gherarducci

Initial "M" with Saints Andrew and Matthew(?) [F61-14]

[see p. 137]

Attributed to the workshop of the Boucicaut Master
King David as Psalmist [34-303/1]
[see p. 139]

Petrus Christus
The Holy Family in a Domestic Interior [56-51]
[see p. 140]

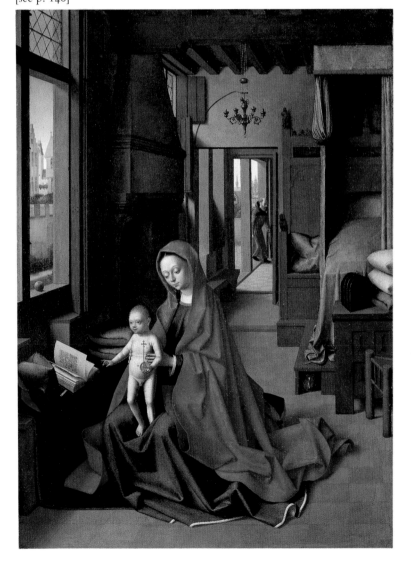

German
The Disrobing of Christ [33-1629]
[see p. 141]

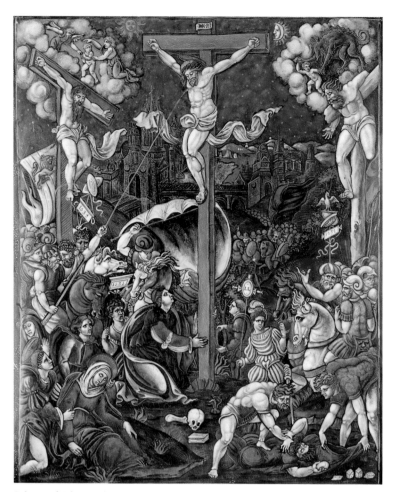

Léonard Limousin
The Crucifixion [31-106]
[see p. 152]

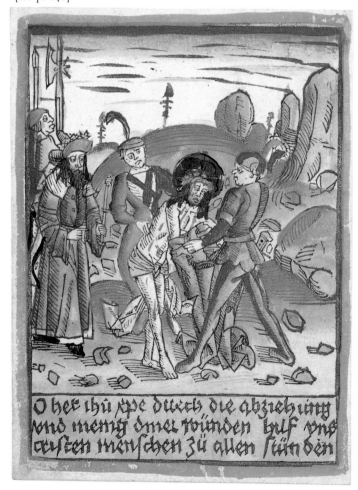

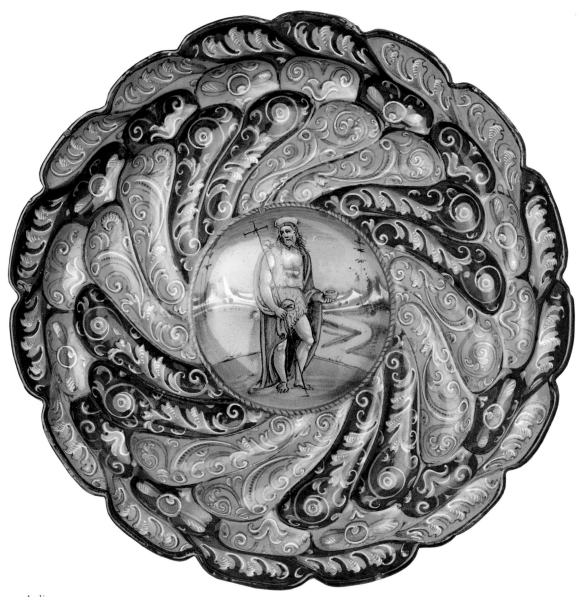

Italian
Dish with Scene of Saint John the Baptist in the Wilderness [43-39/8]
[see p. 152]

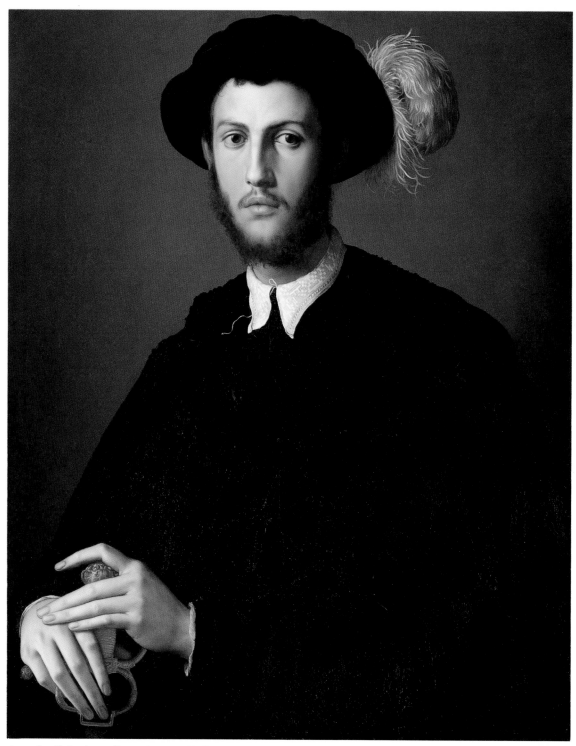

Agnolo di Cosimo di Mariano, called Bronzino
Portrait of a Young Man [49-28]
[see p. 153]

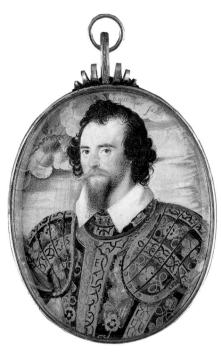

Nicholas Hilliard

Portrait of George Clifford, Third Earl of Cumberland [F58-60/188]
[see p. 175]

Attributed to the workshop of Hubert Gerhard

Saint John the Evangelist and *Saint Jude* [59-71/1,2]
[see p. 156]

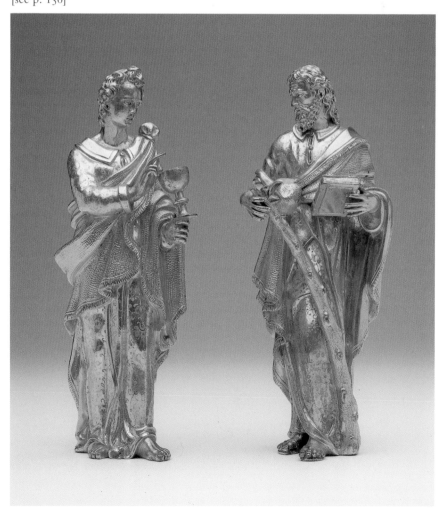

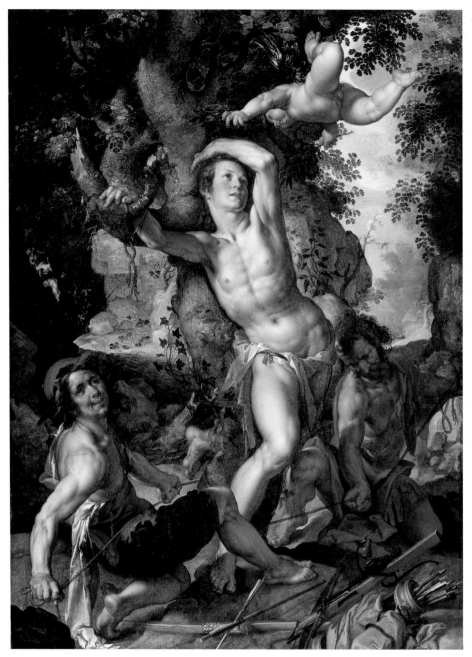

Joachim Anthonisz. Wtewael
The Martyrdom of Saint Sebastian [F84-71]
[see p. 159]

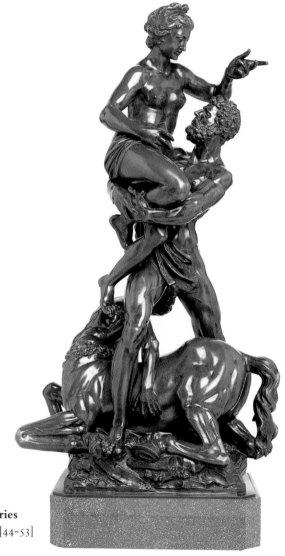

Attributed to Adriaen de Vries
Hercules, Deianeira, and Nessus [44-53]
[see p. 159]

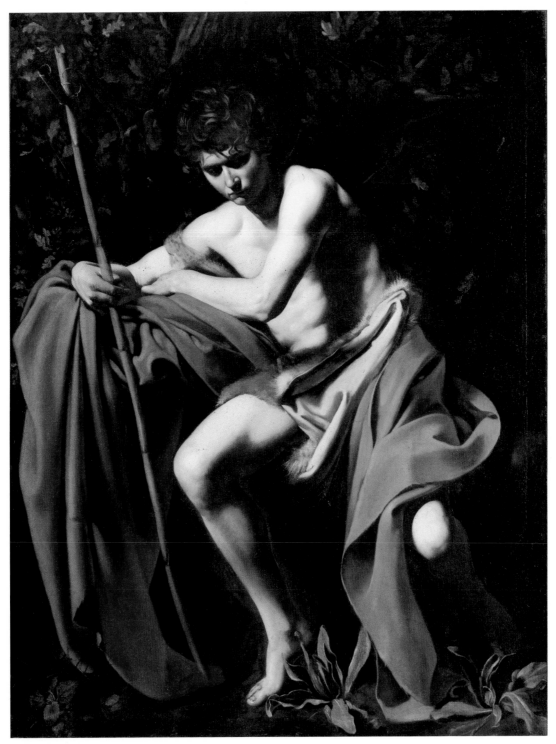

Michelangelo Merisi, called Caravaggio

Saint John the Baptist [52-25]

[see p. 160]

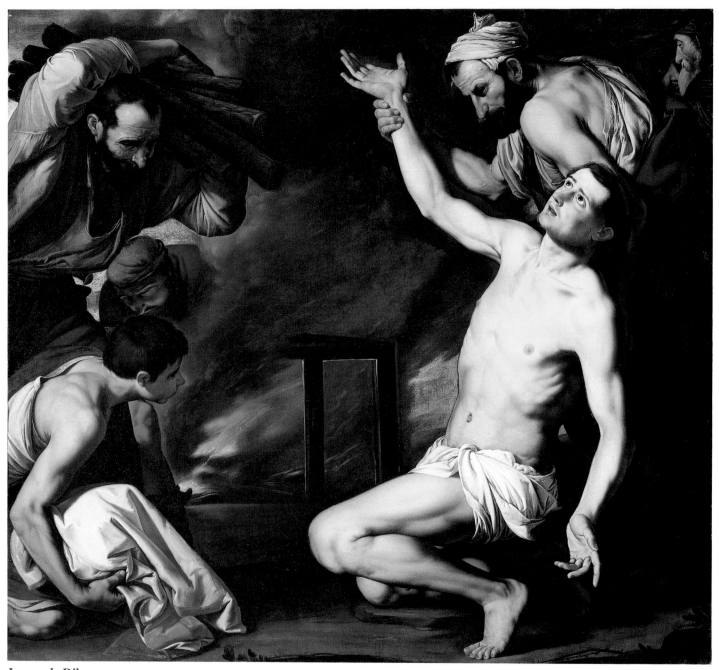

Jusepe de Ribera
The Martyrdom of Saint Lawrence [88–9]
[see p. 161]

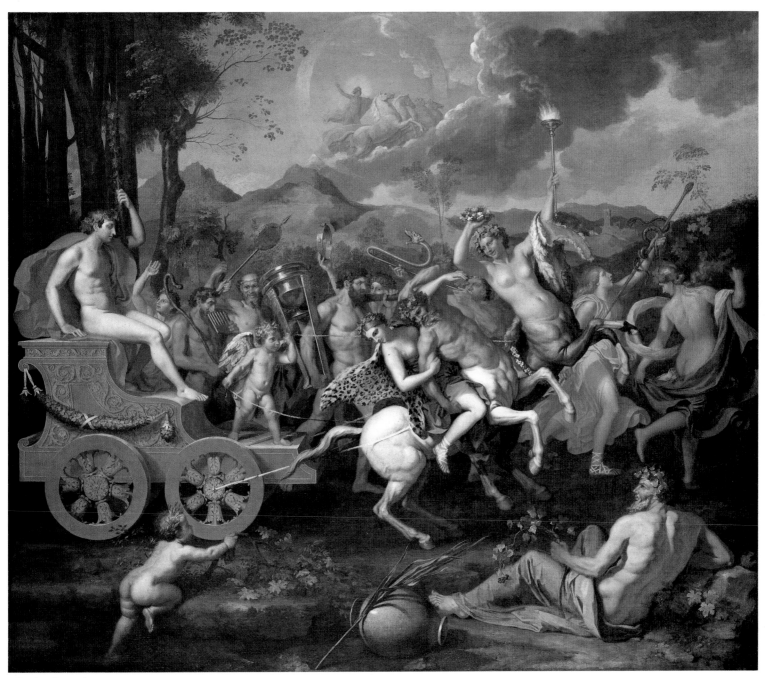

Nicolas Poussin
The Triumph of Bacchus [31-94]
[see p. 164]

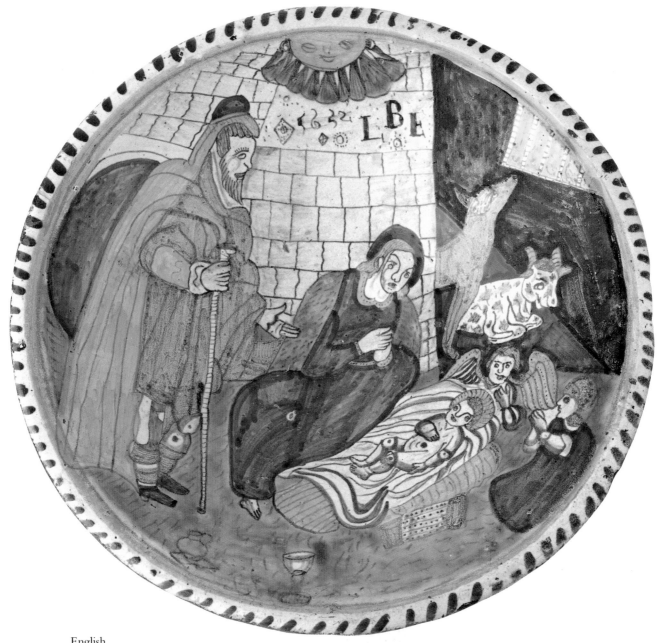

English
Charger with Scene of the Nativity [57-10]
[see p. 176]

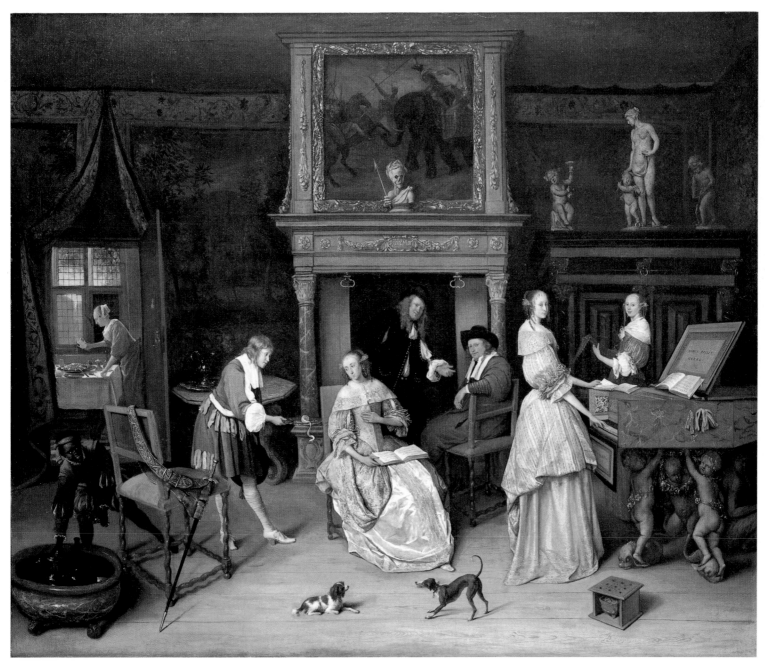

Jan Steen
Fantasy Interior with Jan Steen and Jan van Goyen [67-8]
[see p. 171]

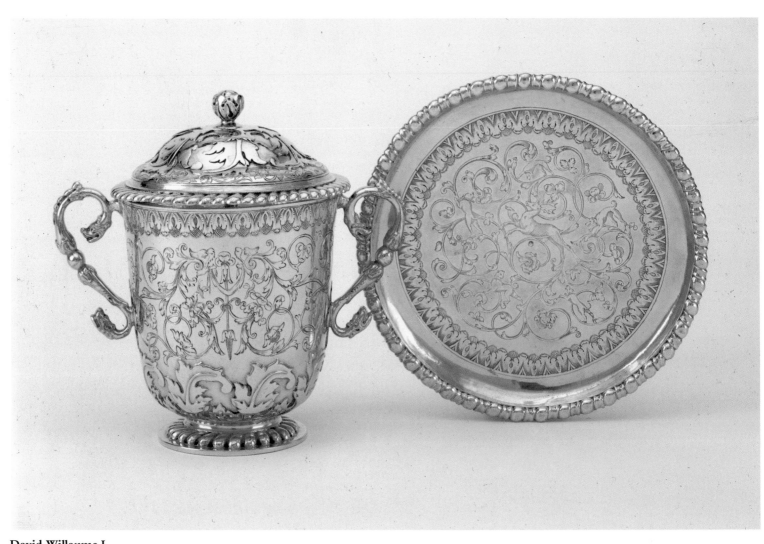

David Willaume I
Covered Cup and Stand [F92-19/1 a–c]
[see p. 178]

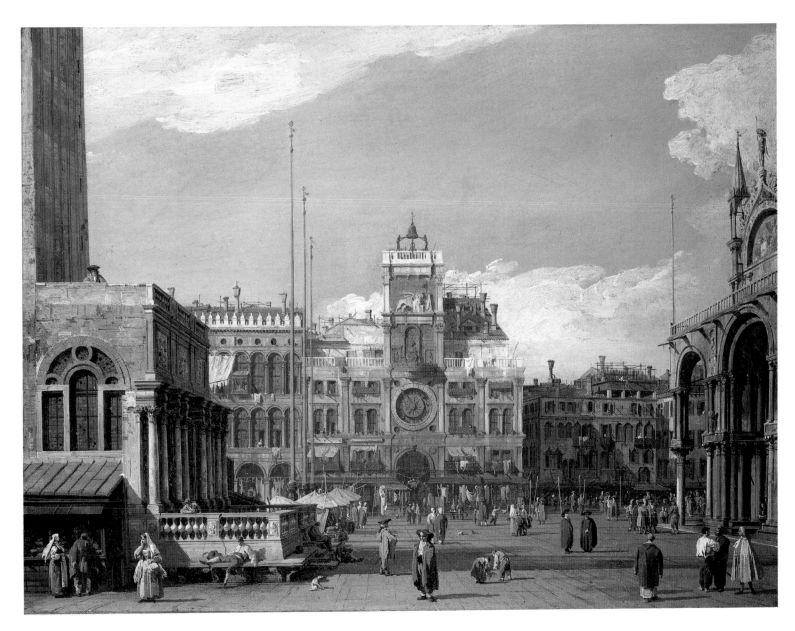

Giovanni Antonio Canale, called Canaletto

The Clock Tower in the Piazza San Marco [55-36]

[see p. 183]

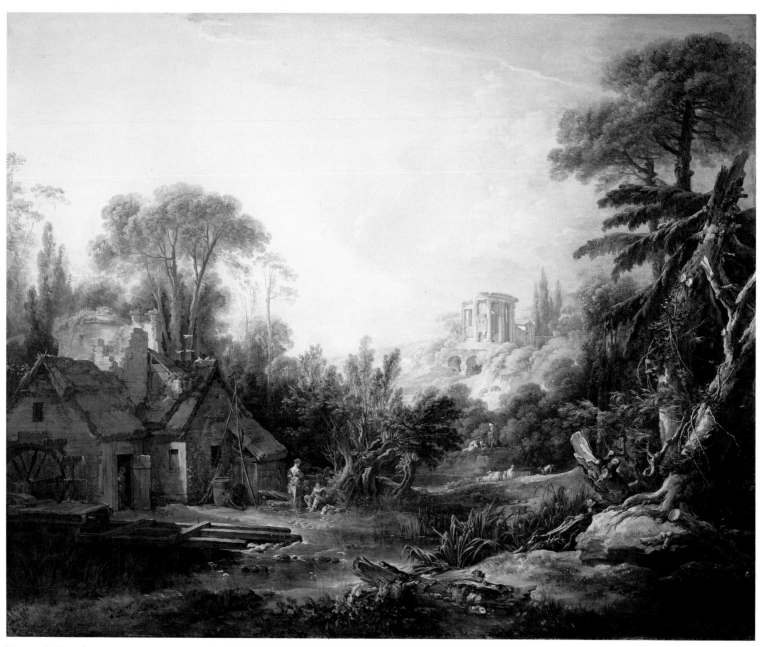

François Boucher

Landscape with a Water Mill [59-1]

[see p. 184]

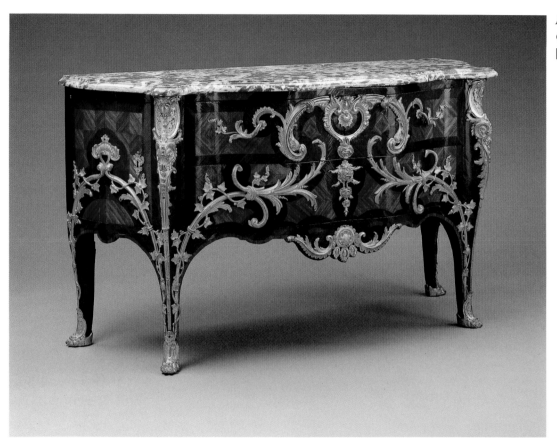

Attributed to Charles Cressent
Chest of Drawers [65-19]
[see p. 187]

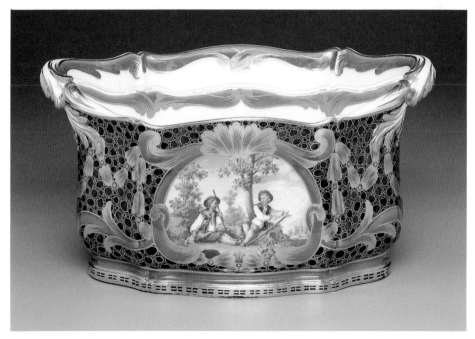

Sèvres Porcelain Manufactory
Vase "Choisy" [90-36]
[see p. 190]

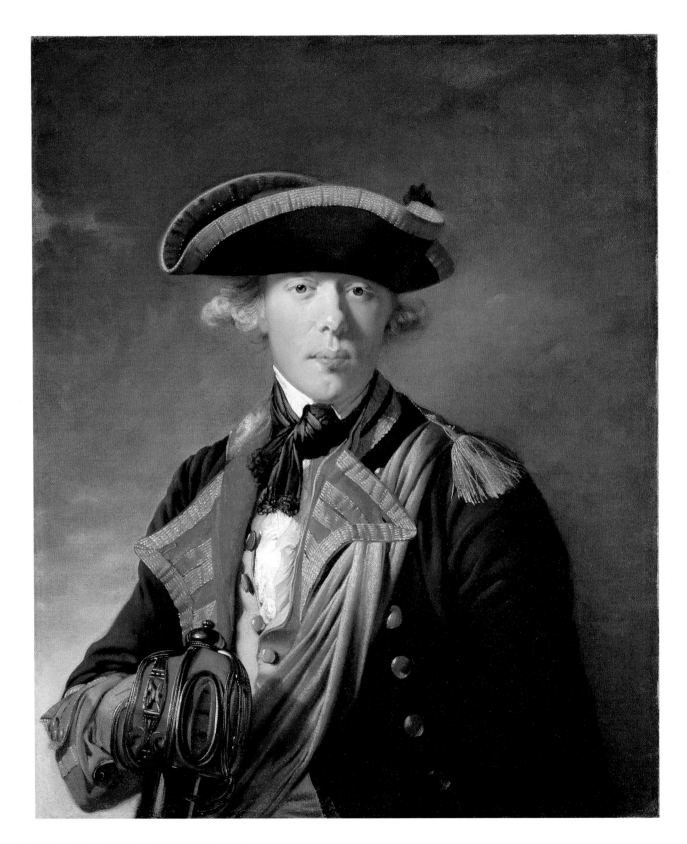

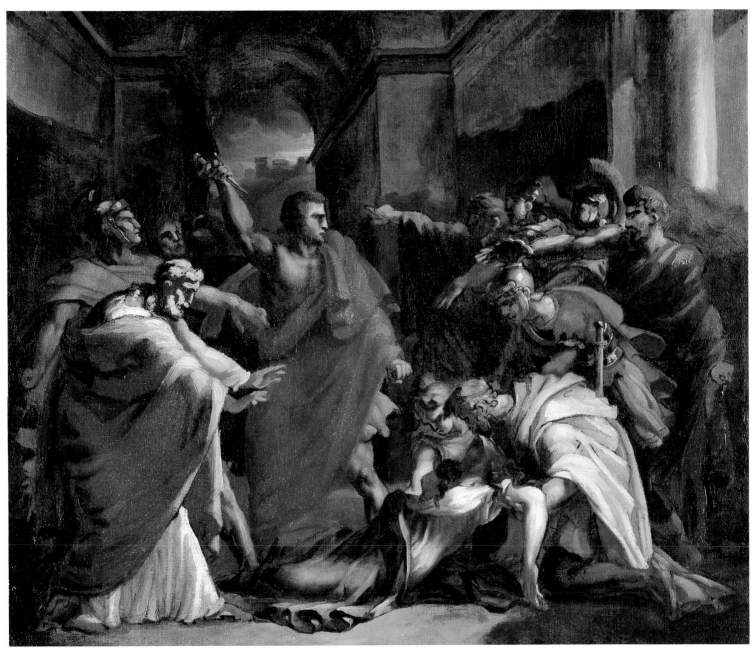

J.-L.-A. Théodore Géricault
The Oath of Brutus after the Death of Lucretia [92-35]
[see p. 199]

Joseph Wright of Derby
Sir George Cooke, Bart. [30-19]
[see p. 192]

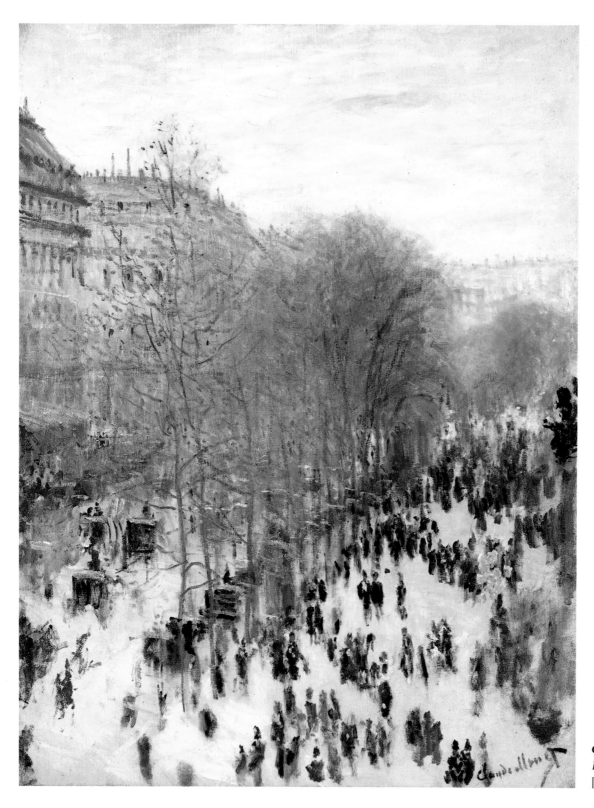

Claude Monet
Boulevard des Capucines [F72-35]
[see p. 206]

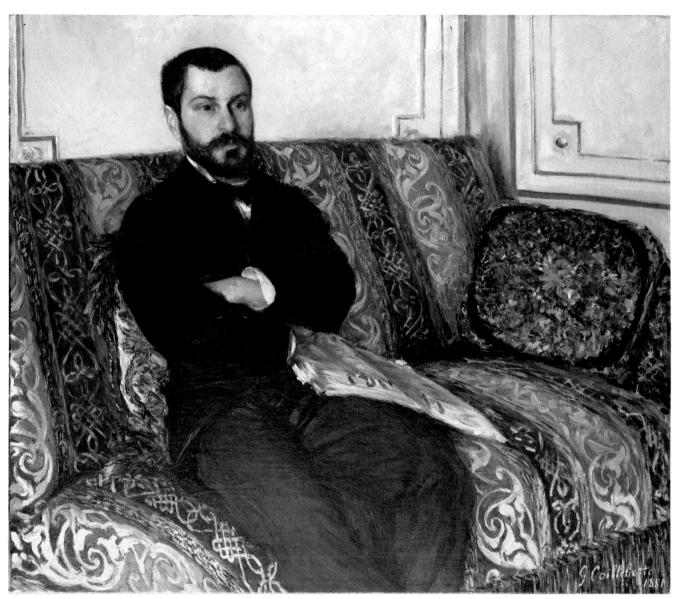

Gustave Caillebotte
Portrait of Richard Gallo [89-35]
[see p. 210]

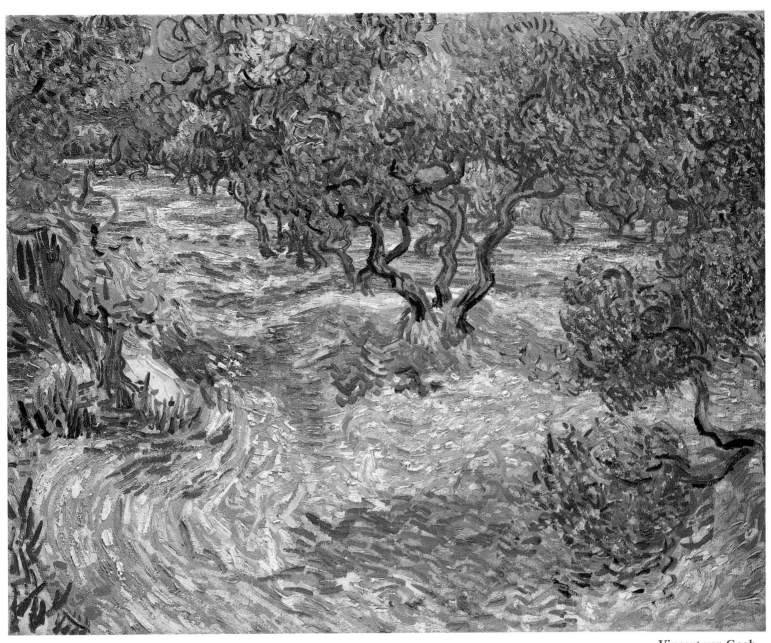

Vincent van Gogh
Olive Orchard [32-2]
[see p. 211]

Anna Alma-Tadema
Interior of the Gold Room [81-30/86]
[see p. 210]

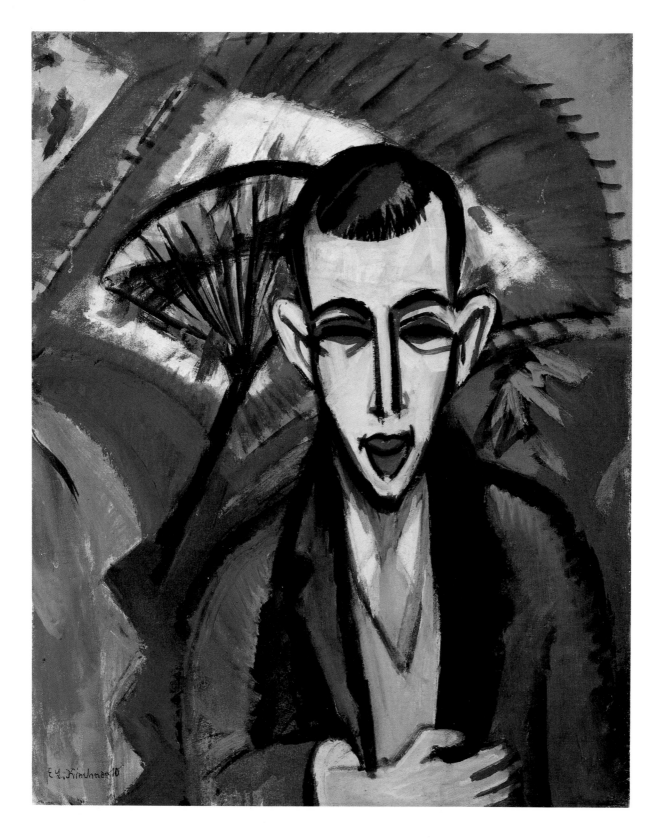

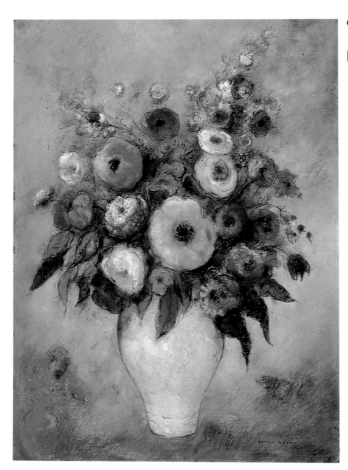

Odilon Redon
Vase of Flowers [F76–1]
[see p. 217]

Wassily Kandinsky
Rose with Gray [F62–9]
[see p. 220]

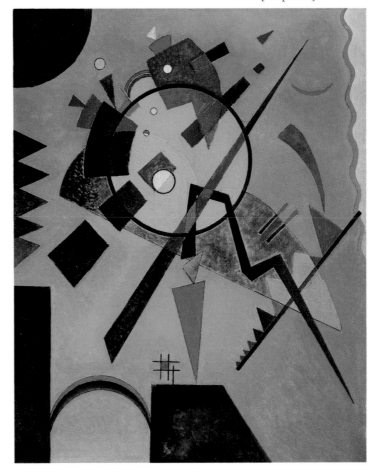

Ernst Ludwig Kirchner
Portrait of the Poet Guthmann [54–88]
[see p. 215]

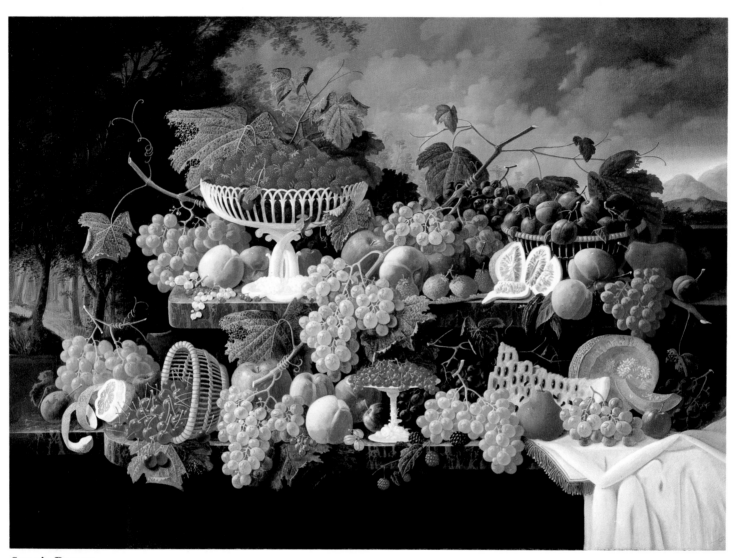

Severin Roesen
Two-Tiered Still Life [F91–58]
[see p. 234]

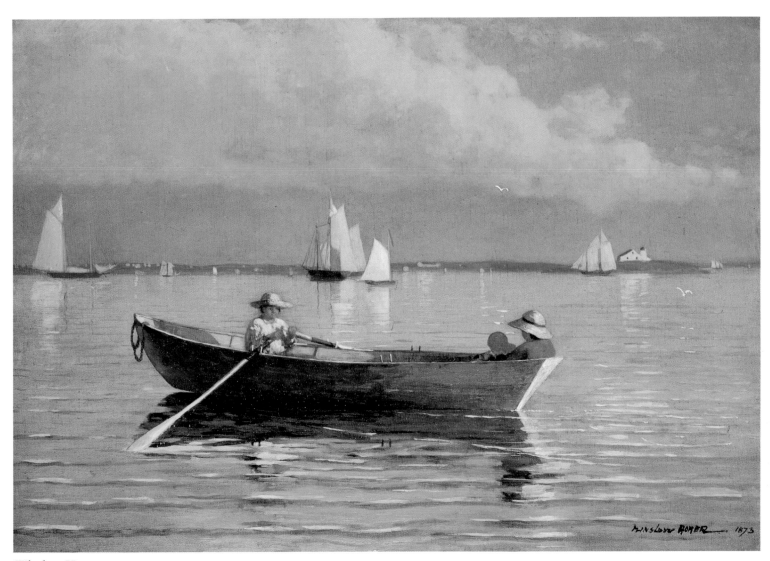

Winslow Homer

Gloucester Harbor [F76-46]

[see p. 236]

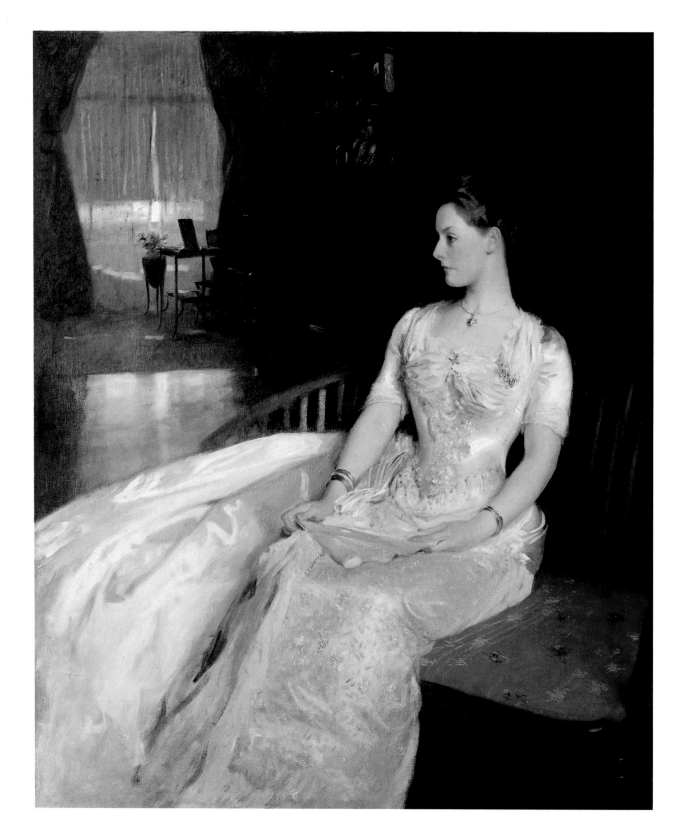

Childe Hassam
Sonata [52-5]
[see p. 240]

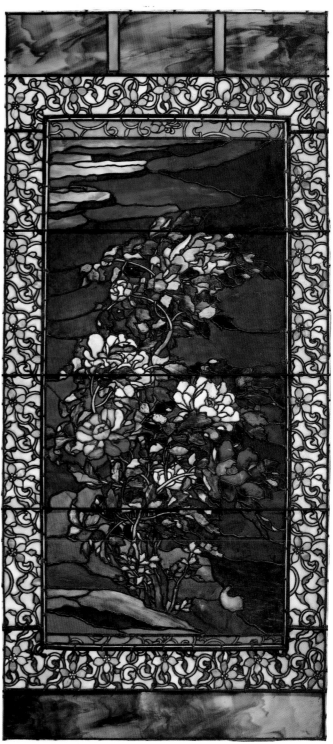

John Singer Sargent
Portrait of Mrs. Cecil Wade [F86-23]
[see p. 238]

John La Farge
Peonies Blowing in the Wind [F88-34]
[see p. 239]

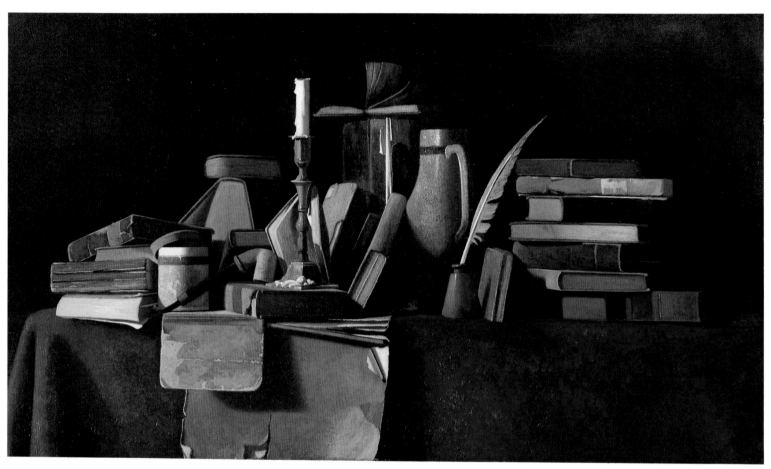

John Frederick Peto
Books on a Table [90-11]
[see p. 242]

Marsden Hartley
Himmel [56-118]
[see p. 245]

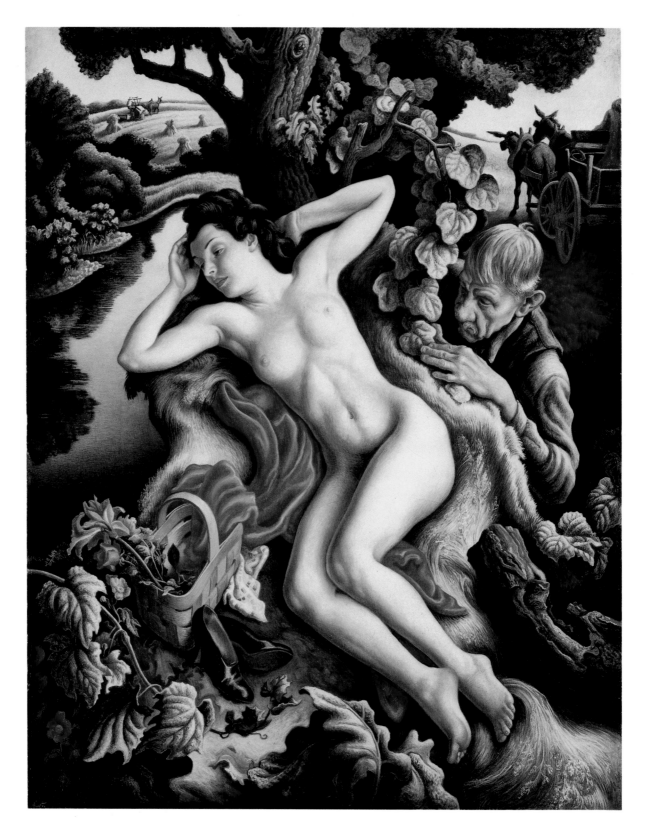

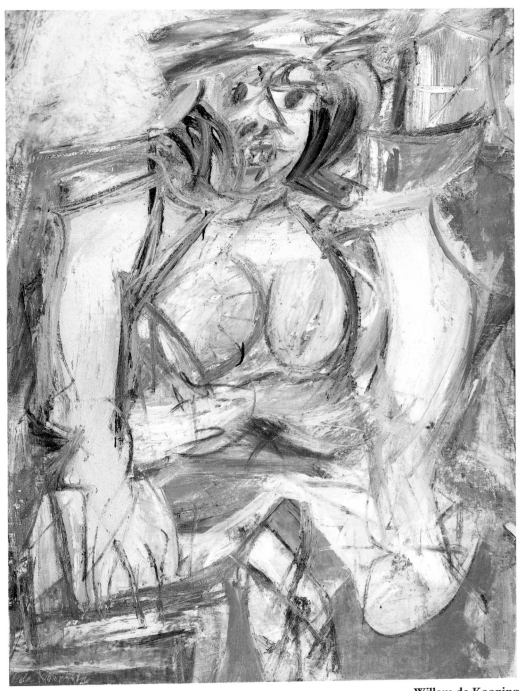

Willem de Kooning
Woman IV [56-128]
[see p. 251]

Thomas Hart Benton
Persephone [F86-57]
[see p. 248]

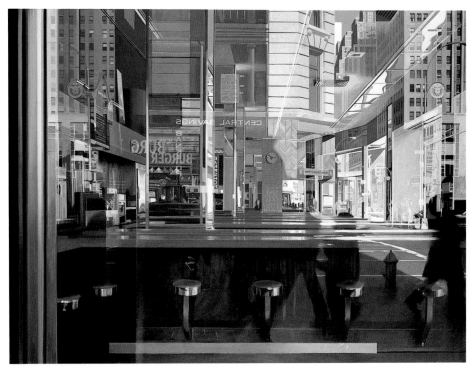

Richard Estes
Central Savings [F75-13]
[see p. 259]

Philip Pearlstein
Two Models from the Other Side of the Easel [F87-25]
[see p. 262]

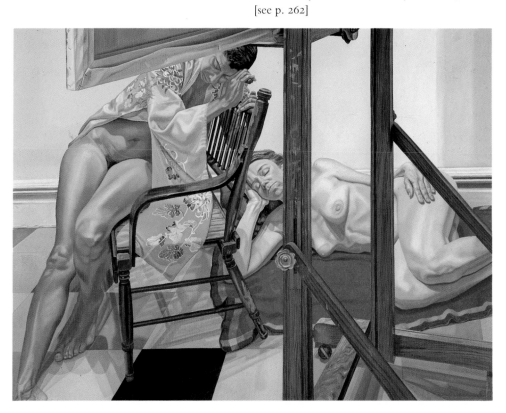

Robert Rauschenberg
Tracer [F84-70]
[see p. 255]

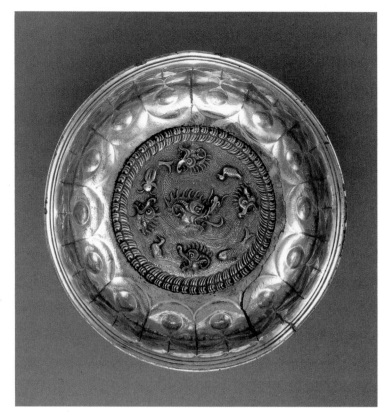

Chinese
Bowl [56-72]
[see p. 338]

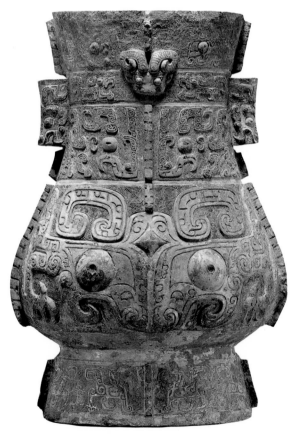

Chinese
Ritual Wine Vessel, type *feng-hu* [55-52]
[see p. 272]

Chinese
Bactrian Camel with Packsaddle [F83-8/3]
[see p. 292]

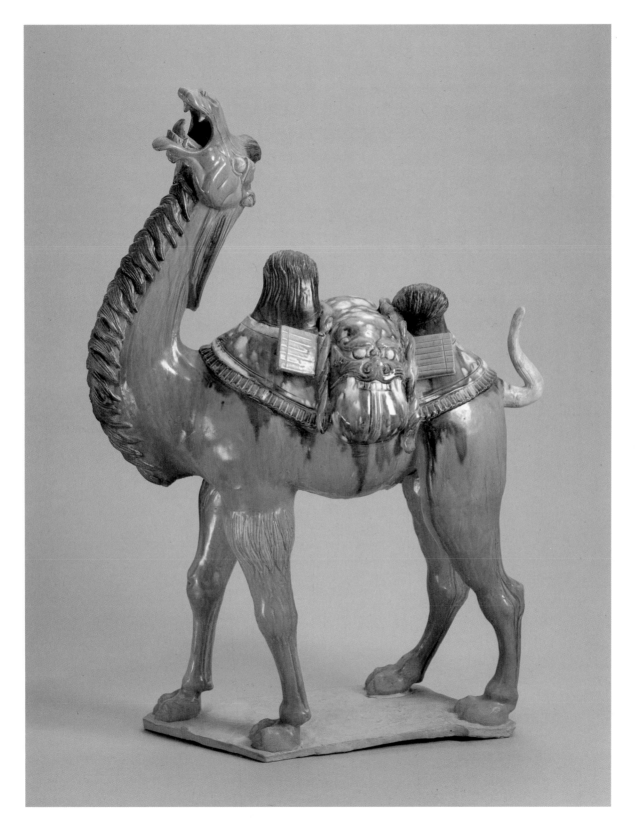

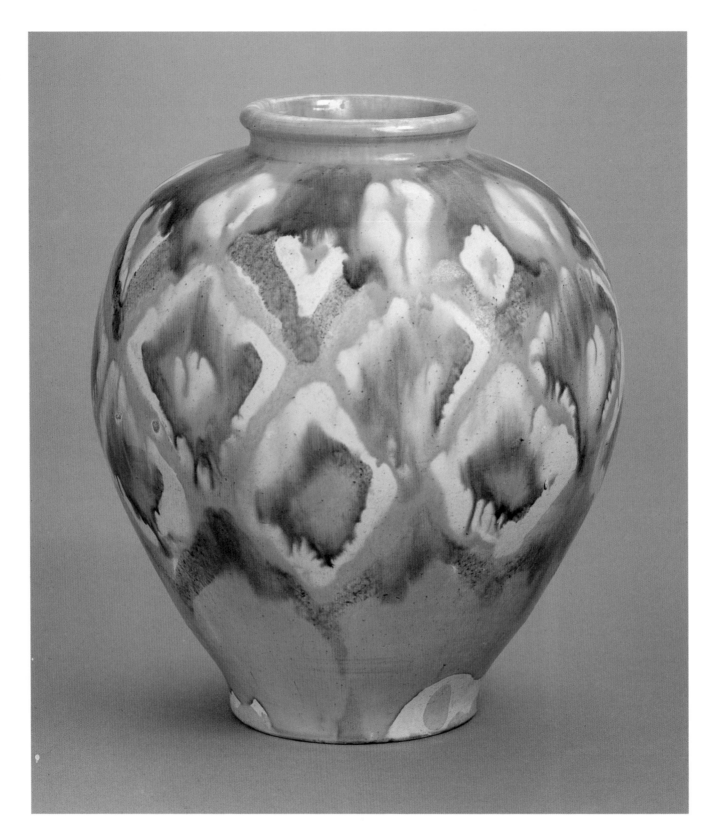

Chinese
Jar [52-19]
[see p. 291]

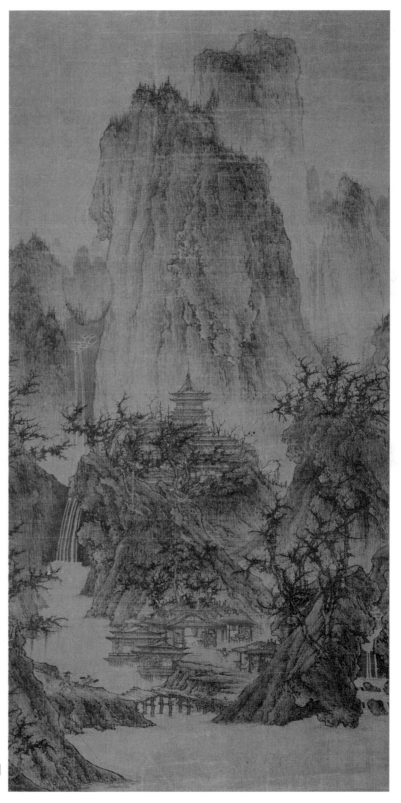

Attributed to Li Ch'eng
A Solitary Temple amid Clearing Peaks [47-71]
[see p. 314]

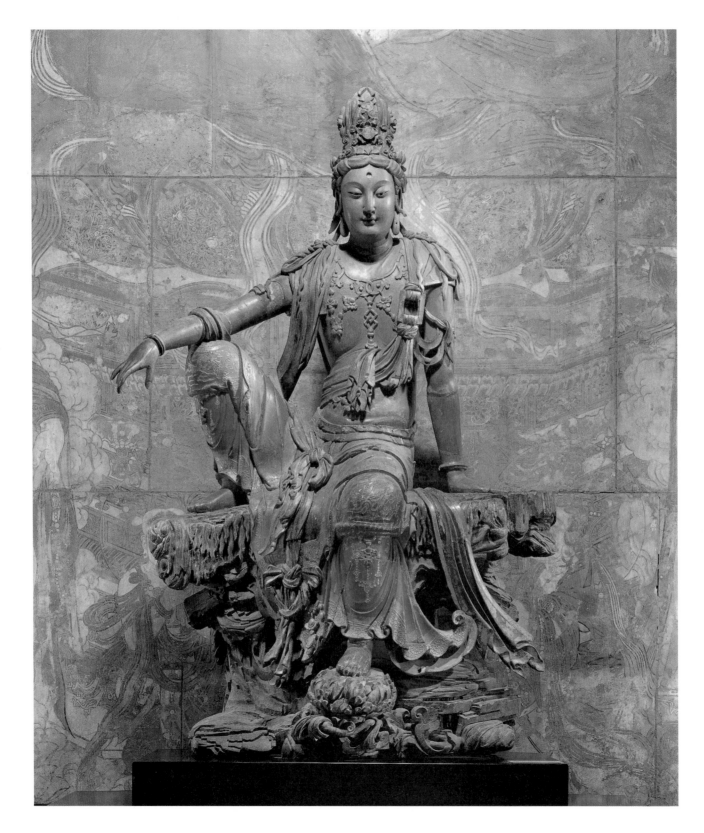

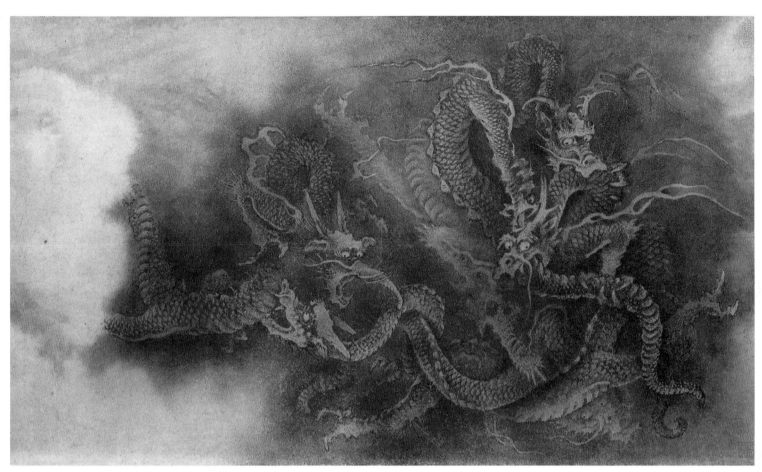

Attributed to Ch'en Jung
Five Dragons [48-15]
[see p. 318]

Chinese
The Water and Moon Kuan-yin Bodhisattva [34-10]
[see p. 310]

Chinese
Pair of Vases [40-45/1,2]
[see p. 298]

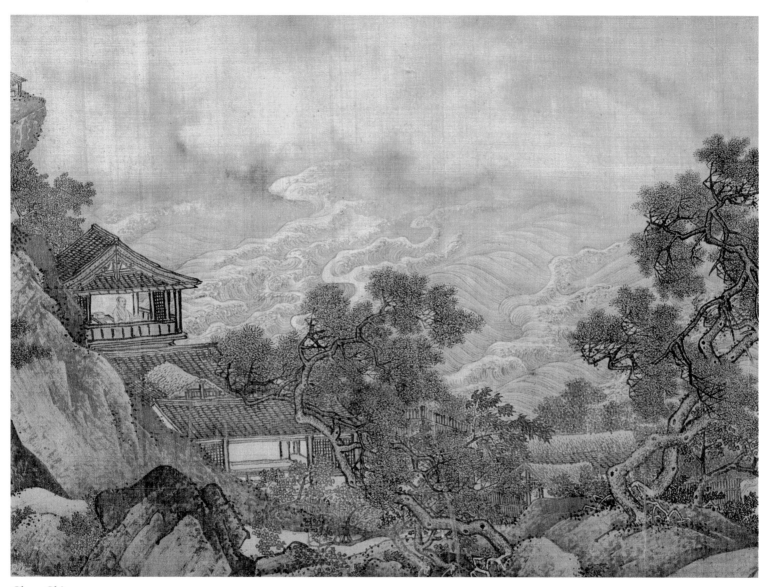

Chou Ch'en
The North Sea (detail) [58-55]
[see p. 324]

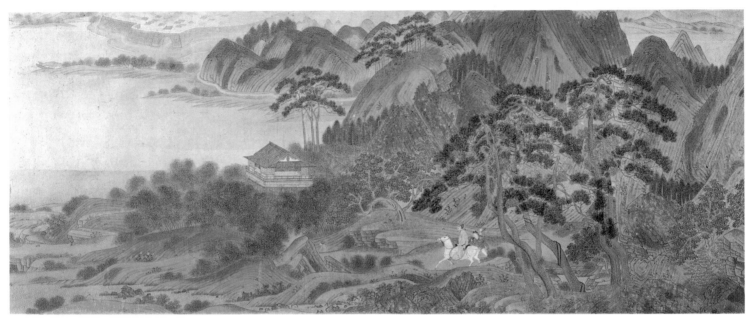

Ch'iu Ying
Saying Farewell at Hsün-yang (section) [46–50]
[see p. 325]

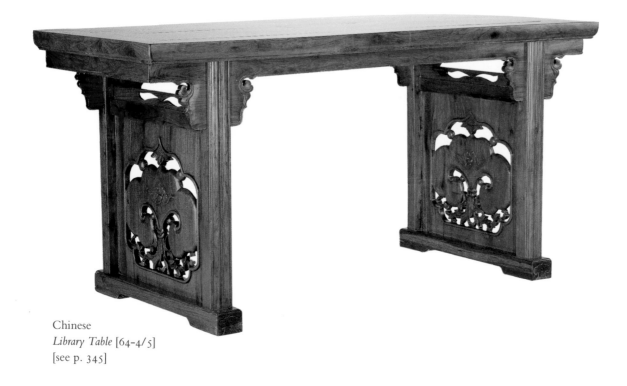

Chinese
Library Table [64-4/5]
[see p. 345]

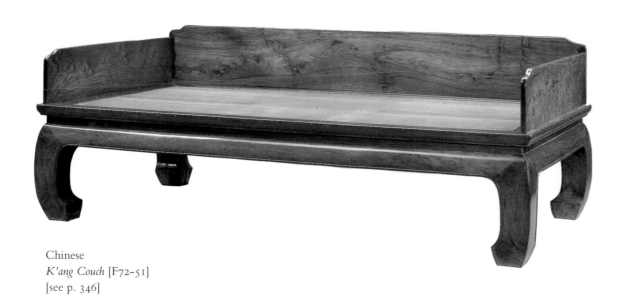

Chinese
K'ang Couch [F72-51]
[see p. 346]

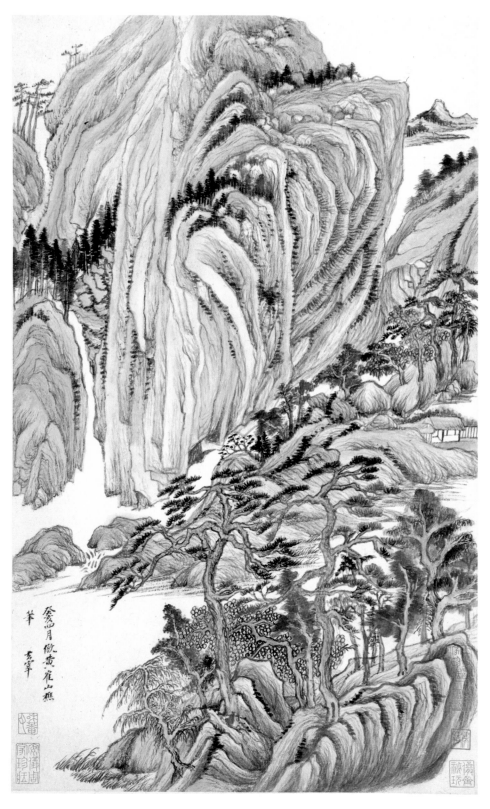

Tung Ch'i-ch'ang
Landscape after Wang Meng [86-3/3]
[see p. 327]

Japanese
Shaka Triad with Sixteen Rakan [F86-27]
[see p. 358]

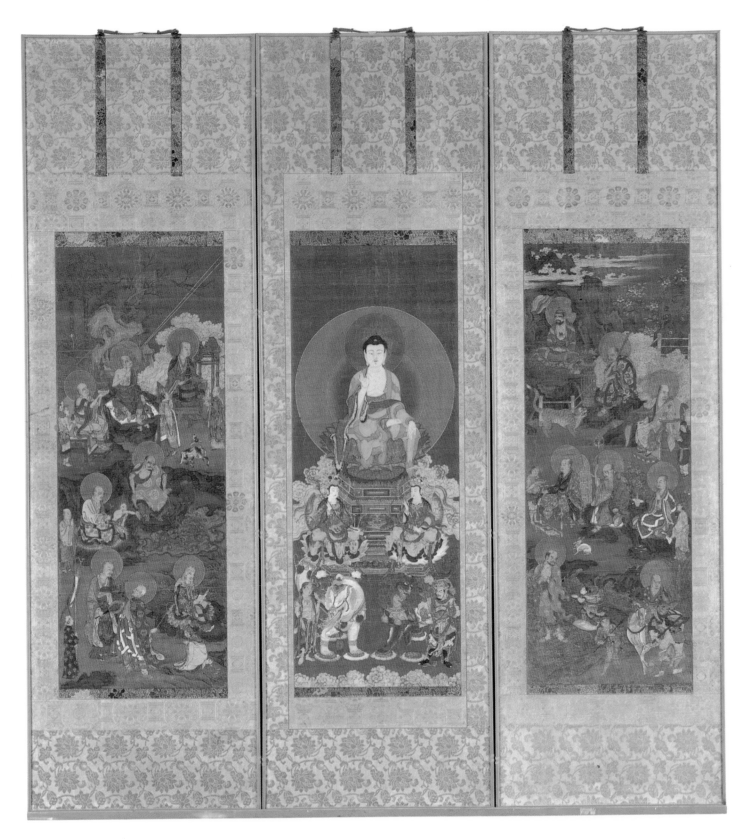

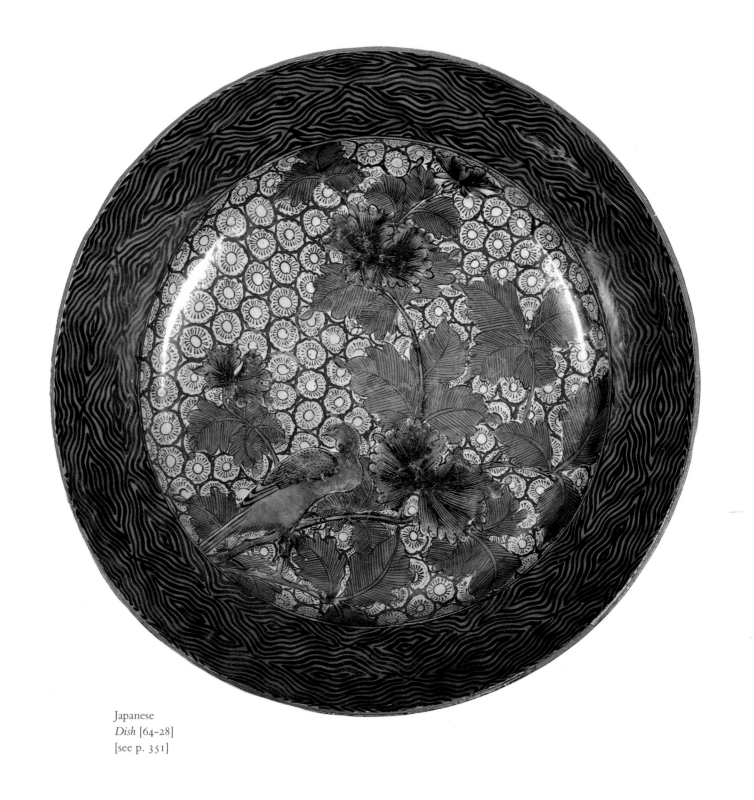

Japanese
Dish [64-28]
[see p. 351]

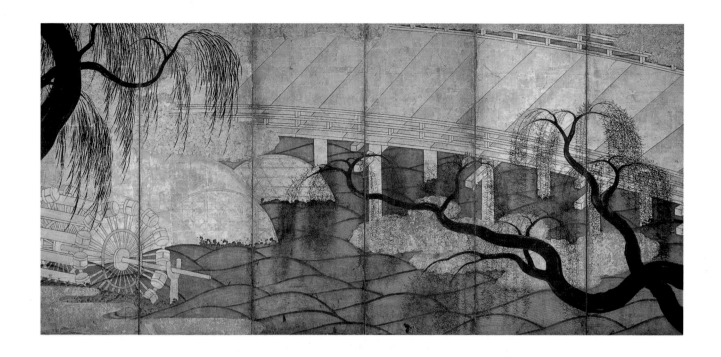

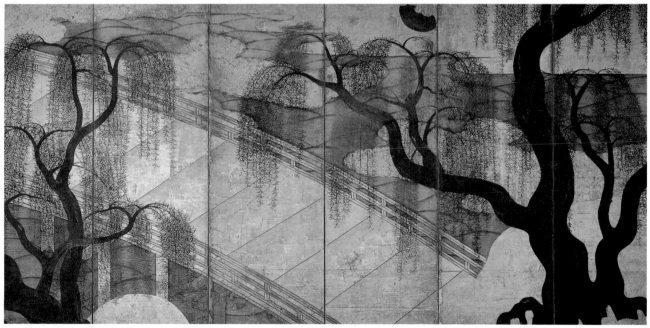

Japanese
The River Bridge at Uji [58-53/1,2]
[see p. 359]

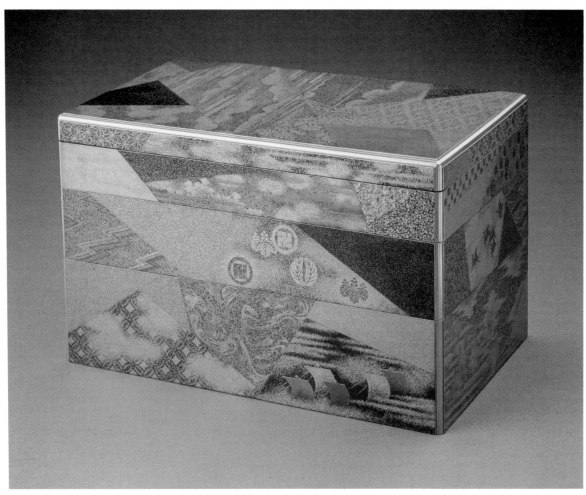

Izuka Tōyō
Tiered Writing Box [F78-23]
[see p. 373]

Katsushika Hokusai
Kirifuri Waterfall at Mount Kurokami [32-143/183]
[see p. 370]

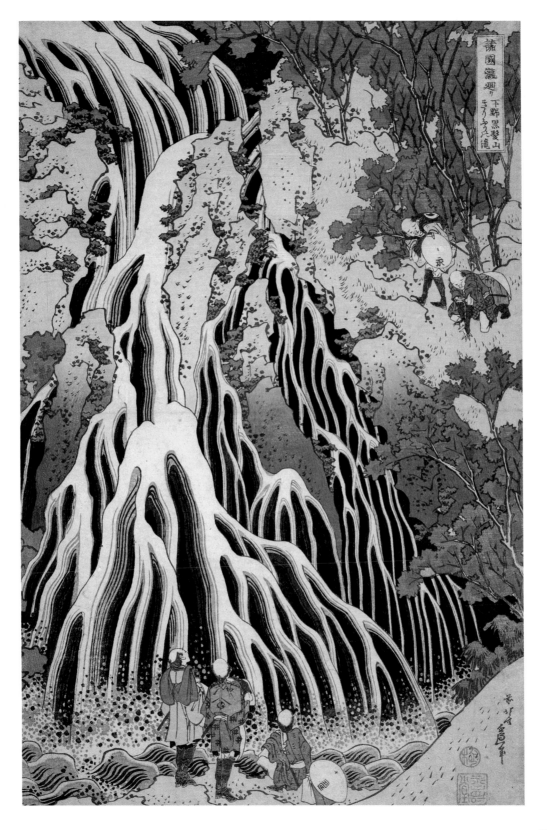

Attributed to Lal
The Poet and the Prince [48-12/1]
[see p. 388]

Indian
Torso of a Buddha [45-15]
[see p. 377]

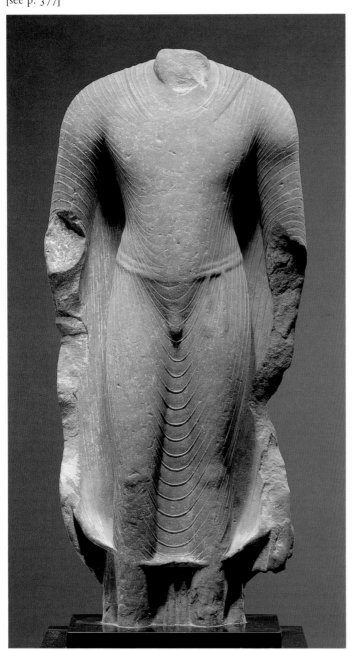

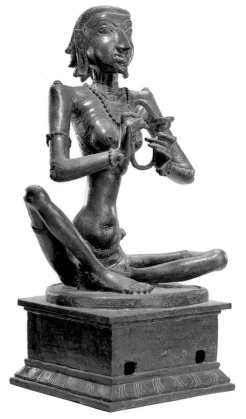

Indian
Karaikkalammaiyar, a Shaiva Saint [33-533]
[see p. 387]

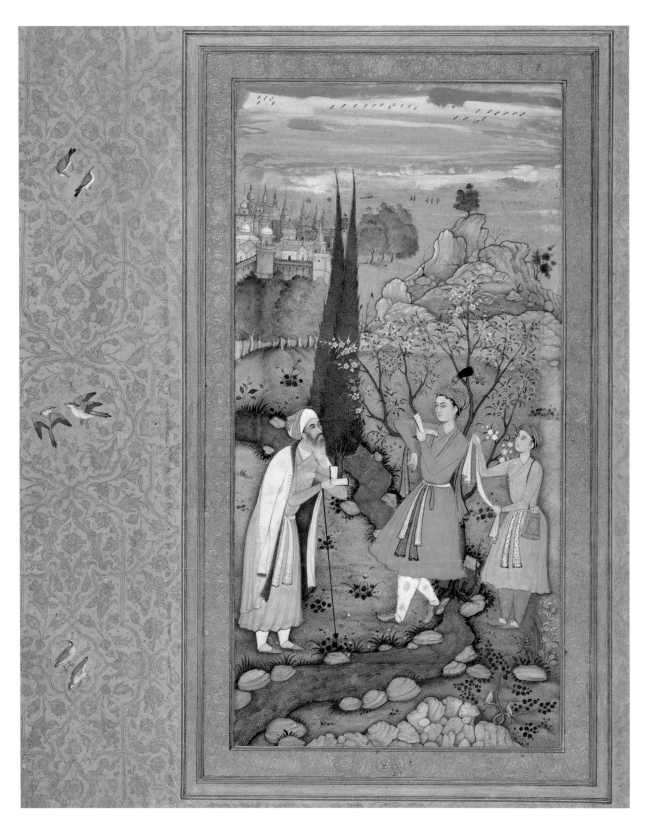

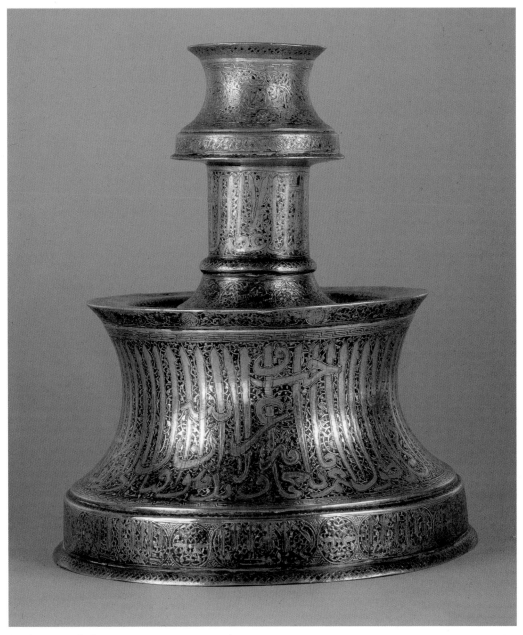

Persian or Turkish
Candlestick [51-6]
[see p. 400]

'Abd Allah Musawwir
The Meeting of the Theologians [43-5]
[see p. 403]

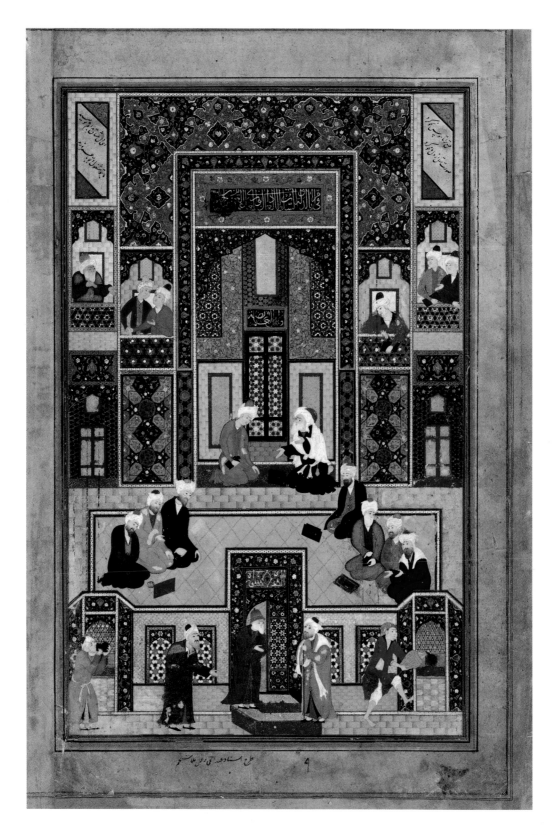

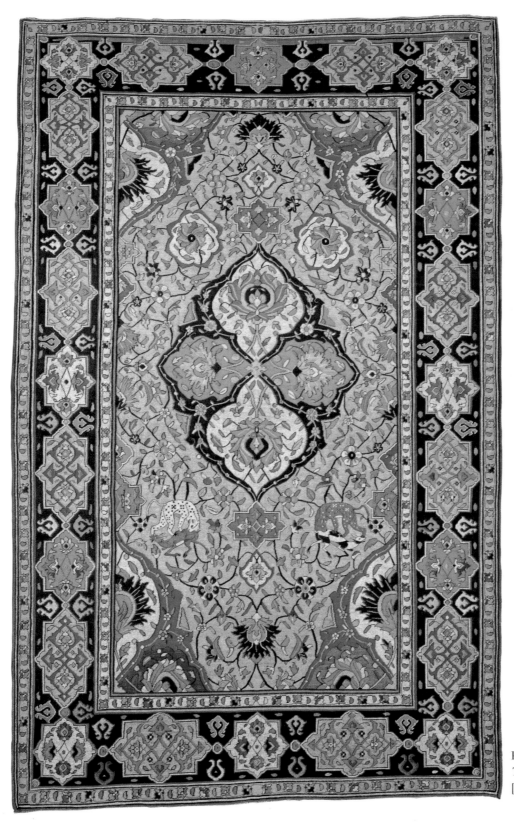

Persian
Tapestry-Woven Medallion Rug [32-70]
[see p. 405]

I

The Arts of Africa, Oceania, and the Americas

Neither the early-day University Trustees nor the museum's small professional staff demonstrated much official interest in the visual records of the civilizations of Africa or of the diverse, multicultural people of the far-flung Pacific islands. It is entirely consistent with the standards of the time that they might have thought of such material as "primitive" or "tribal," and most likely would not have considered it art so much as artifact, better suited to the ethnological collection of a natural-history museum. Therefore it is not surprising that the African objects collected in the 1930s could hardly be described as more than trinkets. It was not until the late 1950s, in fact, that the first important African sculptures—two works from Benin—were acquired. These purchases were followed in 1965 by the acquisition of the magnificent Asante *Stool,* one of the masterpieces of the collection. In recent years, with purchases stimulated and complemented by gifts from private collectors, an admirable group of Central and West African sculpture and masks has been assembled with particular preference shown for the artistic traditions of the people of the modern-day states of Zaire, Congo, Gabon, Cameroon, Nigeria, Ghana, Ivory Coast, and Mali. The Bekom *Helmet Mask* and the Bena Lulua *Standing Figure* are typical of this pattern. Surely the most significant acquisition of recent years is the exceptional *Memorial Head of an Oba* (colorplate, page 21), a ritualistic sculpture, made at the zenith of the Benin kingdom, whose aesthetic and technical merits are equally compelling. While the collection is still limited in size and scope, and cannot yet be described as exhibiting a specialty, the wonderfully distinctive objects are lent a kind of unity by the high standard of quality to which they adhere.

The collection features only a modest number of works from Oceania, that vast area of the Pacific whose disparate islands and archipelagoes are rather generally designated Melanesia, Micronesia, and Polynesia according to the ethnic and cultural affinities of their respective native peoples. Most of these objects have been given by discerning collectors whose interest in this field ran far ahead of the museum's. The handful of material made by the Maori people of New Zealand, who are Polynesians, includes a notably early lintel made of pigmented totara wood and haliotis shell. A miscellany of objects from the Sepik River basin of northern Papua New Guinea includes several masks of powerful design and skilled craftsmanship, a few bowls, an orator's stool, and a striking roof-peak ornament. From elsewhere in Papua New Guinea come some of the best items in the collection: a recently donated shield, for example, was made in the Green River area, while the Malagan carving with fabulous zoomorphic forms (colorplate, page 21) is a creation of the people of New Ireland. These holdings are complemented by a smattering of Asmat weaponry, from southwest New Guinea, such as spears, a shield, and a horn, which are especially exotic to Westerners because they were used for headhunting.

When the museum opened to the public on December 11, 1933, it incorporated a Department of the American Indian which, according to the first edition of the *Handbook,* could boast "a comprehensive group of objects from both the pre- and post-Columbian period, ranging geographically from Alaska to Peru. . . . Because of its propinquity to Kansas City, the work of the Southwestern Indians is especially featured." This statement is misleading in more than one way, but particularly because the collection had little to show for the great Central and South American civilizations of the Mayans, Zapotecs, Mixtecs, Aztecs, and Incans until after the arrival of Ralph T. Coe, in 1959, as curator of painting and sculpture. Within a

short time a substantial number of pre-Columbian objects had been acquired by local collectors and others purchased outright for the museum's permanent collection. Some are true masterworks, like the Zapotec *Figural Urn* (colorplate, page 22) from Monte Albán in the Oaxaca Valley, Mexico, or the Chimu *Feather Mantle* from Chancay, Peru. Today the visitor will see a limited but informative sampling of ancient Peruvian pottery, for the most part stirrup vessels made of painted earthenware; Mayan pottery, including painted vessels, small-scale figures, and boldly modeled face masks; large Mixtec Guardian Figures; small figural carvings in stone and jade from Teotihuacán; and gold jewelry from Costa Rica and Peru.

If the Trustees of the 1930s did not attempt to acquire much in the way of pre-Columbian material, it is nonetheless true that their deliberately focused policy, favoring the art of the Native Americans of the Southwest—the Anasazi, Hohokam, Zuni, Navajo, and Apache—yielded quick and impressive results. During the first three years of buying they amassed a distinguished array of baskets, earthenware vessels, items of clothing and personal adornment, masks, and blankets. These early purchases remain the core of the collection, especially the excellent suite of Navajo blankets and the superb *ollas* made over the course of an entire millennium. From the Great Plains came beautiful and characteristic works such as the Cheyenne *War Bonnet* and *Breast Plate* and the colorful Lakota *Parfleche* (colorplate, page 23). A masterpiece of Crow beadwork, a *Child's Shirt,* was donated in 1950. Thanks to more recent gifts and purchases, still reflecting the enthusiasms of Coe, the collection now offers a small but fine sampling of the arts of the Northwest Coast and Alaskan cultures, including wood and ivory carvings, baskets, masks, and furniture.

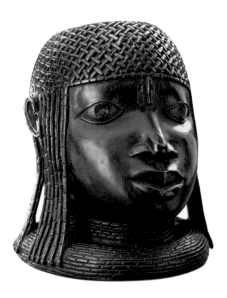

Memorial Head of an Oba, 16th century
Brass
Height: 9⅛ inches (23.2 cm)
Benin (Nigeria)
Purchase: Nelson Trust [87-7]★
[*See colorplate, p. 21*]

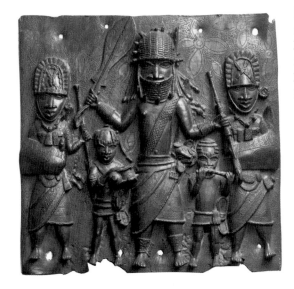

Warrior and Attendants Plaque,
16th/17th century
Brass
14¾ x 15½ inches (37.5 x 39.4 cm)
Benin (Nigeria)
Purchase: Nelson Trust [58-3]

Helmet Mask, 19th century
Wood, human hair, resin, and fiber
Height: 13 inches (33.0 cm)
Yao (Mozambique and Tanzania)
Purchase: the George H. and
Elizabeth O. Davis Fund [F87-35]

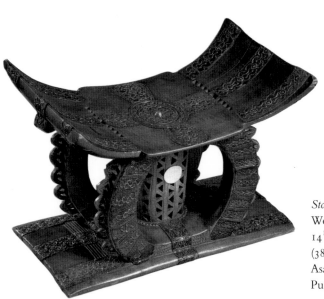

Stool, 19th century
Wood and silver
14¹⁵⁄₁₆ x 23½ x 13¼ inches
(38.0 x 59.7 x 33.7 cm)
Asante (Ghana)
Purchase: Nelson Trust [65-5]

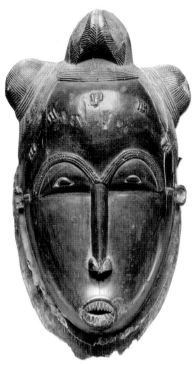

Goli Mask: Kpan, 19th century
Wood
Height: 15¾ inches (40.0 cm)
Baule (Ivory Coast)
Gift of Mr. and Mrs. Morton I.
Sosland [79-56]

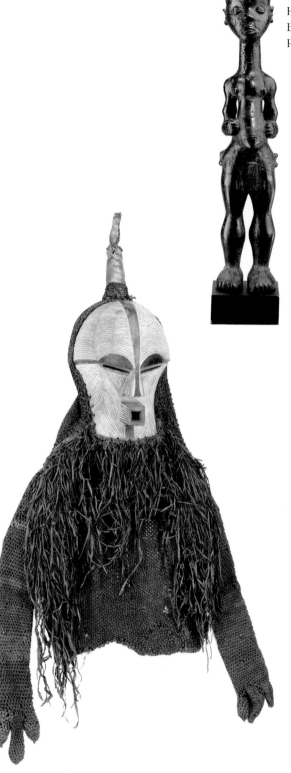

Female Mask, late 19th century
Wood, pigment, fiber, and hide
Height: 54½ inches (138.4 cm)
Songye (Zaire)
Purchase: the George H. and
Elizabeth O. Davis Fund [F92-18]

Standing Figure, 19th century
Wood with pigment
Height: 18¾ inches (47.6 cm)
Bena Lulua (Zaire)
Purchase [F84-50]

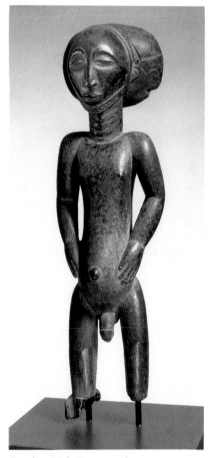

Standing Male Figure, 19th century
Wood
Height: 31¾ inches (80.7 cm)
Hemba (Zaire)
Gift of Mr. and Mrs. Morton I.
Sosland in honor of the fiftieth
anniversary of the Nelson-Atkins
Museum of Art [81-53]

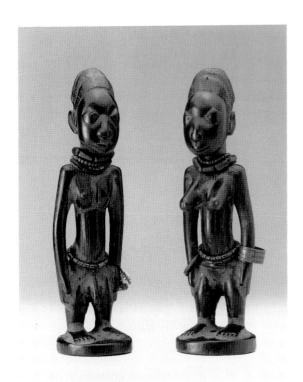

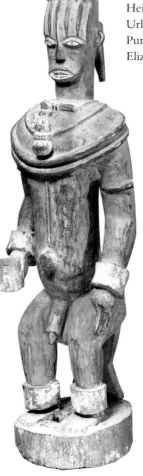

Seated Male Figure, early 20th century
Wood with pigment
Height: 49 inches (124.5 cm)
Urhobo (Nigeria)
Purchase: the George H. and
Elizabeth O. Davis Fund [F86-7]

Pair of Twin Figures (Male and Female),
early 20th century
Wood, pigment, fiber, shell, and beads
Height: 11 inches (27.9 cm), each
Yoruba (Nigeria)
Purchase: the George H. and
Elizabeth O. Davis Fund [F92-16/1,2]

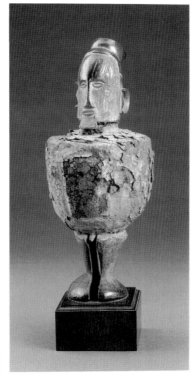

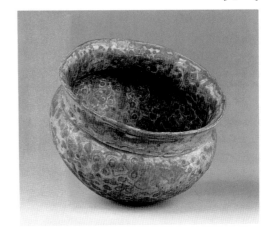

Bowl, 20th century
Earthenware
Height: 6¾ inches (17.2 cm)
Sundi (Zaire)
Purchase: the George H. and
Elizabeth O. Davis Fund [F90-6]

Charm Figure, 20th century
Wood, earth, and ritual material
Height: 13 inches (33.0 cm)
Teke (Zaire and Congo)
Gift of Donald and Sally Tranin [F89-8]

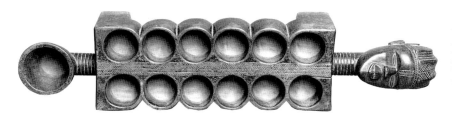

Game Board, 20th century
Wood with metal inlay
Length: 33½ inches (85.1 cm)
Dan (Ivory Coast)
Gift of Mr. and Mrs. Morton I. Sosland [80-50/1]

Helmet Mask, 20th century
Wood
Height: 13⅝ inches (34.7 cm)
Bekom (Cameroon)
Gift of D. J. and L. W. Welling [75-66]

Anthropomorphic Vessels, 20th century
Earthenware
Height: 9¾ inches (24.8 cm);
11 inches (27.9 cm)
Mangbetu (Zaire)
Purchase: the George H. and
Elizabeth O. Davis Fund [F90-8/1,2]

Woman's Overskirt, 20th century
Raffia cloth
Length: 58½ inches (148.6 cm)
Shoowa (Zaire)
Purchase: the George H. and
Elizabeth O. Davis Fund [F91-29]

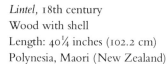

Lintel, 18th century
Wood with shell
Length: 40¼ inches (102.2 cm)
Polynesia, Maori (New Zealand)
Gift of Mr. and Mrs. Morton I. Sosland [76-57]

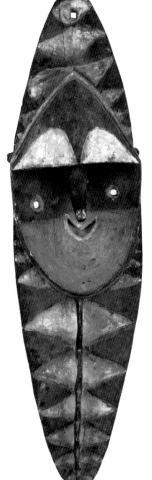

Minja Figure, 20th century
Wood with pigment
Height: 57½ inches (146.1 cm)
Melanesia, Nukuma
(Papua New Guinea)
Gift of Dr. and Mrs. Nathan
Greenbaum [F87-37/3]

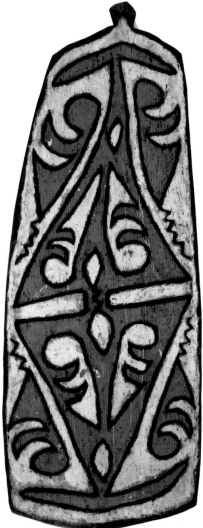

Shield, 20th century
Wood with pigment
Height: 65¼ inches (165.7 cm)
Melanesia, Green River
(Papua New Guinea)
Gift of Dr. and Mrs. Nathan
Greenbaum [F87-37/2]

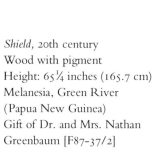

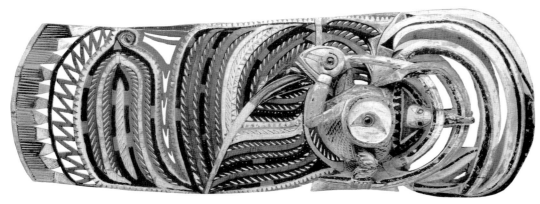

Bird Frieze, 20th century
Wood, pigment, and opercula
Length: 50½ inches (128.3 cm)
Melanesia, New Ireland
(Papua New Guinea)
Gift of Mr. and Mrs. Morton I.
Sosland [F92-8]
[*See colorplate, p. 21*]

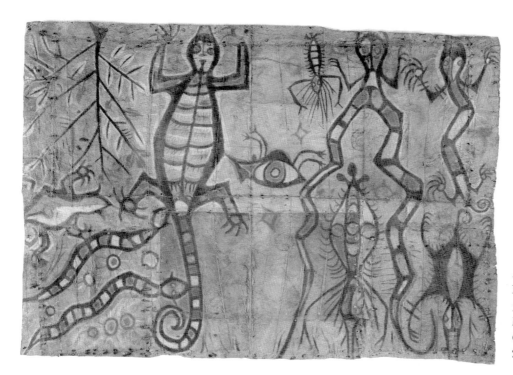

Painted Bark Cloth, 20th century
Bark cloth with pigment
33¼ x 46½ inches (84.4 x 118.1 cm)
Melanesia, Lake Sentani (Irian Jaya)
Gift of Mr. and Mrs. Morton I.
Sosland [F91-65]

Anthropomorphic Mortar,
10th/5th century B.C.
Jade
Length: 3 ½ inches (8.9 cm)
Olmec (Mexico)
Purchase: Nelson Trust [70-32]

Stirrup Spout Vessel, 1st/5th century A.D.
Painted earthenware
Height: 9½ inches (24.1 cm)
Moche (Peru)
Purchase: Nelson Trust [47-27/1]

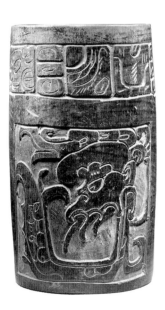

Vase, 8th century A.D.
Slateware (incised earthenware)
Height: 7¾ inches (19.7 cm)
Maya (Mexico)
Gift of Mr. Peter I. Hirsch [67-41]

Figural Urn, 6th/7th century A.D.
Earthenware with traces of paint
Height: 7¾ inches (19.7 cm)
Zapotec, Monte Albán (Mexico)
Purchase: Nelson Trust [61-16]
[*See colorplate, p. 22*]

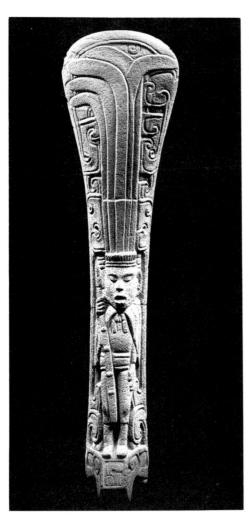

Palma, 7th/10th century A.D.
Volcanic stone
Height: 32 inches (81.3 cm)
Vera Cruz (Mexico)
Purchase: Nelson Trust [49-47]

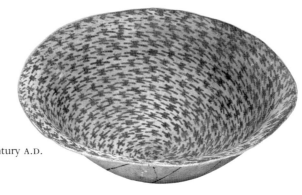

Flare-Rimmed Bowl, 8th/9th century A.D.
Painted earthenware
Diameter: 13 inches (33.0 cm)
Hohokam (Arizona)
Purchase: acquired through the generosity of
Mr. and Mrs. Henry I. Marder [F87-12]

Standing Warrior Priest, 8th/10th century A.D.
Painted earthenware
Height: 12½ inches (31.8 cm)
Maya, Guaymil Island (Mexico)
Purchase: Nelson Trust [61-77]

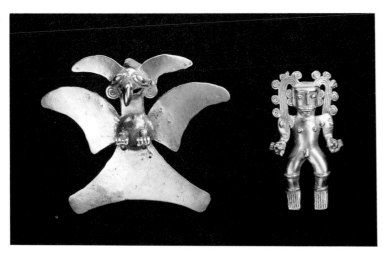

Eagle and Figural Pendants,
8th/16th century
Gold
Height: 3¾ inches (9.5 cm);
3 inches (7.6 cm)
Diquis Zone (Costa Rica)
Purchase: Nelson Trust [52-17,18]

Feather Mantle, 13th/14th century
Feathers and cotton
45 x 44½ inches (114.3 x 113.0 cm)
Chimu (Peru)
Purchase: Nelson Trust [60-79]

Bowl, 11th/15th century
Painted earthenware
Diameter: 11¼ inches (28.6 cm)
Mogollon, Mimbres (New Mexico)
Purchase: Nelson Trust [62-21/10]

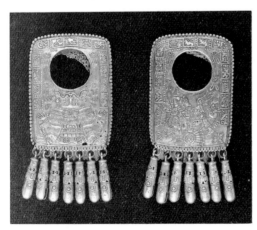

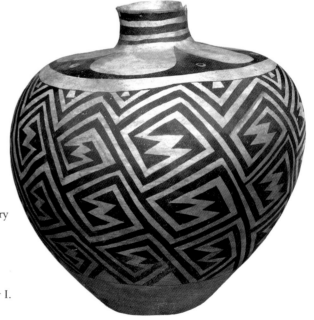

Pair of Earrings, 13th/14th century
Gold
Height: 3³⁄₁₆ inches (8.1 cm), each
Aztec or Mixtec (Mexico)
Purchase: Nelson Trust [62-37/1,2]

Olla (Storage Jar), 11th/13th century
Painted earthenware
Height: 19 inches (48.3 cm)
Anasazi, Socorro (New Mexico)
Purchase: acquired through the
generosity of Mr. and Mrs. Henry I.
Marder [F88-10]

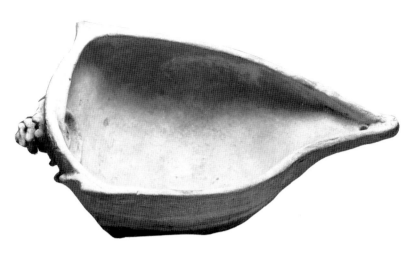

Vessel in the Form of a Conch Shell, 13th/16th century
Earthenware
Length: 10¼ inches (26.0 cm)
Mississippian (Pemiscot County, Missouri)
Purchase: Nelson Trust [32-73/19]

Bowl, 14th century
Painted earthenware
Diameter: 9½ inches (24.1 cm)
Anasazi, Four-Mile Polychrome (Arizona)
Gift of Donald D. Jones in memory of his
parents, Sylvan and LaRue C. Jones [F82-53/1]

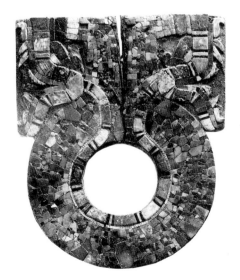

Plaque with Double-Headed Serpent,
14th/15th century
Wood with mosaic of turquoise
and shell
Height: 4¼ inches (10.8 cm)
Mixtec (Mexico)
Purchase: the Elmer Pierson
Foundation [F66-36/23 a]

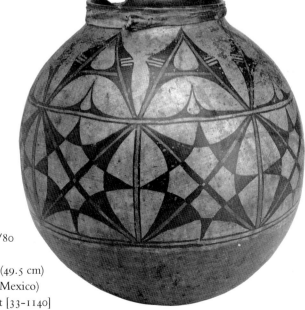

Olla (Storage Jar), 1770/80
Painted earthenware
Diameter: 19½ inches (49.5 cm)
Cochiti Pueblo (New Mexico)
Purchase: Nelson Trust [33-1140]

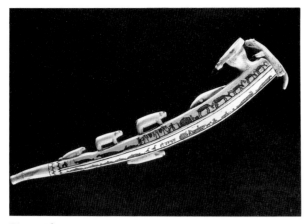

Pipe, 18th century
Ivory and pigment
Length: 12 inches (30.5 cm)
Eskimo (Alaska)
Purchase: Nelson Trust [31-125/15]

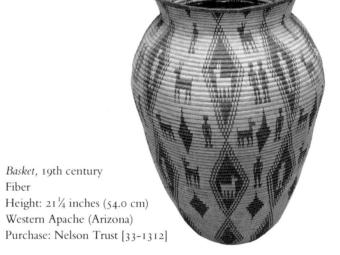

Basket, 19th century
Fiber
Height: 21¼ inches (54.0 cm)
Western Apache (Arizona)
Purchase: Nelson Trust [33-1312]

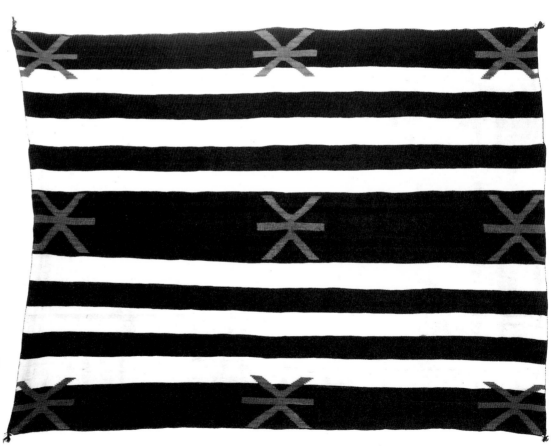

Second-Phase Chief's Blanket, c. 1855/65
Cochineal-dyed and natural wools
54 x 72 inches (137.2 x 182.9 cm)
Navajo (Arizona)
Purchase: Nelson Trust [33-1432]

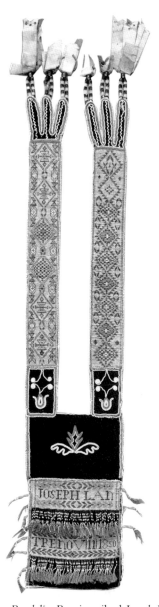

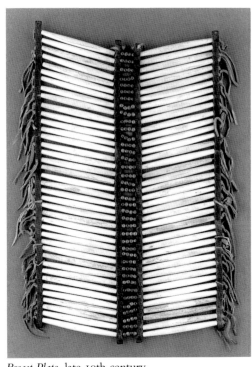

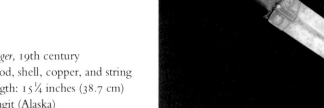

Bandolier Bag, inscribed *Joseph Lan/tre*
Nov. 11, 1850
Woolen trade cloth, cotton, beads,
and silk ribbon
Length: 38¾ inches (98.4 cm)
Ojibwa or Minnesotan
(Western Great Lakes)
Gift of J. Wilson Nance and Martha
T. Nance in honor of Mr. and Mrs.
Reginald G. Thomson [77-26/1]

Basket, 19th century
Fiber
Diameter: 16½ inches (41.9 cm)
Hupa (California)
Purchase: Nelson Trust [33-1338]

Breast Plate, late 19th century
Bone, leather, and brass
17¼ x 11¼ inches (43.8 x 28.6 cm)
Cheyenne (Northern Plains)
Purchase: Nelson Trust [33-1209]

Dagger, 19th century
Wood, shell, copper, and string
Length: 15¼ inches (38.7 cm)
Tlingit (Alaska)
Purchase: Nelson Trust [31-125/5]

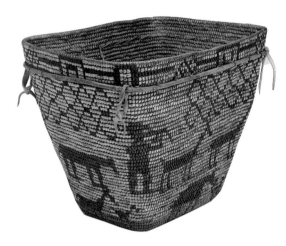

Basket, 19th century
Fiber
Height: 12 inches (30.5 cm)
Chilcotin (British Columbia)
Purchase: Nelson Trust [33-1261]

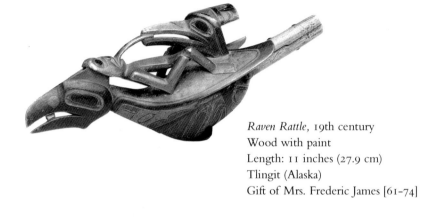

Raven Rattle, 19th century
Wood with paint
Length: 11 inches (27.9 cm)
Tlingit (Alaska)
Gift of Mrs. Frederic James [61-74]

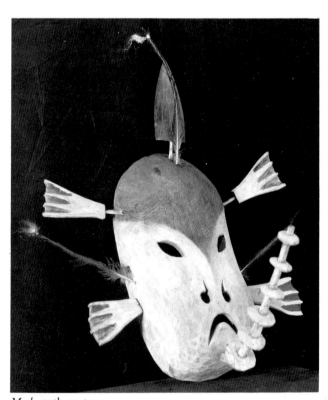

Mask, 19th century
Wood, feathers, and pigment
Height: 15 inches (38.1 cm)
Eskimo (Alaska)
Purchase: Nelson Trust [31-125/61]

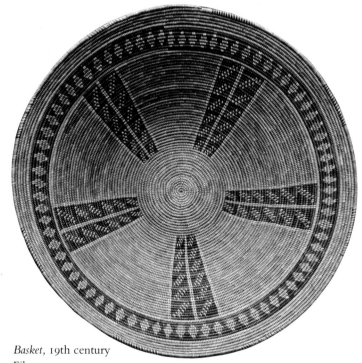

Basket, 19th century
Fiber
Diameter: 20¾ inches (52.7 cm)
Chumash (California)
Purchase: Nelson Trust [31-125/127]

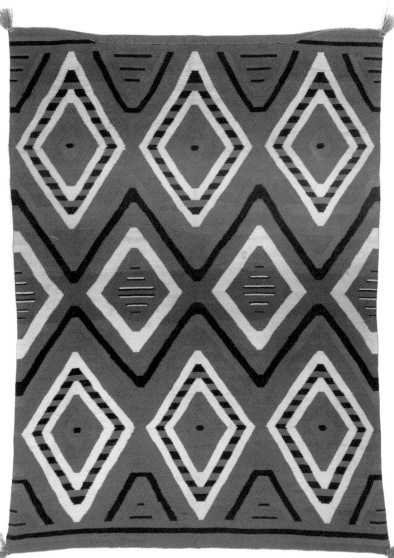

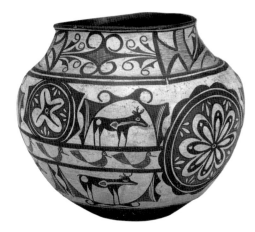

Olla (Storage Jar), 1850/75
Painted earthenware
Diameter: 11½ inches (29.2 cm)
Zuni Pueblo (New Mexico)
Gift of Mrs. Frank Paxton in memory of
Frank Paxton, Sr. [R56-16/326]

Serape Blanket, c. 1865/70
Commercial three-ply Germantown wool
69¾ x 52¼ inches (177.2 x 132.7 cm)
Navajo (Arizona)
Purchase: Nelson Trust [33-1431]

Medicine Bundle Wrapper, c. 1870
Buckskin, quills, horsehair, and feathers
42⅞ x 29⅞ inches (108.9 x 75.9 cm)
Lakota (Northern Plains)
Gift of Donald D. Jones in memory
of his mother, LaRue C. Jones [81-66]

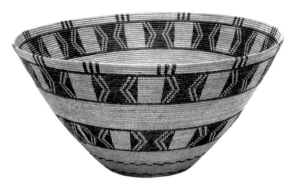

Basket, 19th century
Fiber
Diameter: 15¾ inches (40.0 cm)
Yokuts, Kern River (California)
Purchase: Nelson Trust [33-1324]

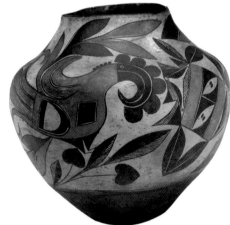

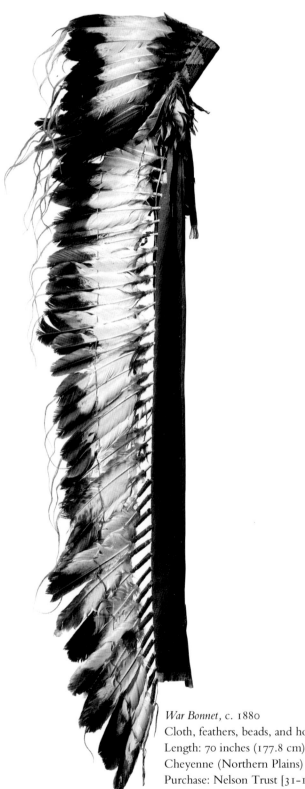

Olla (Storage Jar), c. 1875
Painted earthenware
Height: 12 inches (30.5 cm)
Acoma Pueblo (New Mexico)
Gift of Daniel R. Anthony III and
Mrs. Eleanor Anthony Tenney [50-73/8]
[*See colorplate, p. 23*]

War Bonnet, c. 1880
Cloth, feathers, beads, and horsehair
Length: 70 inches (177.8 cm)
Cheyenne (Northern Plains)
Purchase: Nelson Trust [31-125/38]

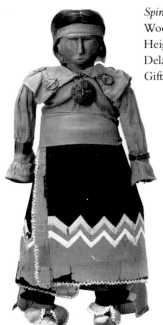

Spirit Doll, late 19th century
Wood, cloth, metal, leather, beads, and hair
Height: 10½ inches (26.7 cm)
Delaware (Eastern Woodlands tradition)
Gift of Mr. and Mrs. Lee R. Lyon [79-8/2]

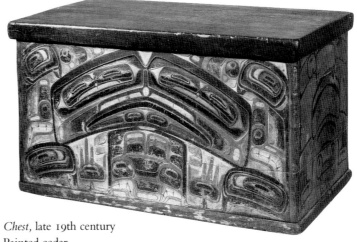

Chest, late 19th century
Painted cedar
17¾ x 33 x 19⅜ inches (45.1 x 83.8 x 49.2 cm)
Tsimshian or Tlingit (British Columbia or Alaska)
Purchase: Nelson Trust [70-31]

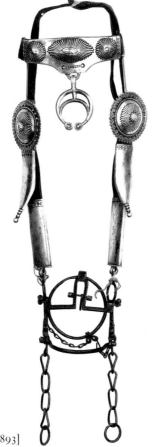

Bridle, late 19th century
Silver, iron, and buckskin
Length: 23 inches (58.4 cm)
Navajo (Arizona)
Purchase: Nelson Trust [33-893]

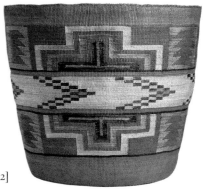

Basket, late 19th century
Spruce root and grass
Height: 16 inches (40.6 cm)
Tlingit (Alaska)
Purchase: Nelson Trust [33-1322]

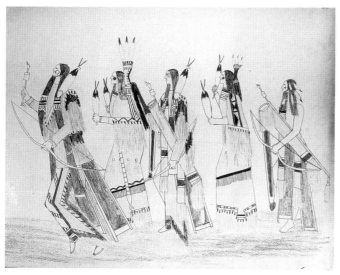

Paughtigh and Braves Performing Tribal Dance,
from *Silverhorn Ledgerbook,* c. 1880
Graphite and chalk on paper
11¾ x 14¾ inches (29.9 x 37.5 cm)
By Haungooah (Silverhorn), Kiowa (Southern Plains)
Gift of Mr. and Mrs. Dudley C. Brown [64-9/64]

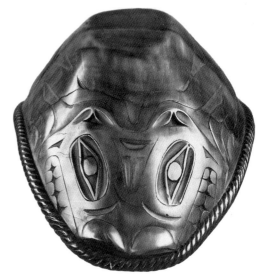

Food Dish, c. 1880
Mountain sheep horn
Length: 9½ inches (24.1 cm)
Haida (British Columbia)
Purchase: Nelson Trust [31-125/35]

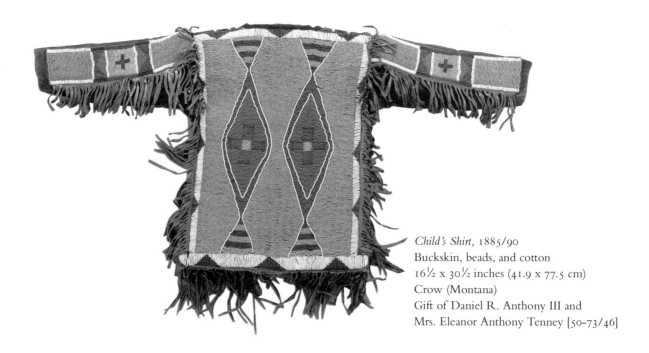

Child's Shirt, 1885/90
Buckskin, beads, and cotton
16½ x 30½ inches (41.9 x 77.5 cm)
Crow (Montana)
Gift of Daniel R. Anthony III and
Mrs. Eleanor Anthony Tenney [50-73/46]

Parfleche (Storage Bag), late 19th century
Rawhide and paint
13 x 26 inches (33.0 x 66.0 cm)
Lakota (Northern Plains)
Purchase: Nelson Trust [31-125/4]
[*See colorplate, p. 23*]

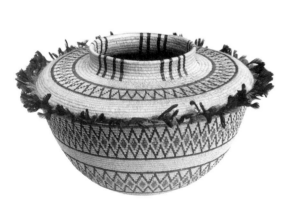

Basket, c. 1900
Grass, quail feathers, and wool
Height: 10¼ inches (26.0 cm)
Yokuts, Kern River (California)
Purchase: Nelson Trust [33-1272]

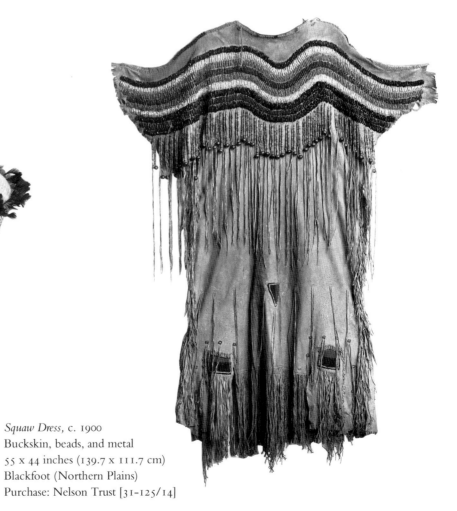

Squaw Dress, c. 1900
Buckskin, beads, and metal
55 x 44 inches (139.7 x 111.7 cm)
Blackfoot (Northern Plains)
Purchase: Nelson Trust [31-125/14]

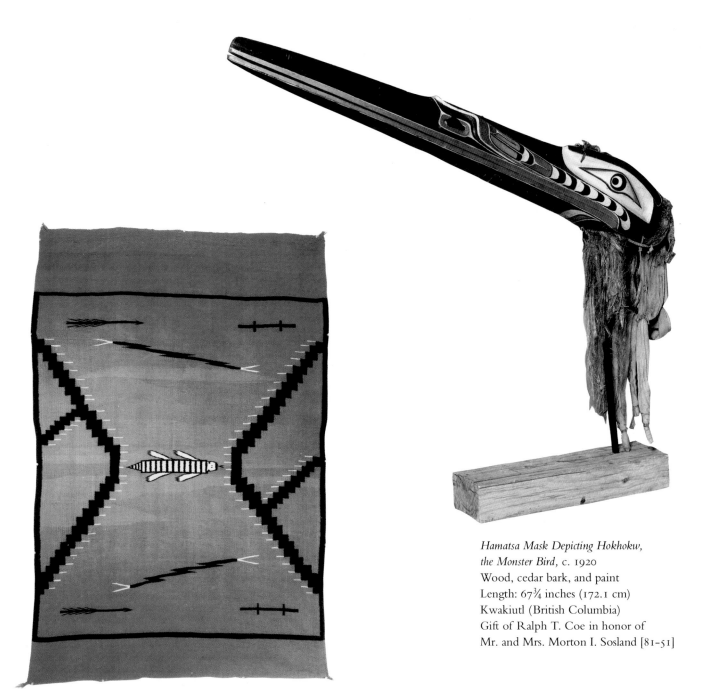

Hamatsa Mask Depicting Hokhokw,
the Monster Bird, c. 1920
Wood, cedar bark, and paint
Length: 67¾ inches (172.1 cm)
Kwakiutl (British Columbia)
Gift of Ralph T. Coe in honor of
Mr. and Mrs. Morton I. Sosland [81-51]

Pictorial Style Blanket, 1900/1910
Commercial four-ply Germantown wool
72 x 47¼ inches (182.9 x 120.0 cm)
Navajo (Arizona)
Gift of Mrs. Richard R. Nelson [74-58/1]

Blanket, early 20th century
Wool, ribbon, and beads
59 x 73 inches (149.9 x 185.4 cm)
Oto or Osage (Southern Plains)
Purchase: Nelson Trust [89-38]★

Jar, c. 1950
Glazed earthenware (black slip on black)
Diameter: 10¼ inches (26.0 cm)
By Maria Martinez (1881?–1980) and
Popovi Da (1921–1971); San Ildefonso
Pueblo (New Mexico)
Gift of Mrs. Nell H. Stevenson from
the Estate of Mr. S. Herbert Hare [60-64]

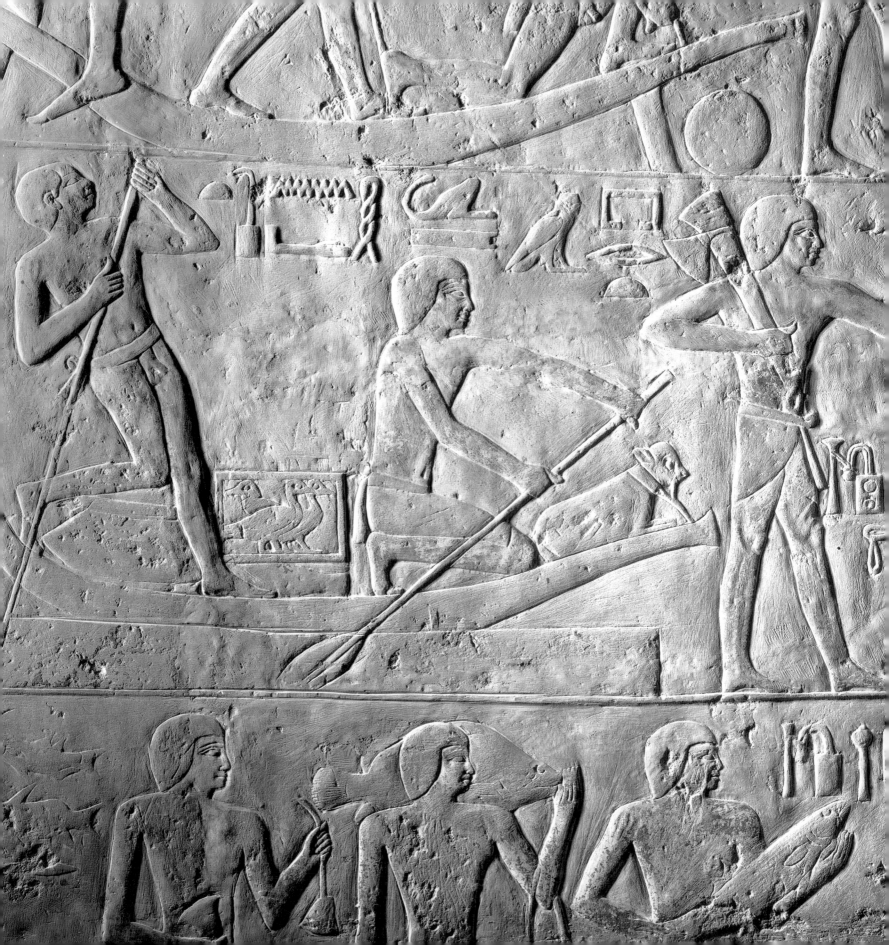

II

The Art of the Ancient Mediterranean World

As might be expected, the University Trustees regarded classical art as the basis for their collection of later European art, and sought from the outset of their activity to secure examples of the major art forms of the principal cultures of ancient Southwest Asia, Egypt, Greece, the Roman Empire, and Byzantium. From the records of some of their earliest meetings it is known that in forming a representative collection of antiquities they hoped to emulate the much older collections of such American cities as Boston, Brooklyn, and Philadelphia. Their enthusiasm for this field is confirmed by the fact that the Nelson Trust's very first purchase, in April 1930, was of a group of archaeological artifacts from a dig at Lagash (modern Tello, in Iraq). Throughout the 1930s, 1940s, and 1950s, the Trustees continued to purchase antiquities at a fairly brisk pace, relying at first on the advice of Harold Woodbury Parsons, their "European Representative," and then more heavily on the acumen of the museum's professional staff.

To a degree that would be unusual today, the Trustees' acquisitions were conditioned by the astute offerings of just two eminent dealers, Jacob Hirsch and Mr. and Mrs. Paul Mallon. As related by the late Laurence Sickman, the annual visit of the Mallons was a much-anticipated event on the museum's calendar. Each year they traveled by train from New York to Kansas City, stopping in Cleveland and Toledo either along the way or on the return trip. Always they brought just one object of great importance for each museum and always, it seemed, they knew which artwork would be most hotly desired by which museum; always they were confident of returning to New York empty-handed. With ever stricter regulations on the excavation and export of antiquities, the stream of fresh material onto the market has today slowed to a trickle, driving auction

prices to unprecedented heights and making regular acquisitions more difficult.

While the ancient art collection is not an especially large one, it is renowned for the overall high standard of quality to which it conforms. The tone is set by a handful of superb artworks created by the succeeding civilizations of ancient Mesopotamia and Iran: Sumeria, Babylonia, Assyria, and Persia. These include the monumental relief of a *Winged Genie Fertilizing a Date Tree* from the palace of Assurnasirpal II at Nimrud, which has been in Missouri since 1857, and the fragmentary but wonderfully powerful *Capital in the Shape of a Bull,* which originally surmounted one of the columns in the resplendent Hall of a Hundred Columns built by Xerxes and Artaxerxes at Persepolis.

The Egyptian collection is numerically much greater. It has long been famous for masterworks from the V and VI Dynasties of the Old Kingdom such as the statue of *The Nobleman Ra-wer,* the painted wood statue of *Methethey, Overseer of the Office of Crown Tenants,* and the large relief from the tomb of Ny-ankh-nesuwt at Saqqara. The awe-inspiring *Head of Sesostris III* (colorplate, page 24) demonstrates the rather more realistic norms for royal portraiture in the Middle Kingdom, while the *Boundary Stele with Queen Nefertiti and Princess Maketaten* is indicative of the unabashed naturalism—sometimes taken almost to the point of caricature—that was favored by the heretic Akhenaten and his queen, Nefertiti. The restrained *Portrait of Rameses II,* one of the most successful propagandists of all time, exhibits the return to a more stylized, conventional canon for depicting the features of the pharaoh. The Late and Ptolemaic periods are represented in Kansas City by a variety of works of great sophistication, demonstrat-

ing the persistent vigor of the Egyptian formal tradition over the course of many centuries. Among the finest are the painted relief of *Mentuemhat Making an Offering,* the superb sculpture in basalt of *Horus as a Falcon,* and the sublime *Torso of Archibeios.*

The fairly small collection of Greek and Hellenistic material is strong in sculpture but less so in that most characteristic of Greek art forms, vase painting. The former category includes the very beautiful *Head of a Youth,* made at the beginning of the fifth century B.C., and the imposing marble *Lion* that is one of the most popular artworks in the entire museum. These are complemented by Hellenistic copies of fine quality after earlier Greek originals, such as the *Torso of a Satyr,* and a few excellent bronze statuettes, of which the *Heracles* (colorplate, page 24) is the largest and most impressive. There are specimens of most of the common forms of Greek vases (amphora, kylix, lekythos, etc.), some decorated by outstanding artists whose styles are distinctive despite their anonymity; today they are known by sobriquets such as the Syleus Painter and the Achilles Painter.

With Etruscan and Roman art the collection demonstrates once again the breadth and consistency that characterize the Egyptian section. The standard of quality was set in the museum's earliest days when the *Statuette of a Warrior God, Probably Tinia* was the Trustees' twelfth acquisition. The Imperial portraits, mostly busts, are exceptionally good as well as distinctive. The remarkable *Funerary Bust of a Woman,* probably made in Roman Egypt during the reign of Hadrian, is also very well preserved. Of a slightly later date is the full-length, life-size *Portrait of a Youth,* formerly belonging to the Marquess of Lansdowne, whose collection of antiquities—displayed at Bowood (Wiltshire) and in the London townhouse—was among the greatest ever assembled. The most recent addition to the collection is the handsome *Sarcophagus of Praecilia Severiana* on which the deceased is depicted in the company of Minerva and the nine Muses. This work of the third century A.D. affects a smooth stylistic transition to the Palmyran and Coptic reliefs of the third through the fifth centuries, such as the well-known *Screen with Depiction of Jason and the Golden Fleece;* separated by more than three millennia from the reliefs depicting Methethy and his children, it is with them that the museum's collection of antiquities draws to a close.

Head of a Woman, c. mid 3rd millennium B.C.
Limestone with shell and lapis lazuli inlays
Height: 2¾ inches (7.0 cm)
Mesopotamian; from Khafaje
Purchase: Nelson Trust [55-43]

Vase, 3rd millennium B.C.
Painted earthenware
Diameter: 10¾ inches (27.3 cm)
Iranian; from Tepe Giyan
Purchase: Nelson Trust [35-37/8]

Winged Genie Fertilizing a Date Tree,
c. 884/860 B.C.
Limestone
91¼ x 71¼ inches (231.8 x 181.0 cm)
Assyrian; from Nimrud
Purchase: Nelson Trust [40-17]

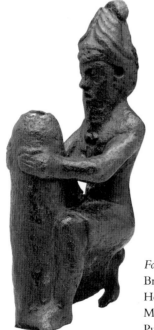

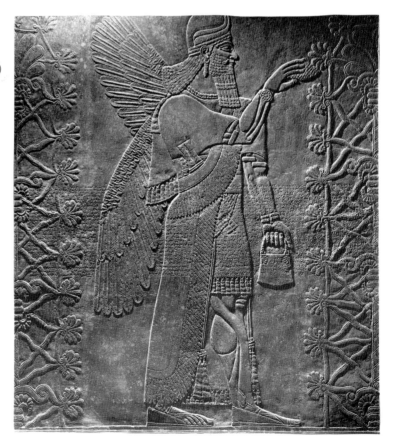

Foundation Figure, late 3rd millennium B.C.
Bronze
Height: 8 inches (20.3 cm)
Mesopotamian; from Lagash
Purchase: Nelson Trust [30-1/50]

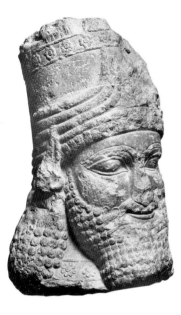

Head of a Bull Man, c. 6th century B.C.
Limestone
Height: 19¾ inches (50.2 cm)
Persian
Purchase: Nelson Trust [57-4]

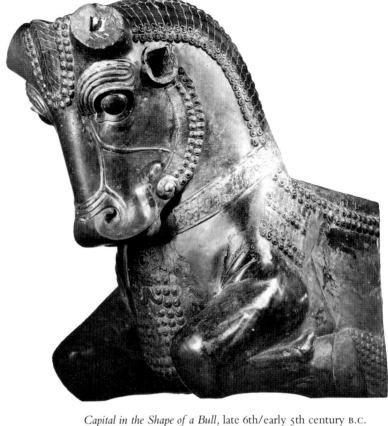

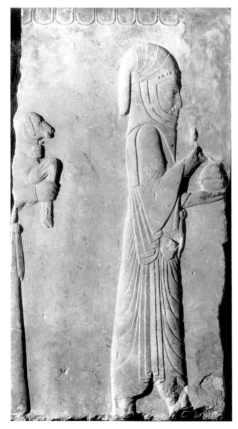

Capital in the Shape of a Bull, late 6th/early 5th century B.C.
Limestone
Height: 28 inches (71.1 cm)
Persian; from Persepolis
Purchase: Nelson Trust [50-14]

Tribute Bearer, 5th or 4th century B.C.
Limestone
32½ x 19½ inches (82.5 x 49.5 cm)
Persian; from Persepolis
Purchase: Nelson Trust [33-101]

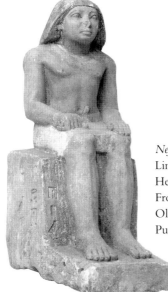

Nefu, Inspector of the Treasury
Limestone with traces of paint
Height: 17½ inches (44.5 cm)
From Giza
Old Kingdom, V Dynasty (2565–2420 B.C.)
Purchase: Nelson Trust [48-47]

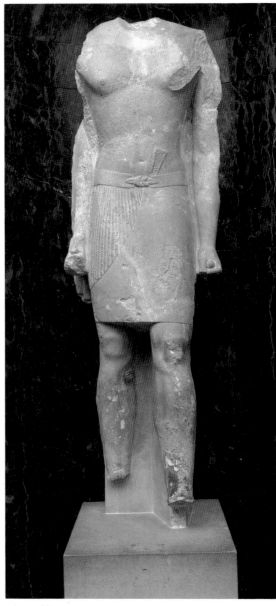

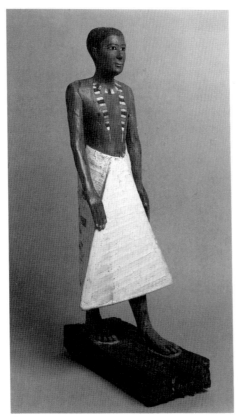

Methethy, Overseer of the Office of Crown Tenants
Gessoed and painted wood with
copper, alabaster, and obsidian inlays
Height: 31⅝ inches (80.3 cm)
From Saqqara
Old Kingdom, V Dynasty
(2565–2420 B.C.)
Purchase: Nelson Trust [51-1]

The Nobleman Ra-wer
Limestone with traces of paint
Height: 69 inches (175.3 cm)
From Giza
Old Kingdom, V Dynasty (2565–2420 B.C.)
Purchase: Nelson Trust [38-11]

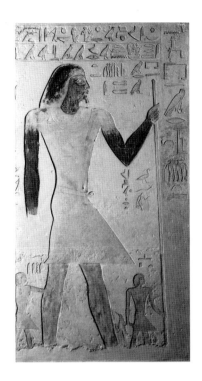 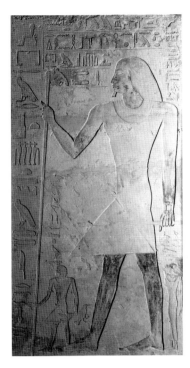

Methethy with His Sons and
Methethy with His Daughter and Son
Limestone with traces of paint
56 x 30½ inches (142.2 x 77.5 cm);
56¼ x 30 inches (142.9 x 76.2 cm)
From Saqqara
Old Kingdom, V Dynasty (2565–2420 B.C.)
Purchase: Nelson Trust [52-7/1,2]

Playful Jousting on the Nile, relief from the tomb of
Ny-ankh-nesuwt (detail), c. 2400 B.C.
Limestone with traces of paint
37 x 100 inches (94.0 x 254.0 cm), overall
From Saqqara
Old Kingdom, VI Dynasty (2420–2258 B.C.)
Purchase: Nelson Trust [30-14]

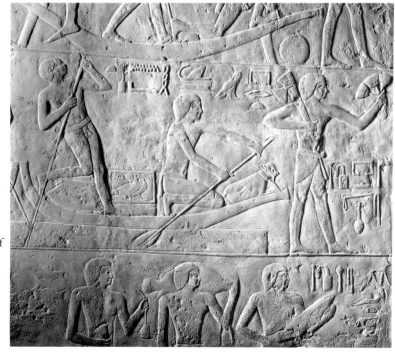

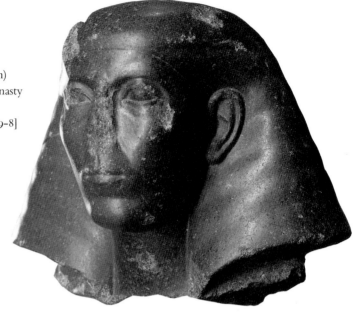

Head of a Man
Black granite or basalt
Height: 12 inches (30.5 cm)
Middle Kingdom, XII Dynasty
(1991–1786 B.C.)
Purchase: Nelson Trust [39-8]

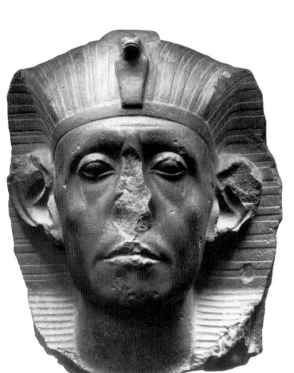

Head of Sesostris III, mid 19th century B.C.
Yellow quartzite
Height: 17¾ inches (45.1 cm)
Middle Kingdom, XII Dynasty (1991–1786 B.C.)
Purchase: Nelson Trust [62-11]
[*See colorplate, p. 24*]

Banquet Scene, c. 1400 B.C.
Painting on mud and straw support,
mounted on Masonite
10¼ x 12¼ inches (26.0 x 31.1 cm)
From Thebes
New Kingdom, XVIII Dynasty
(1570–1314 B.C.)
Purchase: Nelson Trust [64-3]

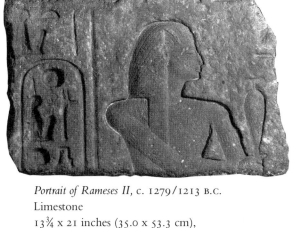

Portrait of Rameses II, c. 1279/1213 B.C.
Limestone
13¾ x 21 inches (35.0 x 53.3 cm),
maximum dimensions
New Kingdom, XIX Dynasty
(1314–1197 B.C.)
Purchase: Nelson Trust [32-195]

*Boundary Stele with Queen Nefertiti and
Princess Maketaten,* mid 14th century B.C.
Limestone
19 x 24½ inches (48.3 x 62.2 cm),
maximum dimensions
From Tell el Amarna
New Kingdom, XVIII Dynasty
(1570–1314 B.C.)
Purchase: Nelson Trust [44-65]

Daughter of the Pharaoh Akhenaten,
mid 14th century B.C.
Limestone
Height: 15½ inches (39.4 cm)
Probably from Tell el Amarna
New Kingdom, XVIII Dynasty
(1570–1314 B.C.)
Purchase: Nelson Trust [47-13]

Figure of a Girl, c. 670/650 B.C.
Wood
Height: 6½ inches (16.5 cm)
Late period, late XXV Dynasty
(730–656 B.C.) or early XXVI
Dynasty (664–525 B.C.)
Purchase: Nelson Trust [47-25]

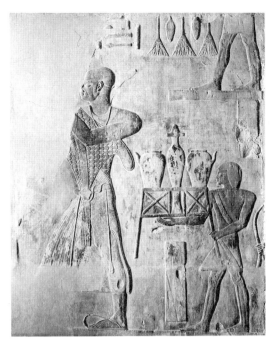

Mentuemhat Making an Offering,
c. 665/650 B.C.
Painted limestone
20⁵⁄₁₆ x 15¹³⁄₁₆ inches
(51.6 x 40.2 cm), maximum
dimensions
From Thebes
Late period, late XXV Dynasty
(730–656 B.C.) or early XXVI
Dynasty (664–525 B.C.)
Purchase: Nelson Trust [48-28/2]

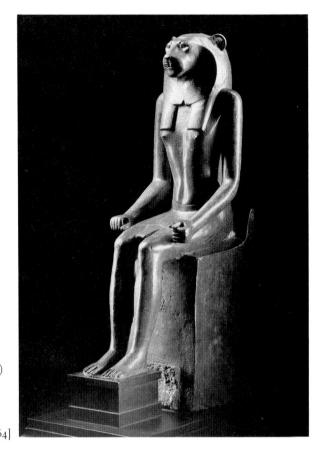

Horus of Buto
Bronze
Height: 23¼ inches (59.1 cm)
Late period, XXVI Dynasty
(664–525 B.C.) to Ptolemaic
period (304–30 B.C.)
Purchase: Nelson Trust [44-64]

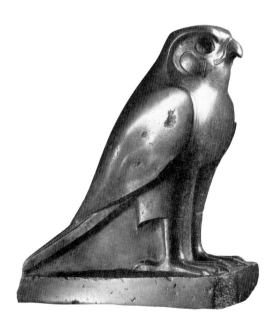

Kneeling Priest
Bronze
Height: 4⁵⁄₈ inches (11.7 cm)
Late period, XXVIII–XXIX
Dynasties (404–378 B.C.) to
Ptolemaic period (304–30 B.C.)
Purchase: Nelson Trust [48-26]

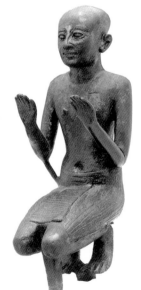

Horus as a Falcon
Basalt
Height: 19½ inches (49.5 cm)
Probably Late period, XXX Dynasty (378–341 B.C.)
to Ptolemic period (304–30 B.C.)
Purchase: Nelson Trust [34-140]

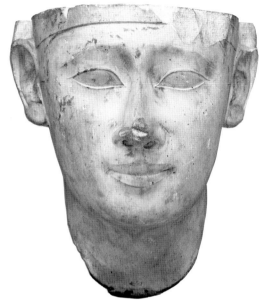

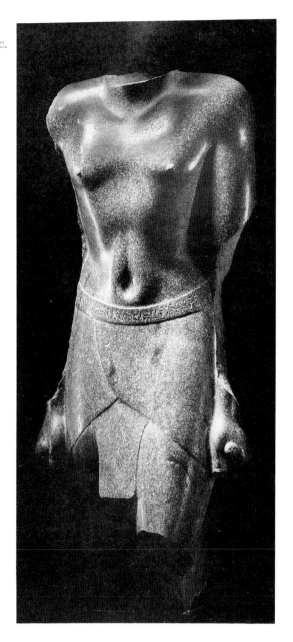

Torso of Archibeios, Royal Scribe and
Overseer of Field Workers, 3rd or 2nd century B.C.
Gray granite
Height: 43½ inches (110.5 cm)
From Mendes
Ptolemaic period (304–30 B.C.)
Purchase: Nelson Trust [47-12]

Head of Ptolemy I, c. 304/282 B.C.
Gypsum
Height: 9½ inches (24.1 cm)
Ptolemaic period (304–30 B.C.)
Purchase: Nelson Trust [34-141]

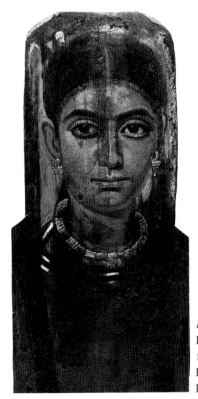

Portrait of a Woman, from a mummy case, c. A.D. 130/60
Encaustic on wood panel with gilt stucco
17½ x 6¾ inches (44.5 x 17.2 cm)
Roman period (30 B.C.–A.D. 640)
Purchase: Nelson Trust [37-40]

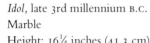

Idol, late 3rd millennium B.C.
Marble
Height: 16¼ inches (41.3 cm)
Probably from Cyclades
Purchase: Nelson Trust [35-41]

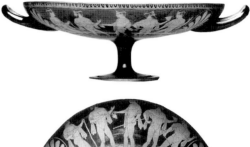

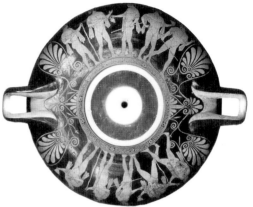

Kylix (Drinking Cup) with Depiction of Revelers
(side and exterior), c. 470/460 B.C.
Painted earthenware (red-figure pottery)
Diameter: 14 inches (35.6 cm)
By the Euaion Painter
Purchase: Nelson Trust [51-58]

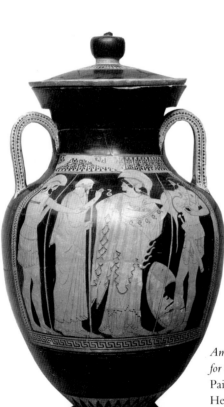

Amphora (Two-handled Vessel) with Depiction of Voting
for the Arms of Achilles, c. 480 B.C.
Painted earthenware (red-figure pottery)
Height: 27½ inches (69.9 cm)
By the Syleus Painter
Purchase: Nelson Trust [30-13]

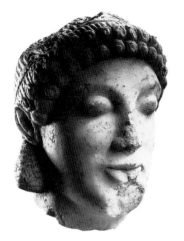

Head of a Youth, C. 490 B.C.
Marble
Height: 7 ½ inches (19.1 cm)
Probably from Attica
Purchase: Nelson Trust [38-7]

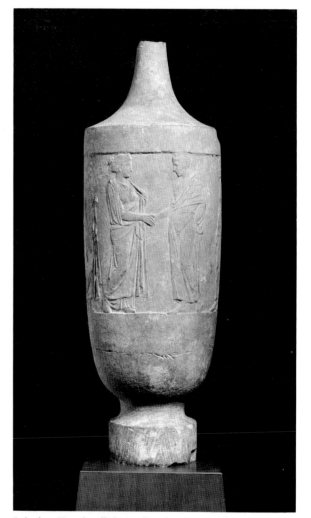

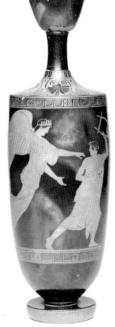

Lekythos (One-handled Vessel) with Depiction of Eos and Tithonus, C. 450/430 B.C.
Painted earthenware (red-figure pottery)
Height: 15 ¾ inches (40.0 cm)
Tradition of the Achilles Painter
Purchase: Nelson Trust [33-3/2]

Lekythos (One-handled Vessel) with Depiction of the Departure of the Deceased, late 5th or early 4th century B.C.
Marble
Height: 35 ¼ inches (89.5 cm)
Probably from Attica
Purchase: Nelson Trust [31-86]

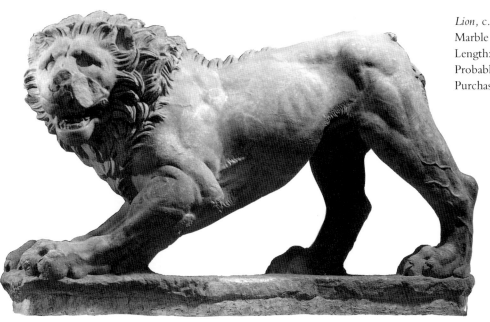

Lion, c. 325 B.C.
Marble
Length: 82 inches (208.3 cm)
Probably from Attica
Purchase: Nelson Trust [33-94]

Male Torso, 1st or 2nd century A.D.(?)
Marble
Height: 36½ inches (92.7 cm)
Roman copy of a 4th-century B.C.(?)
Greek original
Purchase: Nelson Trust [41-48]

Head of a Woman, 4th century B.C.
Marble
Height: 13¾ inches (34.9 cm)
Purchase: Nelson Trust [33-3/4]

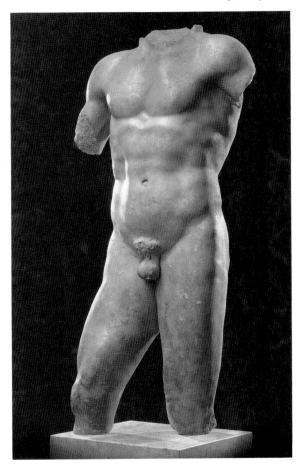

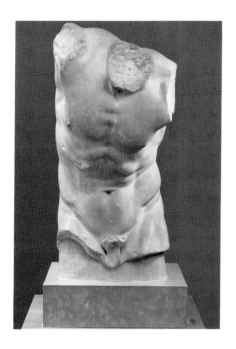
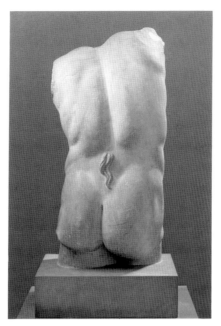

Torso of a Satyr (front and back), 1st or 2nd century A.D.
Marble
Height: 23 inches (58.4 cm)
Roman copy of a 3rd-century B.C. Greek original
Purchase: Nelson Trust [34-135]

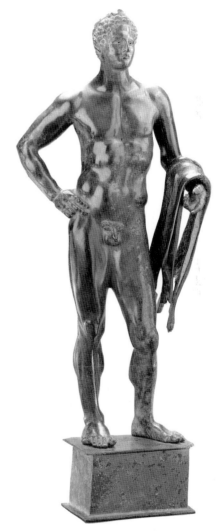

Kneeling Satyr, mid 2nd century B.C.
Bronze with traces of silver
Height: 13½ inches (34.3 cm)
Purchase: Nelson Trust [53-82]

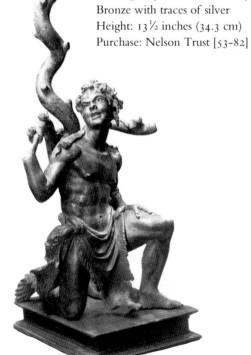

Heracles, possibly 2nd century B.C.
Bronze
Height: 22⅜ inches (56.8 cm)
Roman copy of a Greek original
Purchase: Nelson Trust [46-37]
[*See colorplate, p. 24*]

Youth Pouring Wine, late 5th century B.C.
Bronze
Height: 3¾ inches (9.5 cm)
Purchase: Nelson Trust [50-62]

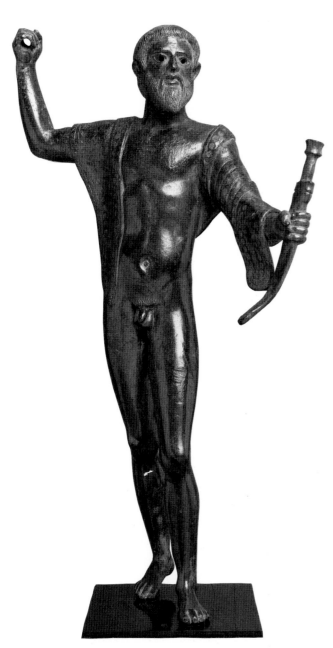

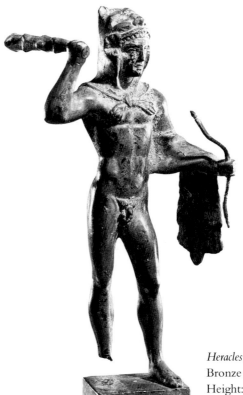

Statuette of a Warrior God, Probably Tinia, c. 460/450 B.C.
Bronze
Height: 16 inches (40.6 cm)
From Apiro
Purchase: Nelson Trust [30-12]

Heracles, 4th century B.C.
Bronze
Height: 7½ inches (19.1 cm)
Purchase: Nelson Trust [49-76]

ROME

Achilles and Penthesilea, 1st century B.C./1st century A.D.
Ivory
Height: 4 inches (10.2 cm)
Roman copy of a 2nd-century B.C. Greek original
Purchase: Nelson Trust [76-11]

Funerary Bust of a Woman, C. A.D. 120/30
Marble
Height: 25 inches (63.5 cm)
Purchase: Nelson Trust [48-9]

The Emperor Hadrian, C. A.D. 130
Marble
Height: 26 inches (66.0 cm)
Purchase: Nelson Trust [31-96]

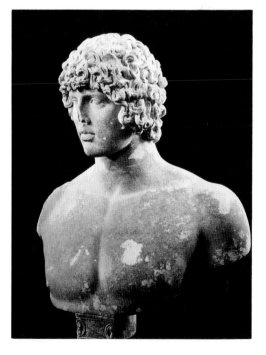

Antinous, C. A.D. 140
Marble
Height: 27½ inches (69.9 cm)
Purchase: Nelson Trust [59-3]

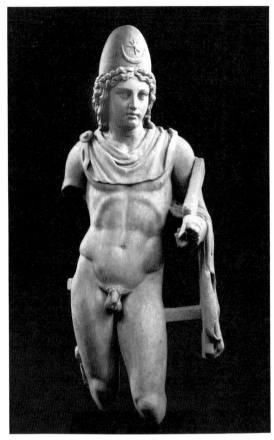

Castor or *Pollux*, c. A.D. 125/50
Marble
Height: 30 inches (76.2 cm)
Purchase: Nelson Trust [33-1533]

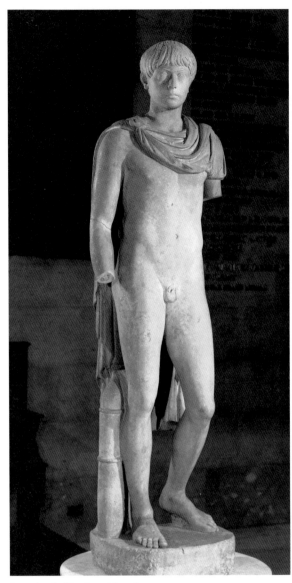

Portrait of a Youth, mid 2nd century A.D.
Marble
Height: 65 inches (165.1 cm)
Purchase: Nelson Trust [34-91/1]

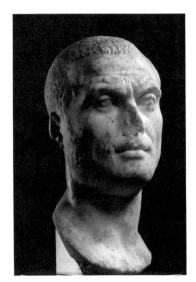

Portrait of a Man, c. A.D. 220/30
Marble
Height: 14½ inches (36.8 cm)
Purchase: Nelson Trust [47-14]

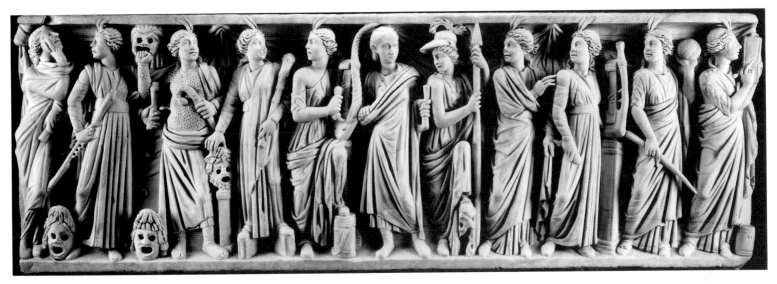

Sarcophagus of Praecilia Severiana, c. A.D. 225/50
Marble
32½ x 94 x 32 inches (82.6 x 238.8 x 81.3 cm)
Purchase: Nelson Trust [87-21]★

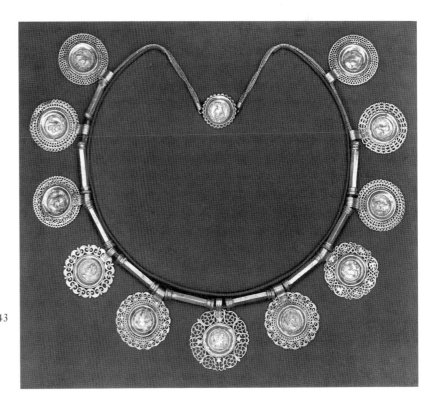

Necklace of Coins Bearing Imperial Portraits, c. A.D. 238/43
Gold
Length: 30¼ inches (76.8 cm)
Purchase: Nelson Trust [56-77]
[*See colorplate, p. 25*]

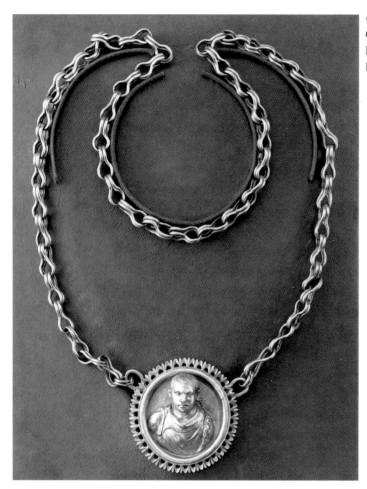

Chain with a Portrait Medallion, c. A.D. 238/43
Gold
Length: 34⅝ inches (87.9 cm)
Purchase: Nelson Trust [56-78]

Mirror Handle in the Form of the Goddess of Love,
possibly 3rd century A.D.
Bronze
Height: 7¾ inches (19.7 cm)
Syrian(?)
Purchase: Nelson Trust [44-25]

Priest of Bel and His Attendant, 3rd century A.D.
Limestone
17½ x 25⅝ inches (44.5 x 65.1 cm)
Syrian; from Palmyra
Purchase: Nelson Trust [65-2]

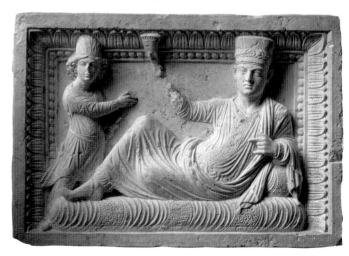

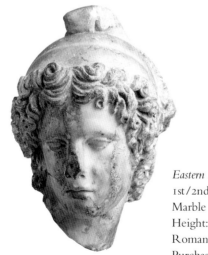

Eastern Figure with a Phrygian Cap,
1st/2nd century A.D.
Marble
Height: 12½ inches (31.8 cm)
Roman copy of a Greek original
Purchase: Nelson Trust [32-146]

THE COPTS

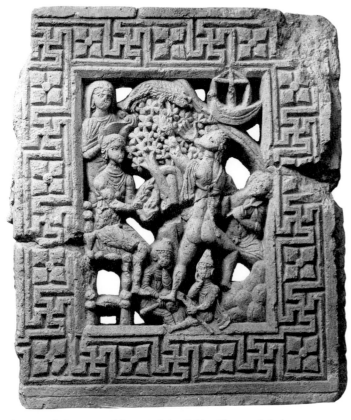

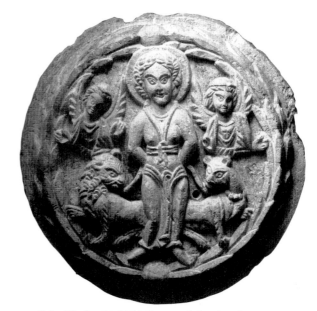

Saint Thecla with Wild Beasts and Angels, 5th century A.D.
Limestone
Diameter: 25½ inches (64.8 cm)
Purchase: Nelson Trust [48-10]

Screen with Depiction of Jason and the Golden Fleece, 4th/5th century A.D.
Limestone
41¾ x 34⅜ inches (106.1 x 87.3 cm)
Purchase: Nelson Trust [41-36]

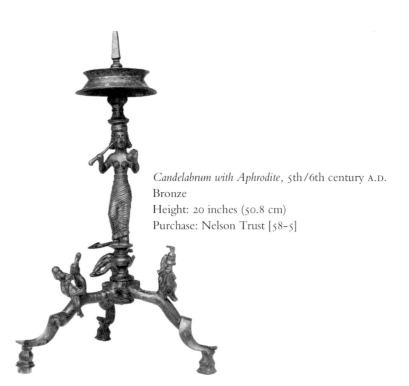

Candelabrum with Aphrodite, 5th/6th century A.D.
Bronze
Height: 20 inches (50.8 cm)
Purchase: Nelson Trust [58-5]

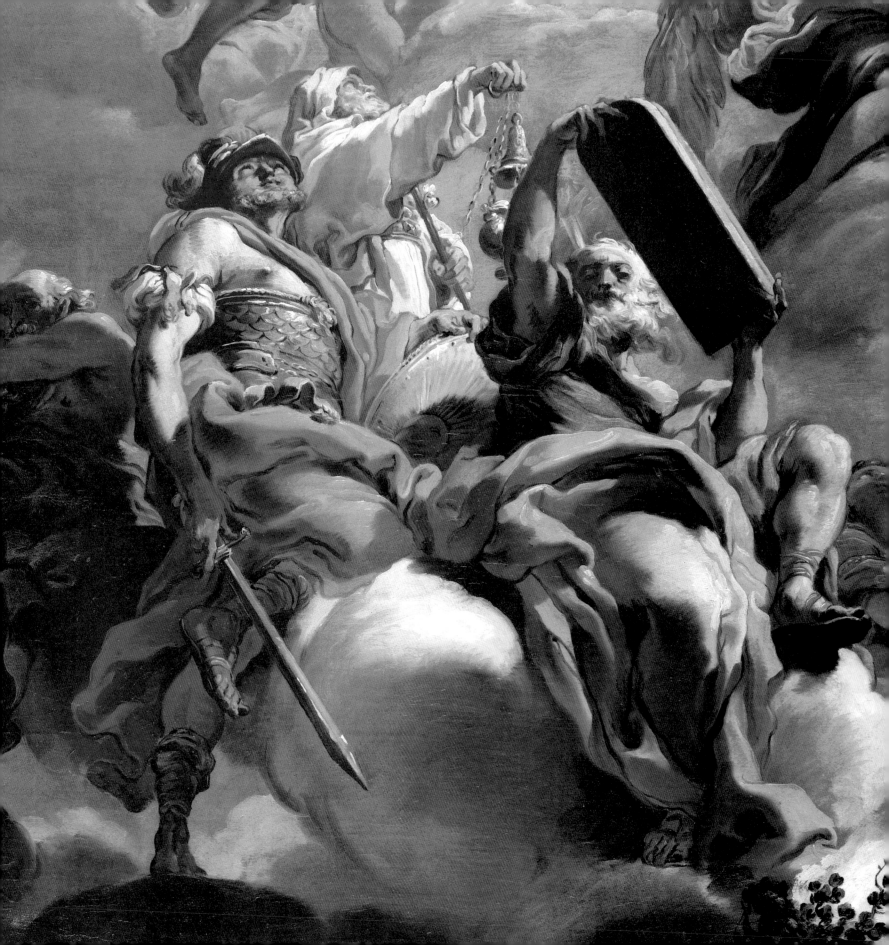

III

The Western Tradition
in Europe

Viewed as a whole, the large collection of postclassical European art in Kansas City is one of the most comprehensive in the United States. Because no core collection was bequeathed by either of the museum's founders, and due to the relatively late date at which the William Rockhill Nelson Trust was formed, there are inevitable lacunae that can never be filled. This reality was acknowledged by the early University Trustees, who never imagined they ought to assemble a truly encyclopedic collection of Western art. Instead they conceived a representative sampling of the most important artistic styles and movements from the Middle Ages to the present day, with a consistent emphasis on quality. Today the collection reflects the modern-day availability and inaccessibility of certain categories of art as well as the aspirations, interests, and prejudices of successive directors and curators. Well balanced but with varying degrees of depth, it is a nearly uninterrupted panorama of European art of the last millennium.

The illustrations have been arranged to demonstrate this continuum of historical and stylistic linkage. Works in different media are juxtaposed without regard for the political boundaries that have separated European nations—whether logically, artificially, or temporarily—since the forging of Charlemagne's empire.

The collection contains hardly any works made between the years 500 and 1100—the great age of Byzantium in the East and of barbarian invasions, migrations, and Gothic kingdoms in Western Europe. The earliest objects are architectural fragments, including capitals made in Italy and France in the first half of the twelfth century. An array of relief sculptures, all of Christian subject matter, includes the wonderful *Angel with a Flowering Staff;* its classically inspired beauty reveals that the example of antiquity was not completely forgotten over the course of the "Dark Ages." Devotional objects and small sculptures in wood, alabaster,

stone, and ivory complement a distinguished group of large-scale sculptures in both wood and stone, such as the Austrian *Saint George and the Dragon* of c. 1500. Paintings of the period are few but extremely fine. All were intended for worship or spiritual refreshment. Bernardo Daddi's *Virgin and Child Enthroned with Saints and Angels,* for example, is the central panel of a portable altar designed for private devotion. The huge, exceptionally complete *Altarpiece with Scenes from the Life of the Virgin,* on the other hand, was destined to fill the apse of a Spanish church. The *Holy Family in a Domestic Interior* by Petrus Christus (colorplate, page 27) demonstrates the dazzling technical mastery of fifteenth-century Flemish artists in their use of oil paint. Several masterpieces of medieval manuscript illumination are noteworthy, such as the *Initial "M" with Saints Andrew and Matthew(?)* attributed to Don Silvestro dei Gherarducci (colorplate, page 26). Rounding out the collection are important early prints, good stained-glass windows, and a handful of excellent tapestries.

The word "Renaissance" (meaning "rebirth") is widely used to characterize both a time period (about 1425–1600) and the works of art, literature, and music produced during that time. It was, specifically, in the courts and urban centers of northern Italy that the revived study of classical languages led to a resuscitation of the art forms favored by the ancient Romans (portrait busts, bronzes, and monumental sculpture), an attempt to imitate the naturalism of their style, and deliberate expansion of the canon of artistic subject matter to include classical mythology. Antonio del Pollaiuolo's engraved *Battle of Male Nudes* typifies the restitution of the human body as the ultimate measure of beauty and proportion, while Giuliano Bugiardini's circular *Virgin and Child with the Infant Saint John the Baptist,* of c. 1510, exemplifies the ideals of clarity, nobility, and

equilibrium that inspired such artists as Leonardo da Vinci and Raphael. The museum's collection contains works representative of many facets of Renaissance style, from the tough, lapidary aspect of Jan Gossaert's *Portrait of Jean de Carondelet* to the elegance of Lucas Cranach's *Three Graces,* from the impassive stylishness of Bronzino's superb *Portrait of a Young Man* (colorplate, page 30) to the highly charged, ecstatic energy of Joachim Wtewael's *Martyrdom of Saint Sebastian* (colorplate, page 32). Of particular importance are several large-scale sculptures, the most spectacular being Francesco Mosca's colossal *Atalanta and Meleager with the Calydonian Boar.* In size and figure style the sculpture emulates the monumental marbles of Michelangelo and Baccio Bandinelli, while its documented history and fine condition make it one of the most important High Renaissance sculptures outside Italy. Equally beautiful is an early cast of the bronze *Hercules, Deianeira, and Nessus* attributed to Adriaen de Vries (colorplate, page 32), its spiraling, multifigure composition directly inspired by the marbles and bronzes of Giambologna. There are excellent works on paper by such artists as Albrecht Dürer, Lucas van Leyden, Pellegrino Tibaldi, Hendrick Goltzius, and Jacques Bellange, and a small sampling of decorative arts featuring maiolica wares and several Limoges enamels. A *Crucifixion* plaque by Léonard Limousin (colorplate, page 28) is a work of special distinction.

The beginning of the seventeenth century is roughly coincidental with the emergence in Italy of two coexistent but different styles of painting, one engendered by the naturalism and drama of works by Michelangelo Merisi, called Caravaggio, the other developed and promoted by the Carracci family of Bologna, who based their art on a study of antique sculpture and the more recent works of Michelangelo and Correggio. The museum's seventeenth-century paintings are among its chief glories, they are so fine and various. Best known is the *Saint John the Baptist* by Caravaggio himself (colorplate, page 33). Caravaggio's potent influence on foreign artists resident in Rome is evident in major works by the Spaniard Jusepe de Ribera and the Dutch artists Hendrick Terbrugghen and Dirck van Baburen. The robust *all'antica* style of the Carracci greatly impressed the Flemish painter Peter Paul Rubens, whose own coupling of monumentality with dynamism can be seen in his *Sacrifice of Isaac,* while the paintings of Guido Reni and Guercino, two pupils of the Carracci, manifest their teachers' instructions to visualize religious experience in clear and immediate terms. One of the Bacchanales painted by Nicolas Poussin for Cardinal Richelieu, *The Triumph of Bacchus* of 1635–36 (colorplate, page 35), testifies to that artist's complete assimilation of the compositional principles of antique relief sculpture, while the primary version of *The Entombment of Saint Catherine of Alexandria,* a major altarpiece by Francisco de Zurbarán, makes the observer privy to a miraculous moment of mystical equipoise. An impressive group of works by Pieter Claesz., Meindert Hobbema, Rembrandt, and Jan Steen, among others, is typical of the range of seventeenth-century Dutch art, with its preponderance of still lifes, landscapes, portraits, and genre scenes. Fine prints and drawings by many of the artists represented in the painting collection—Guercino, Rembrandt, Poussin, Ribera, to name just a few—reveal other, often less formal sides of their personalities.

It is with the seventeenth century, too, that there begin two of the museum's most important specialty collections. One is the Starr Collection of European and American Miniatures. Some 255 works range in date from the late Tudor period, of which Nicholas Hilliard's *Portrait of George Clifford, Third Earl of Cumberland* (colorplate,

page 31) is a fine example, to the first quarter of the nineteenth century. Within the collection is a unique concentration of the works of John Smart. A dated example for each year of his activity (1760 to 1811) offers the rare opportunity to survey the entire development of an artist within the field of miniature painting. The other ensemble of specialized interest is the Burnap Collection of English Pottery, which contains over 1,100 items. Its great strength lies in the richness of its seventeenth- and eighteenth-century wares, with special emphasis on slipware and delftware. Highlights of early date include the tin-glazed earthenware *Charger with Scene of the Nativity,* dated 1652 (colorplate, page 36), and a *Covered Tankard* of c. 1685, made of marbled brown salt-glazed stoneware.

The unprecedented internationalism and diversity of the visual arts in the eighteenth century are documented with some thoroughness. There are multiple examples of most categories of painting, including history and mythology, portraiture, topographical views and landscapes, still life, and genre. Among these a few stand out, such as Gaetano Gandolfi's marvelous *Assumption of the Virgin,* Elisabeth-Louise Vigée Le Brun's exceptional *Portrait of Marie-Gabrielle de Gramont, Duchesse de Caderousse,* François Boucher's *Landscape with a Water Mill* (colorplate, page 40), the delightful *Still Life with Cat and Fish* by Jean-Baptiste-Siméon Chardin, and Gaspare Traversi's splendid allegories of *The Arts: Music* and *The Arts: Drawing.* The drawings in the collection provide still more complete coverage of the century, with examples by Giovanni Battista Piazzetta, Jean-Antoine Watteau, and Jean-Honoré Fragonard, among others who are not represented in the painting collection. There are multiple sheets by many artists, such as Alessandro Magnasco, Boucher, and Hubert Robert, and some treasures of considerable rarity

such as Jan van Huysum's *Vase of Flowers.* There is a wide range of sculpture from the astonishing ivory carving of the *Fall of the Rebel Angels* to life-size bronzes, polychromed wood pieces, and portrait busts. The eighteenth-century decorative arts include major pieces of French cabinet furniture attributed to Charles Cressent and Adam Weisweiler, for example. There are porcelain figures and wares from many European manufactories, including the most important centers at Meissen, near Dresden, and Sèvres, just outside Paris. The level of technical perfection to which artisans aspired during the early years of production at Sèvres is epitomized by the recently acquired *Tea Service,* 1757, and *Vase "Choisy,"* 1759 (colorplate, page 41).

The collection of nineteenth-century European art is markedly dominated by works from France. In painting, most of the major movements or groups are represented with the exception of neoclassicism, at the very beginning of the century, and the Nabis, at the very end. There are quintessential oil sketches by Jean-Auguste-Dominique Ingres, J.-L.-A. Théodore Géricault, and Eugène Delacroix and significant works by the major figures of the Barbizon school. *Chiffa Pass,* painted on a large panel of mahogany, is an especially fine work by the Orientalist Eugène Fromentin. The museum's excellent collection of paintings by the Impressionists and Post-Impressionists includes a number of seminal works that happen also to be immensely popular with the public. Claude Monet's *Boulevard des Capucines* (colorplate, page 44), for example, was radical and controversial when first exhibited in 1874. The most recent addition is that of a perfectly preserved portrait by Gustave Caillebotte, still the least known of the principal figures of Impressionism. There are few British works of consequence apart from a delicious portrait by Thomas Lawrence of his friend Mrs. William Lock of

Norbury, and a very fine landscape by John Constable. The nineteenth-century graphic arts are less exclusively devoted to works by the French, for characteristic drawings and watercolors by artists such as Géricault, Delacroix, Ingres, Théodore Chassériau, Théodore Rousseau, and Odilon Redon are balanced by a large group of topographical drawings by Englishmen such as Edward Lear, Romantic watercolors by John Martin and Joseph Michael Gandy, and a fair number of works by Continental draftsmen such as Karl Friedrich Schinkel. European decorative arts of the nineteenth century are not yet well represented apart from British ceramics, a few pieces of Napoleonic furniture, and some later examples of porcelain from the Sèvres manufactory. In the latter category there is an unusual *Column Clock* of about 1814, its shaft embellished with a spiral of the zodiac and topped by a bronze statuette of Napoleon.

The collecting of modern art in Kansas City was long inhibited by a clause in William Rockhill Nelson's will forbidding the use of income from the Nelson Trust for the purchase of work by any artist not dead at least thirty years. Nelson hoped thus to ensure that the collection formed in his name would always carry the imprimatur of objectivity and authenticity. The provision, recently challenged and set aside, meant that the early University Trustees, who could buy a work by Georges Seurat (died 1891) as soon as they wished (and did so in 1933), perversely were not free to purchase any work by Monet (died 1926) until 1957, when they acquired the magnificent *Water Lilies*. Works by living artists such as Pablo Picasso and Henri Matisse were, of course, out of the question during the first several decades of the museum's existence. As it is constituted today, the twentieth-century collection is made up almost entirely of gifts from the Friends of Art, a membership organization whose original raison d'être was to compensate for the prohibition against contemporary art inherent in the formulation of the Nelson Trust. The result is an erratic sampling of European art from this century, more random in character than any other portion of the collection of Western art. Several works on paper are extremely fine, such as posters by Johan Thorn Prikker and Léon Bakst, and a monumental charcoal landscape by Piet Mondrian. One of Maurice Utrillo's finest panels, *Street in Sannois*, painted during his "white period," is more or less contemporary with excellent Expressionist works by both Ernst Ludwig Kirchner and Emil Nolde. The collection contains a few examples of Synthetic Cubism, notably two fine works by Juan Gris, a collage and a small painting. A superb Synchronist work by Wassily Kandinsky, *Rose with Gray* (colorplate, page 49), stands more or less alone in the collection, which otherwise contains only a few minor Surrealist paintings. Fine Cubist sculptures by Alexander Archipenko and Jacques Lipchitz are now complemented by numerous twentieth-century works deposited with the museum for an indefinite period by the Hall Family Foundation of Kansas City. These include superb examples by Constantin Brancusi, Max Ernst, and Alberto Giacometti as well as a large group of works by Henry Moore—some thirteen pieces of monumental scale, and several dozen working models and maquettes. At present, the Hall Family Foundation's collection constitutes the largest concentration of Moore's sculpture outside the United Kingdom.

ROMANESQUE AND GOTHIC ART (C. 1000–1525)

Panel from a Chancel Screen, c. 1039
Marble
30¼ x 29¼ inches (76.8 x 74.3 cm)
Byzantine (South Italian)
Purchase: Nelson Trust [49-6]

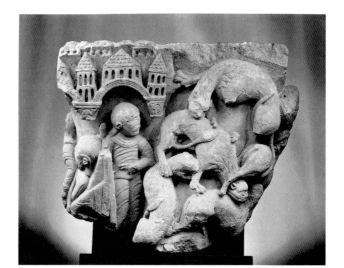

Fragment of a Capital, c. 1150
Limestone
Height: 15 inches (38.1 cm)
French
Purchase: Nelson Trust [55-44]

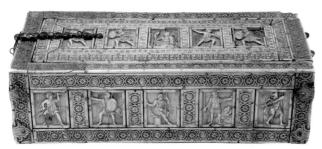

Casket, 11th century with later mounts
Ivory and gilt bronze
3⅞ x 13⅝ x 5¾ inches (9.9 x 34.7 x 14.6 cm)
Byzantine (South Italian)
Purchase: Nelson Trust [49-38]

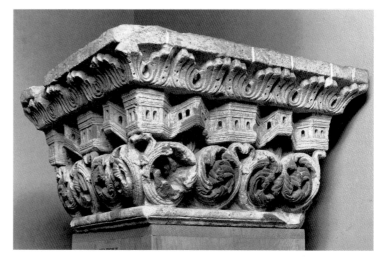

Capital with an Architectural Frieze, mid 12th century
Limestone
14 x 23 x 23¼ inches (35.6 x 58.4 x 59.1 cm)
French
Purchase: Nelson Trust [48-39]

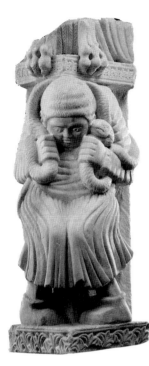

Lectern Support, c. 1200
Marble
Height: 26 inches (66.0 cm)
Italian
Purchase: Nelson Trust [47-35]

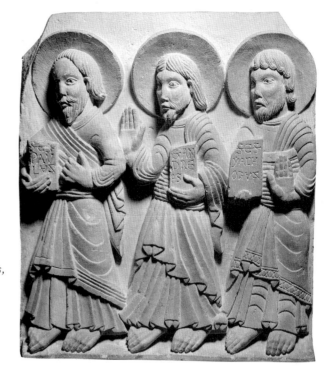

The Apostles Paul, Andrew, and James,
c. 1150/70
Limestone with traces of paint
31 x 27½ inches (78.7 x 69.9 cm)
Catalan
Purchase: Nelson Trust [32-164]

Astronomical and Geometrical Figures,
Animals, and a Man, c. 1250
Brown ink on vellum
10¼ x 8¾ inches (26.0 x 22.2 cm)
French
Purchase: Nelson Trust [63-29]

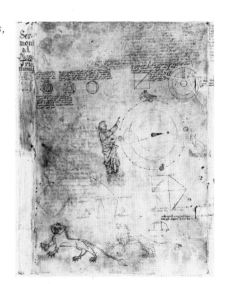

Angel with a Flowering Staff, 1160/70
Limestone
23 x 17¼ inches (58.4 x 43.8 cm)
French
Purchase: Nelson Trust [54-25]

Reliquary, 1225/50
Wooden casket with gilt bronze and
Limoges enamel superstructure
9¼ x 8⁵⁄₁₆ x 3⅛ inches (23.5 x 21.2 x 7.9 cm)
French
Purchase: Nelson Trust [46-35]

The Dead Christ, 1250/1300
Wood with paint
Height: 72 inches (182.9 cm)
Catalan
Purchase: Nelson Trust [44-50/1]

Corpus, 13th century
Gilt bronze with Limoges enamel inlay
Height: 8¾ inches (22.2 cm)
French
Purchase: Nelson Trust [49-39]

Head of a Female Saint, late 13th century
Limestone
Height: 10 inches (25.4 cm)
French
Gift of the Laura Nelson Kirkwood
Residuary Trust [44-37]

Initial "S," leaf from an antiphonary, 1300/25
Colored ink on vellum
28$\frac{15}{16}$ x 19$\frac{5}{8}$ inches (73.5 x 49.8 cm)
Italian
Purchase: Nelson Trust [54-23]

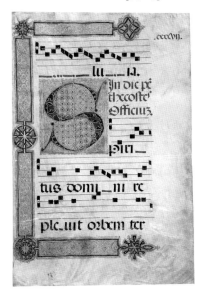

Jacopo del Casentino
Italian, died 1349
The Presentation of the Christ Child in the Temple, dated 1330
Tempera on wood panel
42$\frac{1}{8}$ x 26$\frac{3}{8}$ inches (107.0 x 67.0 cm), gabled top
Gift of the Samuel H. Kress Foundation [F61-59]

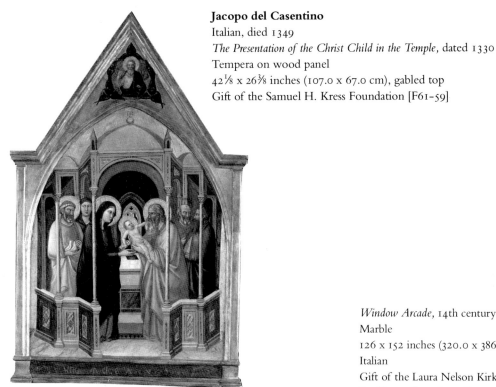

Window Arcade, 14th century
Marble
126 x 152 inches (320.0 x 386.1 cm)
Italian
Gift of the Laura Nelson Kirkwood
Residuary Trust [44-38]

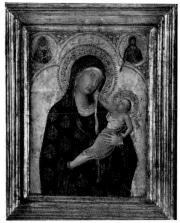

Lippo Memmi
Italian, active c. 1317–1350
The Virgin and Child, c. 1325/30
Tempera and gold leaf on wood panel
13$\frac{3}{4}$ x 10$\frac{1}{4}$ inches (34.9 x 26.0 cm)
Gift of the Samuel H. Kress Foundation [F61-62]

Attributed to the Master of the Death of the Virgin
French, active c. 1310–1340
The Crucifixion, c. 1330
Ivory plaquette (wing of a diptych)
5¹¹⁄₁₆ x 3¹⁵⁄₁₆ inches (14.6 x 10.0 cm)
Purchase: Nelson Trust [51-9]

The Virgin and Child in Glory, 1325/50
Ivory plaquette (wing of a diptych)
6¾ x 4¼ inches (17.2 x 10.8 cm)
French
Purchase: Nelson Trust [51-11]

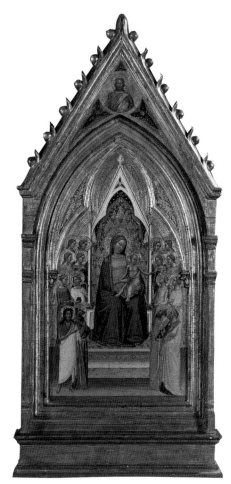

Bernardo Daddi
Italian, active 1312–1348
*The Virgin and Child Enthroned with
Saints and Angels,* c. 1335/40
Tempera and gold leaf on wood panel
38¼ x 18 inches (97.2 x 45.7 cm), gabled top
Gift of the Samuel H. Kress Foundation
[F61-61]

Giovanni and Pacio Bertini da Firenze
Italian, active mid 14th century
Attendant Angels, originally flanking a recumbent effigy, 1340s(?)
Marble
Height: 37¼ inches (94.6 cm), each
Purchase: Nelson Trust [46-68/1,2]

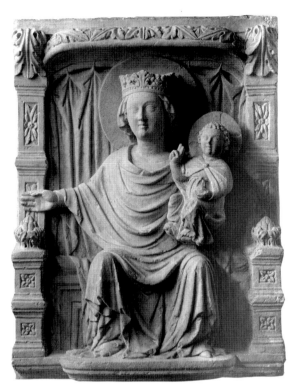

The Virgin and Child Enthroned, mid 14th century
Marble
28½ x 20¼ inches (72.4 x 51.4 cm)
Italian
Purchase: Nelson Trust [41-8]

Bartolo di Fredi
Italian, active 1353–1410
Saint Peter, c. 1375/80
Tempera and gold leaf on wood panel
70⅞ x 19¹¹⁄₁₆ inches (180.0 x 50.0 cm)
Purchase: Nelson Trust [50-13]

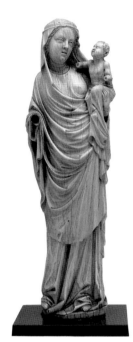

The Virgin and Child, 1350/75
Ivory
Height: 12¾ inches (32.4 cm)
French
Purchase: Nelson Trust [34-139]

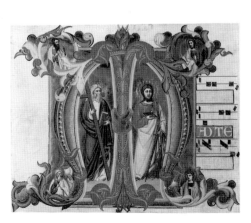

Attributed to Don Silvestro dei Gherarducci
Italian, 1339–1399
Initial "M" with Saints Andrew and Matthew(?),
leaf from an antiphonary, c. 1380
Tempera and gold leaf on vellum
12⅜ x 15¹¹⁄₁₆ inches (31.5 x 39.9 cm)
Purchase: acquired through the
bequest of Ida C. Robinson [F61-14]
[See colorplate, p. 26]

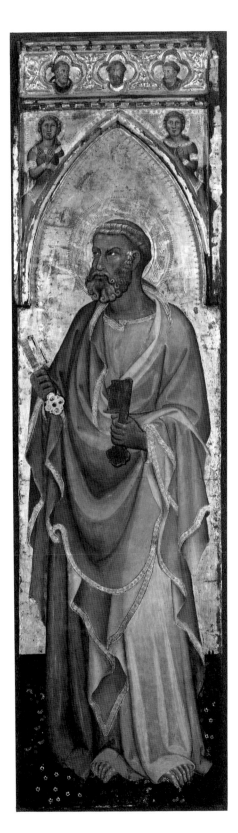

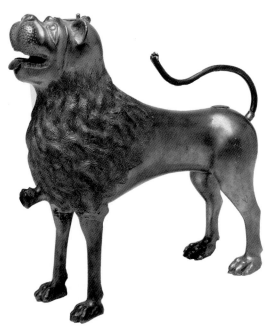

Aquamanile, late 14th/early 15th century
Bronze
Height: 12½ inches (31.8 cm)
German
Purchase: Nelson Trust [43-22]

Kneeling Angel, late 14th/early 15th century
Alabaster
Height: 13½ inches (34.3 cm)
Spanish
Purchase: Nelson Trust [46-36]

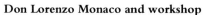

Gherardo di Jacopo Starna, called Starnina
Italian, active 1387–1413
Adoration of the Magi, c. 1405
Tempera on wood panel
13 x 31⅜ inches (33.0 x 79.7 cm)
Gift of the Samuel H. Kress Foundation [F61-60]

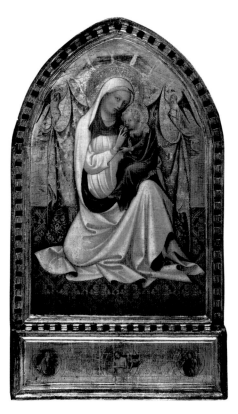

Don Lorenzo Monaco and workshop
Italian, 1370/72–1422/25
The Virgin and Child, c. 1410
Tempera and gold leaf on wood panel
44⅜ x 26³⁄₁₆ inches
(112.8 x 66.5 cm), arched top
Purchase: Nelson Trust [40-40]

The Virgin and Child in Glory, 1400/25
Sandstone with paint
32 x 20¼ inches (81.3 x 51.4 cm)
French
Purchase: Nelson Trust [33-3/5]

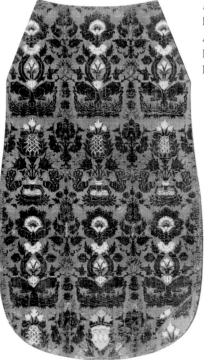

Front of a Chasuble, mid 15th century
Five-color velvet
42¼ x 25 inches (107.3 x 63.5 cm)
Italian
Purchase: Nelson Trust [31-108/1]

Attributed to the workshop of Gonzalo Pérez
Spanish, active early 15th century
Altarpiece with Scenes from the Life of the Virgin, 1420/30
Tempera and gold leaf on wood panel
156 x 113¾ inches (396.2 x 288.9 cm)
Purchase: Nelson Trust [32-207]

Attributed to the workshop of the Boucicaut Master
French, active early 15th century
King David as Psalmist, page from a Book of Hours, c. 1412
Tempera and gold leaf on vellum
8 x 6 inches (20.3 x 15.2 cm)
Purchase: Nelson Trust [34-303/1]
[See colorplate, p. 27]

Saint George or *Saint Michael*,
fragmentary bust, mid 15th century
Limestone with traces of paint
Height: 15 inches (38.1 cm)
French
Purchase: Nelson Trust [35-18]

The Crucifixion, c. 1460/80
Pot metal; white glass with silver stain
40⅛ x 22¼ inches (102.0 x 56.5 cm)
French
Purchase: Nelson Trust [44-49/5]

Petrus Christus
Flemish, c. 1410–c. 1473
The Holy Family in a Domestic Interior, c. 1460
Oil on wood panel
28⅛ x 20½ inches (71.5 x 52.1 cm)
Purchase: Nelson Trust [56-51]
[*See colorplate, p. 27*]

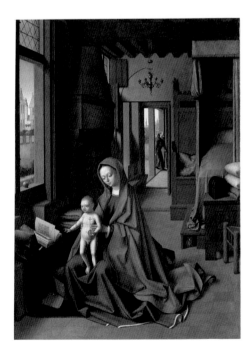

The Crucifixion, 1450/1500
Alabaster with traces of paint
23½ x 10¾ inches (59.7 x 27.3 cm)
English
Purchase: Nelson Trust [43-31]

**Attributed to the workshop of
Peter Hemmel**
German, active late 15th century
*Heraldic Panel with Arms of Anton von
Ramstein,* c. 1482
Pot metal; white glass with silver stain
34 x 21½ inches (86.4 x 54.6 cm)
Purchase: Nelson Trust [44-61]

*Initial "N" with the Stigmatization of
Saint Francis,* leaf from an
antiphonary (detail), 1450/75
Tempera and gold leaf on vellum
28¾ x 20⅝ inches (73.0 x 52.4 cm), overall
Italian
Purchase: Nelson Trust [31-120]

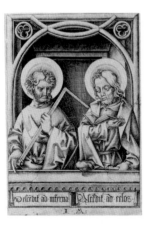

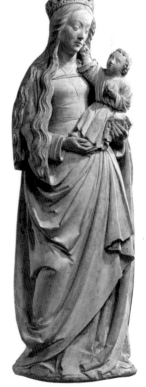

Israhel van Meckenem
German, c. 1440/45–1503
Saint Thomas and Saint James the Less,
c. 1480/85
Engraving (1st state)
8⁵⁄₁₆ x 5⁹⁄₁₆ inches (21.1 x 14.1 cm)
Purchase [F89-34]

The Disrobing of Christ, c. 1475
Hand-colored woodcut
5¾ x 4¼ inches (14.6 x 10.8 cm)
German
Purchase: Nelson Trust [33-1629]
[*See colorplate, p. 28*]

The Virgin and Child, c. 1475
Limestone with traces of paint
Height: 35¼ inches (89.5 cm)
French
Purchase: Nelson Trust [38-8]

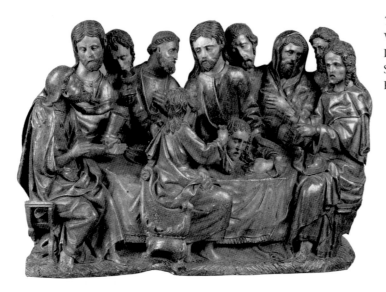

The Last Supper, 15th century
Wood with paint
Length: 34 inches (86.4 cm)
Spanish
Purchase: Nelson Trust [30-41]

The Agony in the Garden; the Betrayal and Capture of Christ, 1475/1500
Wool tapestry
106 x 91 ½ inches (269.2 x 232.4 cm)
Flemish
Purchase: Nelson Trust [70-7]

Master of Zwolle
Dutch, c. 1440–1504
The Last Supper, c. 1485
Engraving
13 ⅝ x 10 ⅜ inches (34.5 x 26.3 cm)
Purchase: Nelson Trust [35-44/2]

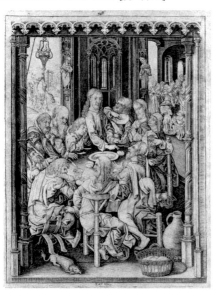

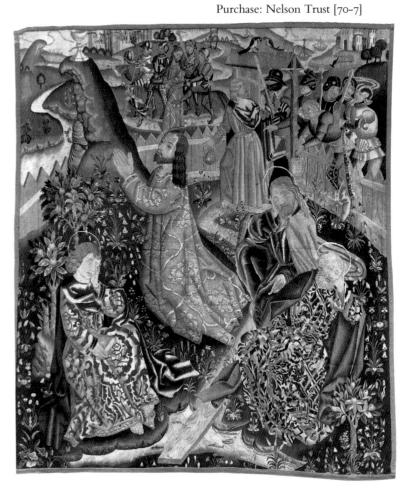

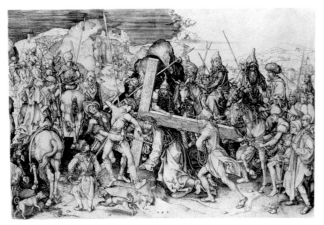

Martin Schongauer
German, c. 1430–1491
The Way to Calvary, c. 1470
Engraving
11⅚ x 17 inches (28.8 x 43.2 cm)
Purchase: Nelson Trust [33-1452]

The Way to Calvary, c. 1510
Silk and wool tapestry
118 x 116 inches (299.7 x 294.6 cm)
Designed by Jean de Camp, Flemish, active early 16th century
Purchase: Nelson Trust [34-41]

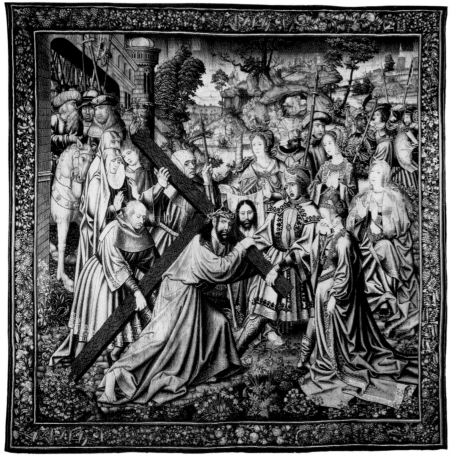

The Crucifixion, center section of an
altarpiece, 1500/25
Wood
62 x 31⅞ inches (157.5 x 81.0 cm)
Flemish
Purchase: Nelson Trust [41-10]

Hans Tilman Riemenschneider
German, c. 1460–1531
The Virgin of the Crucifixion, c. 1510
Linden wood
Height: 23¼ inches (59.1 cm)
Purchase: Nelson Trust [64-6]

Bishop's Throne, from a suite of choir stalls, late 15th century
Carved, inlaid, and painted walnut
108½ x 87¼ x 24 inches (275.6 x 221.6 x 61.0 cm)
Spanish
Purchase: Nelson Trust [42-30]

Saint George and the Dragon, c. 1500
Wood with paint
Height: 73 inches (185.4 cm)
Austrian
Purchase: acquired through the
bequest of Ida C. Robinson [F60-45]

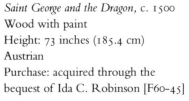

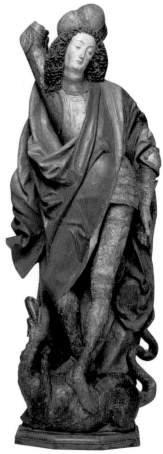

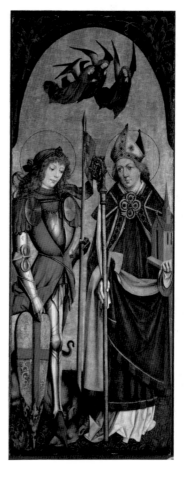

Master of the Housebook
Probably German, active late 15th century
Saint George and Saint Wolfgang
Oil and gold leaf on wood panel
69½ x 26½ inches (176.5 x 67.3 cm)
Purchase: Nelson Trust [34-101]

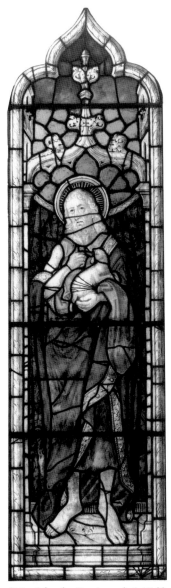

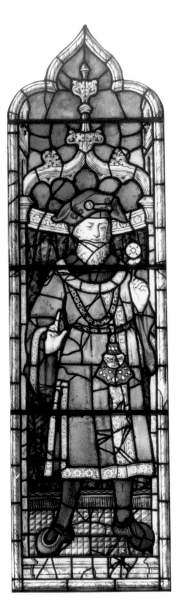

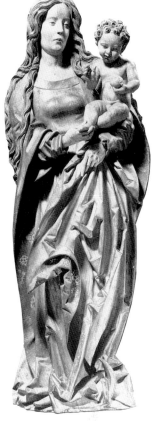

The Virgin and Child, c. 1520
Linden wood with paint
Height: 57½ inches (146.1 cm)
German
Purchase: Nelson Trust [31-107]

Saint John the Baptist and *A Nobleman*, c. 1500
Pot metal; white glass with silver stain
105⅞ x 29⁵⁄₁₆ inches (268.9 x 74.5 cm);
104¼ x 29¹³⁄₁₆ inches (264.8 x 75.7 cm)
French
Purchase: Nelson Trust [44-49/7,6]

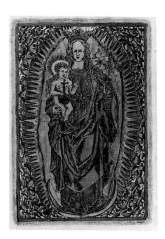

**Master S., identified as Sanders
Alexander van Brugsal**
Flemish, active c. 1505–1554
The Virgin and Child in Glory
Hand-colored engraving
4¼ x 3 inches (10.9 x 7.6 cm),
including border
Purchase [F83-35]

THE RENAISSANCE (C. 1450–1600)

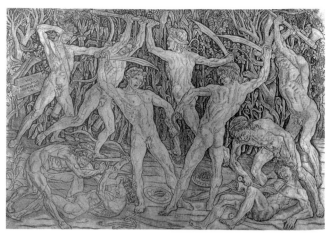

Antonio del Pollaiuolo
Italian, c. 1431/32–1498
Battle of Male Nudes, c. 1460/90
Engraving (2nd state)
15⁵⁄₁₆ x 23 inches (38.9 x 58.4 cm)
Purchase: Nelson Trust [34-188]

Andrea Mantegna
Italian, 1431–1506
Battle of Sea Gods (right half)
Engraving (2nd state)
13⅛ x 17⅝ inches (33.3 x 44.8 cm)
Purchase: Nelson Trust [34-187]

Attributed to Francesco del Cossa
Italian, 1435/36–c. 1477
The Presentation in the Temple, c. 1465/70
Tempera and gold leaf on vellum
6⅝ x 6½ inches (16.9 x 16.5 cm)
Purchase: Nelson Trust [33-1363]

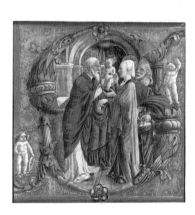

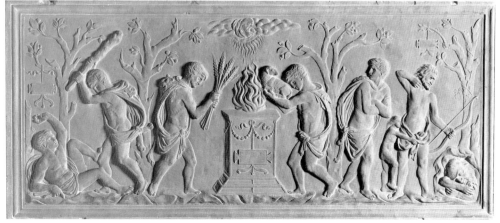

*Scenes from the Book of Genesis: Cain Kills Abel;
the Sacrifice of Abel; Lamech Kills His
Great-Grandfather,* mid 15th century
Istrian stone (*pietra serena*)
30 x 69½ inches (76.2 x 176.5 cm)
Italian
Purchase: Nelson Trust [41-63/1]

Workshop of Andrea della Robbia
Italian, 1435–1525
The Virgin and Child, 1480/90(?)
Glazed earthenware
Diameter: 36½ inches (92.7 cm)
Purchase: Nelson Trust [33-1578]

Francesco di Simone Ferrucci
Italian, 1437–1493
The Virgin and Child
Marble
Diameter: 26 inches (66.0 cm)
Purchase: Nelson Trust [33-111]

Giovanni Bellini
Italian, c. 1432/33–1516
The Virgin and Child, c. 1485
Oil on canvas (transferred from wood panel)
28⁹⁄₁₆ x 21¾ inches (72.6 x 55.3 cm)
Gift of the Samuel H. Kress Foundation [F61-66]

Workshop of Benedetto Briosco and Tommaso Cazzaniga
Italian, 1477–1526 and active 1483–1504
The Annunciation and *The Presentation in the Temple,* after 1484
Marble with gilding
24 x 23¾ inches (61.0 x 60.3 cm); 24 x 23¹³⁄₁₆ inches (61.0 x 60.5 cm)
Purchase: Nelson Trust [51-29/1,2]

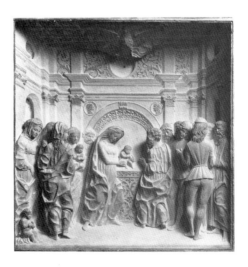

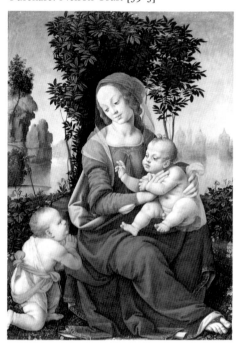

Lorenzo di Credi
Italian, 1456/59–1537
*The Virgin and Child with the Infant
Saint John the Baptist,* c. 1510
Oil and tempera on wood panel
40⅟₁₆ x 28⅝ inches (101.8 x 72.7 cm)
Purchase: Nelson Trust [39-3]

Andrea Bregno
Italian, 1418–1506
Saint James the Less and *Saint Philip,* c. 1495
Marble
41 x 18¼ inches (104.1 x 46.4 cm), each
Gift of the Samuel H. Kress Foundation [F61-67,68]

Workshop of Giovanni Gaggini
Italian, died 1517
Saint George and the Dragon
Marble with traces of gilding and paint
28 x 78 inches (71.1 x 198.1 cm)
Gift of the Laura Nelson Kirkwood
Residuary Trust [41-29/11]

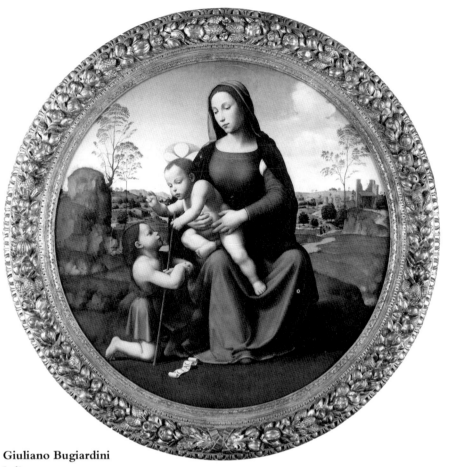

Giuliano Bugiardini
Italian, 1475–1554
The Virgin and Child with the Infant Saint John the Baptist, c. 1510
Oil and tempera on Masonite (transferred from wood panel)
Diameter: 49½ inches (125.7 cm)
Purchase: Nelson Trust [68-10]

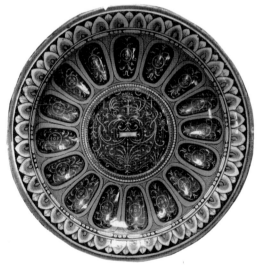

Albrecht Dürer
German, 1471–1528
Four Heads, dated 1513 or 1515 (partly cut)
Brown ink on paper
8¼ x 7⅞ inches (21.0 x 20.0 cm)
Purchase: Nelson Trust [58-62]

Albrecht Dürer
German, 1471–1528
Saint Jerome, dated 1514
Engraving
9⅞ x 7½ inches (25.1 x 19.1 cm)
Gift of Mr. Robert B. Fizzell [58-70/21]

Fruit Dish, early 16th century
Maiolica (tin-glazed earthenware)
Diameter: 11 inches (27.9 cm)
Italian
Gift of Mr. Robert Lehman [43-39/11]

Agostino de Musi, called Veneziano (after Raphael)
Italian, active 1514–1536
The Death of Ananias
Engraving
10 x 15¹¹⁄₁₆ inches (25.4 x 39.8 cm)
Purchase: Nelson Trust [32-74/11]

Bernard van Orley
Flemish, c. 1491/92–1541
Saint Martin Knighted by the Emperor Constantine, c. 1514
Oil on wood panel
27¼ x 29¾ inches (69.2 x 75.6 cm)
Purchase: Nelson Trust through the
bequest of Mr. Henry J. Haskell [53-39]

Lucas van Leyden
Dutch, 1494–1533
Esther before Ahasuerus, dated 1518
Engraving
10⅝ x 8¹¹⁄₁₆ inches (27.0 x 22.1 cm)
Purchase [F86-24]

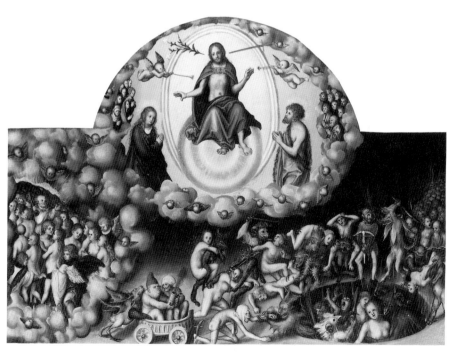

Lucas Cranach the Elder
German, 1472–1553
The Last Judgment, c. 1520/25
Oil on wood panel
28½ x 39⅛ inches (72.4 x 99.4 cm)
Purchase: Nelson Trust [60-37]

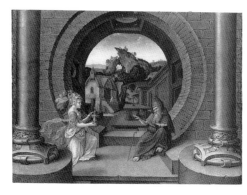

Attributed to Jan Wellens de Cock
Flemish, active 1506–1527
The Temptation of Saint Anthony, c. 1522/25
Oil on wood panel
11¼ x 15⁵⁄₁₆ inches (28.6 x 38.9 cm)
Purchase: Nelson Trust [50-51]

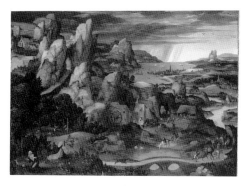

Master of the Female Half-Lengths
Flemish, active 1520s
Landscape with the Penitent Saint Jerome, c. 1525/30
Oil on wood panel
13⅞ x 19¼ inches (35.3 x 48.9 cm)
Purchase: Nelson Trust [61-1]

Jan Gossaert, called Mabuse
Flemish, c. 1478–1532
Portrait of Jean de Carondelet, c. 1525/30
Oil on wood panel
17 x 13½ inches (43.2 x 34.3 cm)
Purchase: Nelson Trust [63-17]

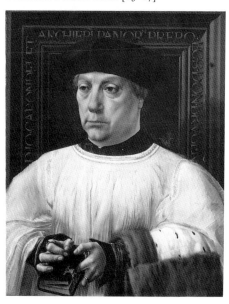

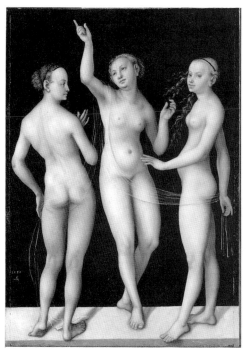

Lucas Cranach the Elder
German, 1472–1553
The Three Graces, dated 1535
Oil on wood panel
19⅞ x 14¹⁄₁₆ inches (50.5 x 35.7 cm)
Purchase: Nelson Trust [57-1]

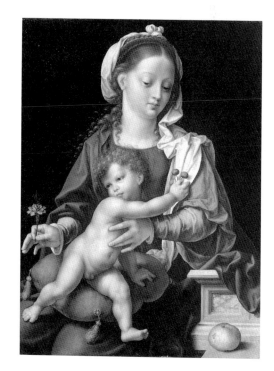

Joos van Cleve
Flemish, c. 1485–1540/41
Virgin with the Carnation, c. 1535
Oil on wood panel
24⅛ x 18¼ inches (61.3 x 46.4 cm)
Purchase: Nelson Trust [33-50]

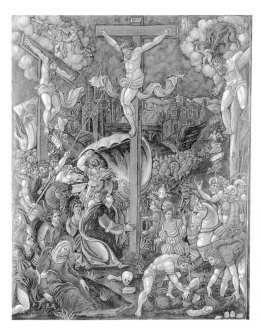

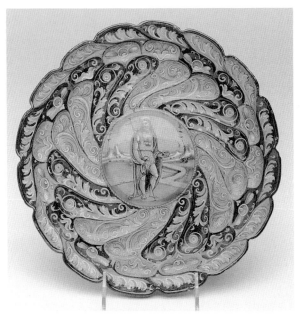

Léonard Limousin
French, c. 1515–c. 1576
The Crucifixion, dated 1535 and 1536
Enamel and gold on copper
9⅝ x 8⅜ inches (24.5 x 21.3 cm)
Purchase: Nelson Trust [31-106]
[*See colorplate, p. 28*]

Dish with Scene of Saint John the Baptist in the Wilderness, c. 1540
Maiolica (tin-glazed earthenware)
Diameter: 10½ inches (26.7 cm)
Italian
Gift of Mr. Robert Lehman [43-39/8]
[*See colorplate, p. 29*]

Georg Pencz
German, c. 1500–1550
Romulus and Remus, dated 1546
Black ink, watercolor, and gouache
over black chalk on paper
Diameter: 11 inches (27.9 cm)
Purchase: Nelson Trust [60-5]

Jean Duvet
French, c. 1485–1561
The Martyrdom of Saint John the Evangelist
Engraving
11¾ x 8⁵⁄₁₆ inches (29.9 x 21.1 cm), arched top
Purchase: Nelson Trust [35-44/3]

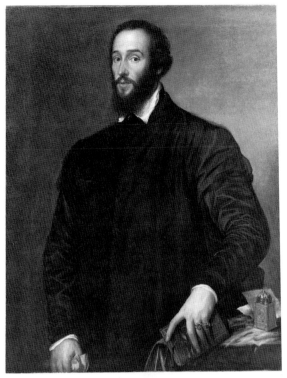

Agnolo di Cosimo di Mariano, called Bronzino
Italian, 1503–1572
Portrait of a Young Man, early 1550s
Oil on wood panel
33¾ x 27 inches (85.7 x 68.6 cm)
Purchase: Nelson Trust [49-28]
[*See colorplate, p. 30*]

Tiziano Vecellio, called Titian, and workshop
Italian, c. 1488/90–1576
Portrait of Antoine Perrenot de Granvelle, 1548
Oil on canvas
44⅛ x 34¾ inches (112.0 x 88.3 cm)
Purchase: Nelson Trust [30-15]

Pellegrino Tibaldi
Italian, 1527–1596
Ulysses before Troy, c. 1555/58
Brown ink and wash over black chalk, heightened
with white, on light brown-washed paper
8⁷⁄₁₆ x 11¹⁄₁₆ inches (21.5 x 28.1 cm)
Gift of the Newhouse Galleries [33-63]

Bartolommeo Passerotti
Italian, 1529–1592
Copy after Michelangelo's "Dawn," c. 1550
Brown ink and red chalk on paper
17⅜ x 11½ inches (44.2 x 29.2 cm)
Purchase: Nelson Trust [39-37]

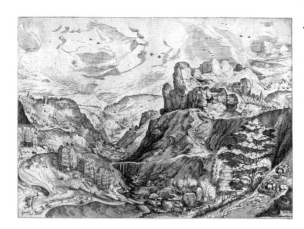

Jan or Johannes and Lucas Duetecum (after Pieter Bruegel the Elder)
Flemish, active c. 1530–after 1606 and active from c. 1555
Alpine Landscape, c. 1555/56
Engraving with etching
11 13/16 x 16 13/16 inches (30.0 x 42.7 cm)
Purchase [F90-21]

Francesco Mosca, called Moschino
Italian, 1525–1578
Atalanta and Meleager with the Calydonian Boar, 1564/65
Marble
Height: 81 inches (205.7 cm)
Purchase: Nelson Trust [34-94]

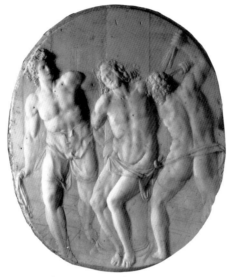

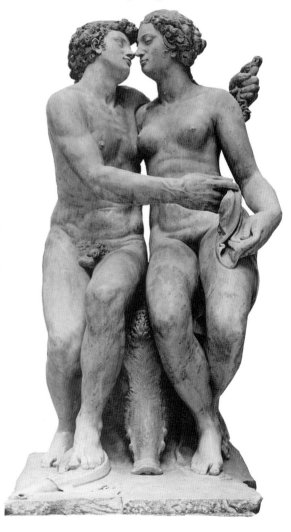

Vincenzo Danti
Italian, 1530–1576
The Flagellation of Christ, c. 1559
Marble
20¼ x 17⅛ inches
(51.4 x 43.5 cm), oval
Purchase: Nelson Trust [51-53]

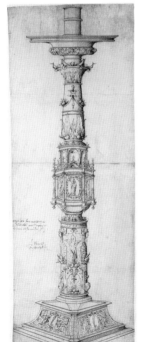

**Anonymous German or French
monogrammist REZ**
Design for an Ecclesiastical Candlestick, dated 1559
Black ink, gray and brown wash over
stylus on paper
28¾ x 10½ inches (73.0 x 26.7 cm)
Purchase: acquired through the generosity of
Mr. and Mrs. Milton McGreevy
through the Westport Fund [54-10]

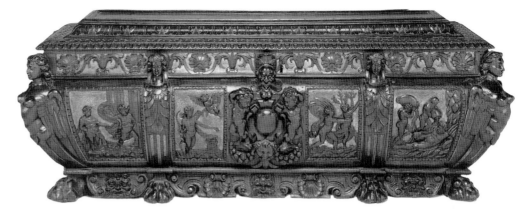

Luca Cambiaso
Italian, 1527–1588
Combat between Horseman and Soldiers, c. 1565
Brown ink and wash on paper
9⅜ x 12¹/₁₆ inches (23.8 x 30.6 cm)
Purchase: Nelson Trust [44-29/1]

Cassone Decorated with Episodes from the Myth of Apollo and Daphne, 1560/70
Parcel-gilt walnut with traces of paint or gesso
25½ x 65½ x 21½ inches (64.8 x 166.4 x 54.6 cm)
Italian
Purchase: Nelson Trust [33-459]

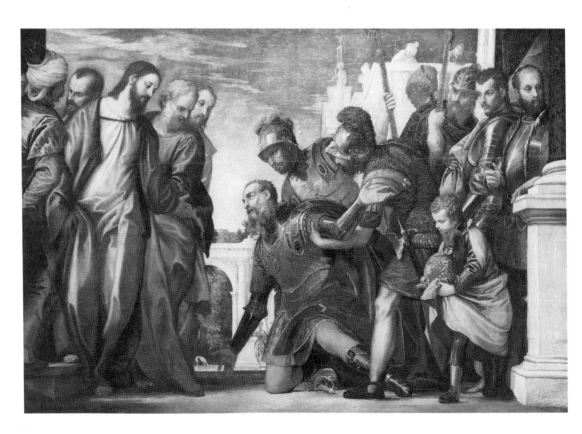

**Paolo Caliari, called Veronese,
and workshop**
Italian, 1528–1588
Christ and the Centurion, c. 1575
Oil on canvas
55⅜ x 81⅛ inches (140.6 x 206.1 cm)
Purchase: Nelson Trust [31-73]

Federico Zuccaro
Italian, 1540/41–1609
Lady Pulling on Her Stockings,
c. 1575/82
Graphite and red chalk on paper
6⅜ x 5¾ inches (16.2 x 14.6 cm)
Gift of Mr. Milton McGreevy
[F61-55/7]

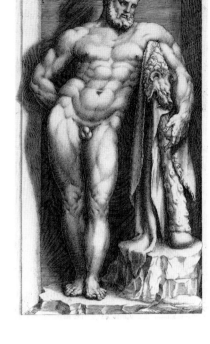

Giorgio Ghisi
Italian, 1520–1582
The Farnese Hercules, late 1570s
Engraving (1st state)
13⅛ x 7⁵⁄₁₆ inches (33.3 x 18.6 cm)
Purchase: Nelson Trust [41-19]

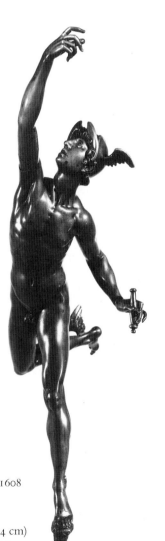

**Attributed to the workshop of
Hubert Gerhard**
Dutch (active in Italy and elsewhere),
c. 1540–1620
Saint John the Evangelist and *Saint Jude,*
c. 1583/84
Gilt bronze
Height: 8¾ inches (22.2 cm), each
Purchase: Nelson Trust [59-71/1,2]
[*See colorplate, p. 31*]

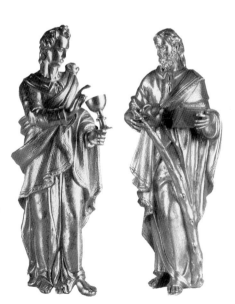

Giovanni da Bologna
Flemish (active in Italy), 1529–1608
Mercury, model c. 1578
Bronze
Height of figure: 23 inches (58.4 cm)
Purchase: Nelson Trust [66-26/1]

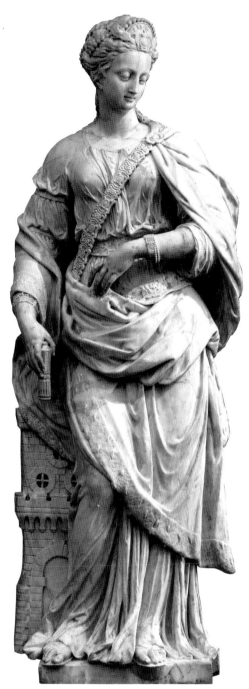

Hans Bol
Flemish, 1534–1593
Landscape with Habakkuk Appearing to Daniel in the Lions' Den, dated 1584
Brown ink and wash over black chalk on paper
5⅝ x 8¼ inches (14.3 x 21.0 cm)
Gift of Mr. and Mrs. Milton McGreevy [F64-51/3]

Attributed to Germain Pilon
French, 1537–1590
Saint Barbara
Marble
Height: 71 inches (180.3 cm)
Purchase: Nelson Trust [49-27]

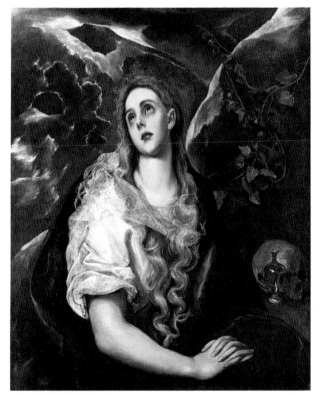

**Domenikos Theotokopoulos,
called El Greco**
Spanish (born Crete), 1541–1614
The Penitent Magdalene, c. 1580/85
Oil on canvas
40 x 32¼ inches (101.6 x 81.9 cm)
Purchase: Nelson Trust [30-35]

Abraham Bloemaert
Dutch, 1564–1651
Diana
Brown ink with brown and red wash on paper
5½ x 4⁹⁄₁₆ inches (14.0 x 11.0 cm), oval
Bequest of Mr. Milton McGreevy [81-30/5]

Hendrick Goltzius
Dutch, 1558–1617
Nox, Goddess of Night, 1588/89
Chiaroscuro woodcut
13¹⁄₁₆ x 10⅛ inches (33.2 x 25.7 cm), oval
Purchase [F84-56]

Saint Anthony Crowned by the Christ Child
Brown ink on paper
8⁷⁄₁₆ x 6⅜ inches (21.5 x 16.3 cm)
Italian
Gift of Mr. Laurence Sickman [64-48]

**Jan Saenredam
(after Abraham Bloemaert)**
Dutch, 1565–1607
Allegory of Vanity
Engraving
14 x 12¾ inches (35.6 x 32.4 cm)
Purchase [F89-12]

Attributed to Adriaen de Vries
Dutch, c. 1560–1626
Hercules, Deianeira, and Nessus, model c. 1603
Bronze
Height: 34 inches (86.4 cm)
Purchase: Nelson Trust [44-53]
[*See colorplate, p. 32*]

Joachim Anthonisz. Wtewael
Dutch, 1566–1638
The Martyrdom of Saint Sebastian, dated 1600
Oil on canvas
66⅝ x 49¼ inches (169.3 x 125.1 cm)
Purchase [F84-71]
[*See colorplate, p. 32*]

Jacques Bellange
French, active 1580–1620
The Martyrdom of Saint Lucy, c. 1615/16
Etching with engraving
18⁵⁄₁₆ x 13⅞ inches (46.6 x 35.3 cm)
Purchase [F83-2]

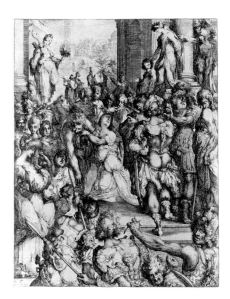

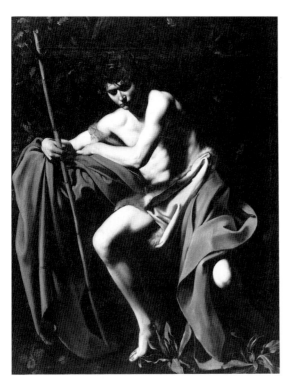

Niccolò Roccatagliata
Italian, active 1593–1636
Pair of Andirons
Bronze
Height: 42 inches (106.7 cm), each
Purchase: Nelson Trust [62-19/1,2]

Michelangelo Merisi, called Caravaggio
Italian, 1571–1610
Saint John the Baptist, c. 1604/5
Oil on canvas
68 x 52 inches (172.7 x 132.1 cm)
Purchase: Nelson Trust [52-25]
[*See colorplate, p. 33*]

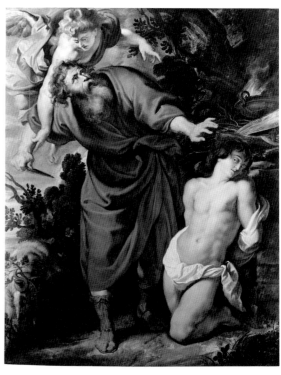

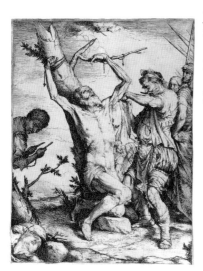

Jusepe de Ribera
Spanish (active in Italy), 1591–1652
The Martyrdom of Saint Bartholomew, 1624
Etching with engraving
12¾ x 9⁵⁄₁₆ inches (32.4 x 23.7 cm)
Purchase [F83-34]

Peter Paul Rubens
Flemish, 1577–1640
The Sacrifice of Isaac, c. 1612/13
Oil on wood panel
55½ x 43½ inches (141.0 x 110.5 cm)
Purchase: Nelson Trust [66-3]

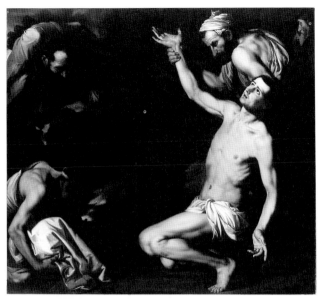

Jusepe de Ribera
Spanish (active in Italy), 1591–1652
The Martyrdom of Saint Lawrence, c. 1612/13(?)
Oil on canvas
47⁵⁄₁₆ x 52⅞ inches (120.2 x 134.3 cm)
Purchase: Nelson Trust [88-9]★
[*See colorplate, p. 34*]

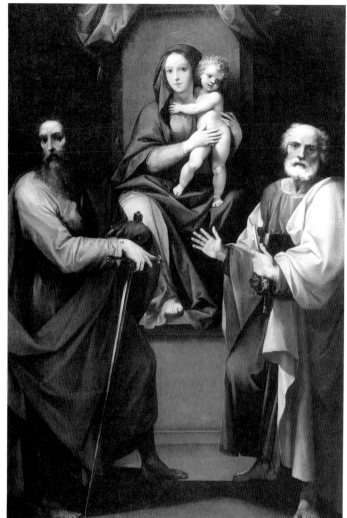

Giuseppe Cesari, called Il Cavaliere d'Arpino
Italian, 1568–1640
The Virgin and Child with Saints Peter and Paul, c. 1608/9
Oil on canvas
68½ x 47¼ inches (174.0 x 120.0 cm)
Purchase: Nelson Trust [91-14]★

Domenikos Theotokopoulos, called El Greco
Spanish (born Crete), 1541–1614
Portrait of a Trinitarian Friar, c. 1609
Oil on canvas
36¼ x 33½ inches (92.1 x 85.1 cm)
Purchase: Nelson Trust [52-23]

Pieter Brueghel the Younger
Flemish, 1564/65–1638
Summer Harvest, c. 1615/20
Oil on wood panel
17³⁄₁₆ x 23³⁄₁₆ inches (43.7 x 58.9 cm)
Purchase: Nelson Trust [34-297]

Hendrick Terbrugghen
Dutch, 1588–1629
The Beheading of Saint John the Baptist,
dated 162[?]
Oil on canvas
58½ x 34⅜ inches (148.6 x 87.3 cm)
Purchase: Nelson Trust [64-7]

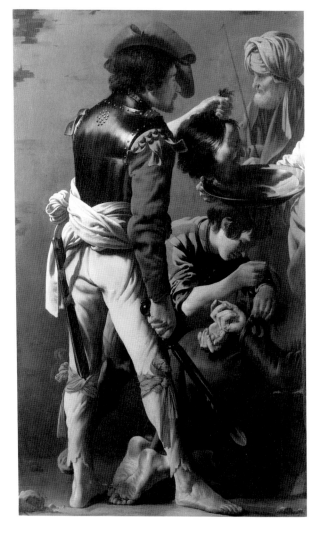

Giovanni Francesco Barbieri, called Il Guercino
Italian, 1591–1666
Boys Bathing, c. 1617/21
Brown ink and wash on paper
7¼ x 10 inches (18.4 x 25.4 cm)
Bequest of Mr. Milton McGreevy [81-30/31]

Gillis Hondecoeter
Dutch, c. 1580–1638
Landscape
Black chalk with brown ink on paper
9 x 12⁷⁄₁₆ inches (22.9 x 31.6 cm)
Gift of Mr. Milton McGreevy [F59-65/9]

Peter Paul Rubens
Flemish, 1577–1640
The Battle of Constantine and Licinius, 1622
Oil on wood panel
14⅝ x 22⅝ inches (37.2 x 57.5 cm)
Purchase: Nelson Trust [55-40]

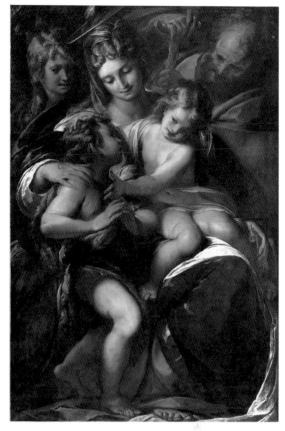

Giulio Cesare Procaccini
Italian, 1574–1625
*The Holy Family with Infant Saint John
the Baptist and an Angel*, c. 1616/18
Oil on canvas
74¾ x 49⅛ inches (189.9 x 124.8 cm)
Purchase: acquired through the generosity
of an anonymous donor [F79-4]

Dirck van Baburen
Dutch, c. 1595–1624
Christ Crowned with Thorns, c. 1621/22
Oil on canvas
51⅜ x 67⅜ inches (130.5 x 171.2 cm)
Purchase: Nelson Trust with assistance from the Helen F. Spencer
Fund and gifts of Mr. Robert Lehman (by exchange) [84-25]

Workshop of Pietro Bernini
Italian, 1562–1629
The Emperor Lucius Verus
Marble
Height: 27 inches (68.6 cm)
Purchase: Nelson Trust [48-46]

Nicolas Poussin
French, 1594(?)–1665
Study for "The Triumph of Bacchus," 1635
Brown ink and blue-gray wash over
traces of black chalk on paper
6³⁄₁₆ x 8¹⁵⁄₁₆ inches (15.7 x 22.7 cm)
Purchase: Nelson Trust [54-83]

Attributed to Jacob Jordaens
Flemish, 1593–1678
Portrait of Joannes de Marschalck, dated 1624
Oil on wood panel
27 x 20¼ inches (68.6 x 51.4 cm)
Purchase: Nelson Trust [57-55]

Nicolas Poussin
French, 1594(?)–1665
The Triumph of Bacchus, 1635–36
Oil on canvas
50½ x 59½ inches (128.3 x 151.1 cm)
Purchase: Nelson Trust [31-94]
[*See colorplate, p. 35*]

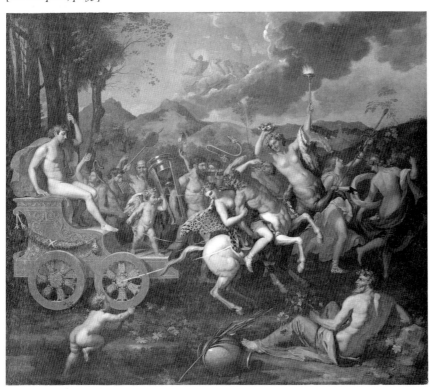

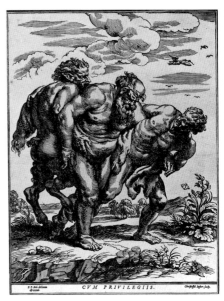

Christoffel Jegher (after Peter Paul Rubens)
Flemish, 1596–1652/53
Silenus Accompanied by a Satyr and a Faun, c. 1635
Woodcut
17⁷⁄₁₆ x 13⁵⁄₁₆ inches (44.3 x 33.7 cm)
Purchase [F84-57]

Guido Reni
Italian, 1575–1642
Saint Francis Adoring a Crucifix, c. 1631/32
Oil on canvas
32¼ x 27¾ inches (81.9 x 70.5 cm)
Purchase: acquired through the bequest of
Katherine Kupper Mosher [F86-32]

Bernardo Strozzi
Italian, 1581/82–1644
Saint Cecilia, c. 1620/25
Oil on canvas
68 x 48¼ inches (172.7 x 122.6 cm)
Purchase: Nelson Trust [44-39]

 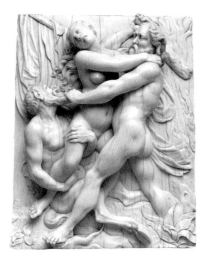

Attributed to David Heschler
Flemish (active in Germany), 1611–1667
Hercules and Antaeus and *Hercules, Deianeira, and Nessus*
Pair of ivory plaquettes
5¾ x 4¼ inches (14.6 x 10.8 cm); 5½ x 4⅜ inches (14.0 x 11.1 cm)
Gift of Mr. and Mrs. Jack Linsky [59-75/1,2]

Jacob Jordaens
Flemish, 1593–1678
Study for "The King Drinks," c. 1635/40
Watercolor and gouache over black chalk on paper
7³⁄₁₆ x 13⁹⁄₁₆ inches (18.3 x 34.5 cm)
Purchase: Nelson Trust [61-2]

Claude Gellée, called Le Lorrain
French, 1600–1682
Mill on the Tiber, c. 1650
Oil on canvas
21³⁄₈ x 28¹⁄₈ inches (54.3 x 71.5 cm)
Purchase: Nelson Trust [32-78]

Pieter Claesz.
Dutch, c. 1597–1661
Still Life, dated 1638
Oil on wood panel
25¼ x 20³⁄₁₆ inches (64.1 x 51.3 cm)
Purchase: Nelson Trust [31-114]

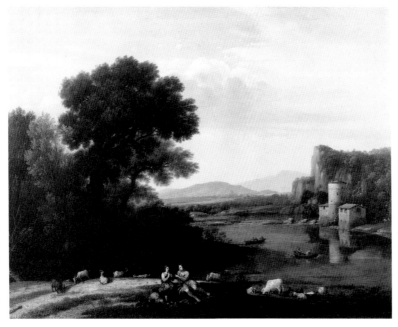

Claude Gellée, called Le Lorrain
French, 1600–1682
View of the Tiber at Rome, c. 1635/40
Brown ink and wash on paper
8 x 10⁹⁄₁₆ inches (20.3 x 26.9 cm)
Purchase: Nelson Trust [33-99]

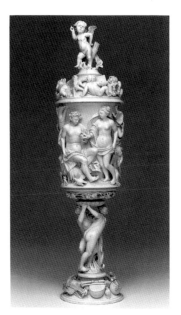

Attributed to the Monogrammist BG
German/Austrian, recorded 1662–1680
Pokal (Covered Goblet) with the Judgment of Paris, c. 1670
Ivory
Height: 16¼ inches (41.3 cm)
Purchase: Nelson Trust [60-80]

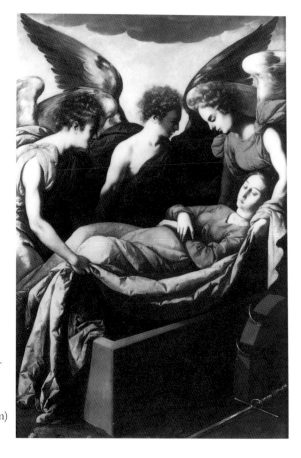

Francisco de Zurbarán
Spanish, 1598–1664
The Entombment of Saint Catherine of Alexandria, c. 1636/37
Oil on canvas
78¾ x 52½ inches (200.0 x 133.4 cm)
Purchase: Nelson Trust [61-21]

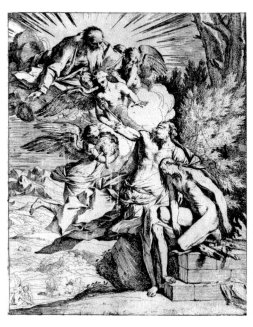

Mortar and Pestle, dated 1638
Bronze
Height: 13¼ inches (33.6 cm)
German
Purchase: acquired through the generosity of Mr. and Mrs. Milton McGreevy through the Westport Fund [F59-61]

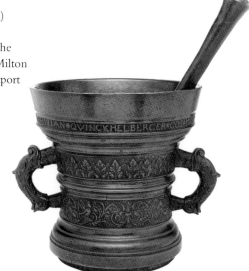

Pietro Testa, called Il Lucchesino
Italian, 1612–1650
The Sacrifice of Isaac, c. 1640/42
Etching
11⅛ x 9¼ inches (28.3 x 23.5 cm)
Purchase [F89-28]

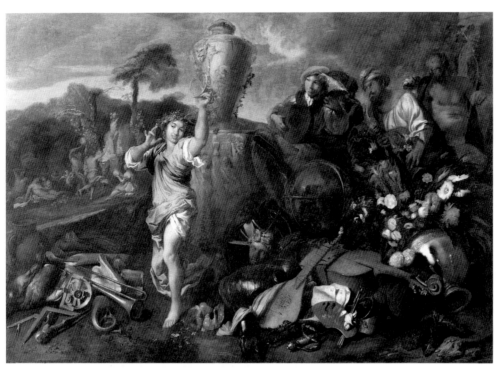

Giovanni Benedetto Castiglione
Italian, c. 1609–1664
Allegory of Vanity, late 1640s
Oil on canvas
39 x 56¹¹⁄₁₆ inches (99.1 x 144.0 cm)
Gift of the Samuel H. Kress Foundation [F61-69]

Rembrandt van Rijn
Dutch, 1606–1669
Christ Healing the Sick, bears date 1649
Etching with drypoint and burin
11 x 15⁹⁄₁₆ inches (27.9 x 39.5 cm)
Purchase: Nelson Trust [36-8]

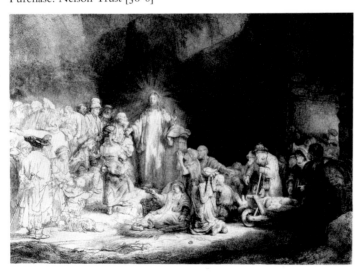

Rembrandt van Rijn
Dutch, 1606–1669
Saul and the Witch of Endor
Brown ink and wash on paper
6¹⁄₁₆ x 8½ inches (15.5 x 21.6 cm)
Purchase: Nelson Trust [61-25/2]

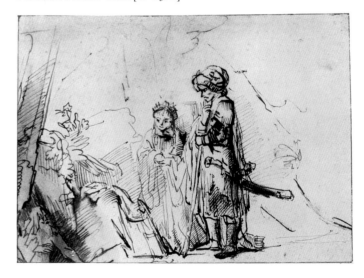

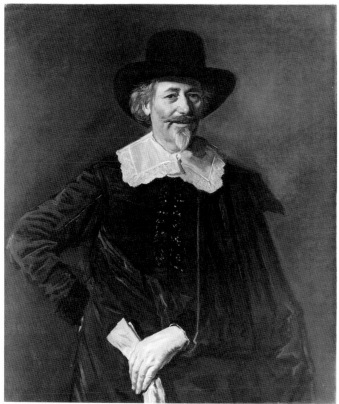

Frans Hals
Dutch, 1581/85–1666
Portrait of a Man, c. 1650
Oil on canvas
42 x 36 inches (106.7 x 91.4 cm)
Purchase: Nelson Trust [31-90]

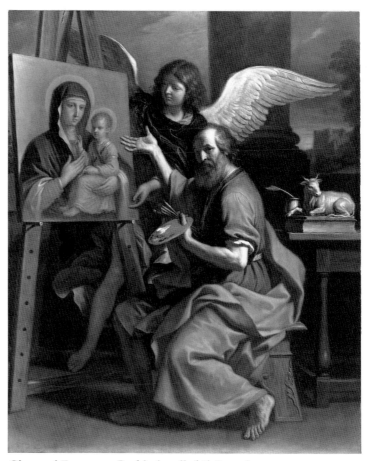

Giovanni Francesco Barbieri, called Il Guercino
Italian, 1591–1666
Saint Luke Displaying a Painting of the Virgin, 1652–53
Oil on canvas
87 x 71 inches (221.0 x 180.3 cm)
Purchase [F83-55]

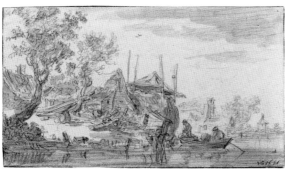

Jan van Goyen
Dutch, 1596–1656
Riverbank, dated 1651
Black chalk and brown wash on paper
4⁷⁄₁₆ x 7¹⁵⁄₁₆ inches (11.3 x 20.2 cm)
Bequest of Mr. Milton McGreevy [81-30/30]

Alessandro Algardi
Italian, 1598–1654
The Baptism of Christ, model c. 1646
Bronze
Height: 18 inches (45.7 cm)
Purchase: Nelson Trust [47-34]

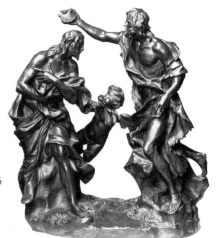
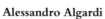

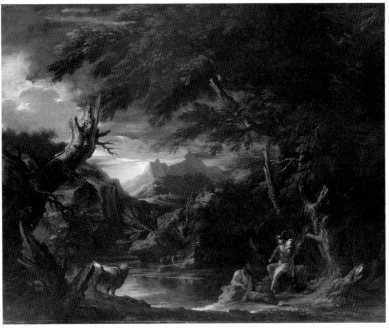

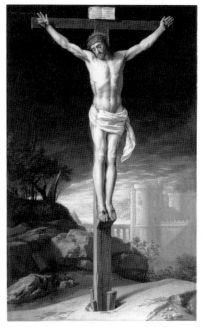

Salvator Rosa
Italian, 1615–1673
Mercury, Argus, and Io, c. 1653/54
Oil on canvas
44⅛ x 55⅞ inches (112.1 x 141.9 cm)
Purchase: Nelson Trust [32-192/1]

Philippe de Champaigne
French, 1602–1674
Christ on the Cross, c. 1655
Oil on canvas
35½ x 22 inches (90.2 x 55.9 cm)
Purchase: Nelson Trust [70-1]

Giovanni Benedetto Castiglione
Italian, 1609–1664
Pastoral Scene, c. 1655
Red, red-brown, blue, and green paint on beige paper
10 x 15¼ inches (25.4 x 38.7 cm)
Purchase: acquired through the generosity of Mr. and Mrs. Milton
McGreevy through the Westport Fund [F59-60/2]

Jan de Bisschop (after Domenico Beccafumi)
Dutch, 1628–1671
Moses Receiving the Law
Brown ink and wash on paper
17⅛ x 23 inches (43.5 x 58.4 cm)
Purchase: Nelson Trust [44-29/5]

Sebastiano Mazzoni
Italian, c. 1611–1678
The Sacrifice of Jephthah's Daughter, c. 1655/60
Oil on canvas
46³⁄₁₆ x 58¹³⁄₁₆ inches (117.3 x 149.5 cm)
Gift of the Samuel H. Kress Foundation [F61-64]

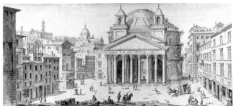

Gerrit Dou
Dutch, 1613–1675
Self-Portrait at Age Fifty, dated 1663
Oil on wood panel
22 x 16⅜ inches (55.9 x 41.6 cm)
Purchase: Nelson Trust [32-77]

Lieven Cruyl
Flemish, c. 1640–c. 1720
The Pantheon, Rome, c. 1667
Brown ink with gray wash on paper
6⅜ x 14¹¹⁄₁₆ inches (16.2 x 37.3 cm)
Purchase: Nelson Trust [50-52]

Jan Steen
Dutch, 1626–1679
Fantasy Interior with Jan Steen and Jan van Goyen, c. 1659/60
Oil on canvas
33¼ x 39¾ inches (84.5 x 101.0 cm)
Purchase: Nelson Trust [67-8]
[*See colorplate, p. 37*]

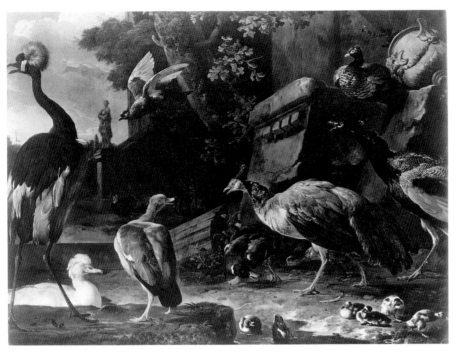

Melchior Hondecoeter
Dutch, 1636–1695
Birds Gathered outside the Gates of a Palace, 1685/90
Oil on canvas
54⅞ x 74⁵⁄₁₆ inches (139.4 x 188.7 cm)
Purchase: Nelson Trust [30-16]

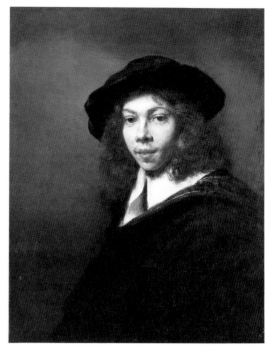

Rembrandt van Rijn
Dutch, 1606–1669
Portrait of a Young Man, dated 1666
Oil on canvas
31¾ x 25½ inches (80.7 x 64.8 cm)
Purchase: Nelson Trust [31-75]

Willem Van de Velde the Younger
Dutch, 1633–1707
Marine View, dated 1668
Oil on canvas
25⁷⁄₁₆ x 31⁷⁄₁₆ inches (64.7 x 79.9 cm)
Purchase: Nelson Trust [32-169]

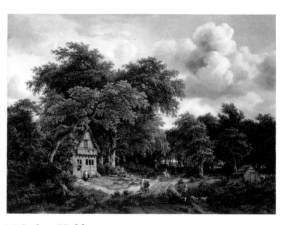

Meindert Hobbema
Dutch, 1638–1709
Road in the Woods, 1670s
Oil on canvas
37 x 51³⁄₁₆ inches (94.0 x 130.0 cm)
Purchase: Nelson Trust [31-76]

Jan Claudius de Cock
Flemish, 1668/70–1735
Medea Rejuvenating Aeson,
Father of Jason, dated 1690
Brown ink on paper
11⅞ x 9½ inches (30.2 x 24.1 cm)
Gift of Mr. and Mrs. Milton
McGreevy [F64-51/14]

Hendrick van Vliet
Dutch, 1611–1675
Interior of the New Church at Delft, c. 1660/70
Oil on canvas
39⅛ x 32⁷⁄₁₆ inches (99.5 x 82.4 cm)
Purchase: Nelson Trust [70-17]

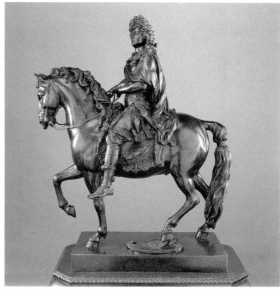

Bartolomé Estebán Murillo
Spanish, 1617/18–1682
Virgin of the Immaculate Conception,
c. 1670
Oil on canvas
54 x 46 inches (137.2 x 116.8 cm)
Purchase: Nelson Trust [30-32]

François Girardon
French, 1628–1715
Louis XIV as a Roman General, model 1685
Bronze
Height of horse and rider:
39⅜ inches (100.5 cm)
Purchase: Nelson Trust [54-32]

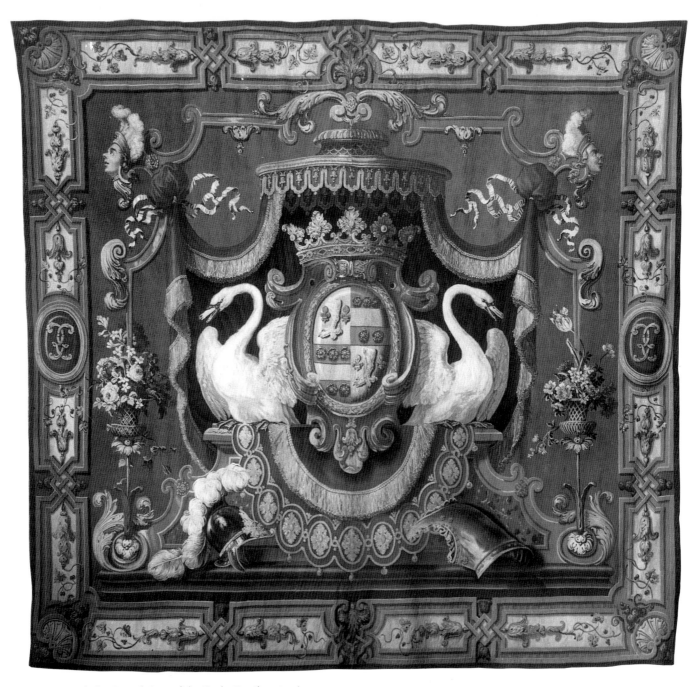

Tapestry with the Coat of Arms of the Greder Family, 1691/94
Wool, silk, and metal thread
119 x 108¾ inches (302.3 x 276.2 cm)
Possibly by the Bacor workshop, Paris
Purchase: Nelson Trust [32-191/3]

Selections from the Starr Collection of European and American Miniatures
(Gifts of Mr. and Mrs. John W. Starr through the Starr Foundation)

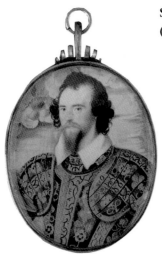

Nicholas Hilliard
English, 1547–1619
Portrait of George Clifford, Third Earl of Cumberland, c. 1595
Watercolor on vellum
2¾ x 2³⁄₁₆ inches (7.0 x 5.6 cm), oval
[F58-60/188]
[*See colorplate, p. 31*]

Thomas Flatman
English, 1635–1688
Portrait of Elizabeth Claypole (Daughter of Oliver Cromwell)
Watercolor on paper
2¼ x 1⅞ inches (5.7 x 4.8 cm), oval
[F58-60/173]

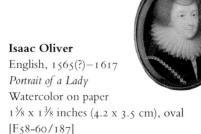

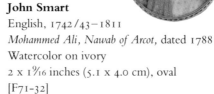

Isaac Oliver
English, 1565(?)–1617
Portrait of a Lady
Watercolor on paper
1⅝ x 1⅜ inches (4.2 x 3.5 cm), oval
[F58-60/187]

John Smart
English, 1742/43–1811
Mohammed Ali, Nawab of Arcot, dated 1788
Watercolor on ivory
2 x 1⁹⁄₁₆ inches (5.1 x 4.0 cm), oval
[F71-32]

Peter Crosse
English, c. 1645–1724
Portrait of Lady Elizabeth Derby
Watercolor on paper
3 x 2⁷⁄₁₆ inches (7.6 x 6.2 cm), oval
[F58-60/28]

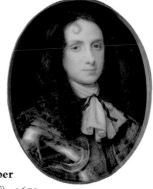

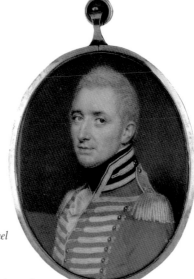

Samuel Cooper
English, 1608(?)–1672
Portrait of Henry Frederick, Earl of Arundel
Watercolor on paper
2¾ x 2¼ inches (7.0 x 5.7 cm), oval
[F58-60/12]

John Smart
English, 1742/43–1811
*Portrait of Colonel Keith Michael
Alexander*, dated 1810
Watercolor on ivory
3⅜ x 2¾ inches (8.7 x 7.0 cm), oval
[F65-41/51]

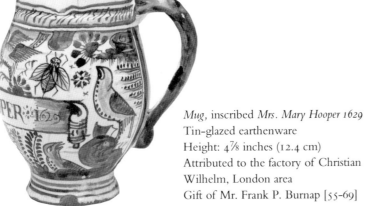

Mug, inscribed *Mrs. Mary Hooper 1629*
Tin-glazed earthenware
Height: 4⅞ inches (12.4 cm)
Attributed to the factory of Christian
Wilhelm, London area
Gift of Mr. Frank P. Burnap [55-69]

Saint George and the Dragon, c. 1770
Lead-glazed earthenware
Height: 12½ inches (31.8 cm)
Attributed to Ralph Wood, 1715–1772
Gift of Mr. and Mrs. Frank P. Burnap [46-8]

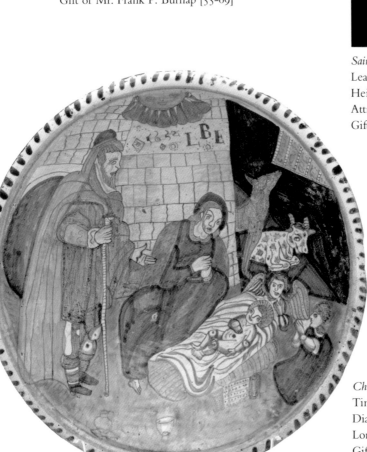

Charger with Scene of the Nativity, dated 1652
Tin-glazed earthenware
Diameter: 15½ inches (39.4 cm)
London area
Gift of Mr. Frank P. Burnap [57-10]
[*See colorplate, p. 36*]

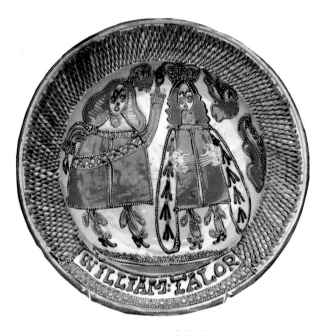

Charger Celebrating the Coronation of Charles II, c. 1661
Earthenware with slip-trailed decoration; lead glaze
Diameter: 16½ inches (41.9 cm)
By William Ta[y]lor, active late 17th century
Gift of Mr. and Mrs. Frank P. Burnap [41-23/782]

Charger with Scene of Pelican Feeding Its Young, 1680/90
Earthenware with slip-trailed decoration; lead glaze
Diameter: 16¾ inches (42.6 cm)
By Ralph Simpson, active late 17th century
Gift of Mr. and Mrs. Frank P. Burnap [41-23/784]

Pew Group, 1740/45
Salt-glazed stoneware
Length: 6¾ inches (17.2 cm)
Attributed to Aaron Wood, 1717–1785
Gift of Mr. and Mrs. Frank P. Burnap [41-23/676]

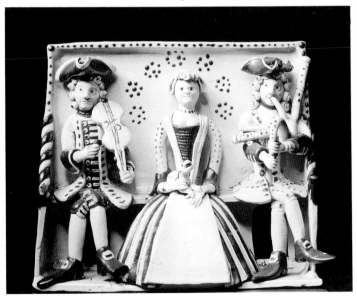

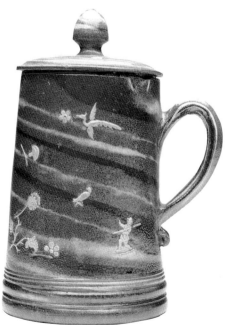

Covered Tankard, c. 1685
Marbled brown salt-glazed
stoneware with applied sprig
molded decoration in white
Height: 10½ inches (26.7 cm)
By the factory of John Dwight,
Fulham
Gift of Mr. Frank P. Burnap
[55-77 a,b]

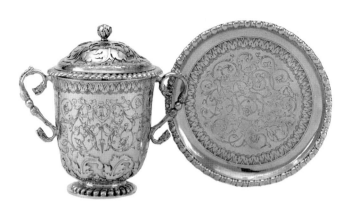

Covered Cup and Stand (one of a pair), 1700
Silver gilt
Height of cup: 5¼ inches (13.3 cm);
diameter of stand: 5 inches (12.7 cm)
By David Willaume I, English (born France), 1658–1741
Purchase: the Lillian M. Diveley Fund [F92-19/1 a–c]
[*See colorplate, p. 38*]

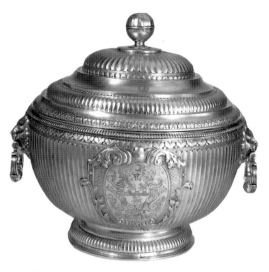

Covered Punch Bowl, 1701
Silver
Height: 18 inches (45.7 cm)
By Benjamin Pyne, English, active 1684–1724
Gift of Mr. and Mrs. Joseph S. Atha [58-65 a,b]

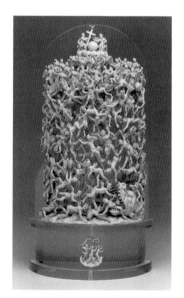

Fall of the Rebel Angels, early 18th century
Ivory
Height: 10¾ inches (27.3 cm)
Italian
Purchase: the George H. and
Elizabeth O. Davis Fund [F69-2]

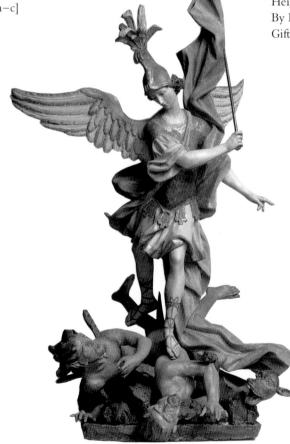

Saint Michael Casting down the Rebel Angels,
early 18th century
Wood with paint, gilding, and glass inlays
Height: 34½ inches (87.6 cm)
Italian
Purchase: Nelson Trust [61-53]

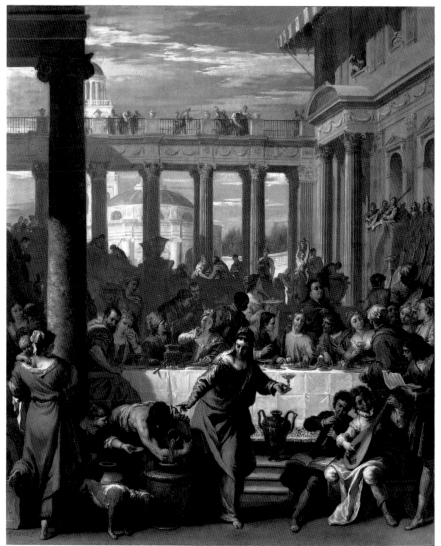

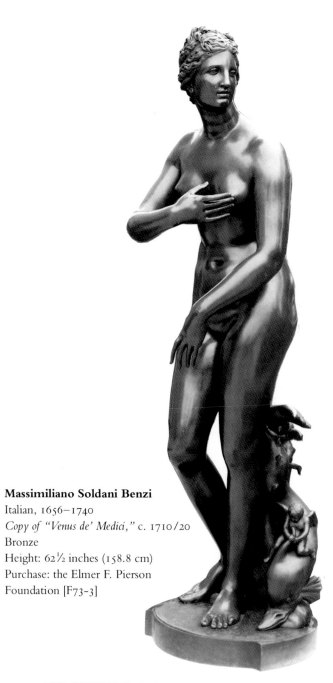

Sebastiano Ricci
Italian, 1659–1734
The Marriage Feast at Cana, c. 1712/15
Oil on canvas
65¾ x 54 inches (167.0 x 137.2 cm)
Purchase: Nelson Trust [59-2]

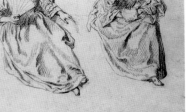

Jean-Antoine Watteau
French, 1684–1721
Two Women, c. 1712
Red chalk on paper
7 x 7⅝ inches (17.8 x 19.4 cm)
Purchase: Nelson Trust [34-145]

Massimiliano Soldani Benzi
Italian, 1656–1740
Copy of "Venus de' Medici," c. 1710/20
Bronze
Height: 62½ inches (158.8 cm)
Purchase: the Elmer F. Pierson
Foundation [F73-3]

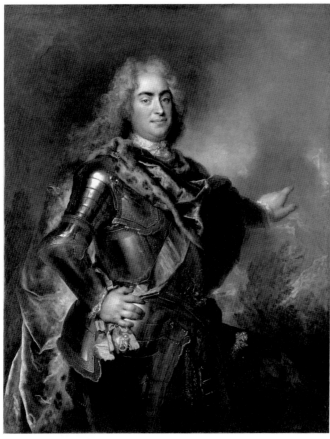

Coffeepot, 1715/20
Glazed and lacquered stoneware
with enamel decoration
Height: 6¼ inches (15.9 cm)
Meissen Porcelain Manufactory,
Germany
Purchase (by exchange) [F84-8 a,b]

Nicolas de Largillière
French, 1656–1746
Augustus the Strong, Elector of Saxony and King of Poland, c. 1715
Oil on canvas
57½ x 45½ inches (146.1 x 115.6 cm)
Purchase: Nelson Trust [54-35]

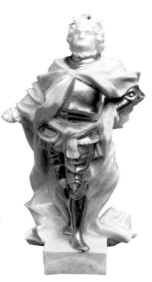

*Augustus the Strong, Elector of Saxony
and King of Poland*, 1715/20
Hard-paste porcelain with gilding
Height: 4⅜ inches (11.1 cm)
Meissen Porcelain Manufactory, Germany;
model attributed to Johann Joachim
Kretzschmar, 1677–1740
Purchase [F84-33]

Side Chair, c. 1717
Gilt walnut and pine with modern velvet upholstery
47½ x 24½ x 29½ inches
(120.7 x 62.2 x 74.9 cm)
English
Purchase: Nelson Trust [77-8]

Kettle and Stand, 1719
Silver with wooden handle
Height: 13¼ inches (33.7 cm)
By William Spackman, English,
active early 18th century
Gift of Mrs. Albert B. Clark
[53-68 a,b]

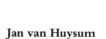

Chest on Stand, c. 1720
"Japanned" oak and pine case;
gilt and gessoed pine stand
98¼ x 42¾ x 22⁷⁄₁₆ inches
(249.6 x 108.6 x 57.0 cm)
English
Purchase: Nelson Trust [33-23]

Jan van Huysum
Dutch, 1682–1749
Vase of Flowers, c. 1720
Oil on wood panel
31 x 23½ inches (78.7 x 59.7 cm)
Purchase: Nelson Trust [32-168]

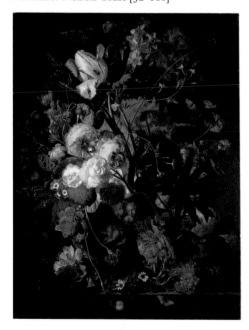

Jan van Huysum
Dutch, 1682–1749
Vase of Flowers
Black ink over black chalk with gray
and brown wash, heightened with
white, on paper
16¼ x 12¾ inches (41.3 x 32.4 cm)
Bequest of Mr. Milton McGreevy [81-30/35]

Jean-Baptiste-Siméon Chardin
French, 1699–1779
Still Life with Cat and Fish, 1728
Oil on canvas
31 ½ x 25 ¼ inches (80.0 x 64.1 cm)
Purchase: acquired through the generosity
of an anonymous donor [F79-2]

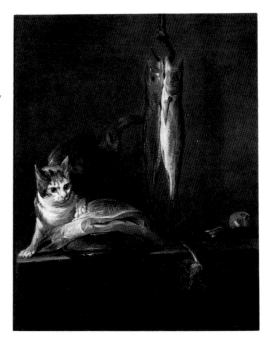

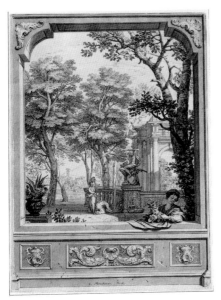

Isaac de Moucheron
Dutch, 1667–1744
Sense of Smell
Brown ink and gray wash on paper
13 ½ x 9 ⅝ inches (33.6 x 24.5 cm)
Purchase: acquired through the generosity
of Mr. and Mrs. Milton McGreevy
through the Mission Fund [F63-51/2]

Hyacinthe Rigaud
French, 1659–1743
Portrait of Samuel Bernard, dated 1727
Black and white chalk on blue paper,
heightened with white; squared in
black chalk
22 ³⁄₁₆ x 16 ¼ inches (56.3 x 41.3 cm)
Purchase: Nelson Trust [66-15]

Pierre-Imbert Drevet (after Hyacinthe Rigaud)
French, 1697–1739
Portrait of Samuel Bernard, 1729
Engraving
24 ⁵⁄₁₆ x 16 ⁷⁄₁₆ inches (61.8 x 41.8 cm)
Gift of Rosenberg and Stiebel, Inc. [66-18]

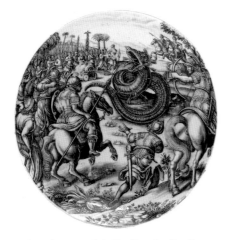

*Dish with Scene of Atilius Regulus Battling
the African Serpent,* 1720/25
Chinese hard-paste porcelain with
enamel decoration
Diameter: 11 inches (27.9 cm)
Decoration attributed to Ignaz Preissler,
German, 1676–1741
Purchase: acquired through the generosity
of Mr. and Mrs. Earl D. Wilberg [F85-5]

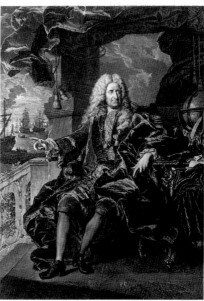

Alessandro Magnasco
Italian, 1667–1749
Elijah Visited by an Angel, c. 1730
Oil on canvas
39 x 28¾ inches (99.1 x 73.0 cm)
Bequest of John K. Havemeyer [F88-8]

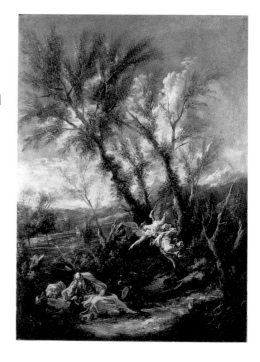

Pier Leone Ghezzi
Italian, 1674–1755
James Stuart, the Old Pretender, with His Physician,
Monsieur de la Rose, c. 1729
Brown ink on paper
12 x 8⁹⁄₁₆ inches (30.5 x 21.7 cm)
Gift of the Trustees and Staff of the Nelson Gallery
in honor of Mr. Milton McGreevy [F80-9/2]

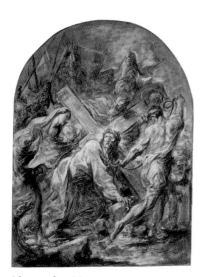

Alessandro Magnasco
Italian, 1667–1749
The Way to Calvary
Gray-brown wash and yellowish gouache
over black chalk on buff paper
13⅜ x 9⅞ inches (34.6 x 25.1 cm), arched top
Purchase: Nelson Trust [49-31/1]

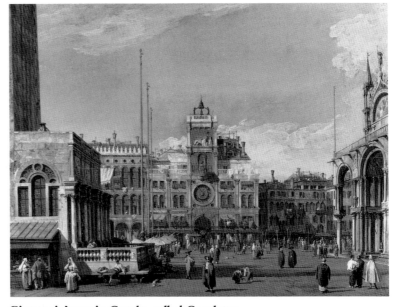

Giovanni Antonio Canale, called Canaletto
Italian, 1697–1768
The Clock Tower in the Piazza San Marco, c. 1730
Oil on canvas
20½ x 27⅜ inches (52.1 x 69.5 cm)
Purchase: Nelson Trust [55-36]
[*See colorplate, p. 39*]

Plate Decorated with Chinoiserie, 1730/35
Hard-paste porcelain with enamel
decoration and gilding
Diameter: 11½ inches (29.2 cm)
Meissen Porcelain Manufactory,
Germany; decoration attributed to
Johann Gregor Höroldt, 1696–1775,
and Christian Friedrich Herold,
1700–1779
Purchase: acquired through the
generosity of Mr. and Mrs. Richard
M. Levin in memory of Marion
Berger Levin [F84-7]

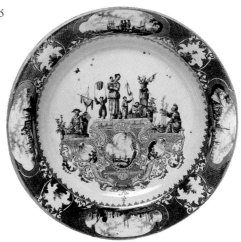

Covered Cup, 1737
Silver
Height: 14½ inches (36.8 cm)
By Paul de Lamerie, English (born
the Netherlands), 1688–1751
Gift of Mr. and Mrs. Joseph S. Atha
[54-17 a,b]

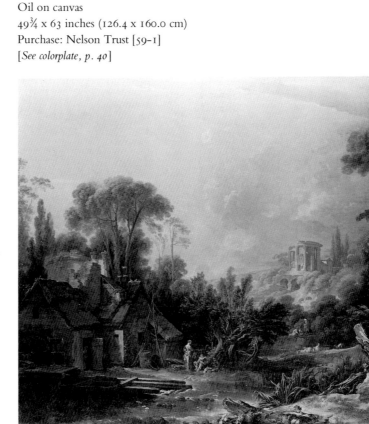

François Boucher
French, 1703–1770
Landscape with a Water Mill, dated 1740
Oil on canvas
49¾ x 63 inches (126.4 x 160.0 cm)
Purchase: Nelson Trust [59-1]
[*See colorplate, p. 40*]

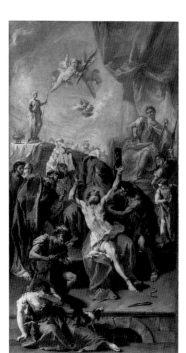

Giovanni Battista Pittoni
Italian, 1687–1767
The Martyrdom of Saint Bartholomew, 1735
Oil on canvas
27½ x 14½ inches (69.9 x 36.8 cm)
Purchase: Nelson Trust [47-29]

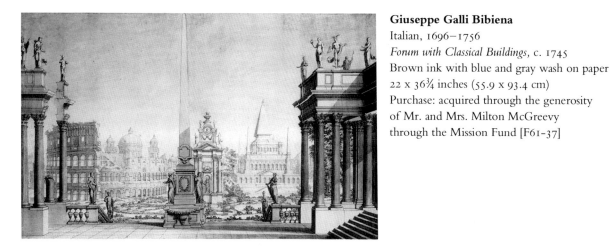

Giuseppe Galli Bibiena
Italian, 1696–1756
Forum with Classical Buildings, c. 1745
Brown ink with blue and gray wash on paper
22 x 36¾ inches (55.9 x 93.4 cm)
Purchase: acquired through the generosity
of Mr. and Mrs. Milton McGreevy
through the Mission Fund [F61-37]

Giovanni Battista Piazzetta
Italian, 1683–1754
Head of an Acolyte
Black and white chalk on gray paper
15½ x 11½ inches (39.4 x 29.2 cm)
Purchase: Nelson Trust [32-192/2]

Secretary Bookcase, 1740/50
Walnut and pine veneered with walnut,
ebony, fruitwoods, and other oaks
84¾ x 41¼ x 23¾ inches
(215.3 x 104.8 x 60.3 cm)
German
Purchase: the Kenneth A. and Helen F.
Spencer Foundation Acquisition Fund [F69-39]

Giovanni Paolo Panini
Italian, 1691–1765
A View of the Piazza del Popolo, Rome, dated 1741
Oil on canvas
38 x 52¾ inches (96.5 x 134.0 cm)
Purchase: acquired through the generosity
of an anonymous donor [F79-3]

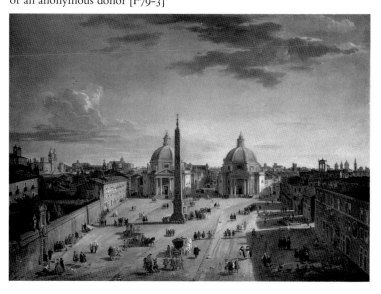

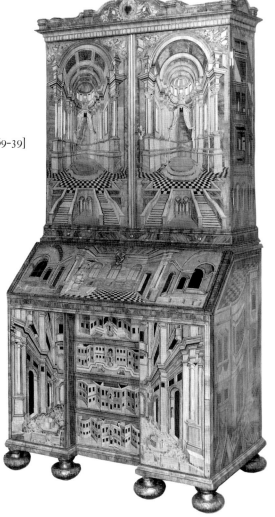

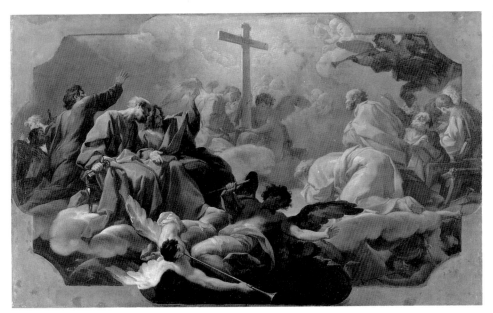

Corrado Giaquinto
Italian, 1703–1766
Adoration of the Holy Cross on the Day of the Last Judgment,
c. 1740/42
Oil on canvas
32³⁄₁₆ x 53⁵⁄₁₆ inches (81.8 x 135.5 cm)
Purchase: Nelson Trust [47-6]

Jean-Etienne Liotard
Swiss, 1702–1789
A Frankish Woman and Her Servant, c. 1750
Oil on canvas
28½ x 22½ inches (72.4 x 57.2 cm)
Purchase: Nelson Trust [56-3]

Giovanni Antonio Canale, called Canaletto
Italian, 1697–1768
View of Dolo on the Brenta, c. 1741
Etching
11⅞ x 17¹⁄₁₆ inches (30.2 x 43.3 cm)
Purchase: acquired through the generosity of
Richard Shields and David T. Beals III [F85-18]

Carle Van Loo
French, 1705–1765
A Man Seated in an Interior, dated 1743
Black and white chalk on discolored gray paper
16 x 12⅛ inches (40.6 x 30.8 cm)
Purchase: Nelson Trust [32-193/1]

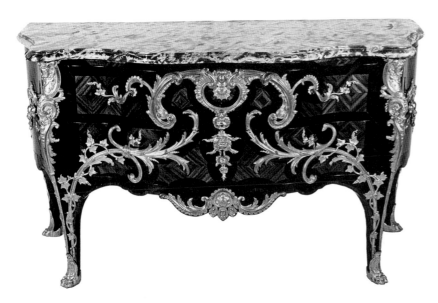

Chest of Drawers, 1745/49
Oak veneered with tulipwood, amaranth, satinwood, and kingwood; gilt-brass mounts; marble top
36⅝ x 63³⁄₁₆ x 24⅞ inches (93.1 x 160.5 x 63.3 cm)
Attributed to Charles Cressent, French, 1685–1768
Purchase: Nelson Trust [65-19]
[*See colorplate, p. 41*]

Lady's Writing Desk, c. 1750
Oak and walnut veneered with tulipwood, kingwood, and amaranth; gilt-brass mounts
34⁷⁄₁₆ x 35⁷⁄₁₆ x 16¹⁵⁄₁₆ inches
(87.5 x 90.0 x 43.0 cm)
By Bernard van Risenburgh, French, c. 1700–c. 1767
Purchase: the Kenneth A. and Helen F. Spencer Foundation Acquisition Fund [F72-26]

Console Table, c. 1750
Carved, gessoed, and gilt oak; marble top
35¹⁄₁₆ x 66⁹⁄₁₆ x 27⅜ inches (89.0 x 169.0 x 69.5 cm)
French
Purchase: Nelson Trust [55-107]

Cartel Clock Case, c. 1747
Oak and gilt brass
Height: 45⅛ inches (114.5 cm)
Attributed to Charles Cressent, French, 1685–1768
Purchase: Nelson Trust [62-1]

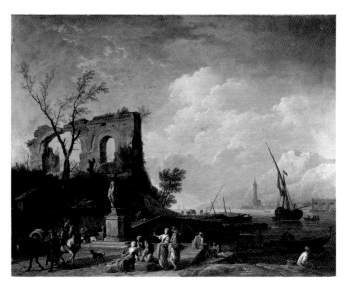

Claude-Joseph Vernet
French, 1714–1789
Seaport with Antique Ruins: Morning and
Coastal Harbor with a Pyramid: Evening, dated 1751
Oil on canvas
26⁵⁄₁₆ x 34⅛ inches (66.7 x 86.7 cm);
26⅜ x 34⅛ inches (67.0 x 86.7 cm)
Purchase: acquired through the generosity of
Sophia K. Goodman [F84-66/1,2]

Giovanni Domenico Tiepolo
Italian, 1727–1804
The Apparition of the Angel to Hagar and Ishmael, c. 1751
Oil on canvas
33¹⁄₁₆ x 41⁵⁄₁₆ inches (84.0 x 105.0 cm)
Purchase: Nelson Trust [30-23]

Tankard, c. 1753
Soft-paste porcelain with blue ground and gilding
Height: 6 inches (15.2 cm)
Vincennes Porcelain Manufactory, France
Purchase [F84-53 a,b]

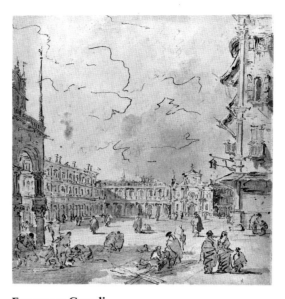

Francesco Guardi
Italian, 1712–1793
The Piazza San Marco Seen from the Piazzetta dei Leoncini
Brown ink with brown and gray wash on paper
10 x 10⅛ inches (25.4 x 25.8 cm)
Purchase: Nelson Trust [70-39]

The Fencing Lesson, 1755/60
Hard-paste porcelain with enamel
decoration and gilding
Height: 6½ inches (16.5 cm)
Höchst Porcelain Manufactory, Germany
Purchase: acquired through the generosity
of Mrs. E. B. Berkowitz [F90-13]

Covered Soup Tureen and Stand, c. 1755
Faience with enamel decoration
Height of tureen and cover: 11⅞ inches (30.1 cm);
length of stand: 17⅞ inches (45.4 cm)
Sceaux Pottery and Porcelain Manufactory, France
Purchase: Nelson Trust [83-43 a–c]

Tea Service, 1757
Soft-paste porcelain with overglaze enamel decoration and gilding
Length of tray: 17⅜ inches (44.2 cm);
height of teapot: 5¹⁄₁₆ inches (12.8 cm)
Sèvres Porcelain Manufactory, France;
painted decoration by Louis-David Armand, active 1750–1800
Purchase: acquired through the generosity of
Mr. and Mrs. Perry Faeth [F89-27/1–11]

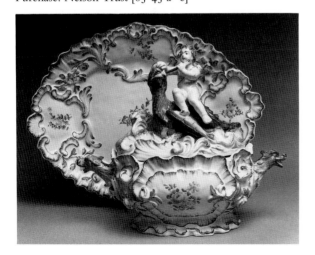

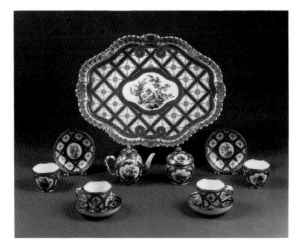

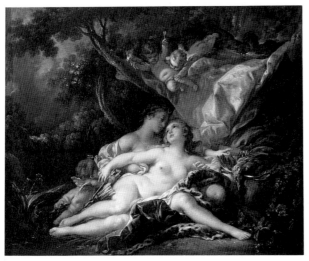

François Boucher
French, 1703–1770
Jupiter in the Guise of Diana and the Nymph Callisto, dated 1759
Oil on canvas
22½ x 27½ inches (57.2 x 69.9 cm)
Purchase: Nelson Trust [32-29]

Vase "Choisy," 1759
Soft-paste porcelain with overglaze
enamel decoration and gilding
Height: 5⅝ inches (14.3 cm)
Sèvres Porcelain Manufactory,
France; painted decoration by
Charles-Nicolas Dodin, 1734–1803
Purchase: Nelson Trust [90-36]★
[*See colorplate, p. 41*]

Secretary Bookcase, c. 1760
Mahogany, oak, and pine
125 x 127 x 23 inches (317.5 x 322.6 x 58.4 cm)
English
Gift of Mrs. Kenneth A. Spencer [F72-41/1]

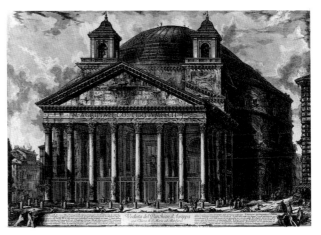

Giovanni Battista Piranesi
Italian, 1720–1778
The Pantheon, Rome, 1761
Engraving
18¼ x 27⅜ inches (46.4 x 69.5 cm)
Purchase: Nelson Trust [32-69/64]

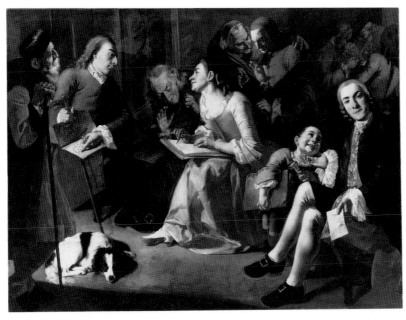

Gaspare Traversi
Italian, c. 1722–1770
The Arts: Music and *Drawing,* c. 1760
Oil on canvas
59¹³⁄₁₆ x 80⁹⁄₁₆ inches (152.0 x 204.6 cm);
59¾ x 80⁵⁄₁₆ inches (151.8 x 204.0 cm)
Gift of the Samuel H. Kress Foundation [F61-70,71]

Giovanni Battista Tiepolo
Italian, 1696–1770
*Head of a Bearded Oriental with a
Jeweled Headdress,* c. 1760
Brown ink and wash on paper
9¾ x 7¾ inches (24.8 x 19.7 cm)
Purchase: Nelson Trust [32-193/18]

Columbine, 1764/65
Hard-paste porcelain with enamel decoration
Height: 6¼ inches (15.9 cm)
Kloster-Veilsdorf Manufactory, Germany;
model by Wenzel Neu, died 1774
Purchase: acquired through the generosity
of Elmer C. Rhoden [F84-32]

Annette and Lubin, 1764/66
Soft-paste (biscuit) porcelain
Height: 11⅛ inches (28.2 cm)
Sèvres Porcelain Manufactory, France;
model by Etienne-Maurice Falconet, 1716–1791
Purchase: the Lillian M. Diveley Fund [F91-17]

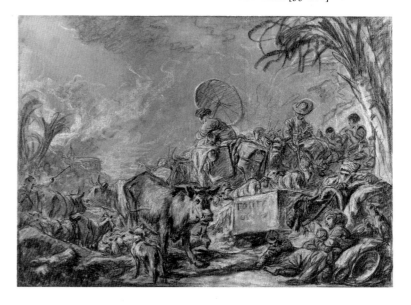

Joseph Wright of Derby
English, 1734–1797
Sir George Cooke, Bart., c. 1766/68
Oil on canvas
30³⁄₁₆ x 25⅛ inches (76.7 x 63.8 cm)
Purchase: Nelson Trust [30-19]
[*See colorplate, p. 42*]

François Boucher
French, 1703–1770
Study for "Returning from Market," c. 1767
Black and white chalk on gray-primed canvas
20¼ x 29½ inches (51.4 x 74.9 cm)
Purchase: Nelson Trust [33-668]

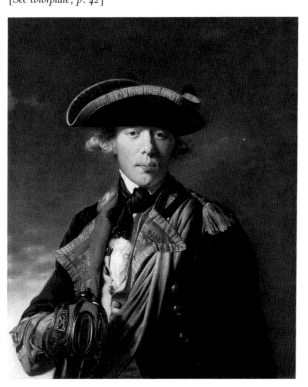

Joseph-Siffred Duplessis
French, 1725–1802
Portrait of Mme Freret Déricour, 1769
Oil on canvas
32 x 25½ inches (81.3 x 64.8 cm)
Purchase: Nelson Trust [53-80]

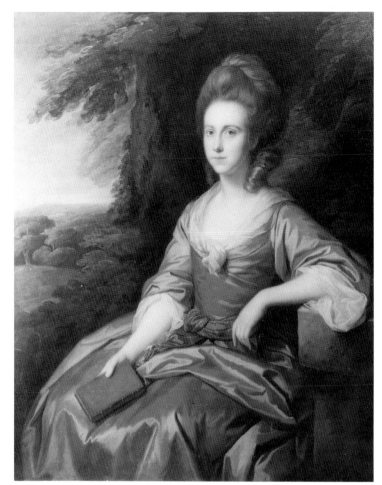

Nathaniel Dance
English, 1735–1811
Portrait of Miss Sarah Cruttenden, 1770/75
Oil on canvas
50 x 40 inches (127.0 x 101.6 cm)
Purchase: Nelson Trust [30-6]

Jean-Honoré Fragonard (after Salvator Rosa)
French, 1732–1806
Soldiers in a Landscape, dated 1774
Brown ink and wash on paper
11⅛ x 14⅝ inches (29.6 x 37.2 cm)
Purchase: Nelson Trust [33-1512]

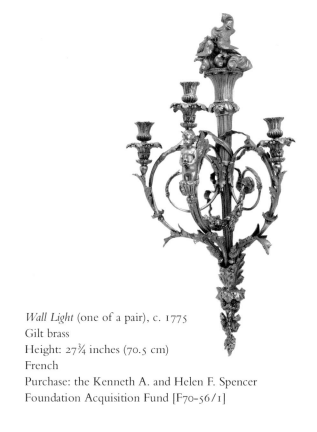

Wall Light (one of a pair), c. 1775
Gilt brass
Height: 27¾ inches (70.5 cm)
French
Purchase: the Kenneth A. and Helen F. Spencer
Foundation Acquisition Fund [F70-56/1]

Attributed to Christian Jorhan the Elder
German, 1727–1804
Saint Florian and *Saint George*
Gilt linden wood with paint
Height: 68¾ inches (174.6 cm); 63¼ inches (160.7 cm)
Purchase: Nelson Trust [59-56,57]

Gaetano Gandolfi
Italian, 1734–1802
The Assumption of the Virgin, c. 1776
Oil on canvas
37¼ x 53½ inches (94.6 x 135.9 cm)
Purchase: acquired through the generosity of
Mr. and Mrs. Louis Larrick Ward [F92-1]

Thomas Gainsborough
English, 1727–1788
Repose, c. 1777/78
Oil on canvas
48⅛ x 58⅞ inches (122.3 x 149.6 cm)
Purchase: Nelson Trust [31-56]

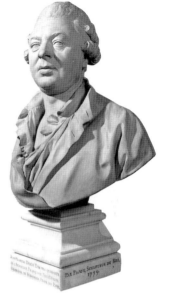

Augustin Pajou
French, 1730–1809
Jean-François Ducis, dated 1779
Earthenware on marble socle
Height: 30¾ inches (78.1 cm)
Purchase: acquired through the
generosity of the McGreevy Family
through the Westport Fund in honor of the fiftieth anniversary
of the Nelson-Atkins Museum of Art [F83-22]

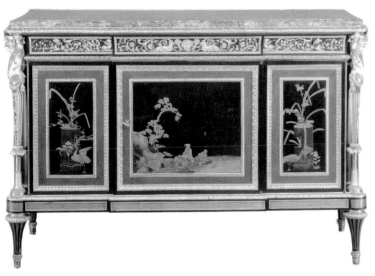

Chest of Drawers, c. 1780
Oak veneered with ebony and mahogany;
Japanese lacquer panels; gilt-brass mounts; marble top
38⅝ x 58⅞ x 24 inches (98.2 x 149.5 x 61.0 cm)
Attributed to Adam Weisweiler, German (active in France), 1744–1820
Purchase: the Kenneth A. and Helen F. Spencer
Foundation Acquisition Fund [F70-43]

Hubert Robert
French, 1733–1808
The Terrace at the Château de Marly, c. 1780
Oil on canvas
35¼ x 52¼ inches (89.5 x 132.7 cm)
Purchase: Nelson Trust [31-97]

Elisabeth-Louise Vigée Le Brun
French, 1755–1842
Portrait of Marie-Gabrielle de Gramont,
Duchesse de Caderousse, dated 1784
Oil on wood panel
41⅜ x 29⅞ inches (105.1 x 75.9 cm)
Purchase: Nelson Trust [86-20]★

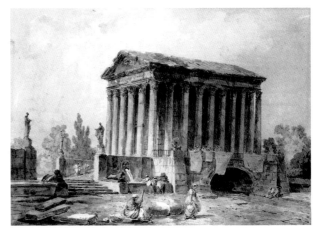

Hubert Robert
French, 1733–1808
The Maison Carrée at Nîmes, c. 1785/87
Watercolor and ink on paper
11⅞ x 16¾ inches (30.2 x 42.6 cm)
Purchase [F78-14]

Jean-Jacques de Boissieu
French, 1736–1810
A Waterfall
Brown ink and wash on paper
15⅞ x 13⅛ inches (40.4 x 33.4 cm)
Gift of Mr. Milton McGreevy
[F75-63/2]

Thomas Gainsborough
English, 1727–1788
Landscape with Ruins and Shepherds, c. 1785
Brown and gray wash with pinkish gouache accented
with black chalk on light blue-washed paper
8¾ x 12½ inches (22.2 x 31.8 cm)
Bequest of Mr. Milton McGreevy [81-30/27]

William Blake
English, 1757–1827
Nimrod, or "Let Loose the Dogs of War,"
possible study for *Night Thoughts,* c. 1795
Graphite on paper
7⅞ x 14½ inches (20.0 x 36.8 cm)
Purchase: Nelson Trust [54-22]

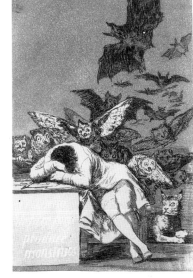

Francisco de Goya y Lucientes
Spanish, 1746–1828
*The Sleep of Reason Gives Birth to
Monsters,* from *Los Caprichos,* 1796
Etching and aquatint
8⅜ x 5¹³⁄₁₆ inches (21.3 x 14.8 cm)
Purchase: Nelson Trust [33-1077]

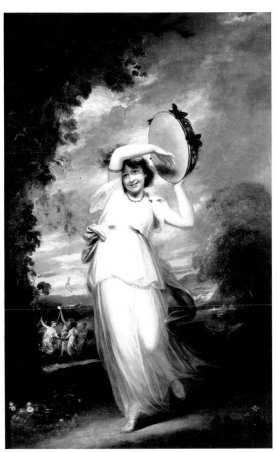

Joseph Wright of Derby
English, 1734–1797
Outlet of Wyburn Lake, 1796
Oil on canvas
22¼ x 30½ inches (56.5 x 77.5 cm)
Bequest of Mr. Milton McGreevy
[81-30/108]

John Hoppner
English, 1758–1810
Portrait of Emily St. Clare as a Bacchante, 1806–7
Oil on canvas
94½ x 59 inches (240.0 x 149.9 cm)
Gift of Mr. Robert Lehman [45-1]

Giovanni Domenico Tiepolo
Italian, 1727–1804
Title Page to the Punchinello Series, c. 1800
Brown ink and wash on paper
11½ x 16 inches (29.2 x 40.6 cm)
Purchase: Nelson Trust [32-193/9]

**Attributed to Charles Percier and
Pierre-François-Léonard Fontaine**
French, 1764–1838 and 1762–1853
Design for a Parade Carriage
Brown ink with watercolor, gold leaf,
and gouache on paper
13⅜ x 27¹⁵⁄₁₆ inches (34.0 x 71.0 cm)
Purchase: acquired through the generosity
of Mr. and Mrs. Milton McGreevy
through the Westport Fund [F68-13]

Antoine-Denis Chaudet
French, 1763–1810
The Emperor Napoleon as a Roman Consul, c. 1806
Bronze
Height: 24 inches (61.0 cm)
Gift of Michael Hall Fine Arts, Inc., New York [66-26/7]

Vincenzo Camuccini
Italian, 1771–1844
Horatio at the Bridge, c. 1810
Brown ink and wash and black chalk,
heightened with white, on paper
8¹⁵⁄₁₆ x 15¼ inches (22.7 x 38.7 cm)
Purchase: Nelson Trust [44-29/9]

Mantel Clock, 1810/14
Gilt brass and marble
Height: 24⅛ inches (61.3 cm)
Unknown French manufactory;
movement by the workshop of
Jean-Joseph Lepaute, 1768–1846
Purchase: Nelson Trust [82-8]

J.-L.-A. Théodore Géricault
French, 1791–1824
The Oath of Brutus after the Death of Lucretia, c. 1815/16
Oil on canvas
15⅛ x 18⅜ inches (38.4 x 46.6 cm)
Purchase: Nelson Trust [92-35]★
[*See colorplate, p. 43*]

J.-L.-A. Théodore Géricault
French, 1791–1824
Study of a Male Nude with a Rearing Horse, c. 1817
Brown ink on paper
10½ x 7⅝ inches (26.7 x 19.4 cm)
Purchase: Nelson Trust [38-31]

Jean-Auguste-Dominique Ingres
French, 1780–1867
Portrait of the Sculptor Paul Lemoyne, c. 1819
Oil on canvas
18¾ x 14½ inches (47.6 x 36.8 cm)
Purchase: Nelson Trust [32-54]

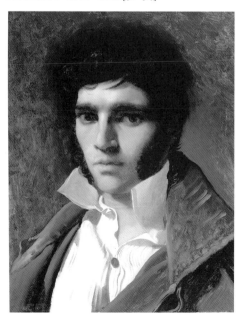

Column Clock, c. 1814
Soft-paste porcelain with blue ground and gilding;
bronze and gilt-brass mounts; brass movement
Height: 51½ inches (130.8 cm)
Sèvres Porcelain Manufactory, France;
movement by Jean-Joseph Lepaute, 1768–1846
Gift of Mr. and Mrs. Harry J. Renken, Sr. [F66-44]

Jean-Auguste-Dominique Ingres
French, 1780–1867
*Studies for "The Martyrdom of Saint
Symphorien"* (recto and verso), after 1826
Black chalk on paper, squared
21⁹⁄₁₆ x 16¼ inches (54.8 x 41.3 cm)
Purchase: Nelson Trust [33-1401]

Karl Friedrich Schinkel
German, 1781–1841
Sacrifice in a Classical Temple
Brown ink and gray wash on paper
15⅝ x 20¾ inches (39.7 x 52.7 cm)
Gift of Mr. Milton McGreevy [F61-55/6]

Joseph Michael Gandy
English, 1771–1843
Iphigenia in the Land of the Tauri, c. 1832
Watercolor on paper
12³⁄₁₆ x 17¹⁵⁄₁₆ inches (31.0 x 45.6 cm)
Gift of Mr. Milton McGreevy [F61-55/8]

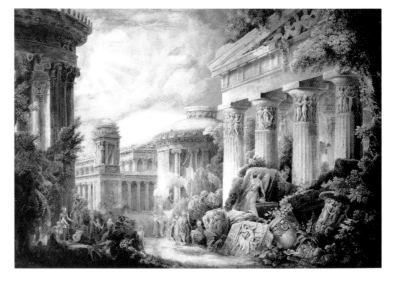

Antonio Canova
Italian, 1757–1822
Hercules and Lichas, cast c. 1834
Bronze
Height: 16¾ inches (42.6 cm)
Purchase: Nelson Trust (by exchange) [89-30]

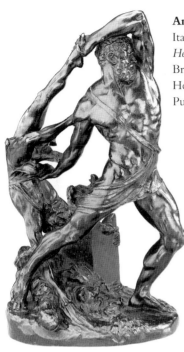

Thomas Lawrence
English, 1769–1830
Portrait of Mrs. William Lock of Norbury, 1829
Oil on wood panel
30 x 24½ inches (76.2 x 62.3 cm)
Purchase: Nelson Trust [54-36]

John Constable
English, 1776–1837
The Dell at Helmingham Park, 1830
Oil on canvas
44⅝ x 51½ inches (113.4 x 130.8 cm)
Purchase: Nelson Trust [55-39]

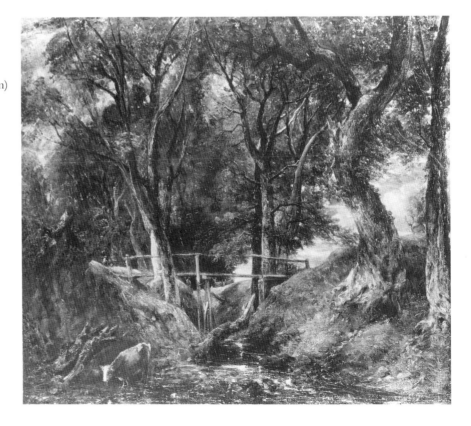

John Martin
English, 1789–1854
Ruins in Moonlight
Brown wash, heightened with white, on paper
7 x 9³⁄₁₆ inches (17.8 x 23.4 cm)
Bequest of Mr. Milton McGreevy [81-30/51]

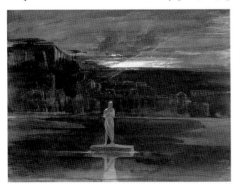

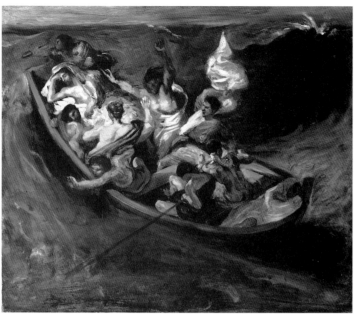

Eugène Delacroix
French, 1798–1863
Christ on the Sea of Galilee, c. 1841
Oil on canvas
18 x 21½ inches (45.7 x 54.6 cm)
Purchase: Nelson Trust [89-16]★

Eugène Delacroix
French, 1798–1863
Two Arabs
Brown ink on paper
6⅜ x 10 inches (16.2 x 25.4 cm)
Purchase: Nelson Trust [32-193/8]

Antoine-Louis Barye
French, 1796–1875
Deer Attacked by a Panther
Watercolor on paper
7¾ x 10⅝ inches (19.7 x 27.0 cm)
Purchase: Nelson Trust [32-32]

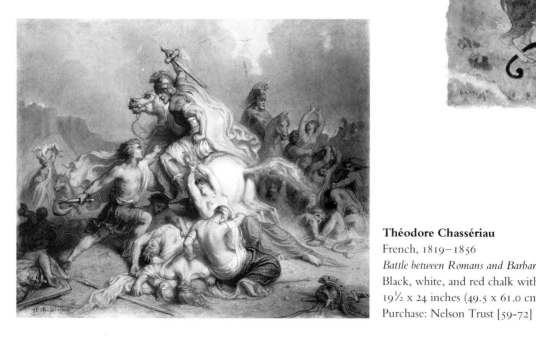

Théodore Chassériau
French, 1819–1856
Battle between Romans and Barbarians
Black, white, and red chalk with brown wash on paper
19½ x 24 inches (49.5 x 61.0 cm)
Purchase: Nelson Trust [59-72]

Théodore Rousseau
French, 1812–1867
Trees at Argenteuil
Brown ink on paper
9 1/16 x 11 3/8 inches (23.1 x 28.9 cm)
Bequest of Mr. Milton McGreevy [81-30/69]

Edward Lear
English, 1812–1888
The Ruins at Baalbek, dated 1860
Brown ink and watercolor on paper
10 15/16 x 17 7/16 inches (27.8 x 44.3 cm)
Bequest of Mr. Milton McGreevy [81-30/38]

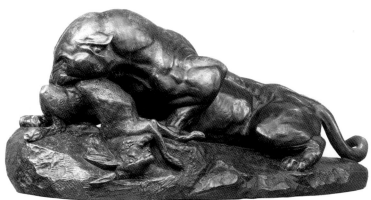

Antoine-Louis Barye
French, 1796–1875
Jaguar Devouring a Hare, model c. 1850
Bronze
Length: 40 inches (101.6 cm)
Purchase: Nelson Trust [44-50/5]

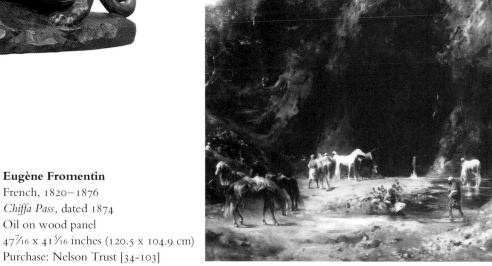

Eugène Fromentin
French, 1820–1876
Chiffa Pass, dated 1874
Oil on wood panel
47 7/16 x 41 5/16 inches (120.5 x 104.9 cm)
Purchase: Nelson Trust [34-103]

Thomas Couture
French, 1815–1879
The Illness of Pierrot, c. 1859/60
Oil on wood panel
13 13/16 x 16 15/16 inches (35.1 x 43.0 cm)
Purchase: Nelson Trust [32-15]

Jean-François Millet
French, 1814–1875
*Waiting (*also called *Tobit and His Wife),* 1860
Oil on canvas
33¼ x 47¾ inches (84.5 x 121.3 cm)
Purchase: Nelson Trust [30-18]

Jean-Baptiste-Camille Corot
French, 1796–1875
View of Lake Garda, c. 1865/70
Oil on canvas
24 x 36⅜ inches (61.0 x 92.5 cm)
Gift of Mr. Clarke Bunting in memory of
his wife, Catherine Conover Bunting [80-44]

Gustave Courbet
French, 1819–1877
Portrait of Jo, 1866
Oil on canvas
20¾ x 25 inches (52.7 x 63.5 cm)
Purchase: Nelson Trust [32-30]

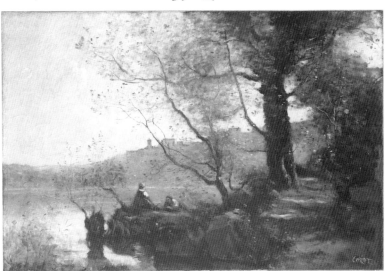

Honoré Daumier

French, 1808–1879

"The Nudes are Disgusting," from *Le Charivari,* 1866

Lithograph

8¾ x 7¹⁵⁄₁₆ inches (22.2 x 20.2 cm)

Gift of Mr. Milton McGreevy [F.59-65/15]

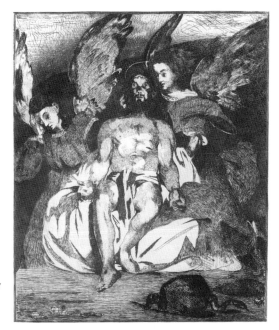

Edouard Manet

French, 1832–1883

Dead Christ with Angels, 1867

Etching and aquatint

15⁹⁄₁₆ x 12¹⁵⁄₁₆ inches (39.5 x 32.9 cm)

Purchase: acquired through the generosity
of Mr. and Mrs. Milton McGreevy
through the Westport Fund [F72-7]

Adolphe-William Bouguereau

French, 1825–1905

Standing Woman (also called *Italian
Woman at a Fountain*), dated 1869

Oil on canvas

39¹¹⁄₁₆ x 31¹⁵⁄₁₆ inches (100.8 x 81.2 cm)

Gift of Mr. and Mrs. M. B. Nelson [F88-17]

Narcisse-Virgile Diaz de la Peña

French, 1807–1876

The Approaching Storm, dated 1872

Oil on wood panel

30¾ x 41½ inches (78.1 x 105.4 cm)

Purchase: Nelson Trust [31-60]

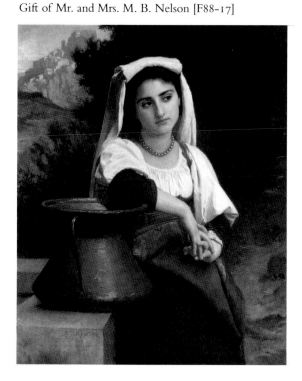

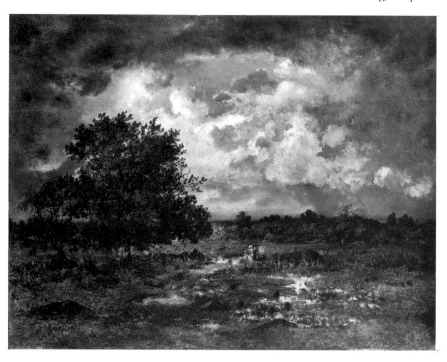

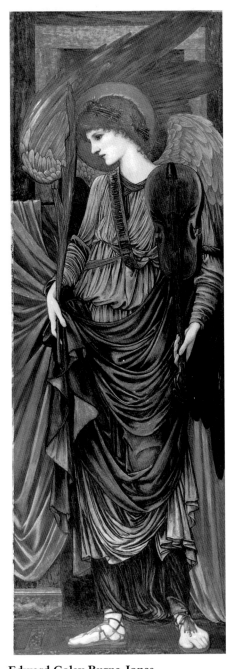

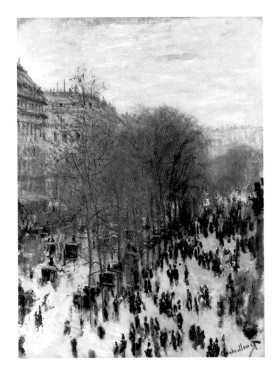

Claude Monet
French, 1840–1926
Boulevard des Capucines, 1873/74
Oil on canvas
31¼ x 23¼ inches (79.4 x 59.1 cm)
Purchase: the Kenneth A. and Helen F. Spencer
Foundation Acquisition Fund [F72-35]
[*See colorplate, p. 44*]

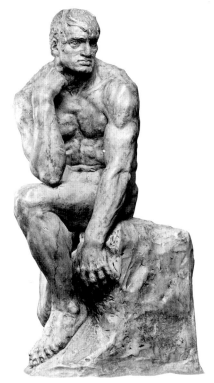

Edward Coley Burne-Jones
English, 1833–1898
Musical Angel, bears date 1878–96
Gouache on pieced paper
64¼ x 22¾ inches (163.2 x 57.8 cm)
Purchase: acquired through the generosity of
Mr. and Mrs. Milton McGreevy through
the Westport Fund [F59-59]

Auguste Rodin
French, 1840–1917
Study for "The Sailor," 1874/75
Wax
Height: 14½ inches (36.8 cm)
Purchase: Nelson Trust [58-61]

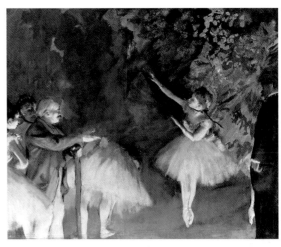

Camille Pissarro
French, 1830–1903
The Garden of Les Mathurins at Pontoise, dated 1876
Oil on canvas
44⅝ x 65⅛ inches (113.3 x 165.4 cm)
Purchase: Nelson Trust [60-38]

Edgar Degas
French, 1834–1917
Rehearsal of the Ballet, c. 1876
Gouache and pastel over monotype on paper
21¾ x 26¾ inches (55.3 x 68.0 cm)
Purchase: the Kenneth A. and Helen F. Spencer
Foundation Acquisition Fund [F73-30]

Camille Pissarro
French, 1830–1903
Wooded Landscape at L'Hermitage, Pontoise, dated 1878
Oil on canvas
18⁵⁄₁₆ x 22¹⁄₁₆ inches (46.5 x 56.0 cm)
Gift of Dr. and Mrs. Nicholas S. Pickard [F84-90]

Camille Pissarro
French, 1830–1903
Wooded Landscape at L'Hermitage, Pontoise, 1879
Soft-ground etching, aquatint, and drypoint
8⁹⁄₁₆ x 10½ inches (21.8 x 26.7 cm)
Purchase [F83-60]

Berthe Morisot
French, 1841–1895
Daydreaming, 1877
Pastel on canvas
19¾ x 24 inches (50.2 x 61.0 cm)
Purchase: acquired through the generosity
of an anonymous donor [F79-47]

Edouard Manet
French, 1832–1883
Portrait of Lise Campineanu, dated 1878
Oil on canvas
21⅞ x 18⅝ inches (55.6 x 46.4 cm)
Purchase: Nelson Trust [36-5]

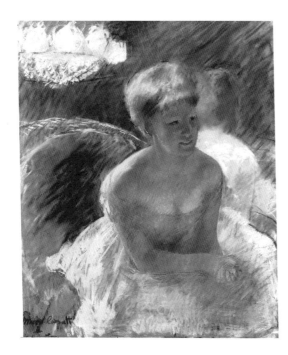

Mary Cassatt
American (active in France), 1844–1926
At the Theater (Woman in a Loge), c. 1879
Pastel on paper
21¹³⁄₁₆ x 18⅛ inches (55.4 x 46.0 cm)
Purchase: acquired through the generosity
of an anonymous donor [F77-33]

Odilon Redon
French, 1840–1916
*Salomé with the Head of Saint John the
Baptist,* c. 1880/85
Black chalk on paper
8⁵⁄₁₆ x 7¼ inches (21.2 x 18.4 cm)
Bequest of Mr. Milton McGreevy
[81-30/67]

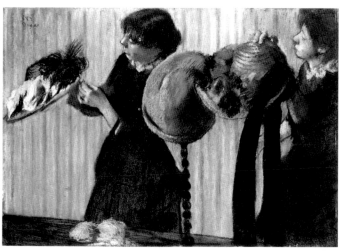

Edgar Degas
French, 1834–1917
Little Milliners, dated 1882
Pastel on paper
19¼ x 28¼ inches (49.0 x 71.8 cm)
Purchase: acquired through the generosity
of an anonymous donor [F79-34]

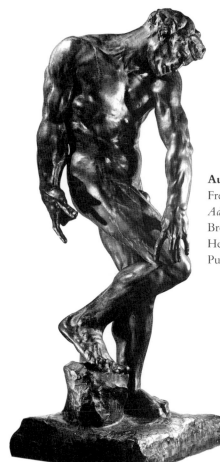

Auguste Rodin
French, 1840–1917
Adam, 1880
Bronze
Height: 77 inches (195.6 cm)
Purchase: Nelson Trust [55-70]

James Ensor
Belgian, 1860–1949
Seated Man, dated 1880
Charcoal on paper
28½ x 22½ inches (72.4 x 57.2 cm)
Gift of Dr. and Mrs. Nicholas S. Pickard
in memory of Dr. M. W. Pickard [58-22]

Emilio Sánchez-Perrier
Spanish, 1855–1907
View of Alcalá
Oil on wood panel
10¼ x 14⅛ inches (26.0 x 35.9 cm)
Gift of Mr. R. M. Chapman [32-34]

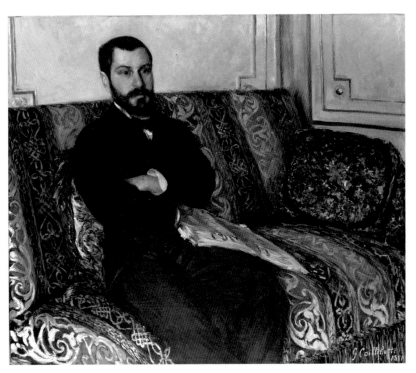

Gustave Caillebotte
French, 1848–1894
Portrait of Richard Gallo, dated 1881
Oil on canvas
38¼ x 45⅞ inches (97.2 x 116.6 cm)
Purchase: Nelson Trust [89-35]★
[*See colorplate, p. 45*]

Anna Alma-Tadema
English, c. 1865–1943
Interior of the Gold Room, c. 1883
Graphite and brown ink with
watercolor on paper
20⁷⁄₁₆ x 13⅞ inches (52.0 x 35.3 cm)
Bequest of Mr. Milton McGreevy
[81-30/86]
[*See colorplate, p. 46*]

Georges Seurat
French, 1859–1891
Study for "A Bathing Place, Asnières," 1883
Oil on wood panel
6⅞ x 10⅜ inches (17.5 x 26.3 cm)
Purchase: Nelson Trust [33-15/3]

Paul Signac
French, 1863–1935
Château Gaillard, Seen from the Artist's Window,
Petit Andely, 1886
Oil on canvas
17¹¹⁄₁₆ x 25⁹⁄₁₆ inches (45.0 x 65.0 cm)
Purchase: acquired through the
generosity of an anonymous donor [F78-13]

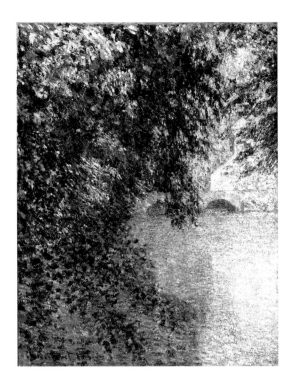

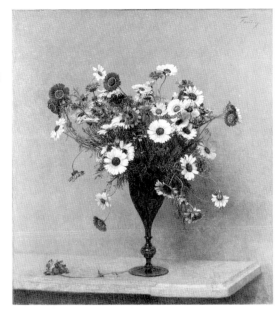

Henri Fantin-Latour
French, 1836–1904
Chrysanthemums, c. 1889
Oil on canvas
38⅜ x 36⅝ inches (97.5 x 93.1 cm)
Purchase: Nelson Trust [33-15/2]

Claude Monet
French, 1840–1926
Mill at Limetz, dated 1888
Oil on canvas
36⅜ x 28½ inches (92.5 x 72.4 cm)
Gift of Mrs. Joseph S. Atha [38-1986]

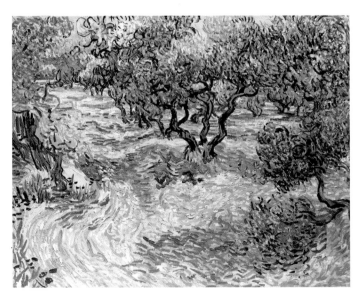

Vincent van Gogh
Dutch, 1853–1890
Olive Orchard, 1889
Oil on canvas
28¾ x 37 inches (73.0 x 94.0 cm)
Purchase: Nelson Trust [32-2]
[*See colorplate, p. 47*]

Paul Gauguin
French, 1848–1903
Faaturuma (Melancholic), dated 1891
Oil on canvas
37 x 26¾ inches (94.0 x 68.0 cm)
Purchase: Nelson Trust [38-5]

Paul Gauguin
French, 1848–1903
Landscape, dated 1894
Oil on canvas
36¼ x 27½ inches (92.1 x 69.9 cm)
Purchase: acquired through the generosity
of an anonymous donor [F77-32]

Paul Gauguin
French, 1848–1903
Te Po (The Great Night)
Woodcut
8¹⁄₁₆ x 14 inches (20.5 x 35.6 cm)
Purchase: Nelson Trust [71-9]

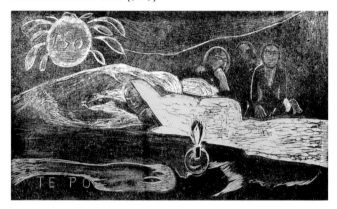

Pierre Bonnard
French, 1867–1947
Street at Night: Rain, 1899
Color lithograph
10¹⁄₁₆ x 13⅞ inches (25.6 x 35.3 cm)
Purchase: acquired through the generosity
of an anonymous donor [F78-3/3]

Camille Pissarro
French, 1830–1903
Poplars, Sunset at Eragny, dated 1894
Oil on canvas
28¹⁵⁄₁₆ x 23⅞ inches (73.5 x 60.7 cm)
Gift of the Laura Nelson Kirkwood
Residuary Trust [44-41/2]

Presentation Cup and Cover, 1901
Silver with enamel decoration
Height: 10⅝ inches (27.0 cm)
Liberty & Co., London; design attributed to
Archibald Knox, 1864–1933
Purchase: acquired through the generosity of
Sarah and Charles Koester [F89-31 a,b]

Armchair, 1898/1900
English oak and tooled leather
35 x 24 x 29 inches
(88.9 x 61.0 x 73.7 cm)
Guild of the Handicraft, Ltd., London;
designed by Charles Robert Ashbee,
1863–1942
Purchase: acquired through the
generosity of Mr. and Mrs. Earl D.
Wilberg [F91-32]

Johan Thorn Prikker
Dutch, 1868–1932
"Holländische Kunstausstellung in Krefeld," 1903
Color lithograph (poster)
33⅝ x 47½ inches (85.4 x 120.7 cm)
Purchase [F84-2]

Jacques Villon
French, 1875–1963
The Red Umbrella, dated 1901
Etching with color aquatint
19½ x 15½ inches (49.5 x 39.4 cm)
Purchase: acquired through the generosity
of an anonymous donor [F78-3/1]

Paul Cézanne
French, 1839–1906
Mont Sainte-Victoire, 1902/6
Oil on canvas
25⅛ x 32⅛ inches (63.8 x 81.5 cm)
Purchase: Nelson Trust [38-6]

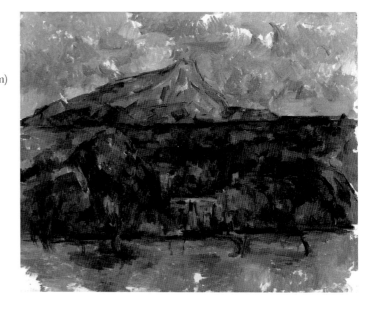

Rosewater Dish, 1904
Silver with repoussé and chased decoration
Diameter: 20 inches (50.8 cm)
Shop of Omar Ramsden and Alwyn C. E. Carr, London;
design attributed to Alwyn C. E. Carr, 1872–1940
Purchase: Nelson Trust through the exchange of
gifts of the Countess Helen L. Villa [91-46]

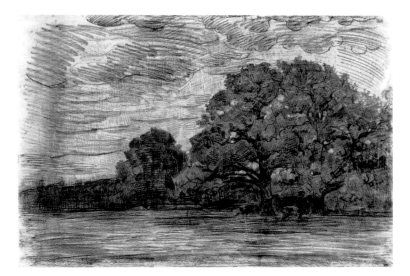

Piet Mondrian
Dutch, 1872–1944
Oak Trees, 1907/8
Charcoal, chalk, and red crayon on paper
34½ x 53½ inches (87.6 x 135.9 cm)
Purchase: Nelson Trust [77-37]

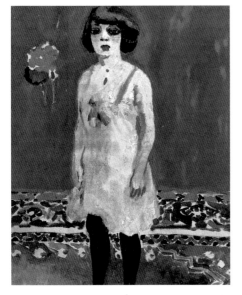

Kees van Dongen
French (born the Netherlands), 1877–1968
Figure, 1905
Oil on canvas
25⅝ x 21¼ inches (65.1 x 54.0 cm)
Gift of Mr. Arthur Wiesenberger [45-41]

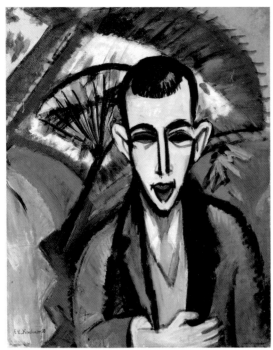

Ernst Ludwig Kirchner
German, 1880–1938
Portrait of the Poet Guthmann, dated 1910
Oil on canvas
32⅛ x 25⅝ inches (81.6 x 65.1 cm)
Gift of the Friends of Art [54-88]
[*See colorplate, p. 48*]

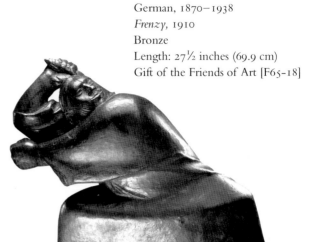

Ernst Barlach
German, 1870–1938
Frenzy, 1910
Bronze
Length: 27½ inches (69.9 cm)
Gift of the Friends of Art [F65-18]

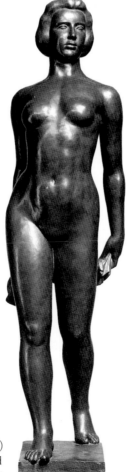

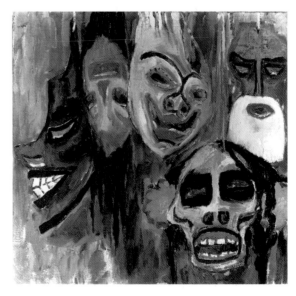

Emil Nolde
German, 1867–1956
Masks, 1911
Oil on canvas
28¾ x 30½ inches (73.0 x 77.5 cm)
Gift of the Friends of Art [54-90]

Aristide Maillol
French, 1861–1944
Ile de France, c. 1910
Bronze
Height: 65½ inches (166.4 cm)
Purchase: the Mary Atkins and
Ellen St. Clair Estates [A54-94]

Käthe Kollwitz
German, 1867–1945
Woman Bending over a Sick Child
Black chalk, charcoal with white
chalk highlights, watercolor,
and graphite on paper
19 x 16 inches (48.3 x 40.6 cm),
maximum dimensions
Bequest of Mr. Laurence Sickman
[F88-48/11]

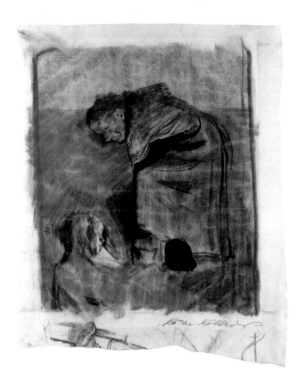

Egon Schiele
Austrian, 1890–1918
Standing Woman in a Jacket, Seen from Behind,
dated 1912
Graphite and watercolor on paper
18 x 12 inches (45.7 x 30.5 cm)
Gift of Mr. Richard S. Davis [53-18]

Léon Bakst
Russian (active in France), 1866–1924
"Le Martyre de Saint Sebastien," 1911
Color lithograph (poster; 2 parts)
51 3/16 x 79 3/8 inches (130.1 x 201.8 cm);
51 1/4 x 79 3/8 inches (130.2 x 201.8 cm)
Purchase [F85-9 a,b]★

Maurice Utrillo
French, 1883–1955
Street in Sannois, c. 1912/13
Oil on Masonite
20⅜ x 29⅛ inches (51.8 x 74.0 cm)
Purchase: the Adele R. Levy Fund, Inc.
[F62-46]

Odilon Redon
French, 1840–1916
Vase of Flowers, c. 1912
Pastel on paper
26¾ x 20¼ inches (68.0 x 51.4 cm)
Purchase: the Kenneth A. and Helen F.
Spencer Foundation Acquisition Fund [F76-1]
[*See colorplate, p. 49*]

Claude Monet
French, 1840–1926
Water Lilies, 1916/20
Oil on canvas
78¾ x 167½ inches (200.0 x 425.5 cm)
Purchase: Nelson Trust [57-26]

Alexander Archipenko
American (born Russia), 1887–1964
Statue on Triangular Base, dated 1914
Bronze
Height: 29⅞ inches (75.9 cm)
Gift of Mrs. Louis Sosland [F77-24]

Lyonel Feininger
American (active in Germany),
1871–1956
Vollersroda III, dated 1914
Charcoal with ink on paper
9⅜ x 12⅛ inches (23.8 x 30.8 cm)
Purchase: acquired through the
generosity of Mr. and Mrs. Milton
McGreevy through the Westport
Fund [50-16/2]

Pierre-Auguste Renoir
French, 1841–1919
The Large Bather, 1917
Bronze
Height: 48½ inches (123.2 cm)
Purchase: the Elmer F. Pierson
Foundation [77-57]

Jacques Lipchitz
American (born Lithuania), 1891–1973
Bather, dated 1917
Bronze
Height: 34¾ inches (88.3 cm)
Gift of the Friends of Art [F70-12]

Juan Gris
Spanish (active in France), 1887–1927
Coffee Grinder and Glass, 1915
Oil on cardboard
15⅛ x 11½ inches (38.5 x 29.2 cm)
Gift of Earle Grant in memory of
Gerald T. Parker [71-22]

Juan Gris
Spanish (active in France), 1887–1927
Book, Glass, and Bottle on a Table, 1913
Collage with black chalk on paper
36⅛ x 23⅝ inches (91.7 x 60.0 cm)
Gift of the Friends of Art [F61-10]

Lyonel Feininger
American (active in Germany), 1871–1956
Gaberndorf No. 2, 1924
Oil on canvas mounted on board
39⅛ x 30½ inches (99.4 x 77.5 cm)
Gift of the Friends of Art [46-10]

Paul Klee
Swiss, 1879–1940
The Virtue Wagon, 1922
Oil-colored drawing and watercolor on chalked paper
12¼ x 16 inches (31.1 x 40.6 cm)
Gift of the Friends of Art [F71-15]

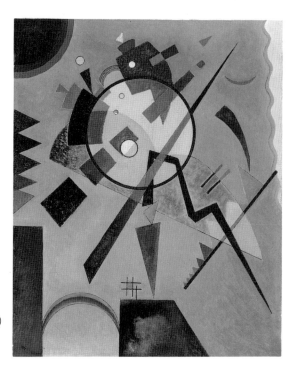

Wassily Kandinsky
French (born Russia), 1866–1944
Rose with Gray, dated 1924
Oil on cardboard
23⁹⁄₁₆ x 19⅛ inches (60.0 x 48.4 cm)
Gift of the Friends of Art [F62-9]
[*See colorplate, p. 49*]

Jacques Lipchitz
American (born Lithuania),
1891–1973
Return of the Prodigal Son, 1931
Bronze
Height: 42 inches (106.7 cm)
Gift of Mrs. R. C. Kemper, Sr.,
through the R. C. Kemper
Charitable Trust [F74-32]

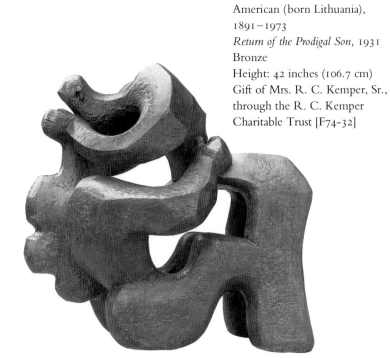

Constantin Brancusi
French (born Rumania), 1876–1957
Portrait of Nancy Cunard, 1925/27
Walnut on marble base
Height: 24¾ inches (62.9 cm)
Lent by the Hall Family Foundation [37-1991/2]★

Oskar Kokoschka
English (born Austria), 1886–1980
Pyramids at Gizeh, 1929
Oil on canvas
34⅝ x 51⅛ inches (87.9 x 129.8 cm)
Gift of the Friends of Art [54-89]

Jean (Hans) Arp
French (born Germany), 1887–1966
Seen and Heard, 1942
Gilt bronze
Height: 13¼ inches (33.7 cm)
Gift of the Friends of Art [F63-14]

Pablo Ruiz y Picasso
Spanish (active in France), 1881–1973
Visage, 1928
Lithograph
8 x 5⅜ inches (20.3 x 14.3 cm)
Gift of Mrs. Thomas K. Baker [73-1]

Yves Tanguy
American (born France), 1900–1955
At the Risk of the Sun, 1947
Oil on canvas
27¾ x 15¾ inches (70.5 x 40.0 cm)
Gift of the Friends of Art [58-68]

Kay Sage
American (active in Europe), 1898–1963
Too Soon for Thunder, dated 1943
Oil on canvas
28 x 36 inches (71.1 x 91.4 cm)
Bequest of the artist [64-36]

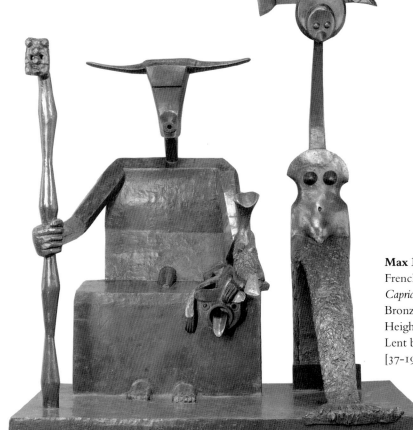

Max Ernst
French (born Germany), 1891–1976
Capricorn, model 1948 (cast 1963/64)
Bronze
Height: 95 inches (241.3 cm)
Lent by the Hall Family Foundation
[37-1991/3]*

Barbara Hepworth
English, 1903–1975
Seated Female Nude Seen from Behind, dated 1949
Graphite on cardboard prepared with gesso ground
14 11/16 x 10 1/4 inches (37.3 x 26.0 cm)
Bequest of Mr. Milton McGreevy [81-30/34]

Robert Doisneau
French, born 1912
The Indignant Woman, 1948
Silver print
9 9/16 x 12 1/16 inches (24.3 x 30.6 cm)
Gift of Dr. Carl Melcher [F81-50/10]

David Hockney
English, born 1937
Invented Man Revealing a Still Life, 1975
Oil on canvas
36 x 28 1/2 inches (91.4 x 72.4 cm)
Gift of Mr. and Mrs. William L. Evans [78-35]

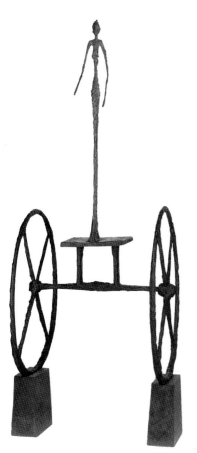

Alberto Giacometti
Swiss (active in France), 1901–1966
The Chariot, 1950
Painted bronze
Height: 56 1/4 inches (142.9 cm)
Lent by the Hall Family Foundation [37-1991/4]★

Sculpture by Henry Moore (Lent by the Hall Family Foundation)

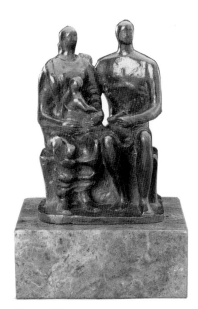

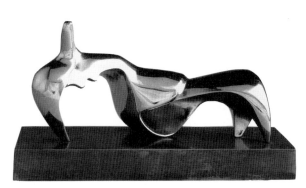

Henry Moore
English, 1898–1986
Family Group, 1944
Bronze
Height: 7⅝ inches (19.5 cm)
[66-1986/42]

Pointed Reclining Figure, 1948
Bronze
Length: 9½ inches (24.1 cm)
[66-1986/28]

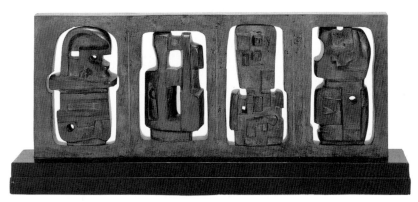

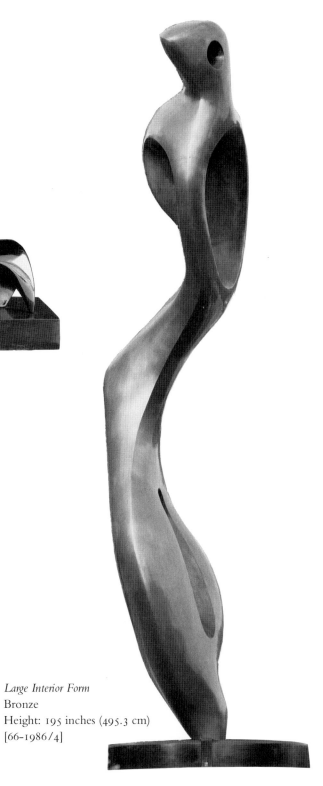

Time-Life Screen, working model, 1952
Bronze
Length: 43 inches (109.2 cm)
[66-1986/7]

Large Interior Form
Bronze
Height: 195 inches (495.3 cm)
[66-1986/4]

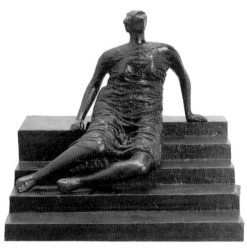

Figure on Steps, working model for
Draped Seated Woman, 1956/57
Bronze
Height: 25¼ inches (64.1 cm)
[67-1986/2]

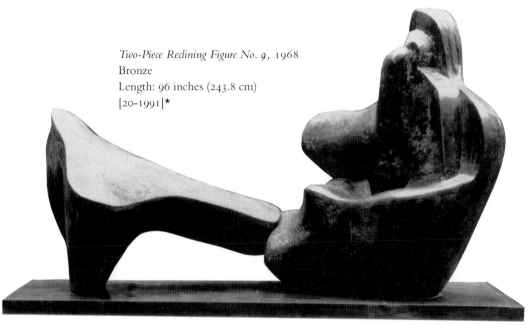

Two-Piece Reclining Figure No. 9, 1968
Bronze
Length: 96 inches (243.8 cm)
[20-1991]★

Architectural Project, 1969
Bronze
Length: 28 inches (71.1 cm)
[66-1986/10]

Animal Form, 1969/71
Bronze
Length: 29½ inches (74.9 cm)
[66-1986/18]

IV

American Art

As a consequence of nationhood, immigration, territorial expansion, and industrialization, American society rapidly diversified in the decades before and after the year 1800. While the museum's collection of eighteenth- and nineteenth-century American art is restricted in both size and scope—there is hardly any sculpture, for example—the paintings and graphic arts illustrate the principal themes in the visual arts that were of most concern to the people of the young country. These people were largely of northern European stock and, like the Dutch of the seventeenth century to whom Americans are so often compared, mostly Protestant, which means that they did not bring with them the taste for or tradition of making art in service of the church. Instead they were attracted to pictures and prints depicting the facts, circumstances, or wonders of the world around them.

Portraiture at the end of the eighteenth century and the beginning of the nineteenth century was dominated by native artists who traveled to London to complete their artistic educations in the studio of the expatriate Benjamin West. In England they were exposed to the styles of British painters such as Sir Joshua Reynolds, John Hoppner, Henry Raeburn, and Thomas Lawrence. Portraits in the collection by John Singleton Copley, Gilbert Stuart, and Thomas Sully demonstrate sophisticated techniques adopted from their British counterparts. By contrast, the depiction of *George and Emma Eastman (A Fashionable Inn)* by Calvin Balis is both striking and charming for the primitiveness of its style. The technical exuberance of John Singer Sargent—another American whose career was pursued in Europe—and the psychological intensity of Thomas Eakins are well represented in major works by both artists.

A small but superb group of still-life paintings includes Raphaelle Peale's *Venus Rising from the Sea—A Deception*

and a large masterpiece by John Frederick Peto, *Books on a Table,* painted in 1900 (colorplate, page 54). The extraordinary diversity of compositional and stylistic strategies employed by nineteenth-century landscape painters is evident from characteristic oils by John Frederick Kensett, Winslow Homer, Martin Johnson Heade, and George Inness, to name just a few, while William Keith's magnificent *Sunset Glow* is typical of that artist's splendid depictions of the virgin terrain of California. Views of Jerusalem, Stonehenge, and Venice by Frederic Edwin Church, Jasper Cropsey, and Thomas Moran, respectively, document interest in the natural and man-made wonders of the Old World. The museum's small group of genre paintings includes *Fishing on the Mississippi* and *Canvassing for a Vote* by George Caleb Bingham, depictions of middle-class domesticity by William Sidney Mount and Eastman Johnson, and the gorgeously painted if somewhat melancholy interior titled *Sonata,* by Childe Hassam (colorplate, page 53).

The erstwhile prohibition of works of recent origin from the collection formed by the William Rockhill Nelson Trust (see page 131) applied equally to European and American works of art. American painting and sculpture of the present century are nonetheless reasonably well represented in the museum's permanent collection because they have been more consistently accumulated, over the last sixty years, by local donor-collectors of vision and taste as well as by the Friends of Art organization. In its present, ever-changing form, the collection clearly embodies the midcentury shift of the center of artistic gravity from Europe to America. American art before World War II is dominated by no-nonsense assessments of modern life by George Bellows, Reginald Marsh, and Walt Kuhn; their canvases are supplemented by major watercolors by Marsh

and Charles Burchfield. A more lyrical tone is sounded by the colorful and rhythmic canvases of Thomas Hart Benton, a Missourian who made his home and career in Kansas City. His greatest easel painting, *Persephone* (colorplate, page 56), is a recapitulation of the ancient myth in midwestern terms of the 1930s.

Though European Surrealism spawned Abstract Expressionism (as evidenced by the Arshile Gorky painting in the collection), the abstract, postwar style created by Americans was distinctly their own; with it they dominated the art of the 1950s and early 1960s. The museum has a choice group of works from this period, with major canvases in a plethora of personal styles by Jackson Pollock, Richard Diebenkorn, Ellsworth Kelly, Franz Kline, and Mark Rothko. Certainly the most significant of them is Willem de Kooning's scintillating *Woman IV* of 1952/53 (colorplate, page 57). A characteristic sculpture by John Chamberlain, assembled from industrial detritus, translates the same vitality into three-dimensional form. The late 1950s witnessed the birth of Minimalism, wherein color was restrained or neutralized and geometry employed to assert discipline over form. One of the "black paintings" of Ad Reinhardt, along with a superb construction by Louise Nevelson, demonstrate with rigor and profundity this highly cerebral approach to the making of abstractions.

Pop art of the 1960s was a relatively short-lived but highly influential movement that focused on the artificiality of a modern consumer society and took delight in the use of various compositional and technical strategies to blur the distinctions between art, advertising, and the electronic media. The result is exemplified by Tom Wesselmann's *Still Life No. 24* of 1962 and Robert Rauschenberg's *Tracer* of 1963 (colorplate, page 58), one of the icons of the period. It led quite naturally to the super-meticulous technique and startling illusionism of Photorealism, from which there emerged, in turn, the new and dramatic synthesis of color, energy, and technical discipline seen in large canvases of the 1980s, such as James Rosenquist's *Venturi and Blue Pinion*. In Philip Pearlstein's *Two Models from the Other Side of the Easel* (colorplate, page 59), even the eccentricity and lyricism of Benton's *Persephone* are to some extent accommodated. The recent popularity of ceramic sculpture is represented in the collection by a wide range of works in many, highly individual styles. Artists whose ceramics are featured include Robert Arneson, Peter Voulkos, Richard Shaw, Richard DeVore, and Kenneth Ferguson.

Justus Engelhardt Kuhn
(born Germany), active 1708–1717
Portrait of a Girl, c. 1710
Oil on canvas
51¼ x 40¾ inches (130.2 x 103.5 cm)
Purchase: the Charles T. Thompson
Fund [F66-48]

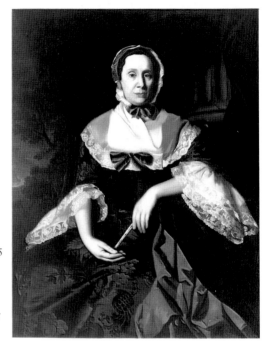

John Singleton Copley, 1738–1815
Portrait of Mrs. John Barrett, c. 1758
Oil on canvas
50 x 40 inches (127.0 x 101.6 cm)
Gift of the Enid and Crosby Kemper
Foundation [F77-1]

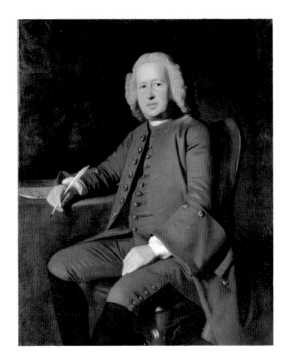

John Singleton Copley, 1738–1815
Portrait of Mr. John Barrett, c. 1758
Oil on canvas
49⅞ x 40⅞ inches (126.7 x 103.8 cm)
Gift of the Enid and Crosby Kemper
Foundation [F76-52]

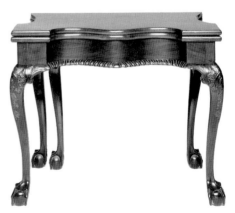

Card Table, 1760/80
Mahogany
27¾ x 34 x 16³⁄₁₆ inches (70.5 x 86.4 x 41.2 cm)
New York
Purchase: Nelson Trust [44-12]

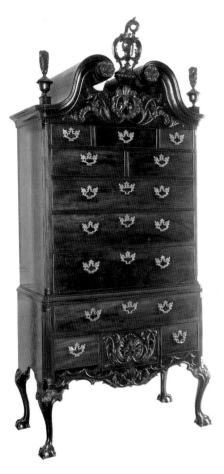

Chest-on-Chest, 1760/80
Mahogany
84 x 45½ x 23 inches (213.4 x 115.6 x 58.4 cm)
Attributed to Henry Rust, 1737–1812
Purchase: Nelson Trust [34-123]

High Chest of Drawers, 1760/85
Mahogany
100½ x 42 x 21¾ inches
(255.3 x 106.7 x 55.3 cm)
Pennsylvania
Purchase: Nelson Trust [33-163]

Benjamin West, 1738–1820
Portrait of Mr. and Mrs. John Custance, dated 1778
Oil on canvas
60⁵⁄₁₆ x 84⅝ inches (153.2 x 215.0 cm)
Purchase: Nelson Trust [34-77]

Gilbert Stuart, 1755–1828
Portrait of Dr. William Aspinwall,
c. 1814/15
Oil on wood panel
28⁹⁄₁₆ x 22¾ inches (72.5 x 57.8 cm)
Gift of Mr. and Mrs. Shepherd
Brooks [81-35]

Gilbert Stuart, 1755–1828
Portrait of the Right Honorable John Foster, 1791
Oil on canvas
83¼ x 59 inches (211.5 x 149.9 cm)
Purchase: Nelson Trust [30-20]

Side Chair, 1790/1805
Carved and inlaid mahogany
31 x 21 x 19 inches (78.7 x 53.3 x 48.3 cm)
New York
Purchase: Nelson Trust [33-37/1]

Thomas Sully (born England), 1783–1872
Portrait of Mrs. James Gore King, dated 1831
Oil on canvas
30 x 25⅛ inches (76.2 x 63.9 cm)
Purchase: Nelson Trust [51-47]

Raphaelle Peale, 1774–1825
Venus Rising from the Sea—A Deception
(formerly known as *After the Bath*), dated 182[2]
Oil on canvas
29¼ x 24⅛ inches (74.3 x 61.3 cm)
Purchase: Nelson Trust [34-147]

Jacob Ward, 1809–1891
Natural Bridge, Virginia, c. 1835
Oil on wood panel
23⅝ x 32 inches (60.0 x 81.3 cm)
Purchase: Nelson Trust [33-4/3]

Calvin Balis, 1817–c. 1863
George and Emma Eastman (A Fashionable Inn), c. 1850
Oil on canvas
53¾ x 67 inches (136.5 x 170.2 cm)
Purchase: Nelson Trust [33-43]

William Sidney Mount, 1807–1868
Winding Up (Courtship), dated 1836
Oil on wood panel
18¼ x 14⅞ inches (46.4 x 37.8 cm)
Gift of the Enid and Crosby Kemper
Foundation [F77-39]

George Caleb Bingham,
1811–1879
Canvassing for a Vote
(Candidate for Electioneering), dated 1852
Oil on canvas
25⅛ x 30¼ inches (63.8 x 76.8 cm)
Purchase: Nelson Trust [54-9]

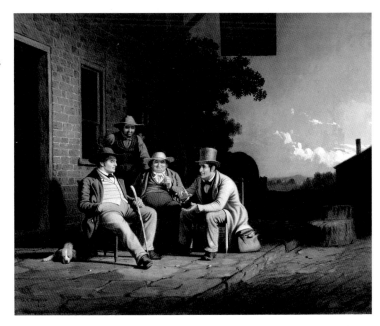

George Caleb Bingham, 1811–1879
Spectator, study for *Stump Orator,* 1847
Graphite on paper
8⅜ x 3⅞ inches (21.3 x 9.8 cm)
Purchase: Nelson Trust [60-74]

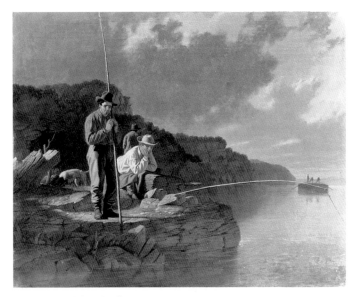

George Caleb Bingham, 1811–1879
Fishing on the Mississippi, dated 1851
Oil on canvas
28¹¹⁄₁₆ x 35⅞ inches (72.9 x 91.1 cm)
Purchase: Nelson Trust [33-4/4]

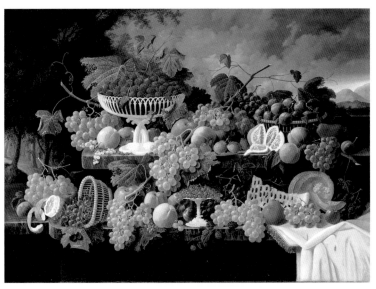

Severin Roesen (born Germany), 1815/16–after 1872
Two-Tiered Still Life, c. 1867
Oil on preprimed linen
36⅛ x 50⅛ inches (91.8 x 127.3 cm)
Purchase: acquired through the bequest of Dorothy K. Rice [F91-58]
[*See colorplate, p. 50*]

Thomas P. Otter, 1832–1890
On the Road, dated 1860
Oil on canvas
22 x 45⅜ inches (55.9 x 115.3 cm)
Purchase: Nelson Trust [50-1]

John Frederick Kensett, 1816–1872
Woodland Waterfall, c. 1855
Oil on canvas
40 x 34⅛ inches (101.6 x 86.7 cm)
Purchase: Nelson Trust [86-10]★

Frederic Edwin Church, 1826–1900
Jerusalem from the Mount of Olives,
dated 1870
Oil on canvas
53½ x 83½ inches (135.9 x 212.1 cm)
Gift of the Enid and Crosby Kemper
Foundation [F77-40]

Winslow Homer, 1836–1910
Gloucester Harbor, dated 1873
Oil on canvas
15⁹/₁₆ x 22⁷/₁₆ inches (39.5 x 57.0 cm)
Gift of the Enid and Crosby Kemper
Foundation [F76-46]
[*See colorplate, p. 51*]

Martin Johnson Heade, 1819–1904
Marsh Scene, c. 1874
Oil on canvas
13 x 26½ inches (33.0 x 67.3 cm)
Gift of the Enid and Crosby Kemper
Foundation [F78-10]

Chauncey Ives, 1810–1894
Bust of a Woman as a Roman Matron,
dated 1878
Marble
Height: 24 inches (61.0 cm)
Bequest of Laura Nelson Kirkwood
[T1988-111]

Jasper Francis Cropsey, 1823–1900
Stonehenge, dated 1876
Oil on canvas
24¼ x 54⅛ inches (61.6 x 137.5 cm)
Gift of Mrs. Thomas King Baker and Mrs. George H. Bunting, Jr. [81-11]

James McNeill Whistler, 1834–1903
Limehouse, 1878
Lithograph
6¾ x 10½ inches (17.2 x 26.7 cm)
Purchase: Nelson Trust [32-69/20]

John La Farge, 1835–1910
Study of Pink Hollyhocks in Sunlight, c. 1879
Watercolor and gouache on paper
11 15⁄₁₆ x 9 11⁄₁₆ inches (30.3 x 24.6 cm)
Gift of Mr. James Maroney [F86-22]

James McNeill Whistler, 1834–1903
San Giorgio, 1879/80
Etching
8¼ x 12 inches (21.0 x 30.5 cm)
Purchase [F86-11]

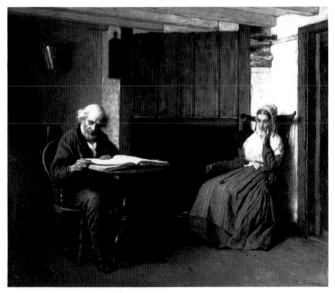

Eastman Johnson, 1824–1906
Thy Word Is a Lamp unto My Feet and a Light unto My Path, c. 1880/81
Oil on canvas
22½ x 27 inches (57.2 x 68.6 cm)
Gift of the Enid and Crosby Kemper Foundation [F79-12]

Alfred Thompson Bricher, 1837–1908
Schooner Close-Hauled, c. 1882
Oil on canvas
24¼ x 44¼ inches (61.6 x 112.4 cm)
Gift of the Enid and Crosby Kemper Foundation [F81-34]

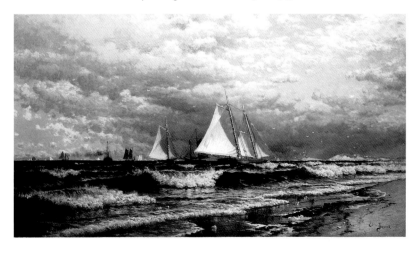

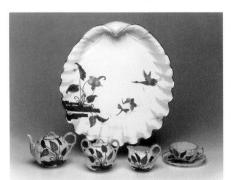

Tea Service, 1882/90
Belleek porcelain with raised gold,
silver, and bronze paste decoration
Diameter of tray: 16½ inches (41.9 cm);
height of teapot: 3⅞ inches (9.9 cm)
Ott and Brewer, Trenton, New Jersey
Purchase: the Charles T. and Marion
M. Thompson Fund [F91-1/1–6]

George Inness, 1825–1894
The Hudson River at Milton, dated 1888
Oil on canvas
26⅞ x 22⅛ inches (68.3 x 56.3 cm)
Purchase: Nelson Trust [33-87]

John Singer Sargent (born Italy), 1856–1925
Portrait of Mrs. Cecil Wade, dated 1886
Oil on canvas
64½ x 53⅜ inches (163.8 x 136.2 cm)
Gift of the Enid and Crosby Kemper Foundation [F86-23]
[*See colorplate, p. 52*]

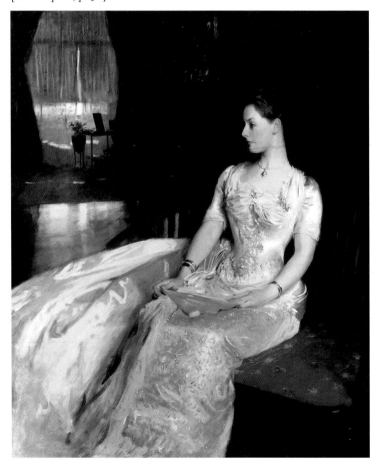

Winslow Homer, 1836–1910
Perils of the Sea, dated 1888
Etching
16½ x 21¾ inches (41.9 x 55.3 cm)
Purchase [F85-10]

Frederic Remington, 1861–1909
Teaching a Mustang Pony to Pack Game, 1890
Oil on canvas
20 x 30 inches (50.8 x 76.2 cm)
Purchase: the Union Pacific Foundation
Art Acquisition Fund [F86-19]

Thomas Moran (born England), 1837–1926
The Grand Canal with the Doge's Palace, Venice, dated 1889
Oil on canvas
24³⁄₁₆ x 36⅛ inches (61.5 x 91.7 cm)
Gift of the Enid and Crosby Kemper Foundation [F88-35]

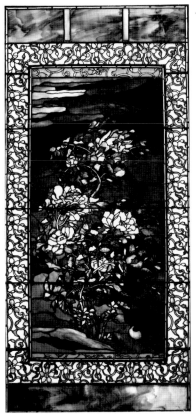

John La Farge, 1835–1910
Peonies Blowing in the Wind, 1889
Leaded-glass window
56½ x 26½ inches (143.5 x 67.3 cm)
Gift of the Enid and Crosby Kemper
Foundation [F88-34]
[*See colorplate, p. 53*]

Theodore Robinson, 1852–1896
Duck Pond, c. 1891
Oil on canvas
25⅞ x 32⅛ inches (65.7 x 81.6 cm)
Purchase: Nelson Trust [33-103]

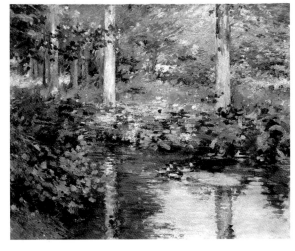

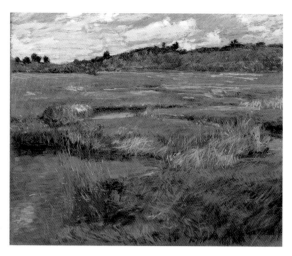

Childe Hassam, 1859–1935
The Concord Meadow, c. 1891
Pastel and gouache on prepared canvas
18 x 22⅛ inches (45.7 x 56.2 cm)
Gift of Pauline A. Dierks in memory
of Mae G. Sutherland [F83-46]

Ernest Lawson (born Nova Scotia), 1873–1939
Woodland Scene, c. 1891/92
Oil on canvas
20 x 25¼ inches (50.8 x 64.1 cm)
Gift of Mr. and Mrs. Albert R. Jones [33-1596]

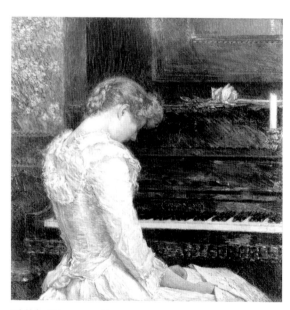

Childe Hassam, 1859–1935
Sonata, dated 1893
Oil on canvas ˙
32 x 32 inches (81.3 x 81.3 cm)
Gift of Mr. and Mrs. Joseph S. Atha [52-5]
[*See colorplate, p. 53*]

William Merritt Chase, 1849–1916
Beach Scene, c. 1895
Oil on canvas
14¾ x 19⅞ inches (37.5 x 50.5 cm)
Bequest of Miss Frances Logan [47-106]

William Keith (born Scotland),
1839–1911
Sunset Glow, dated 1896
Oil on canvas
36⅛ x 72½ inches (91.8 x 184.2 cm)
Gift of Mrs. Ferdinand Heim in
memory of her husband [45-22]

Henry Roderick Newman,
1843–1917
*Room of Tiberius, Temple of Isis,
Philae,* c. 1894
Watercolor over graphite on paper
20⅛ x 13 inches (51.1 x 33.0 cm)
Bequest of Mr. Milton McGreevy
[81-30/57]

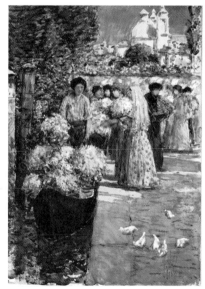

Childe Hassam, 1859–1935
Flower Market, dated 1895
Watercolor, gouache, and pastel on paper
19⅛ x 13⁷⁄₁₆ inches (48.6 x 34.1 cm)
Bequest of Miss Frances Logan [47-118]

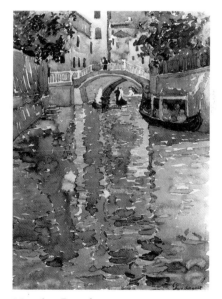

Maurice Prendergast
(born Newfoundland), 1859–1924
Side Canal, Venice, c. 1898/99
Watercolor over graphite on paper
13⁵⁄₁₆ x 9¹⁵⁄₁₆ inches (33.8 x 25.2 cm)
Purchase: acquired through the
generosity of Mrs. George C.
Reuland through the W. J. Brace
Charitable Trust [F81-46]

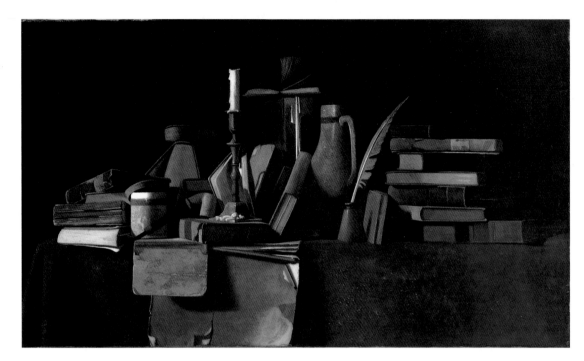

John Frederick Peto, 1854–1907
Books on a Table, 1900
Oil on canvas
24½ x 42⅞ inches (62.2 x 108.9 cm)
Purchase: Nelson Trust through the
exchange of a gift of the Friends of
Art [90-11]
[*See colorplate, p. 54*]

William Merritt Chase, 1849–1916
Still Life with Striped Bass, c. 1907
Oil on canvas
29⁵⁄₁₆ x 36½ inches (74.5 x 92.7 cm)
Gift of Mr. and Mrs. Albert R. Jones [33-1601]

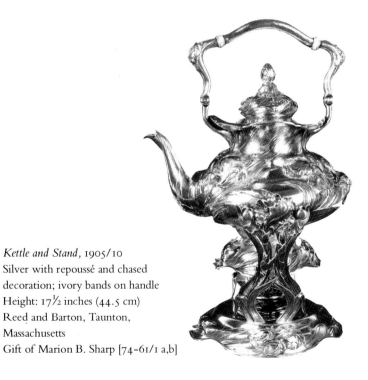

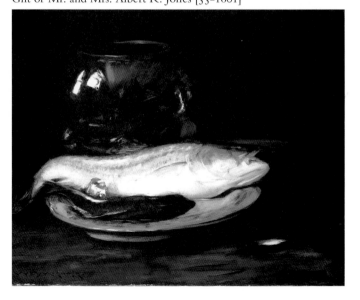

Kettle and Stand, 1905/10
Silver with repoussé and chased
decoration; ivory bands on handle
Height: 17½ inches (44.5 cm)
Reed and Barton, Taunton,
Massachusetts
Gift of Marion B. Sharp [74-61/1 a,b]

George Bellows, 1882–1925
Frankie, the Organ Boy, 1907
Oil on canvas
48³⁄₁₆ x 34³⁄₁₆ inches (122.4 x 86.9 cm)
Purchase: acquired through the
bequest of Ben and Clara Shlyen [F91-22]

Thomas Eakins, 1844–1916
Portrait of Monsignor James P. Turner, c. 1906
Oil on canvas
88 x 42 inches (223.5 x 106.7 cm)
Gift of the Enid and Crosby Kemper
Foundation [F83-41]

John Singer Sargent (born Italy),
1856–1925
Portrait of Francisco Bernareggi, dated 1907
Oil on canvas
26¾ x 19¼ inches (68.0 x 48.9 cm)
Gift of the Enid and Crosby Kemper
Foundation [F86-26]

Cabinet, 1907/9
Mahogany with ebony detailing;
glass doors
56½ x 66 x 22 inches
(143.5 x 167.6 x 55.9 cm)
Greene and Greene, Pasadena,
California; designed by Charles
Sumner Greene, 1868–1957, and
Henry Mathers Greene, 1870–1954
Purchase: acquired through the
generosity of Mr. and Mrs. R. Hugh
Uhlmann [F91-23]

Alfred Stieglitz, 1864–1946
Steerage, 1915
Photogravure print
13⅛ x 10¾ inches (33.3 x 27.3 cm)
Purchase: acquired through the NBC
Fund and the generosity of an
anonymous donor [F79-15]

Thomas Moran (born England), 1837–1926
Grand Canyon, dated 1912
Oil on wood panel
15⅞ x 23⅞ inches (40.3 x 60.7 cm)
Bequest of Katherine Harvey [63-44]

Maurice Prendergast (born Newfoundland), 1859–1924
Castle Island, c. 1912/14
Oil on canvas
18⁹⁄₁₆ x 28⁵⁄₁₆ inches (47.1 x 71.9 cm)
Gift of Mr. and Mrs. Joseph S. Atha [F58-57]

Marsden Hartley, 1877–1943
Himmel, 1915
Oil on canvas with original painted wood border
49½ x 49⅜ inches (125.7 x 126.1 cm)
Gift of the Friends of Art [56-118]
[*See colorplate, p. 55*]

George Bellows, 1882–1925
Pueblo Tesuque, No. 2, 1917
Oil on canvas mounted on Masonite
34⅜ x 44⅜ inches (87.4 x 112.7 cm)
Gift of Julia and Humbert Tinsman [F84-65]

Charles Demuth, 1883–1935
Sails, dated 1919
Gouache and graphite on illustration board
20 x 23¾ inches (50.8 x 60.3 cm)
Gift of the Friends of Art with the assistance
of the Mrs. Alfred B. Clark Fund [F79-25]

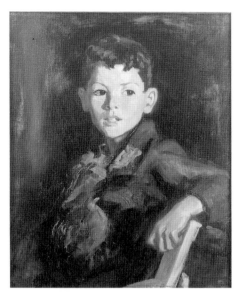

Robert Henri, 1865–1929
Portrait of an Irish Boy (Thomas Cafferty), 1925
Oil on canvas
24 x 20⅛ inches (61.0 x 51.2 cm)
Gift of Mrs. Murat Boyle in memory of her husband [60-70]

Elie Nadelman (born Poland), 1882–1946
Standing Girl, 1918/20
Cherry wood, gesso, and paint
Height: 30¾ inches (78.1 cm)
Gift of Julia and Humbert Tinsman [F91-62]

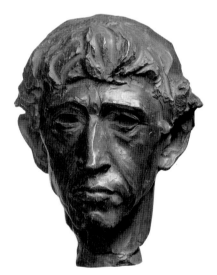

Charles Burchfield, 1893–1967
Edge of Town, dated 1921–41
Watercolor with touches of gouache
over graphite on paper
26¹⁵⁄₁₆ x 39¹³⁄₁₆ inches (68.4 x 101.1 cm)
Gift of the Friends of Art [41-52]

Gaston Lachaise (born France),
1882–1935
John Marin, 1928
Bronze
Height: 12½ inches (31.8 cm)
Gift of the Friends of Art [57-99]

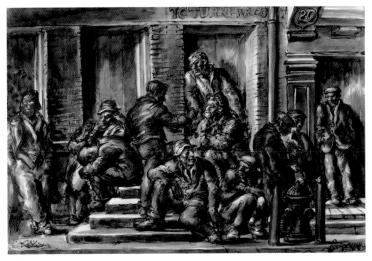

Reginald Marsh (born France), 1898–1954
Street Scene, Twelfth Avenue, dated 1928
Oil on canvas
19½ x 29½ inches (49.5 x 74.9 cm)
Purchase [F90-37]★

Reginald Marsh (born France), 1898–1954
20 South Street, dated 1939
Watercolor and gouache over graphite on paper
26⅝ x 40⁵⁄₁₆ inches (67.6 x 102.4 cm)
Gift of the Friends of Art [41-3]

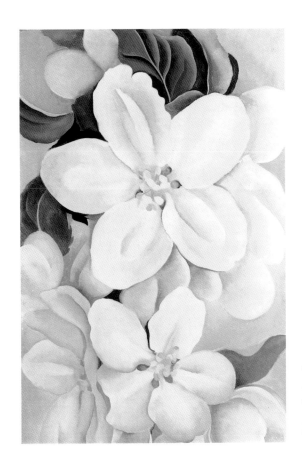

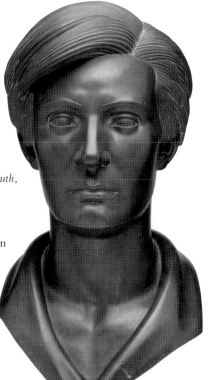

Paul Manship, 1885–1966
Head of Abe Lincoln, the Hoosier Youth,
dated 1931
Bronze
Height: 31 inches (78.7 cm)
Gift of Kansas City school children
through the Patriots and Pioneer
Association [46-7]

Georgia O'Keeffe, 1887–1986
Apple Blossoms, c. 1930
Oil on canvas
36 x 24 inches (91.4 x 61.0 cm)
Gift of Mrs. Louis Sosland [F81-62]

Walker Evans, 1903–1975
Saratoga Springs, New York, 1931, 1931
Gelatin silver print
11⅝ x 9⅜ inches (29.5 x 23.9 cm)
Purchase [F75-2]

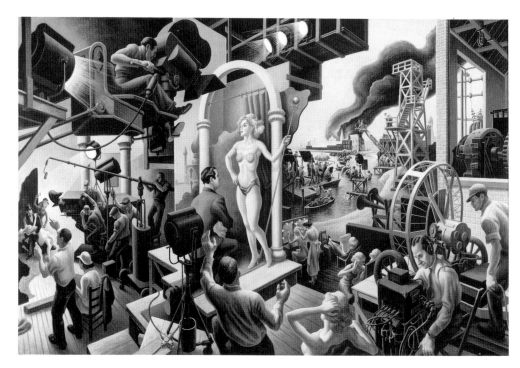

Thomas Hart Benton, 1889–1975
Hollywood, 1937
Tempera with oil on canvas, mounted on wood panel
53½ x 81 inches (135.9 x 205.7 cm)
Bequest of the artist [F75-21/12]

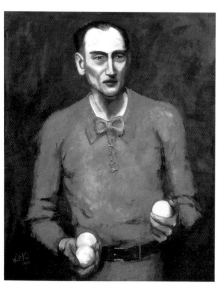

Walt Kuhn, 1880–1949
Juggler, dated 1934
Oil on canvas
30¹⁄₁₆ x 25³⁄₁₆ inches (76.4 x 64.0 cm)
Gift of the Friends of Art [38-1]

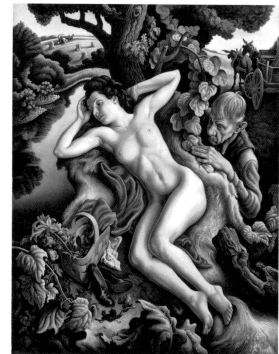

Thomas Hart Benton, 1889–1975
Persephone, 1938
Tempera with oil glazes on linen,
laid down on plywood
72⅛ x 56¹⁄₁₆ inches (183.3 x 142.5 cm)
Purchase [F86-57]★
[*See colorplate, p. 56*]

Thomas Hart Benton, 1889–1975
Working Study for "The Seneca Discover the French," 1956
Casein and graphite on paper; squared in graphite
28⅞ x 22⅞ inches (73.3 x 58.1 cm)
Bequest of the artist [F75-21/19]

Birger Sandzén (born Sweden), 1871–1954
Long's Peak, Colorado, dated 1938
Oil on canvas
40 x 48¼ inches (101.6 x 122.6 cm)
Gift of Mrs. Massey Holmes in memory of her husband [38-10]

Paul Meltsner, 1905–1966
Paul, Marcella, and Van Gogh (No. 2), c. 1940
Oil on canvas
36¹/₁₆ x 30¹/₁₆ inches (91.6 x 76.4 cm)
Gift of Mr. Oscar Serlin [40-2/2]

Edward Hopper, 1882–1967
Light Battery at Gettysburg, 1940
Oil on Masonite
18⅛ x 27⁵/₁₆ inches (46.0 x 69.4 cm)
Gift of the Friends of Art [47-95]

George Ault, 1891–1948
January Full Moon, dated 1941
Oil on canvas
20¼ x 26⅜ inches (51.4 x 67.0 cm)
Purchase: Nelson Trust (by exchange) [91-19]

Arshile Gorky (born Turkish Armenia), 1904–1948
Cornfield of Health II, dated 1944
Oil on canvas
30⅛ x 37¾ inches (76.5 x 95.9 cm)
Gift of the Friends of Art [F66-23]

Joseph Cornell, 1903–1972
A Pantry Ballet (for Jacques Offenbach),
dated 1942
Wood, plastic, paper, and metal
10½ x 18⅛ x 6 inches
(26.7 x 46.1 x 15.2 cm)
Gift of the Friends of Art [F77-34]

Willem de Kooning (born the Netherlands), born 1904
Boudoir, dated 1951
Oil on composition board
27½ x 33¼ inches (69.9 x 84.5 cm)
Gift of Mr. William Inge [56-125]

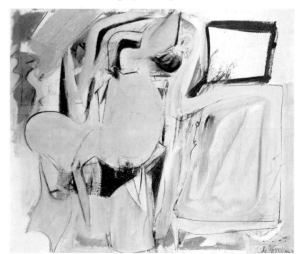

Ansel Adams, 1902–1984
Canyon de Chelly National Monument,
Arizona, 1942
Gelatin silver print
10¾ x 13⅜ inches (27.3 x 34.0 cm)
Gift of Mrs. George H. Bunting, Jr.
[69-11/1]

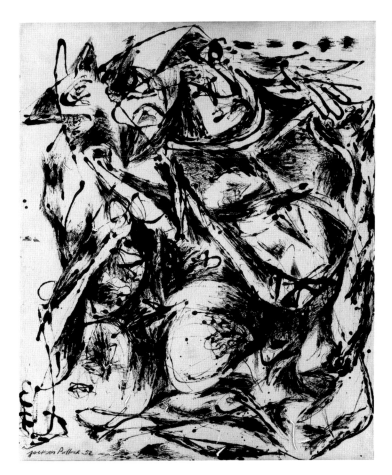

Jackson Pollock, 1912–1956
Number 6, 1952, dated 1952
Oil on canvas
55⅞ x 47 inches (141.9 x 119.4 cm)
Gift of the Friends of Art [F68-18]

Willem de Kooning (born the Netherlands), born 1904
Woman IV, 1952/53
Oil, enamel, and charcoal on canvas
59 x 46¼ inches (149.9 x 117.5 cm)
Gift of Mr. William Inge [56-128]
[*See colorplate, p. 57*]

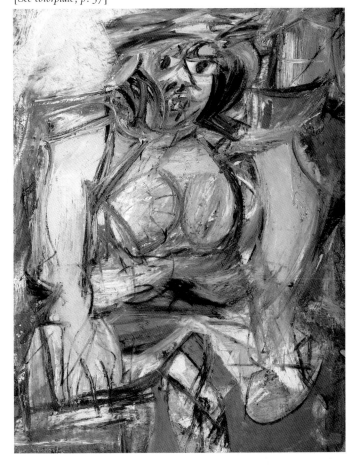

Charles Sheeler, 1883–1965
Conference No. 1, dated 1954
Oil on canvas
20½ x 25⅜ inches (52.1 x 64.5 cm)
Gift of the Friends of Art [55-93]

Larry Rivers, born 1923
Berdie with the American Flag, dated 1955
Oil on canvas
20 x 25⅞ inches (50.8 x 65.7 cm)
Gift of Mr. William Inge [57-120]

Mark Tobey, 1890–1976
Space Ritual No. 6, dated 1957
Sumi ink on paper
44½ x 35 inches (113.0 x 88.9 cm)
Gift of the Friends of Art [F59-62]

Grace Hartigan, born 1922
Broadway Restaurant, dated 1957
Oil on canvas
79 x 62¾ inches (200.7 x 159.4 cm)
Gift of Mr. William T. Kemper [F57-56]

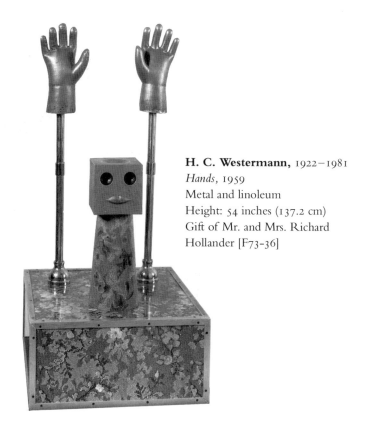

H. C. Westermann, 1922–1981
Hands, 1959
Metal and linoleum
Height: 54 inches (137.2 cm)
Gift of Mr. and Mrs. Richard
Hollander [F73-36]

William Baziotes, 1912–1963
Crescent, 1959
Oil on canvas
60¼ x 72⅜ inches (153.0 x 183.8 cm)
Purchase: Nelson Trust through the exchange
of a gift of the Friends of Art [90-10]

Richard Diebenkorn, 1922–1993
Interior with a Book, dated 1959
Oil on canvas
70 x 64 inches (177.8 x 162.6 cm)
Gift of the Friends of Art [F63-15]

Ad Reinhardt, 1913–1967
No. 10, 1959
Oil on canvas
108 x 40 inches (274.3 x 101.6 cm)
Purchase: Nelson Trust [89-17]★

Franz Kline, 1910–1962
Turin, dated 1960 (on back)
Oil on canvas
80 x 95⅜ inches (203.2 x 242.3 cm)
Gift of Mrs. Alfred B. Clark through the Friends of Art [F61-23]

Ellsworth Kelly, born 1923
Untitled, 1960
Oil on canvas
86 x 48 inches (218.4 x 121.9 cm)
Purchase: Nelson Trust through the bequest of Dorothy K. Rice [92-3]

John Chamberlain, born 1927
Huzzy, 1961
Painted and chromium-plated steel with fabric
Height: 54 inches (137.2 cm)
Gift of Mrs. Charles F. Buckwalter in
memory of her husband [F64-8]

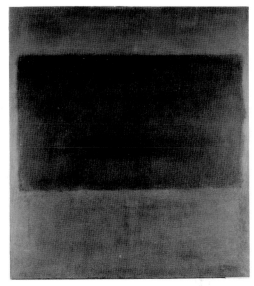

Mark Rothko (born Latvia), 1903–1970
Untitled No. 11, 1963, 1963
Oil on canvas
75⅛ x 69⅛ inches (190.9 x 175.6 cm)
Gift of the Friends of Art [F64-15]

Andy Warhol, 1925–1987
Baseball, 1962
Oil and silkscreen on canvas
91½ x 82 inches (232.4 x 208.3 cm)
Gift of the Guild of the Friends of Art
and other Friends of the Museum [F63-16]

Tom Wesselmann, born 1931
Still Life No. 24, 1962
Acrylic polymer on board; fabric curtain
48 x 59⅞ inches (121.9 x 152.1 cm)
Gift of the Guild of the Friends of Art
[F66-54]

Robert Rauschenberg, born 1925
Tracer, 1963
Oil and silkscreen on canvas
84 x 60 inches (213.4 x 152.4 cm)
Purchase [F84-70]
[*See colorplate, p. 58*]

Claes Oldenburg (born Sweden), born 1929
Switches Sketch, 1964
Vinyl
47 x 47 inches (119.4 x 119.4 cm)
Gift of the Chapin Family in memory of
Susan Chapin Buckwalter [65-29]

Wayne Thiebaud, born 1920
Bikini, dated 1964
Oil on canvas
72 x 35⅞ inches (182.9 x 91.1 cm)
Gift of Mr. and Mrs. Louis Sosland [F66-35]

John Mason, born 1927
Brown Monolith, 1964
Earthenware
Height: 66 inches (167.6 cm)
Gift of the Friends of Art [82-43]

Fairfield Porter, 1907–1975
The Mirror, dated 1966
Oil on canvas
72¾ x 60¾ inches (184.8 x 154.3 cm)
Gift of the Enid and Crosby Kemper
Foundation [F86-25]

Frederic James, 1915–1985
White Sycamore, 1967
Watercolor over graphite on paper
23 1/16 x 29 inches (58.6 x 73.6 cm)
Anonymous gift [67-40]

Andrew Wyeth, born 1917
Battleground, 1981
Tempera on wood panel
49 1/2 x 45 3/4 inches (125.7 x 116.2 cm)
Gift of the Enid and Crosby Kemper Foundation
in memory of Jerome H. Scott, Jr. [F81-19]

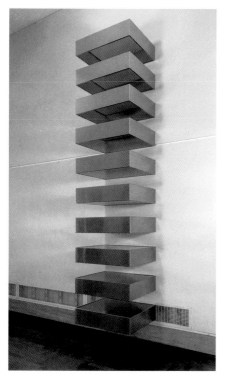

Donald Judd, born 1928
Large Stack, 1968
Stainless steel and amber Plexiglas (10 units)
9 x 40 x 31 inches (22.8 x 101.6 x 78.7 cm), each
Gift of the Friends of Art [F76-41]

Carl Andre, born 1935
Aluminum and Magnesium Plain, 1969
Aluminum and magnesium (36 plates)
3/8 x 72 x 72 inches
(1.0 x 182.9 x 182.9 cm), overall
Lent by the Hall Family Foundation
[37-1991/1]★

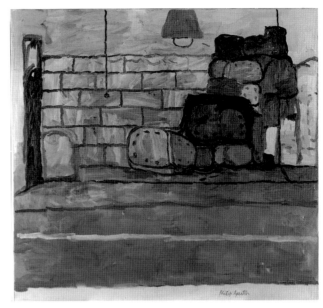

Edward Ruscha, born 1937
Bouncing Marbles, Bouncing Apple, Bouncing Olive, 1969
Oil on canvas
60 x 55 inches (152.4 x 139.7 cm)
Gift of Norman and Elaine Polsky,
Fixtures Furniture, Kansas City
[F86-50/3]

Philip Guston, 1912–1980
The Wall, dated 1972
Oil on canvas
72⅞ x 79⅛ inches (185.1 x 201.0 cm)
Bequest of Musa Guston [F92-21]

Louise Nevelson (born Russia), 1899–1988
End of Day, Nightscape IV, 1973
Painted wood
95 x 167 inches (241.3 x 424.2 cm)
Gift of the Friends of Art [74-30]

Jasper Johns, born 1930
Souvenir, dated 1970
Color lithograph
30¾ x 22⅜ inches (78.1 x 56.8 cm)
Gift of Mr. and Mrs. Tom H. Parrish
[F83-18]

Richard Estes, born 1936
Central Savings, 1975
Oil on canvas
36 x 48 inches (91.4 x 121.9 cm)
Gift of the Friends of Art [F75-13]
[*See colorplate, p. 59*]

Wayne Thiebaud, born 1920
Apartment Hill, dated 1980
Oil on linen
65 x 48 inches (165.1 x 121.9 cm)
Purchase: acquired with the assistance of the Friends of Art [F86-4]

Deborah Butterfield, born 1949
Horse, 1979
Chicken wire, sticks, mud, paper,
dextrin, and grass on steel armature
Length: 96 inches (243.8 cm)
Purchase [F87-24]

Nancy Graves, born 1940
Zaga, 1983
Cast bronze with polychrome
chemical patination
Height: 72 inches (182.9 cm)
Gift of the Friends of Art [F84-27]

Robert Arneson, 1930–1992
Pablo Ruiz with Itch, 1980
Glazed earthenware
Height: 87½ inches (222.3 cm)
Gift of the Friends of Art [F82-38 a,b]

Richard Shaw, born 1941
Lighthouse at Bolinas, 1983
Porcelain with decal overglaze
Height: 18 inches (45.7 cm)
Gift of the Morgan Family to the Jim
Morgan Memorial Clay Collection [F84-15]

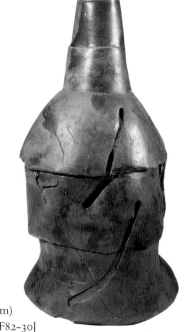

Peter Voulkos, born 1924
Wood-fired Stack, 1982
Glazed earthenware
Height: 38½ inches (97.8 cm)
Gift of the Friends of Art [F82-30]

Jennifer Bartlett, born 1941
Boy, 1983
Oil on canvas
84 x 180 inches (213.4 x 457.2 cm)
Gift of the Friends of Art [F83-67 a–c]

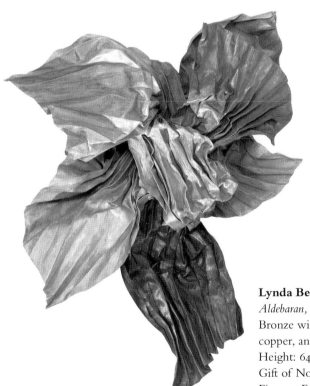

Richard DeVore, born 1933
Pot R No. 401, 1983
Stoneware
Height: 15¾ inches (40.0 cm)
Gift of the Friends of Art [F83-62]

Lynda Benglis, born 1941
Aldebaran, 1983
Bronze wire mesh sprayed with zinc,
copper, and aluminum
Height: 64 inches (162.6 cm)
Gift of Norman and Elaine Polsky,
Fixtures Furniture, Kansas City [F85-37]

James Rosenquist, born 1933
Venturi and Blue Pinion, 1983
Oil on canvas
78 x 198 inches (198.1 x 502.9 cm)
Purchase [F84-35 a–c]

Philip Pearlstein, born 1924
Two Models from the Other Side of the Easel, dated 1984
Oil on canvas
72 x 96½ inches (182.9 x 245.1 cm)
Purchase [F87-25]
[*See colorplate, p. 59*]

Neil Welliver, born 1920
Late Squall, 1984
Oil on canvas
96 x 120 inches (243.8 x 304.8 cm)
Gift of the Enid and Crosby Kemper Foundation [F84-69]

Jim Dine, born 1935
The Crommelynck Gate with Tools, 1984
Cast bronze with welded appendages
Length: 132 inches (335.3 cm)
Gift of the Friends of Art [F84-76]

Agnes Martin, born 1912
White Flower II, 1985
Acrylic and graphite on canvas
72 x 72 inches (182.9 x 182.9 cm)
Purchase [F88-23]

Charles Arnoldi, born 1946
Cannibal, 1986
Acrylic on carved plywood
120 x 300 inches (304.8 x 762.0 cm)
Purchase: acquired with the assistance of an anonymous donor [F86-62 a–e]

Kenneth Ferguson, born 1928
Leaping Hare, 1987
Stoneware
Diameter: 22¾ inches (57.8 cm)
Purchase [F87-19]

Keith Jacobshagen, born 1941
Crow Call (Near the River), dated 1990–91
Oil on canvas
46⅛ x 80¼ inches (117.2 x 203.8 cm)
Purchase: acquired through the generosity of
the National Endowment for the Arts [F91-12]

James Surls, born 1943
I and Eye, Truth and Truth, 1987
Oak and bois d'arc
Height: 103 inches (261.6 cm)
Purchase [F87-20]

Roger Shimomura, born 1939
Kabuki Party, dated 1988
Color screenprint
12 x 24 inches (30.5 x 61.0 cm)
Gift of the Print Society [F88-13]

V

The Arts of Asia

The collection of Asian art in Kansas City is counted among the finest in America by virtue of its size, depth, and overall level of quality. Due to the quantity of material to be presented, the illustrations in this section have been organized along traditional lines of national identity or geographical designation and then, for China and Japan, further categorized by medium.

Virtually every phase and form of China's incomparably long history of continuous artistic activity—from Neolithic times to the twentieth century—are documented in the collection with excellent examples, reflecting the priorities of the University Trustees' first advisers (Langdon Warner and Laurence Sickman) and the three curators who have carefully fostered the development of the collection (Laurence Sickman, Marc Wilson, and Wai-kam Ho). The bronze age is especially well represented, from about 1200 to 500 B.C., in a spectacular series of ceremonial vessels and weapons. Of unique interest is the famous *Zoomorphic Spiral,* a fantastic dragon whose body curls into a spiral-shaped ornament; it must have been affixed to the top of a staff or pole (similar in appearance, therefore, to a bishop's crozier). A number of bronzes from the fifth to third centuries, including sculptures of animals and human subjects, mirrors, and garment hooks, are opulently embellished with inlays of gold, silver, or turquoise.

The Chinese have excelled all other Asian peoples in the ceramic arts. So great is the range and diversity of their production that no collection can be considered definitive. Nonetheless, the visitor to the museum will find examples of most of the better-known wares and types over a span of some three thousand years—from the Shang Dynasty capital at Yin to the Peking palaces of the Manchu emperors. The evolution and variety of ceramic objects made exclusively for burial in the tombs are fully represented from the early unglazed and painted pieces, such as the remarkable earthenware house model from the Han Dynasty, through the rich diversity appearing in the sixth century, to the large and brilliantly glazed horses, camels, guardians, and attendants of the T'ang Dynasty, when this funerary art reached its apogee. The perfection of stoneware and porcelaneous wares, realized in the Northern (960–1127) and Southern (1127–1279) Sung Dynasties, is illustrated by numerous splendid examples, while the fourteenth-century development of high-fired porcelains with underglaze blue decoration, the most famous of all Chinese export wares, is likewise exemplified by a wide array of objects, including a superb pair of vases (colorplate, page 66). From the seventeenth and eighteenth centuries there are porcelains decorated with polychrome overglaze enamels (known as *famille verte* and *famille rose),* porcelains with stunning monochromatic glazes, and *I-hsing* stonewares created in a variety of shapes.

The museum's collection of Chinese sculpture is nothing less than comprehensive. The earliest examples date from the first to third centuries and are associated with funerary monuments, such as the pair of large chimeras that served as ceremonial guardians to a tomb. From the fourth century Buddhism was the primary influence on sculpture, and the collection is noteworthy for two rare stelae from the sixth century and a monumental relief representing *The Empress as Donor with Attendants* from the fabled Pin-yang cave at Lung-men. The relief and its pendant, which depicts the emperor and his court (now in the Metropolitan Museum of Art), were plundered between 1931 and 1934 and the fragments scattered all over China. Literally hundreds of pieces were diligently recovered, thanks to Laurence Sickman, and painstakingly reassembled on this side of the Pacific in the late 1930s. The small but unrivaled group of later Buddhist wood sculptures includes

a majestic image of Kuan-yin that is celebrated for the splendor of its carved and painted surfaces (colorplate, page 64). Magnificent and serene, the renowned sculpture presides over the main hall of a Buddhist temple in the company of representations of other deities of near-equal presence. A choice group of bronze and gilt-bronze sculptures, several bequeathed by Mr. Sickman, rounds out the collection.

The collection of more than seven hundred Chinese paintings is one of the best outside Asia. The long and involved history of Chinese painting is fully documented by works of great quality, many by the most celebrated artists of China. Probably its real glory derives from the group of landscape paintings executed between the eleventh and thirteenth centuries, including such masterworks as the towering mountain landscape attributed to Li Ch'eng (colorplate, page 63) and *Fishermen's Evening Song* by the eleventh-century artist Hsü Tao-ning. Traditional figure painting may be seen in scrolls retaining the style of the eighth and ninth centuries, and in its final but brilliant revival during the fourteenth century in the *Nine Horses* scroll of Jen Jen-fa. Recent acquisitions include the late Northern Sung masterpiece *Illustration to the Second Prose Poem on the Red Cliff,* attributed to Ch'iao Chung-ch'ang; *Fisherman's Flute Heard over the Lake* by the great Ming painter Ch'iu Ying; and an album of ten *Landscapes in the Styles of Old Masters* by the highly original calligrapher and painter Tung Ch'i-ch'ang (colorplate, page 70). Compared with earlier periods, painting of the Ch'ing Dynasty is less completely represented in the collection at Kansas City. There are, nonetheless, excellent examples of the highly individual and boldly expressive style of Kung Hsien, of the more traditional, orthodox manner of Wang Yüan-ch'i, and of the elegant naturalism of Chin Nung.

Chinese decorative arts are represented by fine examples, both early and late, of jade, metalwork, lacquerware, and textiles. Among the most beautiful works of art exhibited in Kansas City are the *Ritual Disc with Dragon Motif*—practically a logo of the collection—and the luxurious silver and parcel-gilt bowl (colorplate, page 60), made in the T'ang Dynasty. The museum's collection of classic Chinese domestic furniture, mostly from the fifteenth to seventeenth centuries, is one of the most extensive anywhere. It includes two examples of the *k'ang,* or massive couch, of which one is considered among the finest in existence for the beauty of its wood and the power and simplicity of its design (colorplate, page 69). The Ming Dynasty *Canopy Bed with Alcove* is a perennial favorite of visitors to the museum. A selection of outstanding pieces of furniture and other decorative arts has been assembled in a recreation of a scholar's studio—that micro-environment that was for centuries central to the literary and artistic culture of China.

The arts of Japan are less comprehensively represented than those of China, but the collection is nonetheless various and interesting with pockets of exceptional strength. An impressive array of ceramics is dominated by the spectacular sixteenth-century *Echizen Water Jar* whose monumentality is complemented by the boldness of its glazes. Completely different in terms of scale and embellishment are the subtle *Shino* wares favored for the tea ceremony, and *Kyoto* pottery attributed to Ogata Kenzan. From the Edo period there is a small array of underglaze blue and polychrome overglaze enamel porcelains of the *Imari, Kakiemon,* and *Nabeshima* types. A large dish (colorplate, page 72) is an outstanding example of the boldly conceived and dramatically colored *Kutani* wares in the collection. Some of the finest Japanese porcelains have come to the museum since the last publication of the *Handbook,* in 1973, by way of the bequests of two great collectors, Mrs.

George H. Bunting, Jr. (1981), and John S. Thacher (1985).

The few pieces of Japanese sculpture feature Buddhist images in wood primarily from the ninth and tenth centuries, such as the regal depiction of *Jizō Bosatsu.* By the Kamakura period (1185–1333) such unperturbed elegance had been abandoned in favor of the more dynamic, even violent, sculptural style that characterizes both the *Head of a Guardian King* and the *Striding Lion: Mount for the Buddhist Deity Monju.*

The museum exhibits a representative group of Japanese Buddhist paintings, but the strength of the collection lies in the number and quality of its folding paper screens, an art form that is a unique contribution of Japan. Paramount among the screens is the sublime pair *Pine and Plum by Moonlight* by Kaihō Yūshō of the Momoyama period. From this same period dates the famous Uji Bridge composition (colorplate, page 73), while other screens illustrate the art through the Edo period and conclude with the elegant *River Landscape with Fireflies* by Shiokawa Bunrin of the early Meiji period. Tawaraya Sōtatsu's *Illustration from "Tale of Ise,"* in full color, and Ike Taiga's hanging scroll in ink of the *Impressive View of the Go River* show the breadth and versatility of the great artists of the Rimpa and Nanga schools. In addition, a portfolio of more than five hundred color woodblock prints of the Edo period contains examples of all the famous masters of the *ukiyo-e* school. They are notable for their excellent condition, and a few are unique impressions (*Two Women of the Lower Class,* for instance).

Finally, there is an assortment of armor and blade weapons, a sampling of textiles, and several superlative pieces of lacquerware. Izuka Tōyō's *Tiered Writing Box* (colorplate, page 74), for example, is a masterpiece of the latter genre.

The long suit of the collection of South Asian art is sculpture, whether bronze or stone, and whether inspired by the Buddhist, Hindu, or Jain religion. The ensemble is introduced by a few pieces from the ancient kingdom of Gandhara, which occupied a territory corresponding to large areas of both modern-day states of Afghanistan and Pakistan. It was here, through contact with the conquering armies of Alexander the Great, that the aesthetic influence of classical art of the Greco-Roman world was most keenly felt. In a fine Gandharan sculpture such as the museum's *Scene from the Life of the Buddha,* the postures, costumes, and facial features of the images all betray the impact of Hellenistic prototypes on sculpture of the local school. There are excellent examples of Buddhist and Hindu sculpture from India, ranging from the second and third centuries through the classic Gupta period, best characterized by an heroic *Torso of a Buddha* (colorplate, page 76). Of comparably early date (c. A.D. 400) is a remarkable bronze depiction of the *Standing Buddha,* one of a very small group of Gupta-period images in metal that have survived into our own time. The collection is especially strong in South Indian Hindu bronzes, among them such celebrated and unique pieces as the *Karaikkalammaiyar, a Shaiva Saint* (colorplate, page 76) and the *Tree of Life.* The museum also owns a number of lavishly colored Indian miniature paintings of a multitude of subjects. Two examples from the eighteenth century, the *Dhanasri Ragini* and *Ramakali Ragini,* depict scenes from romantic Hindu literature.

Indian religious art spread throughout neighboring countries, and the way in which it was modified to conform to different national concepts is well illustrated by sculpture from Java, Thailand, and Cambodia. A *Standing Buddha,* for instance, made in Thailand sometime during the seventh or eighth century, displays evidence of influence by Indian art of the Gupta and post-Gupta periods; the physiognomy nonetheless conveys something of the individu-

ality of Mon culture. The development of sculpture in the Khmer Empire is demonstrated by several freestanding figures as well as reliefs dating from the tenth through the thirteenth centuries. Sculpture from Nepal and Tibet is represented by a fine group of gilt bronzes that came to the museum mostly through the bequest of Joseph H. Heil. With them came a fine group of *thankas* (hanging scrolls and banners) and other Lamaistic ritual material.

The arts of Islamic Persia and its dependent territories along the ancient Silk Route of Central Asia are displayed in a medley of ceramics, metalwork, miniatures, and textiles. The pottery ranges from the decorated wares of the ninth and tenth centuries found at Nishapur, to the brilliantly glazed ceramics of Kashan and Rayy. Although the group of miniatures is not large, it contains a number of pages from famous manuscripts such as *De Materia Medica* of 1224 and two pages from the famous so-called *"Demotte" Shah-namah (Book of Kings)*. Among the most sumptuous of these precious illuminations is *The Meeting of the Theologians* by 'Abd Allah Musawwir (colorplate, page 79), painted at Bukhara in modern Uzbekistan during the decade of the 1540s. The prized textile of the Persian collection, a stupendous "polonaise" carpet (colorplate, page 80), was made for the court of the great Safavid ruler Shah Abbas I (1580–1620).

Bronzes

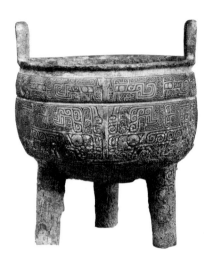

Ritual Cooking Vessel, type *ting*,
13th/12th century B.C.
Bronze
Height: 5⅜ inches (13.7 cm)
From An-yang
Shang Dynasty, Yin period
(c. 1300–1050 B.C.)
Purchase: Nelson Trust [33-1467]

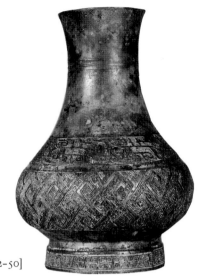

Ritual Wine Vessel, type *hu*,
12th century B.C.
Bronze
Height: 7¼ inches (18.4 cm)
Probably from An-yang
Shang Dynasty, Yin period
(c. 1300–1050 B.C.)
Gift of Mr. John S. Thacher in
memory of Charles B. Hoyt [52-50]

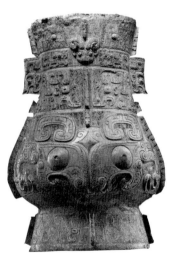

Ritual Wine Vessel, type *feng-hu*,
12th/11th century B.C.
Bronze
Height: 16 inches (40.6 cm)
From An-yang
Shang Dynasty, Yin period
(c. 1300–1050 B.C.)
Purchase: Nelson Trust [55-52]
[*See colorplate, p. 60*]

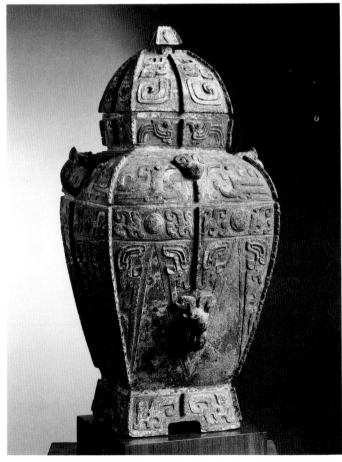

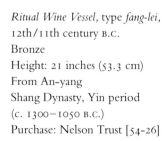

Ritual Wine Vessel, type *fang-lei*,
12th/11th century B.C.
Bronze
Height: 21 inches (53.3 cm)
From An-yang
Shang Dynasty, Yin period
(c. 1300–1050 B.C.)
Purchase: Nelson Trust [54-26]

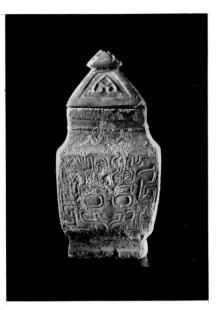

Ritual Wine Vessel, type *fang-i* or *fang-chih*,
12th/11th century B.C.
Marble with traces of pigment
Height: 5⅝ inches (14.3 cm)
From An-yang
Shang Dynasty, Yin period
(c. 1300−1050 B.C.)
Gift of Dr. M. Piacentini [47-78]

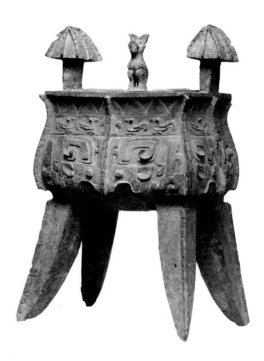

Ritual Wine Vessel, type *chia*,
12th/11th century B.C.
Bronze
Height: 13½ inches (34.3 cm)
From An-yang
Shang Dynasty, Yin period
(c. 1300−1050 B.C.)
Purchase: Nelson Trust [34-66]

Spatula Fragments, 12th/11th century B.C.
Bone
Length: 3¹⁵⁄₁₆ inches (10.0 cm);
7¼ inches (18.4 cm); 4 inches (10.2 cm)
From An-yang
Shang Dynasty, Yin period
(c. 1300−1050 B.C.)
Purchase: Nelson Trust [35-79/4;
35-115/1; 35-79/1]

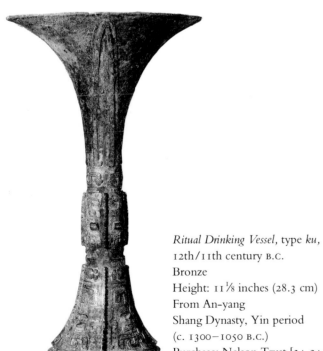

Ritual Drinking Vessel, type *ku*,
12th/11th century B.C.
Bronze
Height: 11⅛ inches (28.3 cm)
From An-yang
Shang Dynasty, Yin period
(c. 1300−1050 B.C.)
Purchase: Nelson Trust [34-244]

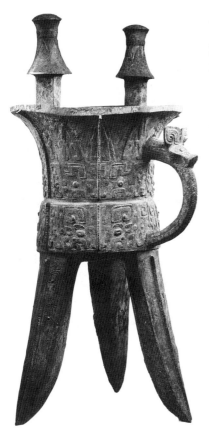

Ritual Wine Vessel, type *chia,*
12th/11th century B.C.
Bronze
Height: 20 inches (50.8 cm)
From An-yang
Shang Dynasty, Yin period
(c. 1300–1050 B.C.)
Purchase: Nelson Trust [58-9]

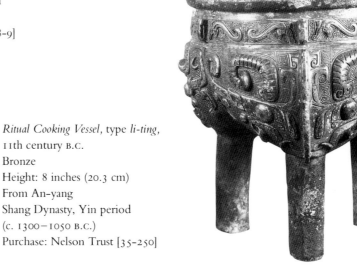

Ritual Cooking Vessel, type *li-ting,*
11th century B.C.
Bronze
Height: 8 inches (20.3 cm)
From An-yang
Shang Dynasty, Yin period
(c. 1300–1050 B.C.)
Purchase: Nelson Trust [35-250]

Ritual Wine Vessel, type *yu,* 11th century B.C.
Bronze
Height: 10¼ inches (26.0 cm)
Shang Dynasty, Yin period
(c. 1300–1050 B.C.)
Purchase: Nelson Trust [47-73]

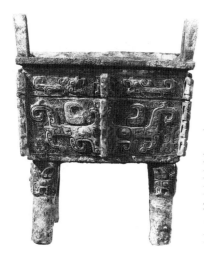

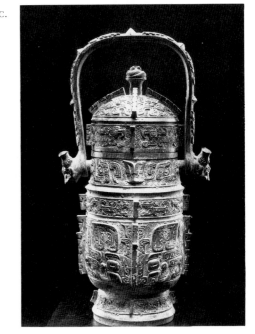

Ritual Cooking Vessel, type *fang-ting,*
11th century B.C.
Bronze
Height: 7⅜ inches (18.7 cm)
From An-yang
Shang Dynasty, Yin period
(c. 1300–1050 B.C.)
Purchase: Nelson Trust [35-73]

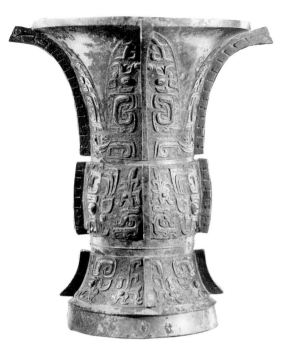

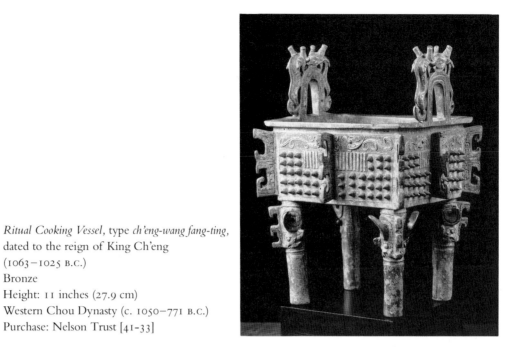

Ritual Cooking Vessel, type *ch'eng-wang fang-ting*,
dated to the reign of King Ch'eng
(1063–1025 B.C.)
Bronze
Height: 11 inches (27.9 cm)
Western Chou Dynasty (c. 1050–771 B.C.)
Purchase: Nelson Trust [41-33]

Ritual Wine Vessel, type *tsun*, 11th century B.C.
Bronze
Height: 12½ inches (31.8 cm)
Shang Dynasty, Yin period
(c. 1300–1050 B.C.)
Purchase: Nelson Trust [50-67]

Ritual Wine Vessel, type *fang-i*,
early 10th century B.C.
Bronze
Height: 11⅛ inches (28.3 cm)
Western Chou Dynasty (c. 1050–771 B.C.)
Purchase: Nelson Trust [51-28]

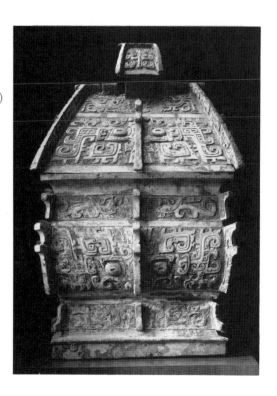

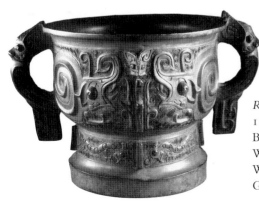

Ritual Food Vessel, type *kuei*,
11th/10th century B.C.
Bronze
Width: 9⅝ inches (24.5 cm)
Western Chou Dynasty (c. 1050–771 B.C.)
Gift of Mr. Milton McGreevy [F77-41/1]

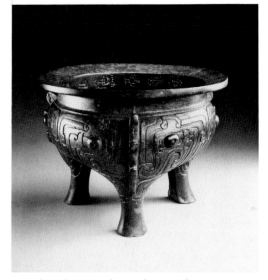

Ritual Cooking Vessel, type *li-ting*, 8th century B.C.
Bronze
Diameter: 7¼ inches (18.4 cm)
Eastern Chou Dynasty (771–256 B.C.)
Purchase: Nelson Trust [32-68/15]

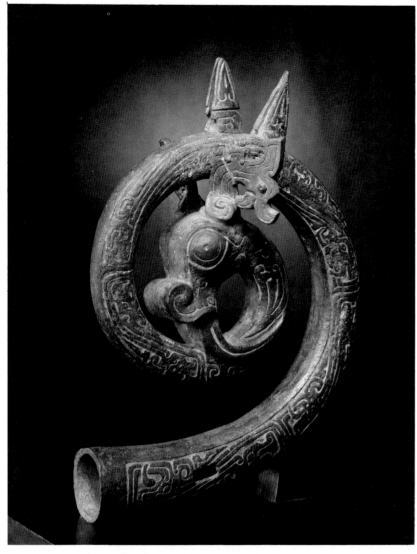

Zoomorphic Spiral, c. early 9th century B.C.
Bronze
Height: 13½ inches (34.3 cm)
Western Chou Dynasty (c. 1050–771 B.C.)
Purchase: Nelson Trust [32-44]

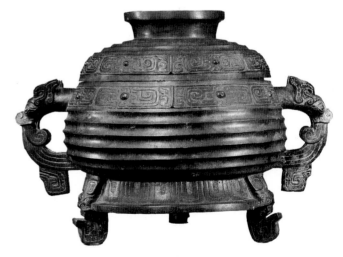

Ritual Food Vessel, type *kuei*, dated 825 B.C.
Bronze
Width: 15⅛ inches (38.5 cm)
Western Chou Dynasty (c. 1050–771 B.C.)
Purchase: Nelson Trust [32-68/4]

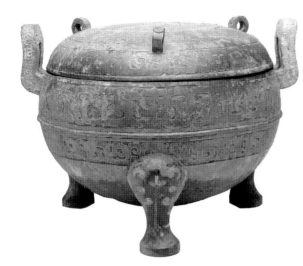

Ritual Cooking Vessel, type *ting*, late 6th century B.C.
Bronze
Width: 16 inches (40.6 cm)
Eastern Chou Dynasty, Spring and
Autumn period (722–481 B.C.)
Purchase: Nelson Trust [31-136/21]

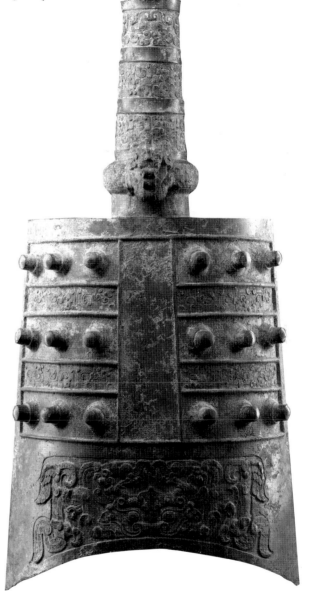

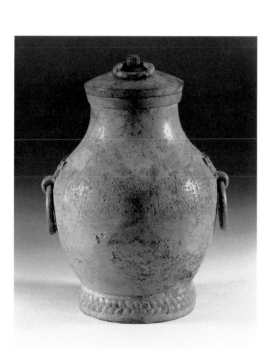

Ritual Wine Vessel, type *hu*, 4th/3rd century B.C.
Bronze
Height: 7⅜ inches (18.7 cm)
Eastern Chou Dynasty, Warring States period (480–221 B.C.)
Purchase: Nelson Trust [47-20]

Ritual Bell, type *chung*, 5th century B.C.
Bronze
Height: 22½ inches (57.2 cm)
Eastern Chou Dynasty, Spring and Autumn period (722–481 B.C.)
Purchase: Nelson Trust [41-34]

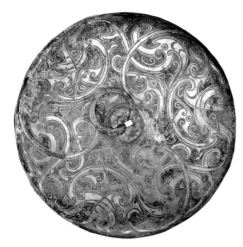

Lid with Ring Handle
Bronze with silver inlay
Diameter: 4⅞ inches (12.4 cm)
Eastern Chou Dynasty,
Warring States period (480–221 B.C.)
Purchase: Nelson Trust [44-4]

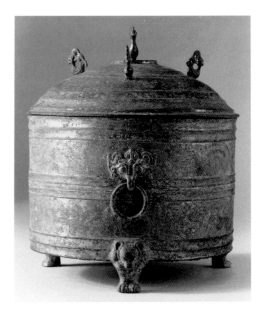

Ritual Vessel, type *lien*
Gilt bronze
Height: 8¾ inches (22.2 cm)
Western Han Dynasty (206 B.C.–A.D. 9)
Purchase: Nelson Trust [46-91]

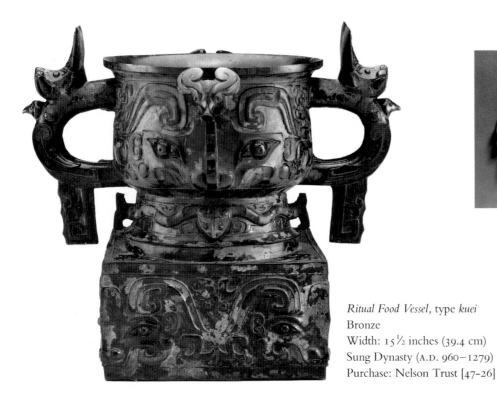

Dagger Ax, type *ko*, C. 1200 B.C.
Bronze; jade blade
Length: 12¼ inches (31.1 cm)
From An-yang
Shang Dynasty, Yin period
(C. 1300–1050 B.C.)
Purchase: Nelson Trust [35-78]

Ritual Food Vessel, type *kuei*
Bronze
Width: 15½ inches (39.4 cm)
Sung Dynasty (A.D. 960–1279)
Purchase: Nelson Trust [47-26]

Ax, type *qi,* 12th century B.C.
Bronze
Length: 9¼ inches (23.5 cm)
From An-yang
Shang Dynasty, Yin period
(c. 1300–1050 B.C.)
Purchase: Nelson Trust [35-77]

Tiger Mask, 10th/9th century B.C.
Bronze
Height: 6⅛ inches (15.6 cm)
From Hsun Hsien
Western Chou Dynasty (c. 1050–771 B.C.)
Purchase: Nelson Trust [50-32]

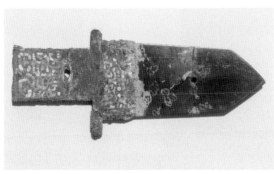

Dagger Ax, type *ko,* c. 1200 B.C.
Bronze with turquoise inlay; jade blade
Length: 6⅞ inches (17.5 cm)
From An-yang
Shang Dynasty, Yin period
(c. 1300–1050 B.C.)
Purchase: Nelson Trust [34-239]

Butt of a Hafted Weapon, 5th/3rd century B.C.
Bronze
Length: 6¼ inches (15.9 cm)
Eastern Chou Dynasty, Warring States period
(480–221 B.C.)
Purchase: Nelson Trust [46-28]

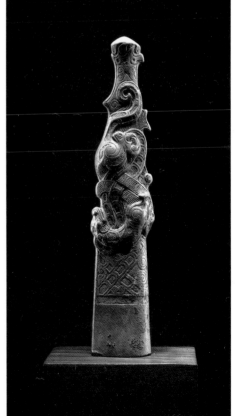

Pair of Tiger Plaques, 6th/5th century B.C.
Bronze
5½ x 3⅞ inches (14.0 x 9.8 cm);
5¾ x 4⅝ inches (14.6 x 11.7 cm)
Eastern Chou Dynasty (771–256 B.C.)
Purchase: Nelson Trust [35-61,62]

Kneeling Figure, 5th/4th century B.C.
Bronze
Height: 9½ inches (24.1 cm)
Eastern Chou Dynasty, Warring
States period (480–221 B.C.)
Purchase: Nelson Trust [32-185/4]

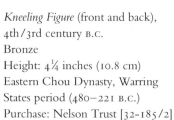

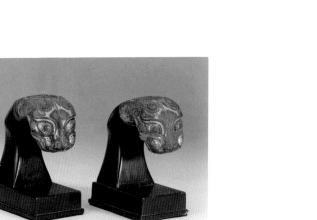

Pair of Finials in the Form of Tiger Heads,
5th/3rd century B.C.
Bronze with gold and silver inlays
Height: 2½ inches (6.4 cm), each
Eastern Chou Dynasty, Warring
States period (480–221 B.C.)
Purchase: Nelson Trust [32-66/1,2]

Kneeling Figure (front and back),
4th/3rd century B.C.
Bronze
Height: 4¼ inches (10.8 cm)
Eastern Chou Dynasty, Warring
States period (480–221 B.C.)
Purchase: Nelson Trust [32-185/2]

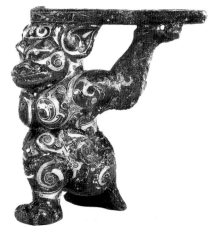

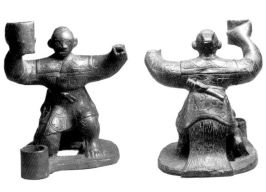

Table Leg in the Form of a Bear (one of a pair),
5th/3rd century B.C.
Bronze with gold and silver inlays
Height: 4¾ inches (12.1 cm)
Eastern Chou Dynasty, Warring
States period (480–221 B.C.)
Purchase: Nelson Trust [31-137/30]

Pair of Horses, c. 3rd century B.C.
Bronze
Length: 10½ inches (26.7 cm); 9¼ inches (23.5 cm)
Eastern Chou Dynasty, Warring States period (480–221 B.C.)
Purchase: Nelson Trust [32-185/7 a,b]

Corner Bracket in Animal Form, 2nd century B.C.
Gilt bronze
4¾ x 5¼ inches (12.1 x 13.3 cm)
Western Han Dynasty (206 B.C.–A.D. 9)
Purchase: Nelson Trust [33-556]

Incense Burner: Po-shan Lu, late 2nd century B.C.
Bronze
Height: 9½ inches (24.1 cm)
Western Han Dynasty (206 B.C.–A.D. 9)
Purchase: Nelson Trust [43-15]

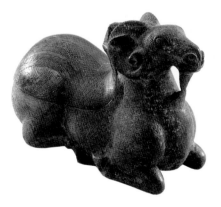

Lamp in the Form of a Ram, 2nd/1st century B.C.
Bronze
Length: 5⅝ inches (14.3 cm)
Western Han Dynasty (206 B.C.–A.D. 9)
Purchase: Nelson Trust [35-218]

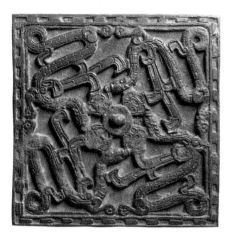

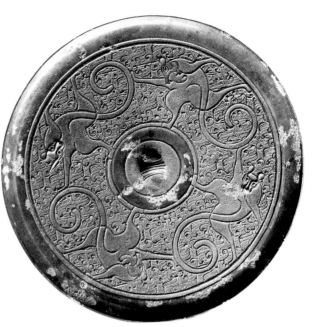

Mirror with Dragon Motif,
c. 5th century B.C.
Bronze
3⅝ x 3⅝ inches (9.3 x 9.3 cm)
Eastern Chou Dynasty (771–256 B.C.)
Purchase: Nelson Trust [35-76/2]

Mirror, late 5th/3rd century B.C.
Bronze
Diameter: 7¾ inches (19.7 cm)
Eastern Chou Dynasty, Warring
States period (480–221 B.C.)
Purchase: Nelson Trust [47-45]

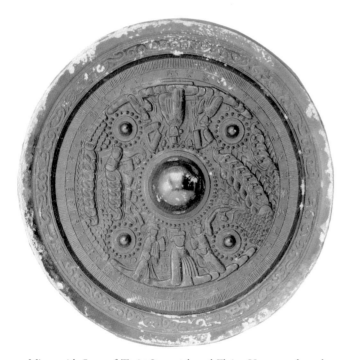

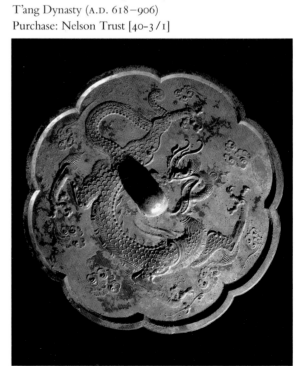

Mirror with Dragon Motif, 8th century
Bronze with silver inlay
Diameter: 12¼ inches (31.1 cm)
T'ang Dynasty (A.D. 618–906)
Purchase: Nelson Trust [40-3/1]

Mirror with Scene of Taoist Immortals and Flying Horses, early 3rd century
Bronze with malachite
Diameter: 9¼ inches (23.5 cm)
From Shao-hsing
Three Kingdoms period (A.D. 220–65)
Gift of the Friends of Art in memory of Mrs. George H. Bunting, Jr. [F86-2]

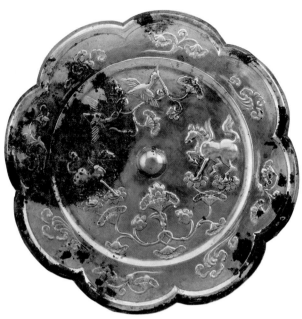

Mirror with Scene of Dancing Celestial Horses and Auspicious Birds,
dated to the reign of Hsüan-tsung (A.D. 729–56)
Silvered bronze
Diameter: 9⁵⁄₁₆ inches (23.7 cm)
T'ang Dynasty (A.D. 618–906)
Purchase: acquired through the generosity of
the Hall Family Foundations [F87-6]

Garment Hook, 5th/3rd century B.C.
Bronze with gold, silver, and
malachite inlays; partial gilding
Length: 5⅞ inches (15.0 cm)
Eastern Chou Dynasty, Warring
States period (480–221 B.C.)
Gift of Mr. C. T. Loo [49-26]

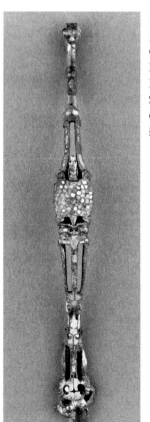

Garment Hook with Zodiacal Designs,
5th/3rd century B.C.
Gilt bronze with turquoise inlay
Length: 8⁵⁄₁₆ inches (21.1 cm)
Eastern Chou Dynasty, Warring
States period (480–221 B.C.)
Gift of Mr. and Mrs. Myron Falk, Jr.,
in honor of Laurence Sickman [77-9]

Garment Hook
Gilt bronze with gold and silver inlays
Length: 7⅛ inches (18.2 cm)
Han Dynasty (206 B.C.–A.D. 220)
Purchase: Nelson Trust [33-1471]

Garment Hook
Bronze with gold, silver, and turquoise inlays
Length: 4⅜ inches (11.2 cm)
Han Dynasty (206 B.C.–A.D. 220)
Purchase: Nelson Trust [34-153]

Ceramics

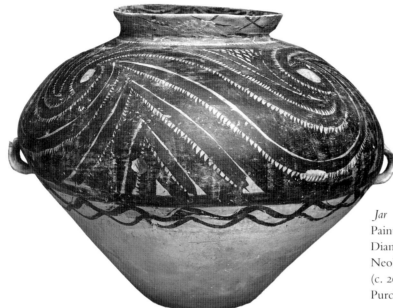

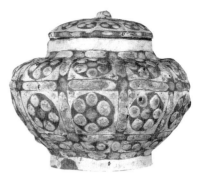

Covered Jar, 5th/3rd century B.C.
Glazed stoneware with relief decoration
Diameter: 8¾ inches (22.2 cm)
Eastern Chou Dynasty,
Warring States period (480–221 B.C.)
Purchase: Nelson Trust [34-254]

Jar
Painted earthenware
Diameter: 18½ inches (47.0 cm)
Neolithic, Yang-shao culture
(c. 2000–1500 B.C.)
Purchase: Nelson Trust [53-8]

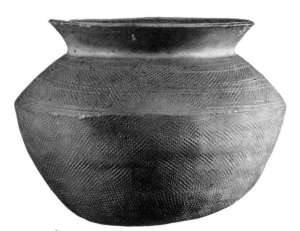

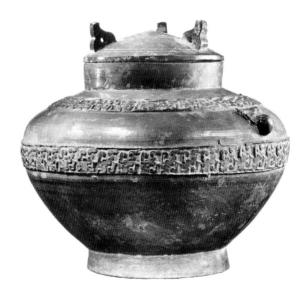

Jar
Proto-stoneware with cord markings
Diameter: 8⅜ inches (21.3 cm)
From An-yang
Shang Dynasty, Yin period
(c. 1300–1050 B.C.)
Purchase: Nelson Trust [34-253]

Covered Jar, 5th/3rd century B.C.
Glazed stoneware with relief decoration
Diameter: 8¾ inches (22.2 cm)
Eastern Chou Dynasty, Warring States period (480–221 B.C.)
Purchase: Nelson Trust [34-254]

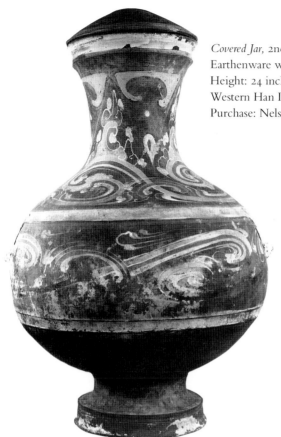

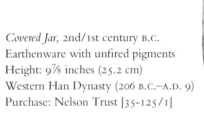

Covered Jar, 2nd century B.C.
Earthenware with unfired pigments
Height: 24 inches (61.0 cm)
Western Han Dynasty (206 B.C.–A.D. 9)
Purchase: Nelson Trust [32-49]

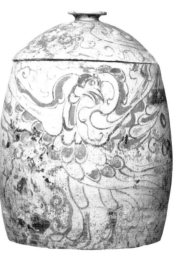

Covered Jar, 2nd/1st century B.C.
Earthenware with unfired pigments
Height: 9⅞ inches (25.2 cm)
Western Han Dynasty (206 B.C.–A.D. 9)
Purchase: Nelson Trust [35-125/1]

Tray, c. 2nd century
Earthenware with unfired pigments
Diameter: 15 inches (38.1 cm)
Eastern Han Dynasty (A.D. 25–220)
Purchase: Nelson Trust [34-218]

Pair of Jars, 1st century B.C./1st century A.D.
Glazed earthenware
Height: 15 inches (38.1 cm), each
Han Dynasty (206 B.C.–A.D. 220)
Purchase: Nelson Trust [31-136/1,2]

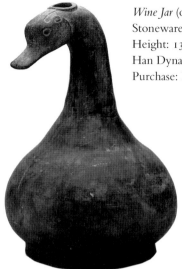

Wine Jar (one of a pair)
Stoneware with incised decoration
Height: 13¼ inches (33.7 cm)
Han Dynasty (206 B.C.–A.D. 220)
Purchase: Nelson Trust [31-136/5]

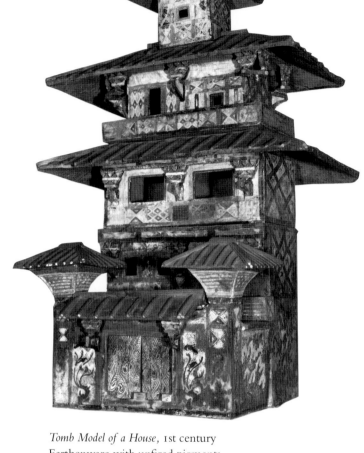

Tomb Model of a House, 1st century
Earthenware with unfired pigments
52 x 33½ x 27 inches (132.1 x 85.1 x 68.6 cm)
Eastern Han Dynasty (A.D. 25–220)
Purchase: Nelson Trust [33-521]

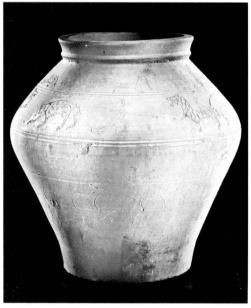

Jar
Stoneware with incised decoration
Height: 17 inches (43.2 cm)
Eastern Han Dynasty (A.D. 25–220)
Purchase: Nelson Trust [32-13]

Grain Yard, 2nd century
Earthenware with iridescent green glaze
2½ x 8¾ x 6 inches (6.3 x 22.3 x 15.2 cm)
Eastern Han Dynasty (A.D. 25–220)
Purchase: Nelson Trust [34-207]

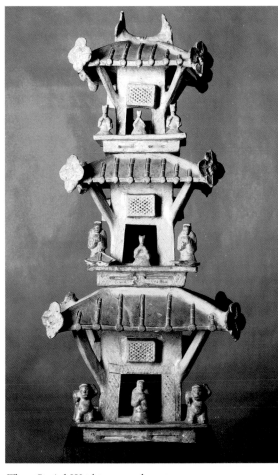

Three-Storied Watchtower, 2nd century
Earthenware with iridescent green glaze
34½ x 14 x 15 inches (87.6 x 35.6 x 38.1 cm)
Eastern Han Dynasty (A.D. 25–220)
Purchase: Nelson Trust [34-206]

Storehouse, 2nd century
Earthenware with iridescent green glaze
16 x 8¼ x 16¼ inches (40.6 x 21.0 x 41.3 cm)
Eastern Han Dynasty (A.D. 25–220)
Purchase: Nelson Trust [34-204]

Lampstand (one of a pair), 2nd century
Earthenware with iridescent green glaze
Height: 11½ inches (29.2 cm)
Eastern Han Dynasty (A.D. 25–220)
Purchase: Nelson Trust [34-213/1]

Gnome (Earth Spirit?), c. 3rd century
Earthenware with traces of slip and unfired pigments
Height: 7½ inches (19.1 cm)
Eastern Han Dynasty (A.D. 25–220)
Gift of Mr. Laurence Sickman [77-45]

Shaman, late 3rd/early 4th century
Earthenware with traces of unfired pigments
Height: 13 ¼ inches (33.7 cm)
Western Chin Dynasty (A.D. 265–317)
Purchase: Nelson Trust [33-555]

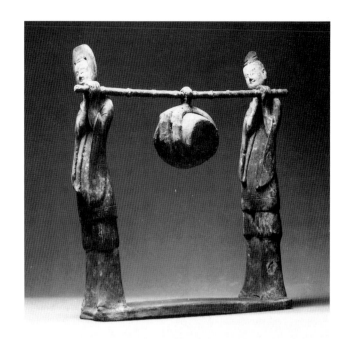

Two Men Bearing a Drum, early 6th century
Mold-pressed clay with traces of unfired pigments
Height: 12 inches (30.5 cm)
Northern Wei Dynasty (A.D. 386–534)
Purchase: Nelson Trust [32-186/7]

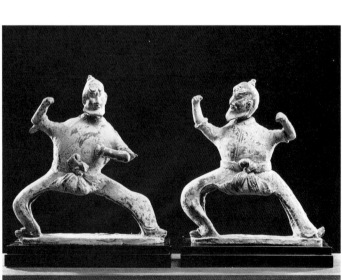

Pair of Acrobats, A.D. 500/550
Earthenware with traces of unfired pigments
Height: 11 ½ inches (29.3 cm), each
Northern Wei (A.D. 386–534) to Western Wei (A.D. 535–56) Dynasty
Purchase: Nelson Trust [34-45/1,2]

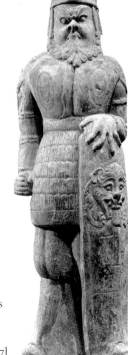

Warrior, c. A.D. 550
Earthenware with traces of unfired pigments
Height: 12 ¼ inches (31.1 cm)
Northern Ch'i Dynasty (A.D. 550–77)
Gift in memory of Lt. Harrell H. Rule [43-7]

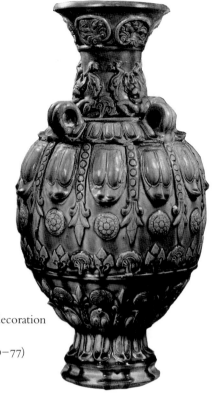

Vase
Glazed stoneware with molded decoration
Height: 20½ inches (52.1 cm)
Northern Ch'i Dynasty (A.D. 550–77)
Purchase: Nelson Trust [40-3/3]

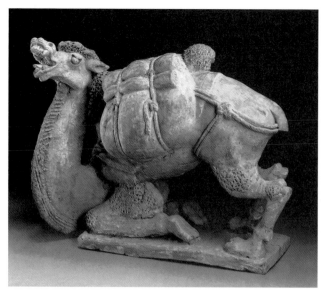

Loaded Camel, late 6th/early 7th century
Earthenware with unfired pigments
Height: 10½ inches (26.7 cm)
Sui (A.D. 581–618) to T'ang (A.D. 618–906) Dynasty
Purchase: Nelson Trust [31-136/10]

Four Ladies of the Court Playing Polo, A.D. 650/700
Earthenware with traces of unfired pigments
Height: 10 inches (25.4 cm), average of each figure
T'ang Dynasty (A.D. 618–906)
Purchase: acquired through the generosity of
Mrs. Katherine Harvey [48-31/1–4]

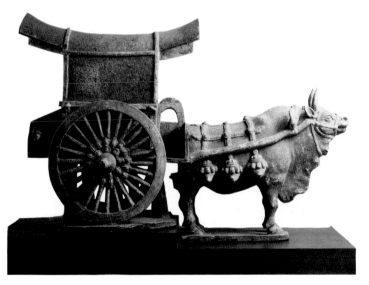

Bullock Cart, early 7th century
Earthenware with unfired pigments
Length: 31 inches (78.7 cm)
T'ang Dynasty (A.D. 618–906)
Gift of Mr. C. T. Loo [31-143]

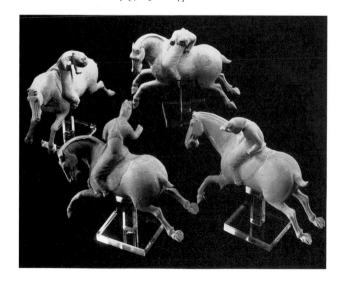

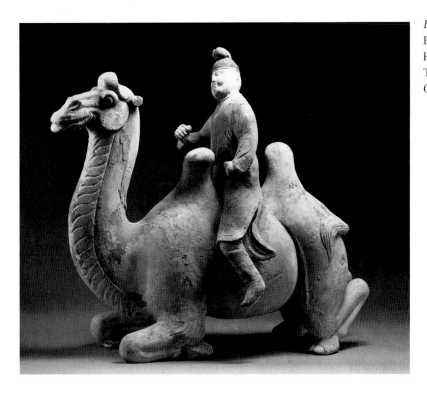

Bactrian Camel with Central Asian Rider, c. A.D. 700
Earthenware with unfired pigments
Height: 15½ inches (39.4 cm)
T'ang Dynasty (A.D. 618–906)
Gift in memory of Mrs. M. R. Sickman [54-65]

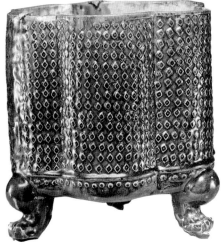

Tripod Jar, 8th century
Earthenware with three-color lead glaze
Height: 7⅞ inches (20.0 cm)
T'ang Dynasty (A.D. 618–906)
Purchase: Nelson Trust [39-39]

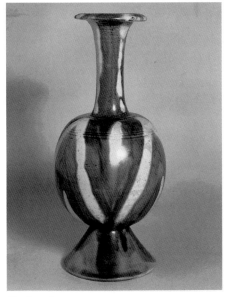

Bottle, 8th century
Earthenware with three-color lead glaze
Height: 8⅞ inches (22.6 cm)
T'ang Dynasty (A.D. 618–906)
Purchase: Nelson Trust [55-47]

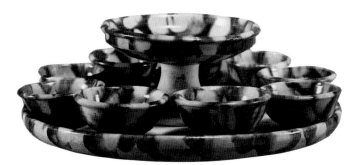

Tray with Footed Dish and Wine Cups, 8th century
Earthenware with three-color lead glaze
Diameter: 9½ inches (24.1 cm)
T'ang Dynasty (A.D. 618–906)
Purchase: Nelson Trust [72-1/1–11]

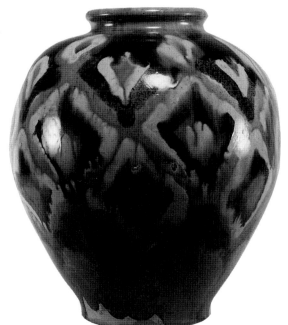

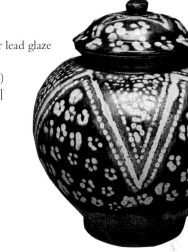

Covered Jar, 8th century
Earthenware with three-color lead glaze
Height: 9 inches (22.9 cm)
T'ang Dynasty (A.D. 618–906)
Purchase: Nelson Trust [39-6]

Jar, 8th century
Earthenware with three-color lead glaze
Height: 12 inches (30.5 cm)
T'ang Dynasty (A.D. 618–906)
Purchase: Nelson Trust [52-19]
[*See colorplate, p. 62*]

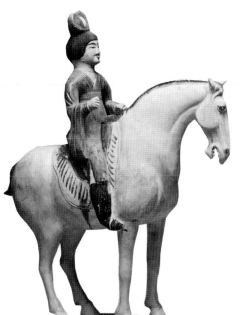

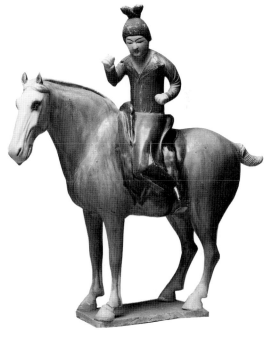

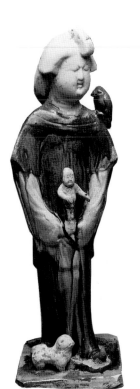

Lady Holding a Child, 8th century
Earthenware with three-color lead glaze
Height: 15¾ inches (40.0 cm)
T'ang Dynasty (A.D. 618–906)
Purchase: Nelson Trust [39-27]

Pair of Equestrian Figures, early 8th century
Earthenware with three-color lead glaze
Height: 15½ inches (39.4 cm), each
T'ang Dynasty (A.D. 618–906)
Purchase: Nelson Trust [49-22/1,2]

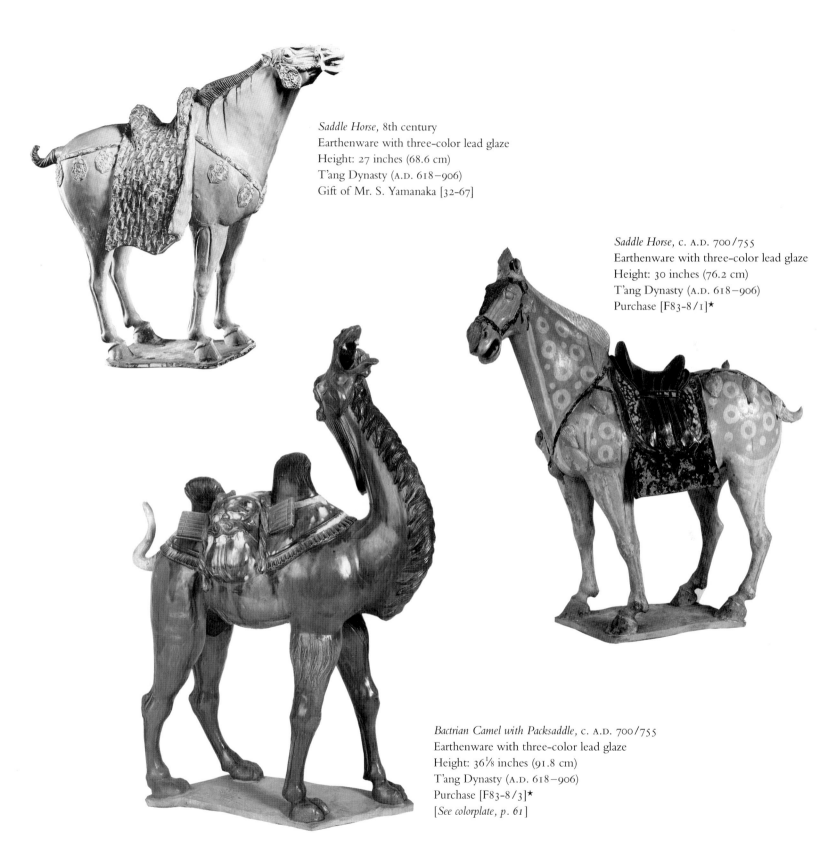

Saddle Horse, 8th century
Earthenware with three-color lead glaze
Height: 27 inches (68.6 cm)
T'ang Dynasty (A.D. 618–906)
Gift of Mr. S. Yamanaka [32-67]

Saddle Horse, c. A.D. 700/755
Earthenware with three-color lead glaze
Height: 30 inches (76.2 cm)
T'ang Dynasty (A.D. 618–906)
Purchase [F83-8/1]★

Bactrian Camel with Packsaddle, c. A.D. 700/755
Earthenware with three-color lead glaze
Height: 36⅛ inches (91.8 cm)
T'ang Dynasty (A.D. 618–906)
Purchase [F83-8/3]★
[*See colorplate, p. 61*]

Lokapala, the Guardian King, c. A.D. 700/755
Earthenware with three-color lead glaze
Height: 35½ inches (90.2 cm)
T'ang Dynasty (A.D. 618–906)
Purchase [F83-8/9]★

Court Official, c. A.D. 700/755
Earthenware with three-color lead glaze
Height: 35½ inches (90.2 cm)
T'ang Dynasty (A.D. 618–906)
Purchase [F83-8/7]★

Guardian of the North, c. A.D. 740/50
Earthenware with traces of unfired pigments
Height: 28 inches (71.1 cm)
T'ang Dynasty (A.D. 618–906)
Purchase: Nelson Trust [34-70]

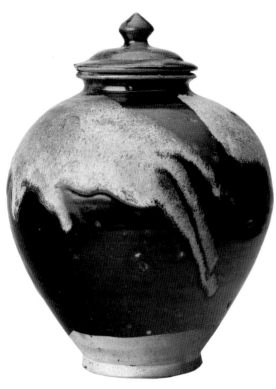

Jar, late 7th/early 8th century
Glazed porcelaneous ware (white ware)
Height: 5¹⁄₁₆ inches (12.8 cm)
T'ang Dynasty (A.D. 618–906)
Purchase: Nelson Trust [84-5]

Covered Jar, 8th century
Stoneware with suffused (black and gray-blue) glaze
Height: 11½ inches (29.2 cm)
T'ang Dynasty (A.D. 618–906)
Purchase: acquired through the generosity of Mrs. DeVere
Dierks in memory of Ruth Dierks Konstantinou [F80-34]

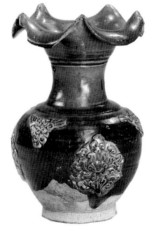

Vase
Glazed stoneware with appliqué decoration
Height: 5⅞ inches (14.9 cm)
Liao Dynasty (A.D. 907–1125)
Purchase: Nelson Trust [35-109]

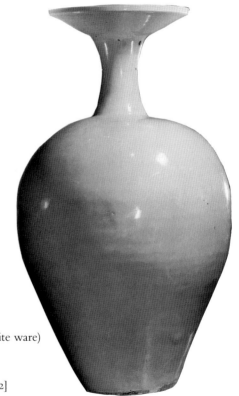

Amphora Jar
Glazed porcelaneous ware (white ware)
Height: 16¼ inches (41.3 cm)
Liao Dynasty (A.D. 907–1125)
Purchase: Nelson Trust [40-3/2]

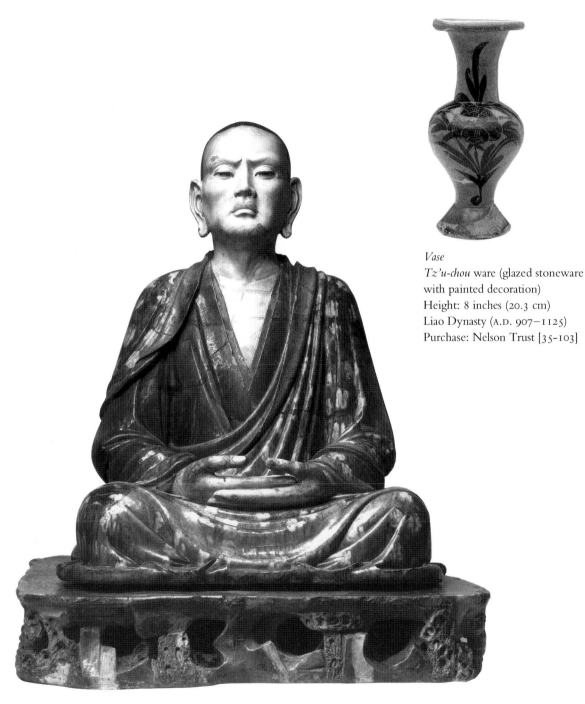

Vase
Tz'u-chou ware (glazed stoneware
with painted decoration)
Height: 8 inches (20.3 cm)
Liao Dynasty (A.D. 907–1125)
Purchase: Nelson Trust [35-103]

Luohan, 10th/12th century
Earthenware with three-color lead glaze
Height: 40 inches (101.6 cm)
Liao (A.D. 907–1125) to Chin (1115–1234) Dynasty
Purchase: Nelson Trust [34-6]

Vase
Tz'u-chou ware (glazed stoneware
with sgraffito decoration)
Height: 22⅜ inches (56.8 cm)
Northern Sung Dynasty
(A.D. 960–1127)
Purchase: Nelson Trust [35-116]

Peony Jar (one of a pair), early 12th century
Tz'u-chou ware (glazed stoneware with molded decoration)
Diameter: 6½ inches (16.6 cm)
Northern Sung Dynasty (A.D. 960–1127)
Bequest of Mr. Laurence Sickman [F88-39/20]

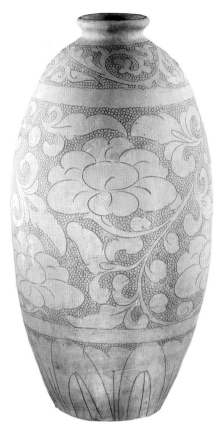

Vase, early 11th century
Tz'u-chou ware (stoneware with sgraffito decoration)
Height: 15¼ inches (38.7 cm)
Northern Sung Dynasty (A.D. 960–1127)
Purchase: Nelson Trust [70-3]

Jar, 12th century
Jian ware (stoneware with
brown-black glaze; slip decoration)
Height: 10½ inches (26.7 cm)
Northern Sung Dynasty (A.D. 960–1127)
Purchase: Nelson Trust [40-53]

Receptacle for Flower Petals
Ting ware (glazed porcelain; pierced design)
Height: 7⅛ inches (18.2 cm)
Northern Sung Dynasty (A.D. 960–1127)
Purchase: Nelson Trust [35-95]

Plate, 12th century
Ting ware (glazed porcelain with incised underglaze decoration)
Diameter: 10½ inches (26.7 cm)
Northern Sung Dynasty (A.D. 960–1127)
Purchase: Nelson Trust [33-7/11]

Covered Jar, late 11th/early 12th century
Ting ware (glazed porcelaneous ware)
Height: 5¼ inches (13.3 cm)
Northern Sung Dynasty (A.D. 960–1127)
Purchase: Nelson Trust [35-99]

Dish, 12th century (glaze cut and inscription engraved in 1777)
Chün ware (glazed stoneware)
Diameter: 6⅝ inches (16.8 cm)
Northern Sung Dynasty (A.D. 960–1127)
Gift of Dr. and Mrs. Maurice H. Cottle [73-22]

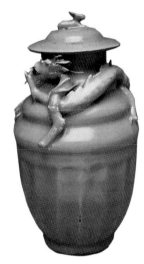

Covered Jar
Lung-ch'üan ware (glazed porcelaneous ware with molded decoration)
Height: 9⅝ inches (24.4 cm)
Southern Sung Dynasty (1127–1279)
Purchase: Nelson Trust [33-7/21]

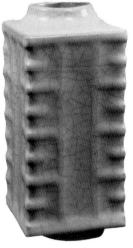

Vase to Hold Divining Rods
Kuan ware (glazed stoneware)
Height: 7¼ inches (18.4 cm)
Southern Sung Dynasty (1127–1279)
Purchase: Nelson Trust [32-158/2]

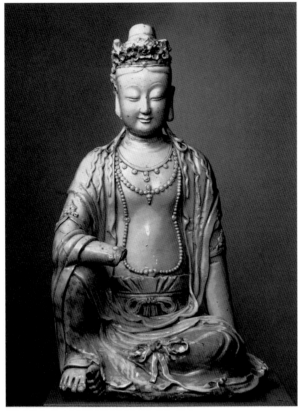

Kuan-yin Bodhisattva, dated 1298 or 1299
Ying-ch'ing ware (glazed porcelain)
Height: 20¼ inches (51.4 cm)
Yüan Dynasty (1279–1368)
Purchase: Nelson Trust [35-5]

Vase, 14th century
Porcelain with underglaze blue decoration
Height: 12 inches (30.5 cm)
Yüan Dynasty (1279–1368)
Purchase: Nelson Trust [33-7/9]

Pair of Vases, dated to the reign of Hsüan-te (1426–35)
Porcelain with underglaze blue decoration
Height: 21¾ inches (55.3 cm), each
Ming Dynasty (1368–1644)
Purchase: Nelson Trust [40-45/1,2]
[See colorplate, p. 66]

Stem Cup (interior and side), 14th century
Glazed porcelain with relief and incised decoration
Diameter: 5 inches (12.7 cm)
Yüan (1279–1368) to Ming (1368–1644) Dynasty
Purchase: Nelson Trust [35-533]

Plate (one of a pair), early 15th century
Porcelain with underglaze blue decoration
Diameter: 12¼ inches (31.1 cm)
Ming Dynasty (1368–1644)
Purchase: Nelson Trust [64-4/1]

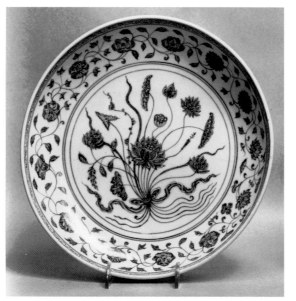

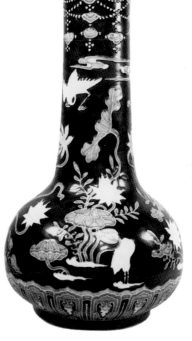

Vase, early 16th century
Fa-hua ware (stoneware with enamel
cloisonné-style decoration)
Height: 17⅝ inches (44.8 cm)
Ming Dynasty (1368–1644)
Purchase: Nelson Trust [33-353]

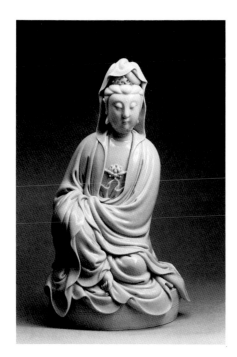

Kuan-yin Bodhisattva, late 16th/early 17th century
Te-hua ware (glazed porcelain)
Height: 11¼ inches (28.6 cm)
By Ho Ch'ao-tsung
Ming Dynasty (1368–1644)
Purchase: Nelson Trust [33-588]

Brush Holder, 17th century
Steatite (soapstone)
Height: 6⅜ inches (16.2 cm)
Ming Dynasty (1368–1644)
Purchase: acquired through the Nellie Hussey Fund
and the generosity of Mr. and Mrs. Milton
McGreevy through the Westport Fund [F65-17]

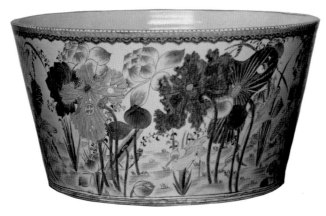

Fish Bowl, dated to the reign of K'ang-hsi (1662–1722)
Porcelain with five-color enamel decoration (*famille verte*)
Diameter: 21⅝ inches (54.9 cm)
Ch'ing Dynasty (1644–1911)
Purchase: Nelson Trust [55-106]

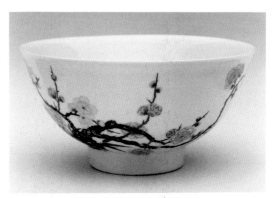

Footed Bowl, dated to the reign of Yung-cheng (1723–35)
Porcelain with overglaze enamel decoration (*famille rose*)
Diameter: 5⅞ inches (15.0 cm)
Ch'ing Dynasty (1644–1911)
Purchase: Nelson Trust [33-11/14]

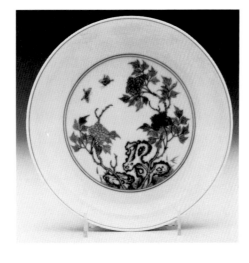

Dish, dated to the reign of Yung-cheng (1723–35)
Porcelain with underglaze blue and overglaze enamel decoration
Diameter: 8³⁄₁₆ inches (20.8 cm)
Ch'ing Dynasty (1644–1911)
Purchase: Nelson Trust [46-19]

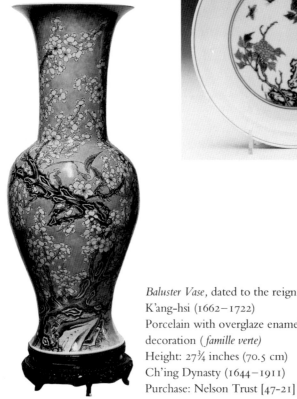

Baluster Vase, dated to the reign of
K'ang-hsi (1662–1722)
Porcelain with overglaze enamel
decoration (*famille verte*)
Height: 27¾ inches (70.5 cm)
Ch'ing Dynasty (1644–1911)
Purchase: Nelson Trust [47-21]

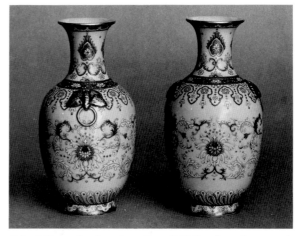

Pair of Vases, dated to the reign of Ch'ien-lung (1736–95)
Porcelain with overglaze enamel and gold decoration (*famille rose*)
Height: 7¾ inches (19.7 cm), each
Ch'ing Dynasty (1644–1911)
Purchase: Nelson Trust [45-21/1,2]

Pair of Rabbits, dated to the reign of Ch'ien-lung (1736–95)
Biscuit porcelain with glazes and enamel decoration
Length: 9 inches (22.9 cm), each
Ch'ing Dynasty (1644–1911)
Gift of Mrs. David T. Beals, Sr. [F75-55/1,2]

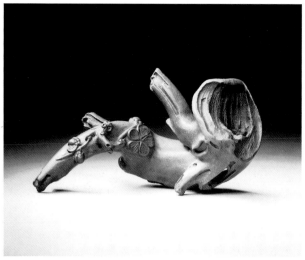

Brush Rest in the Form of a Plum Branch, early 17th century
I-hsing ware (stoneware with molded decoration)
Length: 4¼ inches (10.8 cm)
By Ch'en Ming-yüan, active 1573–1620
Ming Dynasty (1368–1644)
Purchase: Nelson Trust [58-16]

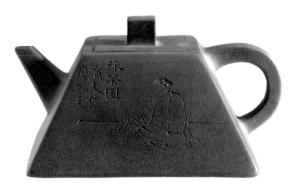

Teapot in the Form of a Rice Measure, late 18th century
I-hsing ware (stoneware with incised decoration and inscriptions)
2⅝ x 5 inches (6.7 x 14.0 cm)
By Huang Yü-lin
Ch'ing Dynasty (1644–1911)
Purchase: Nelson Trust [58-15]

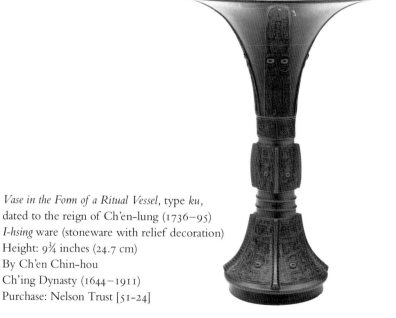

Vase in the Form of a Ritual Vessel, type *ku,*
dated to the reign of Ch'en-lung (1736–95)
I-hsing ware (stoneware with relief decoration)
Height: 9¾ inches (24.7 cm)
By Ch'en Chin-hou
Ch'ing Dynasty (1644–1911)
Purchase: Nelson Trust [51-24]

Sculpture

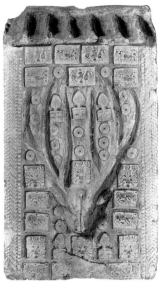

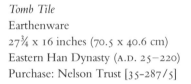

Tomb Tile
Earthenware
27¾ x 16 inches (70.5 x 40.6 cm)
Eastern Han Dynasty (A.D. 25–220)
Purchase: Nelson Trust [35-287/5]

Casing Slab of Tomb or Offering Chamber
Limestone
40 x 24 inches (101.6 x 61.0 cm)
From Tung-hsien
Eastern Han Dynasty (A.D. 25–220)
Purchase: Nelson Trust [34-73]

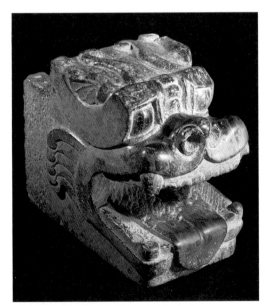

Chimera Head (one of a pair), 3rd century
Limestone
Height: 16¼ inches (41.3 cm)
Probably from Yeh, Lin-chang county, Honan Province
Three Kingdoms period (A.D. 220–65)
Purchase: Nelson Trust [34-95/1]

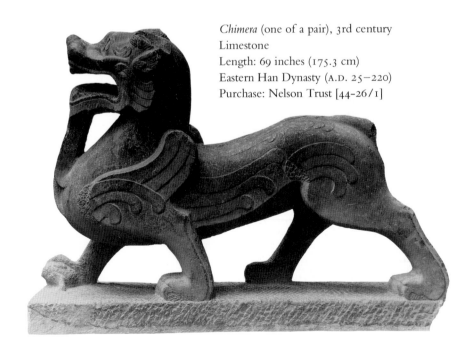

Chimera (one of a pair), 3rd century
Limestone
Length: 69 inches (175.3 cm)
Eastern Han Dynasty (A.D. 25–220)
Purchase: Nelson Trust [44-26/1]

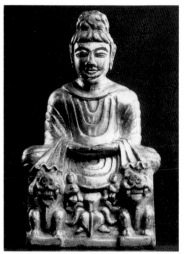

Shakyamuni Buddha Seated on the Lion Throne, early 5th century
Gilt bronze
Height: 4½ inches (11.4 cm)
Kingdom of Hsia (A.D. 407–31) or
Northern Wei Dynasty (A.D. 386–534)
Purchase: Nelson Trust [51-25]

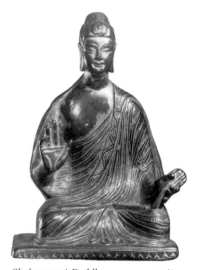

Shakyamuni Buddha, c. A.D. 475/80
Gilt bronze
Height: 6¼ inches (15.9 cm)
Northern Wei Dynasty (A.D. 386–534)
Purchase: Nelson Trust [31-137/29]

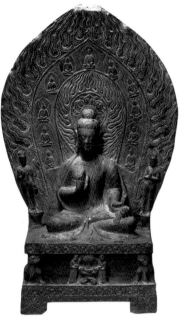

Shakyamuni Buddha, dated A.D. 494
Stone with traces of paint
Height: 21¼ inches (54.0 cm)
Northern Wei Dynasty (A.D. 386–534)
Purchase: Nelson Trust [59-47]

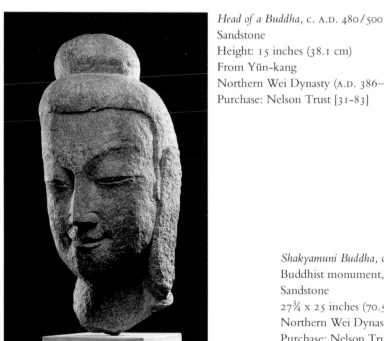

Head of a Buddha, c. A.D. 480/500
Sandstone
Height: 15 inches (38.1 cm)
From Yün-kang
Northern Wei Dynasty (A.D. 386–534)
Purchase: Nelson Trust [31-83]

Shakyamuni Buddha, casing slab from a
Buddhist monument, early 6th century
Sandstone
27¾ x 25 inches (70.5 x 63.5 cm)
Northern Wei Dynasty (A.D. 386–534)
Purchase: Nelson Trust [51-27]

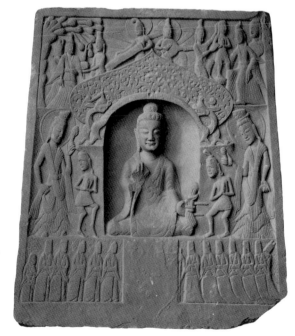

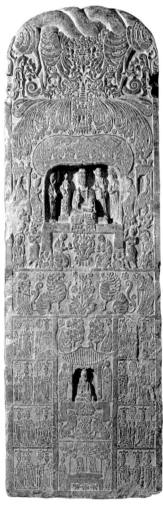

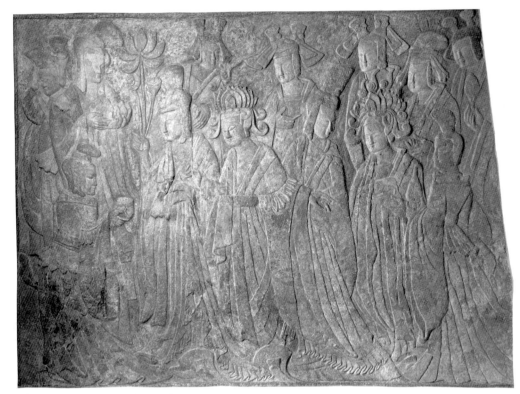

The Empress as Donor with Attendants,
c. A.D. 505/23
Limestone with traces of color
76 x 109 inches (193.0 x 276.9 cm)
From Lung-men, Pin-yang cave
Northern Wei Dynasty (A.D. 386–534)
Purchase: Nelson Trust [40-38]

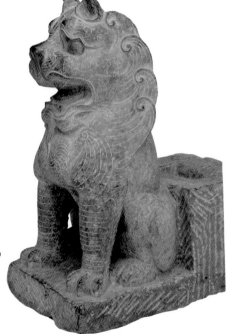

Buddhist Stele with Scenes from the
Lotus Sutra, c. A.D. 537
Limestone
98 x 31¼ inches (248.9 x 79.4 cm)
From Jui-ch'eng Hsien
Western Wei Dynasty (A.D. 535–56)
Purchase: Nelson Trust [37-27]

Guardian Lion (one of a pair), c. A.D. 510/40
Gray stone
Height: 20½ inches (52.1 cm)
Northern Wei (A.D. 386–534) to
Western Wei (A.D. 535–56) Dynasty
Purchase: Nelson Trust [40-31/1]

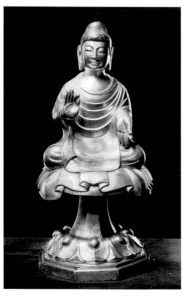

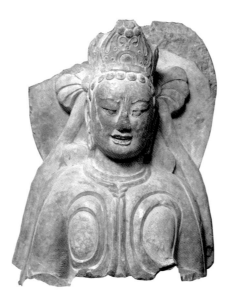

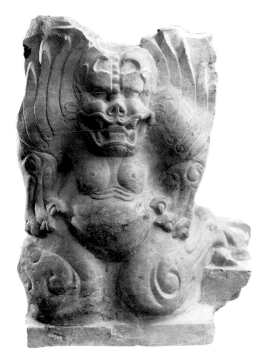

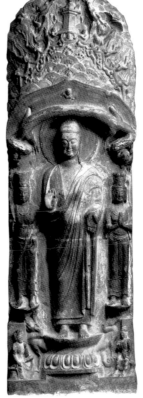

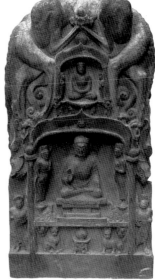

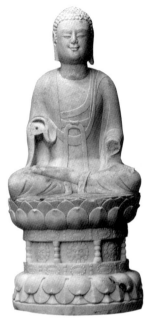

Buddha Seated on the Lotus Throne
Marble
Height: 25 inches (63.5 cm)
Northern Ch'i Dynasty (A.D. 550–77)
Purchase: Nelson Trust [59-15]

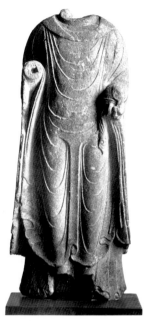

Torso of a Buddha, c. A.D. 570/90
Conglomerate stone
Height: 28 inches (71.1 cm)
Northern Chou (A.D. 557–81) to Sui
(A.D. 581–618) Dynasty
Purchase: Nelson Trust [33-91]

Kuan-yin Shrine, A.D. 599
Gilt bronze
Height: 8½ inches (21.6 cm)
Sui Dynasty (A.D. 581–618)
Gift of Mr. Laurence Sickman in
memory of Mrs. Paul Mallon [79-41]

Kuan-yin Bodhisattva
Sandstone with traces of gilding
Height: 52 inches (132.1 cm)
Sui Dynasty (A.D. 581–618)
Purchase: Nelson Trust [35-308]

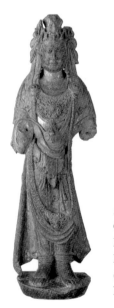

Kuan-yin Bodhisattva, c. A.D. 580/600
Conglomerate stone with traces of color
Height: 20¼ inches (51.4 cm)
Northern Chou (A.D. 557–81) to Sui
(A.D. 581–618) Dynasty
Purchase: Nelson Trust [59-39]

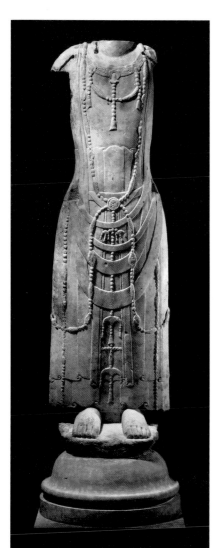

Bodhisattva Torso
Marble
Height: 62 inches (157.5 cm)
Sui Dynasty (A.D. 581–618)
Purchase: Nelson Trust [40-46]

Pair of Bodhisattvas
Gilt bronze
Height: 4¼ inches (10.8 cm);
4 inches (10.2 cm)
Sui Dynasty (A.D. 581–618)
Gift of Mr. Laurence Sickman
[F87-8/2,3]

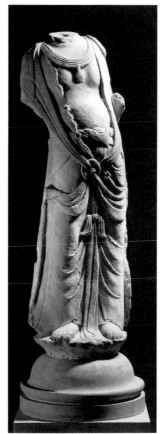

Pair of Bodhisattva Torsos, early 7th century
Marble
Height: 43 inches (109.2 cm);
42½ inches (108.0 cm)
Sui Dynasty (A.D. 581–618)
Purchase: Nelson Trust [40-32,33]

Kuan-yin Bodhisattva
Bronze with turquoise inlay
Height: 12 inches (30.5 cm)
Sui Dynasty (A.D. 581–618)
Purchase: Nelson Trust [32-186/9]

Front of a Buddhist Shrine, 7th century
Limestone
Height: 27¼ inches (69.2 cm)
Sui (A.D. 581–618) to T'ang
(A.D. 618–906) Dynasty
Purchase: Nelson Trust [37-17]

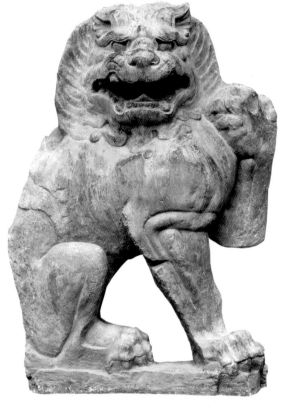

Guardian Lion, c. A.D. 681
Limestone
Height: 55½ inches (141.0 cm)
From Lung-men
T'ang Dynasty (A.D. 618–906)
Purchase: Nelson Trust [33-670]

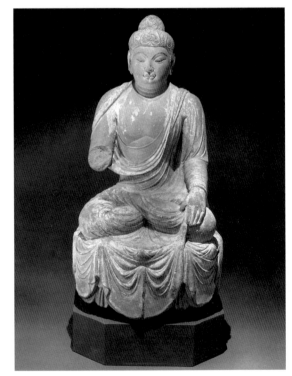

Seated Buddha, 8th century
Sandstone with traces of pigment
Height: 26 inches (66.0 cm)
T'ang Dynasty (A.D. 618–906)
Purchase: acquired through the generosity of
the Hall Family Foundations [F85-11]

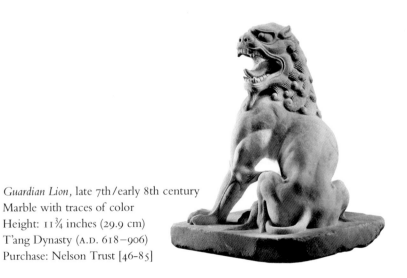

Guardian Lion, late 7th/early 8th century
Marble with traces of color
Height: 11¾ inches (29.9 cm)
T'ang Dynasty (A.D. 618–906)
Purchase: Nelson Trust [46-85]

Seated Maitreya, early 8th century
Sandstone with traces of paint
Height: 20 inches (50.8 cm)
From T'ien-lung Shan
T'ang Dynasty (A.D. 618–906)
Purchase: Nelson Trust [32-65/2]

Seated Potalaka Avalokitesvara, 8th century
Bronze
Height: 6⅛ inches (15.6 cm)
T'ang Dynasty (A.D. 618–906)
Bequest of Mr. Laurence Sickman [F88-37/52]

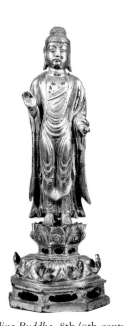

Standing Buddha, 8th/9th century
Gilt bronze
Height: 9¾ inches (24.7 cm)
Korean
Great Silla Dynasty (A.D. 668–918)
Purchase: Nelson Trust [49-18]

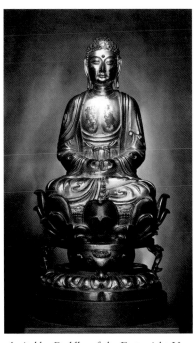

Amitabha Buddha of the Forty-eight Vows,
early 11th century
Gilt bronze
Height: 10¼ inches (26.0 cm)
Liao Dynasty (A.D. 907–1125)
Purchase: Nelson Trust [46-84]

*Traveling Shrine with Depiction of an
Eight-Bodhisattva Mandala*, 9th century
Sandalwood with traces of paint
12¼ x 14 inches (31.1 x 35.6 cm)
T'ang Dynasty (A.D. 618–906)
Purchase: Nelson Trust [44-18]

Manjusri of the Five Chignons,
10th century
Gilt bronze
Height: 6¾ inches (17.2 cm)
Liao Dynasty (A.D. 907–1125)
Bequest of Mr. Laurence Sickman
[F88-37/75]

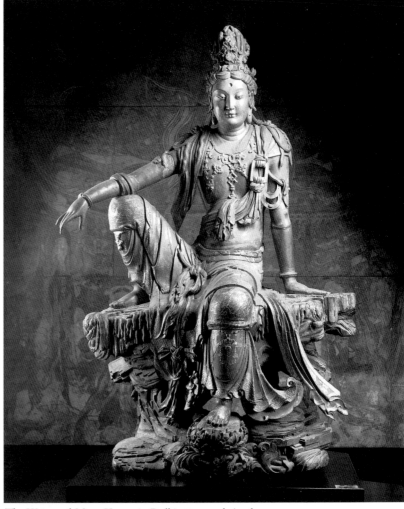

The Water and Moon Kuan-yin Bodhisattva, 11th/12th century
Wood with paint
Height: 95 inches (241.3 cm)
Northern Sung (A.D. 960–1127) or Liao (A.D. 907–1125) Dynasty
Purchase: Nelson Trust [34-10]
[*See colorplate, p. 64*]

Head of a Luohan, 11th/12th century
Dry-lacquer with gesso and paint
Height: 12 inches (30.5 cm)
Liao (A.D. 907–1125) or Northern
Sung (A.D. 960–1127) Dynasty
Purchase: Nelson Trust [31-84]

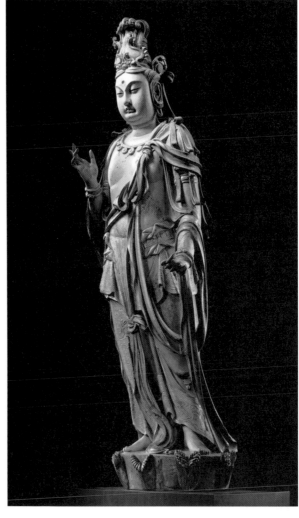

Standing Bodhisattva, c. 1200
Wood with paint
Height: 75 inches (190.5 cm)
Chin Dynasty (1115–1234)
Purchase: Nelson Trust [51-42]

Kuan-yin Bodhisattva, late 13th century
Wood with traces of paint
Height: 69 inches (175.3 cm)
Yüan Dynasty (1279–1368)
Purchase: Nelson Trust [59-70]

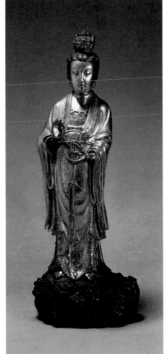

Female Taoist Divinity, late 13th/early 14th century
Gilt bronze with traces of paint
Height: 10⅜ inches (26.4 cm)
Yüan Dynasty (1279–1368)
Gift of Frederick W. and Grace R. Kaler [F82-29/2]

Paintings

Episode from Stories of Filial Piety
(detail of left side of a sarcophagus), C. A.D. 525
Engraved limestone
24½ x 88 inches (62.2 x 223.5 cm)
Northern Wei Dynasty (A.D. 386–534)
Purchase: Nelson Trust [33-1543/2]

Copy after Chou Fang, active A.D. 766–after 796
Palace Ladies Tuning the Lute, 12th-century copy of a T'ang Dynasty original
Handscroll; ink and color on silk
11 x 29⅝ inches (28.0 x 75.3 cm)
Sung Dynasty (A.D. 960–1279)
Purchase: Nelson Trust [32-159/1]

Attributed to Ch'en Hung, active c. A.D. 725–after 756
The Eight Noble Officials (section)
Handscroll; ink, color, and silver and gold pigment on silk
9⅞ x 32⅜ inches (25.2 x 82.3 cm), overall
T'ang Dynasty (A.D. 618–906)
Purchase: Nelson Trust [49-40]

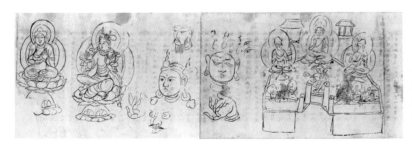

Sketches on the Back of a Sutra Fragment (section), late 9th/early 10th century
Handscroll; ink on paper
8¾ x 55½ inches (22.2 x 141.0 cm), overall
T'ang Dynasty (A.D. 618–906) to Five Dynasties (A.D. 907–60)
Purchase: Nelson Trust [51-78]

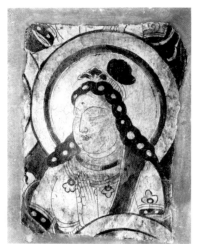

Fragment of a Buddhist Wall Painting, 8th/9th century
Ink and color on clay
17½ x 13¾ inches (44.4 x 35.0 cm)
Bazaklik, Turfan, Sinkiang Province
T'ang Dynasty (A.D. 618–906)
Purchase: Nelson Trust [43-17]

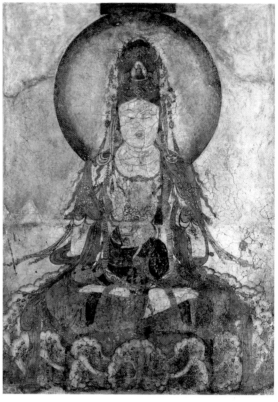

*Ju-i-lun Kuan-yin (Cintamani-chakra) Bodhisattva
Seated on a Lotus,* dated to the reign
of Kuang-shun (A.D. 951–53)
Ink and color on clay
84 x 61½ inches (213.4 x 156.2 cm)
Tz'u-sheng Ssu, Wen Hsien, Honan Province
Five Dynasties (A.D. 907–60)
Purchase: Nelson Trust [52-6]

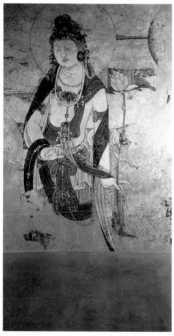

Kuan-yin Bodhisattva, dated to the
2nd year of the reign of T'ien-fu
(A.D. 937)
Ink and color on clay
69 x 35⅛ inches (175.3 x 89.2 cm)
Tz'u-sheng Ssu, Wen Hsien,
Honan Province
Five Dynasties (A.D. 907–60)
Gift of Mr. C. T. Loo [50-64 b]

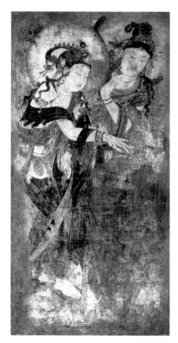

Two Puja Bodhisattvas Burning Incense,
dated to the reign of Kuang-shun
(A.D. 951–53)
Ink and color on clay
68⅝ x 35 inches (174.3 x 88.9 cm)
Tz'u-sheng Ssu, Wen Hsien,
Honan Province
Five Dynasties (A.D. 907–60)
Gift of Mr. C. T. Loo [50-64 a]

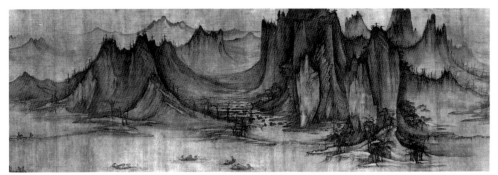

Hsü Tao-ning, c. A.D. 970–1051/52
Fishermen's Evening Song (section), c. 1049
Handscroll; ink and slight color on silk
19 x 82½ inches (48.3 x 209.6 cm), overall
Northern Sung Dynasty (A.D. 960–1127)
Purchase: Nelson Trust [33-1559]

Ching Hao, c. A.D. 870/80–c. 935/40
Travelers in Snow-Covered Mountains
Hanging scroll (laid down on panel);
ink, white pigment, and slight color on silk
53½ x 29½ inches (135.9 x 75.0 cm)
Five Dynasties (A.D. 907–60)
Purchase: Nelson Trust [40-15]

Attributed to Li Ch'eng, A.D. 919–967
A Solitary Temple amid Clearing Peaks
Hanging scroll; ink and slight color on silk
44 x 22 inches (111.8 x 55.9 cm)
Northern Sung Dynasty (A.D. 960–1127)
Purchase: Nelson Trust [47-71]
[*See colorplate, p. 63*]

Attributed to Ch'iao Chung-ch'ang,
active late 11th/early 12th century
*Illustration to the Second Prose Poem on
the Red Cliff* (section), after 1082
Handscroll; ink on paper
11⅝ x 220⅝ inches
(29.5 x 560.4 cm), overall
Northern Sung Dynasty (A.D. 960–1127)
Purchase [F80-5]

Chiang Shen, c. 1090–1138
Verdant Mountains (section)
Handscroll; ink and slight color on silk
12¹⁄₁₆ x 116½ inches
(30.6 x 296.0 cm), overall
Sung Dynasty (A.D. 960–1279)
Purchase: Nelson Trust [53-49]

Fighting Birds on a Branch of Camellia, 12th century
Album leaf; ink and color on silk
9¼ x 10½ inches (23.5 x 26.7 cm)
Southern Sung Dynasty (1127–1279)
Purchase: Nelson Trust [49-13]

Wang Li-yung, active 1120–after 1145
The Transformations of Lao-chün (section)
Handscroll; ink and color on silk
17⅝ x 152½ inches
(44.8 x 387.4 cm), overall
Southern Sung Dynasty (1127–1279)
Purchase: Nelson Trust [48-17]

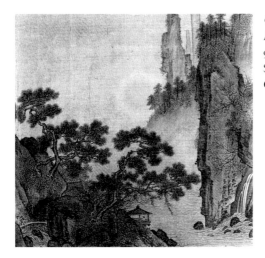

Gazing at a Waterfall, late 12th century
Album leaf; ink and color on silk
9⅜ x 9⅞ inches (23.8 x 25.2 cm)
Southern Sung Dynasty (1127–1279)
Gift of Mr. Robert H. Ellsworth [R70-2]

*Chao Yü's Pacification of the Barbarians
South of Lü* (2 sections), 1150/1200
Handscroll; ink and color on silk
15½ x 156 inches (39.3 x 396.2 cm), overall
Chin Dynasty (1115–1234)
Purchase: Nelson Trust [58-10]

Winter Mountains, late 11th/12th century
Hanging scroll; ink on silk
56⅞ x 36⅜ inches (144.5 x 92.5 cm)
Chin Dynasty (1115–1234)
Gift of Mr. John M. Crawford, Jr.,
in honor of Laurence Sickman [79-9]

Li Sung, active 1190–1230
The Red Cliff (Second Excursion)
Album leaf mounted as hanging scroll;
ink and slight color on silk
9¾ x 10¼ inches (24.8 x 26.0 cm)
Southern Sung Dynasty (1127–1279)
Purchase: Nelson Trust [49-79]

Li Sung, active 1190–1230
T'ang Emperor Ming-huang Watching a Cockfight
Album leaf; ink and slight color on silk
9¼ x 8¼ inches (23.5 x 21.0 cm)
Southern Sung Dynasty (1127–1279)
Purchase: Nelson Trust [59-17]

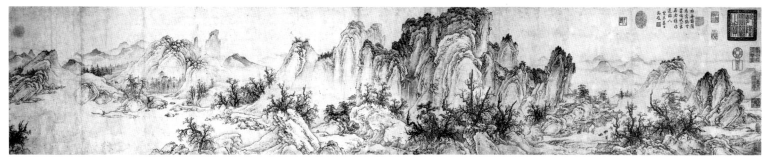

T'ai-ku i-min (unidentified artist)
Traveling among Streams and Mountains (section), 1200/1250
Handscroll; ink on paper
15⅛ x 164⁹⁄₁₆ inches (38.4 x 418.0 cm), overall
Chin Dynasty (1115–1234)
Purchase: the Kenneth A. and Helen F. Spencer Foundation Acquisition Fund [F74-35]

Hsia Kuei, active c. 1220–c. 1250
Twelve Views of Landscape (section)
Handscroll; ink on silk
11 x 90¾ inches (28.0 x 230.5 cm), overall
Southern Sung Dynasty (1127–1279)
Purchase: Nelson Trust [32-159/2]

Attributed to Ma Yüan, active before
1190–after 1225
Composing Poetry on a Spring Outing (2 sections)
Handscroll; ink and color on silk
11⅝ x 119 inches (29.5 x 302.3 cm), overall
Southern Sung Dynasty (1127–1279)
Purchase: Nelson Trust [63-19]

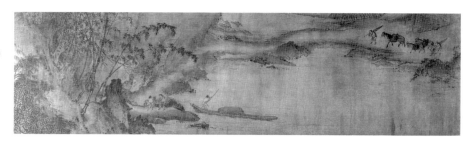

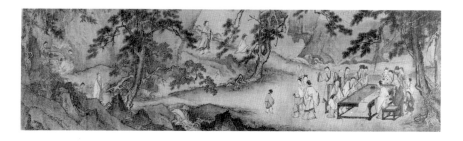

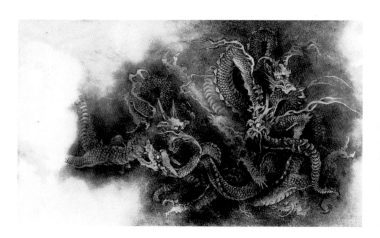

Attributed to Ch'en Jung, c. 1200–1266
Five Dragons
Handscroll; ink on paper
13½ x 23½ inches (34.3 x 59.7 cm)
Southern Sung Dynasty (1127–1279)
Purchase: Nelson Trust [48-15]
[*See colorplate, p. 65*]

The Sixteen Luohan (section), 13th century
Handscroll; ink and slight color on paper
12⅞ x 147⁷⁄₁₆ inches (32.7 x 374.5 cm), overall
Southern Sung Dynasty (1127−1279)
Purchase: Nelson Trust [50-11]

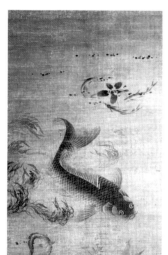

Fish and Water Grasses, 13th century
Hanging scroll; ink on silk
27¾ x 17¾ inches (70.5 x 45.1 cm)
Southern Sung Dynasty (1127−1279)
Purchase: Nelson Trust [46-54]

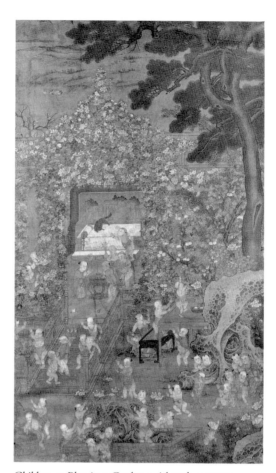

Children at Play in a Garden, mid 13th century
Hanging scroll; ink and color on silk
68⅛ x 39 inches (173.0 x 99.0 cm)
Southern Sung Dynasty (1127−1279)
Purchase: acquired through the generosity of
the Hall Family Foundations [F83-51]

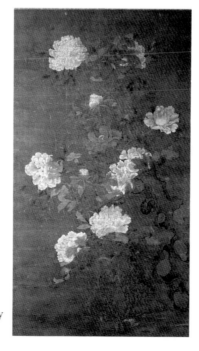

Tree Peonies, Garden Rocks, and Insects,
13th/14th century
Hanging scroll (laid down on panel);
ink and color on silk
60¼ x 31⅞ inches (153.0 x 81.0 cm)
Southern Sung (1127−1279) to Yüan
(1279−1368) Dynasty
Gift of Mr. Bronson Trevor in memory
of John B. Trevor [76-10/7 a]

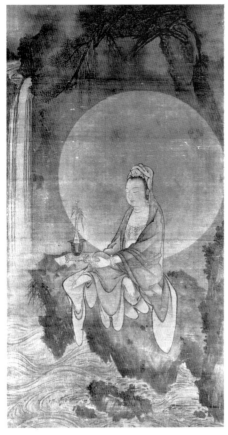

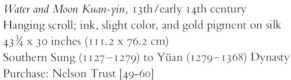

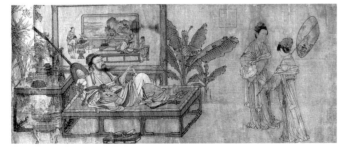

Li K'an, 1245–1320
Ink Bamboo (section), 1308
Handscroll; ink on paper
14¾ x 93½ inches (37.5 x 237.5 cm), overall
Yüan Dynasty (1279–1368)
Purchase: Nelson Trust [48-16]

Hunting Falcon Attacking a Swan, late 13th/early 14th century
Hanging scroll (laid down on panel); ink and color on paper
60 x 41¾ inches (152.4 x 106.1 cm)
Yüan Dynasty (1279–1368)
Purchase: Nelson Trust [33-86]

Jen Jen-fa, 1255–1328
Nine Horses (detail and section),
dated 1324
Handscroll; ink and color on silk
12⅜ x 103 inches (31.5 x 261.6 cm),
overall
Yüan Dynasty (1279–1368)
Purchase: Nelson Trust [72-8]

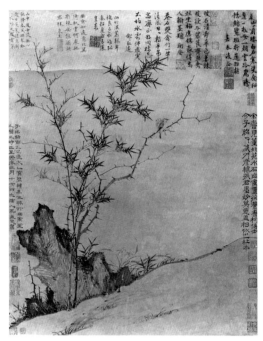

Chang Yen-fu, active 1300–1350
Thorns, Bamboo, and Quiet Birds, 1343
Hanging scroll; ink on paper
30 x 25 inches (76.2 x 63.5 cm)
Yüan Dynasty (1279–1368)
Purchase: Nelson Trust [49-19]

Taoist Deities Paying Court, 14th century
Hanging scroll; ink and color on silk
50½ x 35¼ inches (128.3 x 89.5 cm)
Yüan Dynasty (1279–1368)
Gift of Mr. Laurence Sickman [73-29]

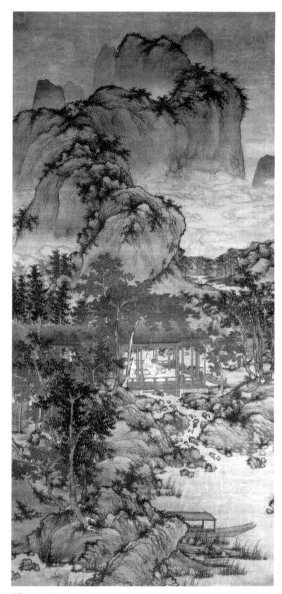

Sheng Mou, active c. 1330–1369
Enjoying Fresh Air in a Mountain Retreat
Hanging scroll; ink and color on silk
47⁹⁄₁₆ x 22⁷⁄₁₆ inches (120.9 x 57.0 cm)
Yüan Dynasty (1279–1368)
Purchase: Nelson Trust [35-173]

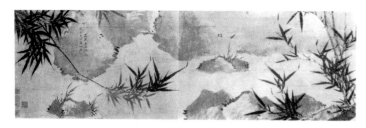

Wang Fu, 1362–1416
Bamboo and Rocks (section)
Handscroll; ink on paper
14 x 91½ inches (35.6 x 232.4 cm), overall
Ming Dynasty (1368–1644)
Purchase: Nelson Trust [58-8]

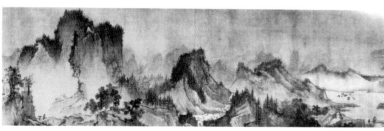

Landscape (section), late 14th/early 15th century
Handscroll; ink and light color on silk
9⅜ x 187³⁄₁₆ inches (23.8 x 475.5 cm), overall
Ming Dynasty (1368–1644)
Purchase: Nelson Trust [35-262]

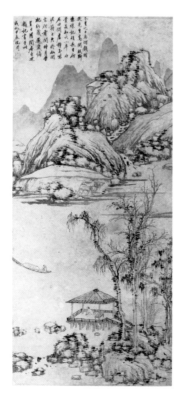

Shen Chou, 1427–1509
Landscape in the Style of Ni Tsan, dated 1484
Hanging scroll; ink on paper
54¼ x 24⅜ inches (137.8 x 61.9 cm)
Ming Dynasty (1368–1644)
Purchase: Nelson Trust [46-45]

Hsüan-tsung, 1399–1435
Dog and Bamboo, dated 1427
Hanging scroll; ink and slight color on paper
79½ x 28⅜ inches (202.0 x 72.0 cm)
Ming Dynasty (1368–1644)
Purchase: Nelson Trust [45-39]

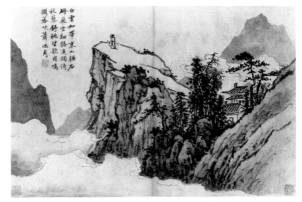

Shen Chou, 1427–1509

Gardeners and *Poet on a Mountaintop,* from *Landscape Album: Five Leaves by Shen Chou, One Leaf by Wen Cheng-ming*

Album leaves mounted as handscroll; ink and light color on paper; ink on paper

15¼ x 23¾ inches (38.7 x 60.3 cm), each

Ming Dynasty (1368–1644)

Purchase: Nelson Trust [46-51/1,2]

Shen Chou, 1427–1509

Farewell to Lu Chih, c. 1499

Handscroll; ink and color on paper

10⅜ x 58¼ inches (26.4 x 148.0 cm)

Ming Dynasty (1368–1644)

Purchase: Nelson Trust [46-90]

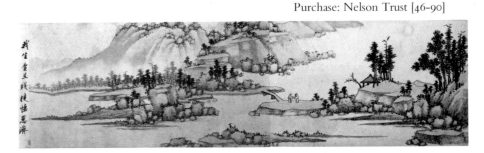

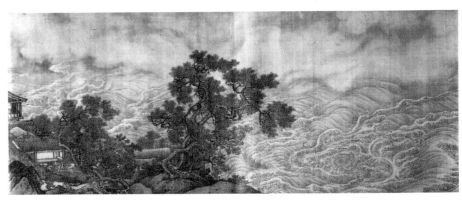

Chou Ch'en, c. 1455–after 1536

The North Sea (section)

Handscroll; ink and light color on silk

11¼ x 53¾ inches (28.5 x 136.6 cm), overall

Ming Dynasty (1368–1644)

Purchase: Nelson Trust [58-55]

[*See colorplate, p. 67*]

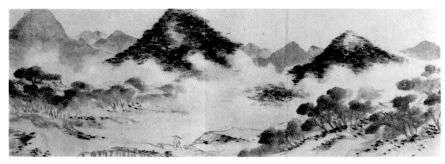

Ch'en Shun, 1483–1544
Hills and Streams after Rain (section)
Handscroll; ink and color on paper
10⅜ x 65¾ inches (26.3 x 167.1 cm), overall
Ming Dynasty (1368–1644)
Purchase: Nelson Trust [46-42]

Ch'en Shun, 1483–1544
Lotus (section)
Handscroll; color on paper
12 x 229¾ inches (30.5 x 583.6 cm), overall
Ming Dynasty (1368–1644)
Purchase: Nelson Trust [31-135/34]

Ch'iu Ying, 1494/95–1552
Saying Farewell at Hsün-yang (section)
Handscroll; ink and full color on paper
13¼ x 157⅜ inches (33.7 x 399.7 cm), overall
Ming Dynasty (1368–1644)
Purchase: Nelson Trust [46-50]
[*See colorplate, p. 68*]

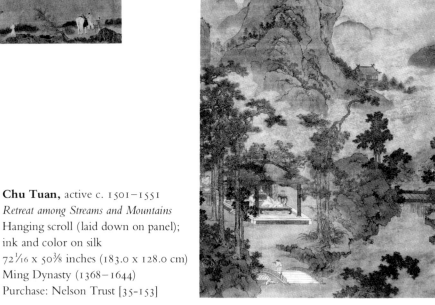

Chu Tuan, active c. 1501–1551
Retreat among Streams and Mountains
Hanging scroll (laid down on panel);
ink and color on silk
72¹⁄₁₆ x 50⅜ inches (183.0 x 128.0 cm)
Ming Dynasty (1368–1644)
Purchase: Nelson Trust [35-153]

Yu Ch'iu, active c. 1540–1590
Elegant Gathering in a Garden (section)
Handscroll; ink on paper
9⅞ x 303¾ inches (25.1 x 771.5 cm), overall
Ming Dynasty (1368–1644)
Purchase: Nelson Trust [50-23]

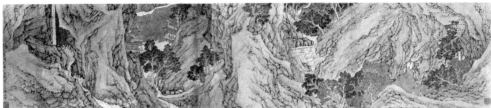

Lu Chih, 1496–1576
The Jade Field, dated 1549
Handscroll; ink and color on paper
9½ x 53⁹⁄₁₆ inches (24.2 x 136.1 cm), overall
Ming Dynasty (1368–1644)
Purchase: Nelson Trust [50-68]

Ch'iu Ying, 1494/95–1552
Fisherman's Flute Heard over the Lake, c. 1547
Hanging scroll; ink and light color on paper
62⅞ x 33⅛ inches (159.7 x 84.2 cm)
Ming Dynasty (1368–1644)
Gift of Mr. John M. Crawford, Jr., in honor of the
fiftieth anniversary of the Nelson-Atkins Museum of Art [F82-34]

Wen Cheng-ming, 1470–1559
Old Cypress and Rock, 1550
Handscroll; ink on paper
10¼ x 19¼ inches (26.1 x 48.9 cm)
Ming Dynasty (1368–1644)
Purchase: Nelson Trust [46-48]

Ting Yün-p'eng, 1547–c. 1621
*Five Forms of Kuan-yin Together with the Complete Lung-yen
Sutra Written by Yü Jo-ying* (section), c. 1579/80
Handscroll; ink, color, and gold pigment on paper
11 x 52¾ inches (28.0 x 134.0 cm), painting;
10⅛ x 165½ inches (25.7 x 420.4 cm), sutra
Ming Dynasty (1368–1644)
Purchase: Nelson Trust [50-22]

Tung Ch'i-ch'ang, 1555–1636
Landscape after Lü Hung's "Ten Views of a Thatched Hut"
and *Landscape after Wang Meng,* from the album
Landscapes in the Styles of Old Masters, 1621/24
Album leaves; ink on paper or ink and color on paper
24½ x 16 inches (62.3 x 40.6 cm), each
Ming Dynasty (1368–1644)
Purchase: acquired through the generosity
of the Hall Family Foundations and the
exchange of other Trust properties [86-3/1,3]
[*See colorplate, p. 70*]

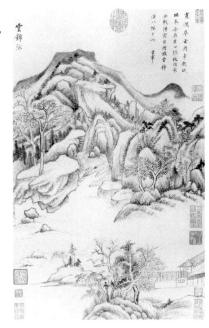 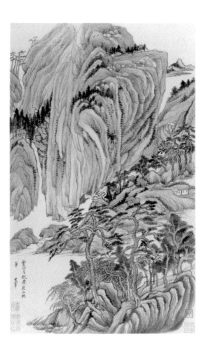

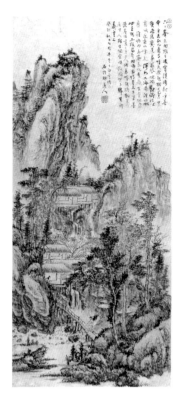

K'un-ts'an, 1612–1673
*The Mood of Autumn among Streams
and Mountains,* dated 1663
Hanging scroll; ink and light color on paper
42½ x 19 inches (108.0 x 48.3 cm)
Ch'ing Dynasty (1644–1911)
Purchase [F75-41]

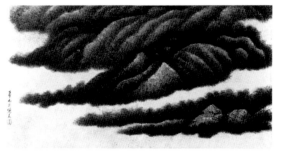

Kung Hsien, 1619–1689
Mountains and Mist-Filled Valleys and
The Peachblossom Studio, from
Landscape Album, dated 1671
Album leaves mounted as hanging
scrolls; ink and light color on paper
9½ x 17⅝ inches (24.1 x 44.8 cm), each
Ch'ing Dynasty (1644–1911)
Purchase: Nelson Trust [60-36/4,8]

Kung Hsien, 1619–1689
Cloudy Peaks (2 sections), 1674
Handscroll; ink on paper
6⅜ x 354½ inches (16.3 x 900.4 cm), overall
Ch'ing Dynasty (1644–1911)
Purchase: Nelson Trust [68-29]

Yün Shou-p'ing, 1633–1690
Pear Blossoms, from *Album of Flowers*
Album leaf; ink and color on paper
9⅝ x 11½ inches (24.5 x 29.3 cm)
Ch'ing Dynasty (1644–1911)
Purchase: Nelson Trust [58-50/3]

Kung Hsien, 1619–1689
Landscape in the Manner of Tung Yüan (section)
Handscroll; ink on paper
10½ x 370¾ inches (26.7 x 941.7 cm), overall
Ch'ing Dynasty (1644–1911)
Purchase: Nelson Trust [48-44]

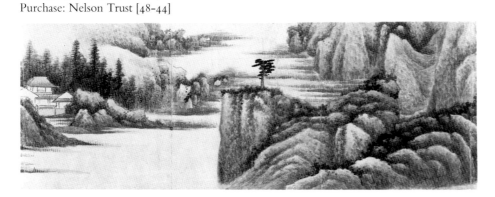

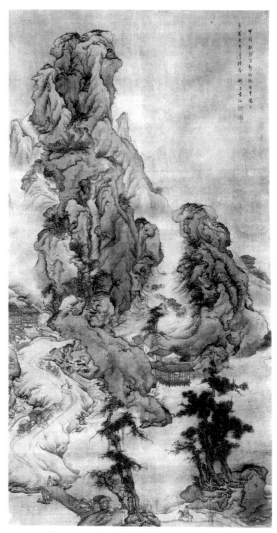

Yüan Chiang, active c. 1690–1724
Carts on a Winding Mountain Road, dated 1694
Hanging scroll (laid down on panel);
ink and color on silk
71¼ x 36¾ inches (181.0 x 93.4 cm)
Ch'ing Dynasty (1644–1911)
Purchase: Nelson Trust [35-151]

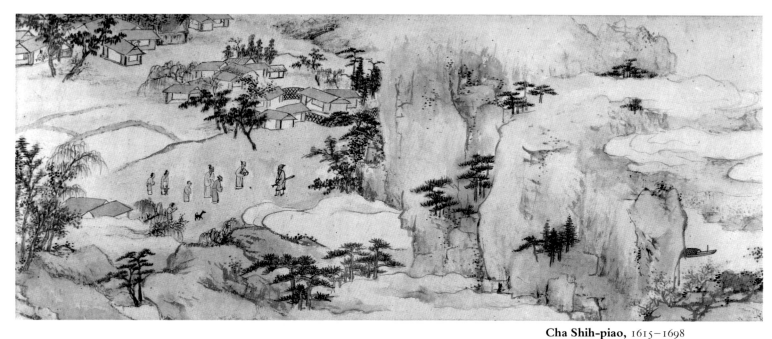

Cha Shih-piao, 1615–1698
The Peachblossom Spring (section), 1695
Handscroll; ink and light color on paper
13⅞ x 123⅛ inches (35.2 x 312.9 cm), overall
Ch'ing Dynasty (1644–1911)
Purchase: Nelson Trust [72-4]

Chu Ta, 1626–1705
Mynah Birds and Rocks and
Mynah Birds, Old Tree, and Rocks
Pair of hanging scrolls; ink on satin
80½ x 21¼ inches (204.5 x 54.0 cm), each
Ch'ing Dynasty (1644–1911)
Purchase: Nelson Trust [67-4/1,2]

Wang Yüan-ch'i, 1642–1715
The Three Friends of Winter, dated 1702
Hanging scroll; ink on paper
33½ x 18½ inches (85.1 x 47.0 cm)
Ch'ing Dynasty (1644–1911)
Purchase: Nelson Trust [51-77]

Wang Yüan-ch'i, 1642–1715
Springtime at the Peachblossom Spring
Album leaf mounted as hanging
scroll; ink and color on paper
12¼ x 9¾ inches (31.2 x 24.8 cm)
Ch'ing Dynasty (1644–1911)
Gift of Mr. Arthur Rothwell [62-16]

Kao Ch'i-p'ei, 1660–1734
A Pine Branch, from the album *Finger
Paintings of Assorted Subjects,* before 1712
Album leaf; ink and light color on paper
14¼ x 22¾ inches (36.2 x 57.8 cm)
Ch'ing Dynasty (1644–1911)
Purchase: acquired through the generosity of
Mrs. George H. Bunting, Jr. [F79-48/9]

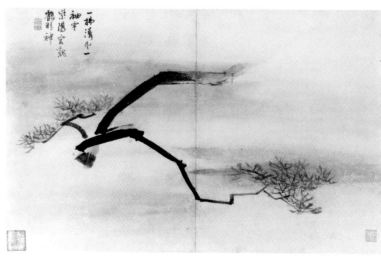

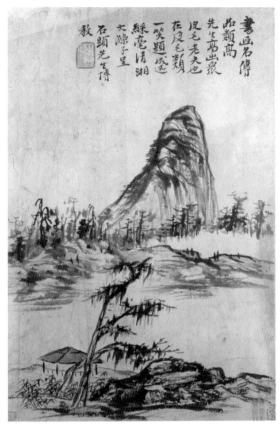

Shih-t'ao (Yüan-chi), 1642–1707
Mountain on the Other Side of the River,
from *Wonderful Conceptions of the Bitter Melon:*
Landscape Album for Liu Shih-t'ou, dated 1703
Album leaf; ink and color on paper
22¾ x 14 inches (57.8 x 35.6 cm)
Ch'ing Dynasty (1644–1911)
Purchase: acquired through the generosity of
the Hall Family Foundations [F83-50/10]

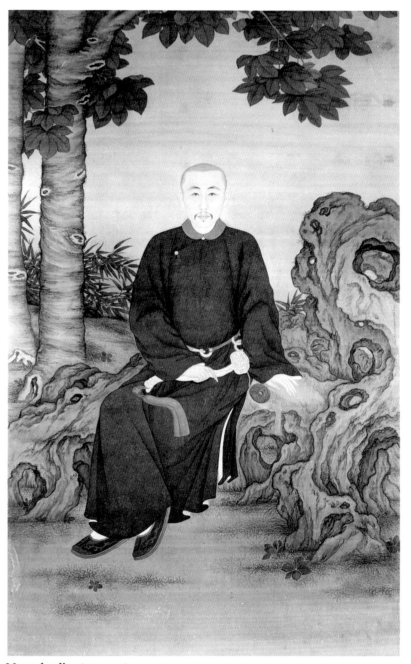

Mang-ku-li, 1672–1736
Portrait of Prince Kuo, dated 1729
Hanging scroll; ink and color on silk
84⅝ x 52¾ inches (215.0 x 134.0 cm)
Ch'ing Dynasty (1644–1911)
Purchase: Nelson Trust [33-1534]

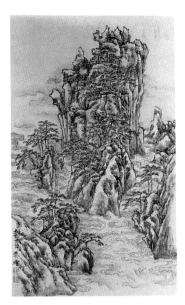

Li Shih-cho, c. 1690–1770
Clouds on the Pine Mountains, from *Landscape Album*
Album leaf; ink or ink and color on paper
9½ x 5¹¹⁄₁₆ inches (24.1 x 14.5 cm)
Ch'ing Dynasty (1644–1911)
Purchase: acquired through the generosity of
an anonymous donor [F78-18/1]

Chin Nung, 1687–1764
Blossoming Plum, dated 1760
Hanging scroll; ink and slight color on paper
45¹¹⁄₁₆ x 23¾ inches (116.0 x 60.3 cm)
Ch'ing Dynasty (1644–1911)
Purchase: Nelson Trust [58-54]

Lo P'ing, 1733–1799
Han-shan and Shih-te
Hanging scroll; ink and light color on paper
30¾ x 20¼ inches (78.2 x 51.5 cm)
Ch'ing Dynasty (1644–1911)
Purchase: Nelson Trust [72-5]

Bird
Jade (nephrite)
Height: 1¾ inches (4.4 cm)
Neolithic (c. 2000–1500 B.C.)
Purchase: Nelson Trust [35-89]

Ceremonial Dagger Ax with Grooved Tang, type *ko*, 13th/12th century B.C.
Jade (nephrite) with traces of cinnabar
Length: 17⅞ inches (45.5 cm)
Shang Dynasty, Yin period (c. 1300–1050 B.C.)
Purchase: Nelson Trust [49-25]

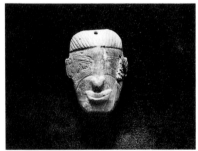

Pendant in the Form of a Human Mask
Jade (nephrite)
Height: 1¾ inches (4.5 cm)
Shang Dynasty, Yin period
(c. 1300–1050 B.C.)
Purchase: Nelson Trust [34-247]

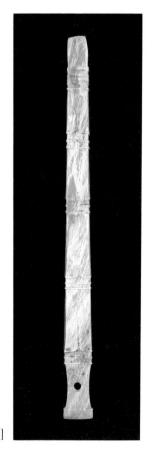

Celt, c. 11th century B.C.
Jade (nephrite)
Length: 7¾ inches (19.7 cm)
From An-yang
Shang Dynasty, Yin period
(c. 1300–1050 B.C.)
Purchase: Nelson Trust [47-18]

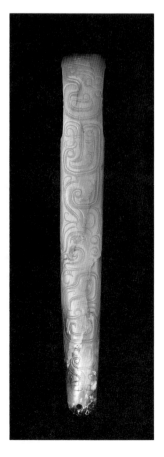

Celt, 9th/8th century B.C.
Jade (nephrite)
Length: 7⅞ inches (20.0 cm)
Western Chou Dynasty
(c. 1050–771 B.C.)
Gift of Mr. C. T. Loo [49-2]

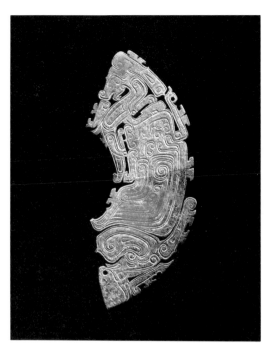

Plaque with Composite Bird and Animal Forms, c. 11th century B.C.
Jade (nephrite) with traces of cinnabar
Height: 6⅝ inches (16.9 cm)
Shang (c. 1600–1050 B.C.) to Western Chou (c. 1050–771 B.C.) Dynasty
Purchase: Nelson Trust [50-45]

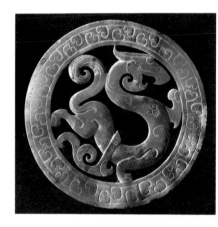

Ring with Rampant Tiger Motif,
5th/3rd century B.C.
Jade (nephrite) with traces of cinnabar
Diameter: 2⅛ inches (5.4 cm)
From Chin-ts'un
Eastern Chou Dynasty, Warring
States period (480–221 B.C.)
Purchase: Nelson Trust [50-21]

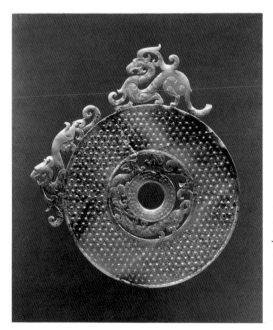

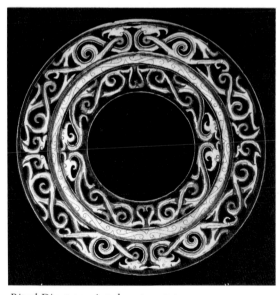

Ritual Disc with Dragon Motif, type *pi*,
4th/3rd century B.C.
Jade (nephrite)
Diameter: 6½ inches (16.5 cm)
From Chin-ts'un
Eastern Chou Dynasty, Warring
States period (480–221 B.C.)
Purchase: Nelson Trust [33-81]

Ritual Disc, type *pi*, 3rd century B.C.
Jade (nephrite)
Diameter: 6½ inches (16.5 cm)
From Chin-ts'un
Eastern Chou Dynasty, Warring
States period (480–221 B.C.)
Purchase: Nelson Trust [50-43]

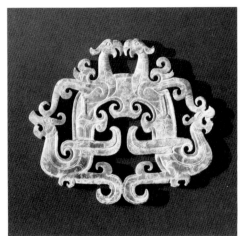

Pendant with Pairs of Phoenix and Dragons, 4th/3rd century B.C.
Jade (nephrite)
Height: 2⅛ inches (5.4 cm)
From Chin-ts'un
Eastern Chou Dynasty, Warring States period (480–221 B.C.)
Purchase: Nelson Trust [35-88]

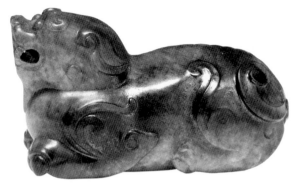

Recumbent Lion, 4th/6th century
Jade (nephrite)
Length: 3⁷⁄₁₆ inches (8.7 cm)
Southern (A.D. 317–589) or
Northern (A.D. 386–581) Dynasty
Bequest of Mr. Laurence Sickman [F88-40/26]

Ape, 8th/9th century
Jade (nephrite)
Height: 3⅛ inches (7.9 cm)
T'ang Dynasty (A.D. 618–906)
Bequest of Mr. Laurence Sickman [F88-40/28]

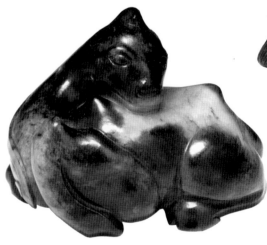

Recumbent Camel, 8th/9th century
Jade (nephrite)
Length: 2¹⁵⁄₁₆ inches (7.5 cm)
T'ang Dynasty (A.D. 618–906)
Bequest of Mr. Laurence Sickman [F88-40/27]

Chimera, 14th century
Jade (nephrite)
Length: 3 inches (7.6 cm)
Yüan Dynasty (1279–1368)
Bequest of Mr. Laurence Sickman [F88-40/30]

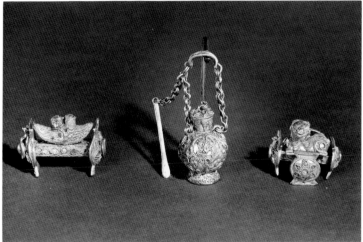

Two Hairpin Heads and Bottle
Gold with granular work; gold with turquoise inlay
Height: ⅝ inch (1.6 cm); 1⁹⁄₁₆ inches (3.9 cm); ¾ inch (1.9 cm)
Eastern Han Dynasty (A.D. 25–220)
Purchase: Nelson Trust [34-33; 40-50; 34-32]

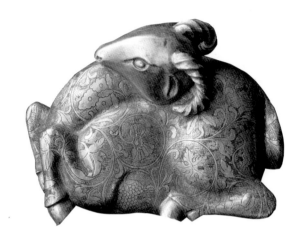

Box in the Form of a Ram, late 7th/8th century
Silver with parcel gilt and engraved decoration
Length: 3⅛ inches (7.9 cm)
T'ang Dynasty (A.D. 618–906)
Purchase: Nelson Trust [50-10]

Cup with Ring Handle, late 7th/early 8th century
Silver with engraved decoration
Diameter: 2¾ inches (7.0 cm), excluding handle
T'ang Dynasty (A.D. 618–906)
Purchase: Nelson Trust [50-15]

Stem Cup, late 7th/early 8th century
Silver with repoussé decoration
Diameter: 2½ inches (6.3 cm)
T'ang Dynasty (A.D. 618–906)
Purchase: Nelson Trust [52-20]

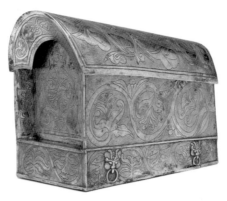

Miniature Sarcophagus, c. 1100
Silver with repoussé and engraved decoration
5⅛ x 6⅜ x 3⁷⁄₁₆ inches
(13.0 x 16.2 x 8.7 cm), maximum dimensions
Northern Sung Dynasty (A.D. 960–1127)
Purchase: Nelson Trust [69-10]

Bowl (exterior and interior), 8th century
Silver with parcel gilt; repoussé and
engraved decoration
Diameter: 6⅜ inches (16.2 cm)
T'ang Dynasty (A.D. 618–906)
Purchase: Nelson Trust [56-72]
[*See colorplate, p. 60*]

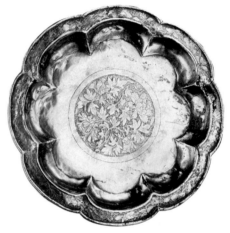

Plate, 14th century
Silver with engraved decoration
Diameter: 8⅞ inches (22.6 cm)
Yüan Dynasty (1279–1368)
Purchase: Nelson Trust [35-124/4]

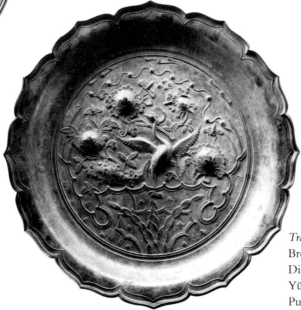

Tray, 14th century
Bronze with repoussé decoration
Diameter: 19 inches (48.2 cm)
Yüan Dynasty (1279–1368)
Purchase: Nelson Trust [31-117/28]

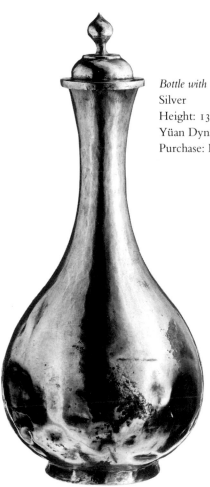

Bottle with Lid, 14th century
Silver
Height: 13¾ inches (34.9 cm)
Yüan Dynasty (1279–1368)
Purchase: Nelson Trust [35-124/1]

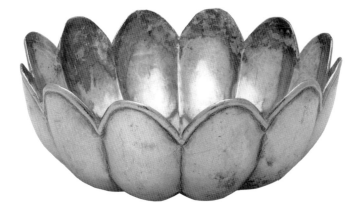

Lotus-Shaped Bowl, 14th century
Silver
Diameter: 8¼ inches (21.0 cm)
Yüan Dynasty (1279–1368)
Purchase: Nelson Trust [35-124/2]

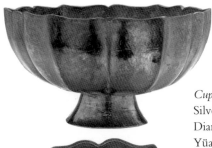

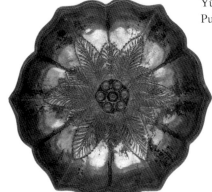

Cup (exterior and interior), 14th century
Silver with engraved decoration
Diameter: 4⅜ inches (11.2 cm)
Yüan Dynasty (1279–1368)
Purchase: Nelson Trust [35-124/8]

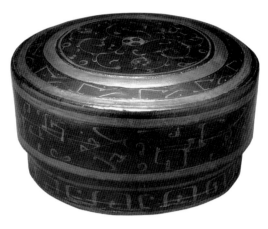

Round Container with Lid, early 2nd century B.C.
Lacquered wood
Diameter: 8¼ inches (21.0 cm)
From Ch'ang-sha
Western Han Dynasty (206 B.C.–A.D. 9)
Purchase: Nelson Trust [48-36/2]

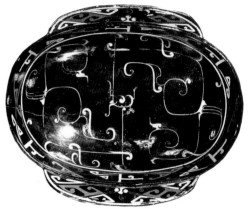

Wine Cup (one of a pair), early 2nd century B.C.
Lacquered wood
Length: 6¾ inches (17.2 cm)
From Ch'ang-sha
Western Han Dynasty (206 B.C.–A.D. 9)
Purchase: Nelson Trust [48-36/5]

Box with Cover (side and top), mid 16th century
Lacquered wood with mother-of-pearl inlay
3¾ x 7 x 7 inches (9.5 x 17.7 x 17.7 cm)
Ming Dynasty (1368–1644)
Gift of Mr. David T. Beals III [F77-44]

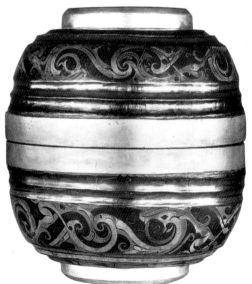

Round Container with Lid, early 2nd century B.C.
Lacquered wood with gilt bronze mounts
Diameter: 8⅛ inches (20.6 cm)
From Ch'ang-sha
Western Han Dynasty (206 B.C.–A.D. 9)
Purchase: Nelson Trust [48-36/1]

Box with Hinged Lid, dated 1610
Lacquered wood with brass frame
and hinges; basketry panels and
painted decoration
4½ x 10¼ x 7½ inches
(11.4 x 26.0 x 19.0 cm)
Ming Dynasty (1368–1644)
Purchase: Nelson Trust [59-76/5]

Box with Hinged Lid, 1600/1650
Lacquered wood with brass frame
and inlay; basketry panels
4½ x 16¼ x 8½ inches
(11.5 x 41.3 x 21.6 cm)
Ming Dynasty (1368–1644)
Gift of Mr. Robert H. Ellsworth in
honor of Laurence Sickman [F85-32]

Brush Pot with Scene of "The Eighteen Academicians,"
dated to the reign of Ch'ien-lung (1736–95)
Lacquered wood
Height: 6¹⁵⁄₁₆ inches (17.6 cm)
Ch'ing Dynasty (1644–1911)
Gift of Mr. Bronson Trevor in honor of
John B. Trevor [76-10/1]

Dish in the Shape of a Chrysanthemum,
dated 1774
Lacquered wood over silk armature;
painted inscription
Diameter: 4¾ inches (12.1 cm)
Ch'ing Dynasty (1644–1911)
Purchase: Nelson Trust [76-23]

*The Four Seasons: Bright Moonlight on
the Autumn Stream*, 18th century
Ta-li (figured) marble
20½ x 27 inches (52.1 x 68.6 cm)
Ch'ing Dynasty (1644–1911)
Purchase: Nelson Trust [59-76/3]

Furniture

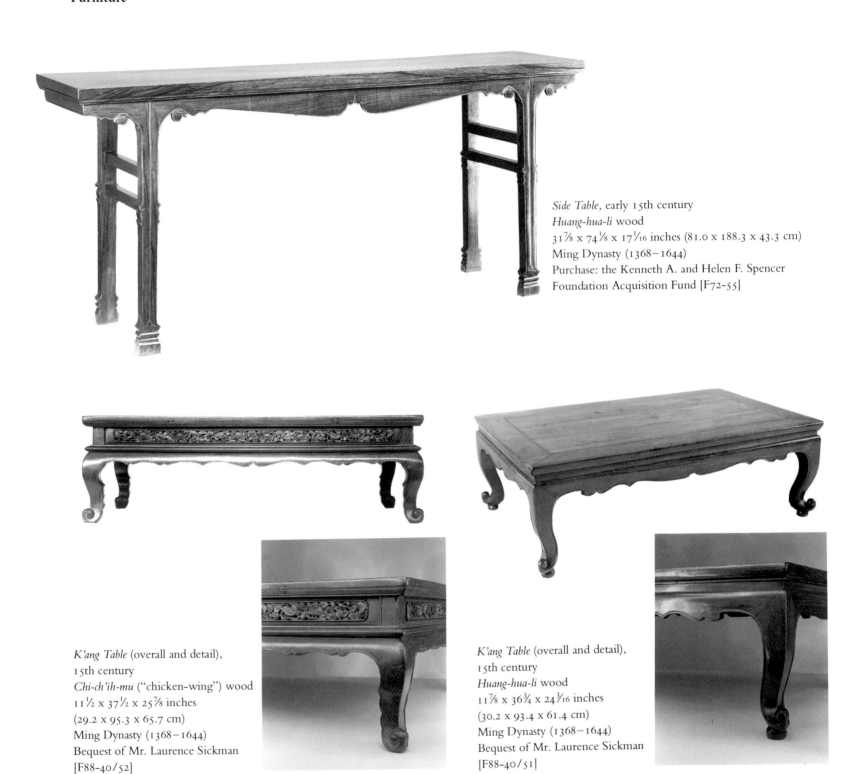

Side Table, early 15th century
Huang-hua-li wood
31⅞ x 74⅛ x 17¹⁄₁₆ inches (81.0 x 188.3 x 43.3 cm)
Ming Dynasty (1368–1644)
Purchase: the Kenneth A. and Helen F. Spencer
Foundation Acquisition Fund [F72-55]

K'ang Table (overall and detail),
15th century
Chi-ch'ih-mu ("chicken-wing") wood
11½ x 37½ x 25⅞ inches
(29.2 x 95.3 x 65.7 cm)
Ming Dynasty (1368–1644)
Bequest of Mr. Laurence Sickman
[F88-40/52]

K'ang Table (overall and detail),
15th century
Huang-hua-li wood
11⅞ x 36¾ x 24³⁄₁₆ inches
(30.2 x 93.4 x 61.4 cm)
Ming Dynasty (1368–1644)
Bequest of Mr. Laurence Sickman
[F88-40/51]

K'ang Table, 15th century
Huang-hua-li wood
10⅛ x 30⅜ x 20⅞ inches (25.7 x 77.1 x 53.0 cm)
Ming Dynasty (1368–1644)
Purchase: the Kenneth A. and Helen F. Spencer
Foundation Acquisition Fund [F72-52]

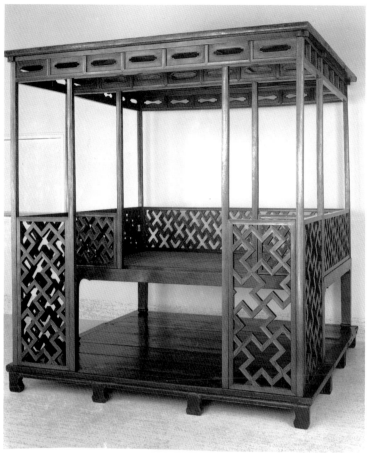

Canopy Bed with Alcove, 15th/16th century
Huang-hua-li and painted soft wood
91 x 86¼ x 84¼ inches (231.1 x 219.1 x 214.0 cm)
Ming Dynasty (1368–1644)
Purchase: Nelson Trust [64-4/4]

Pair of Book Cabinets, early/mid 16th century
Huang-hua-li wood; brass hardware with copper inlays; lacquered interior
73½ x 36⅝ x 20½ inches (186.7 x 93.0 x 52.1 cm), each
Ming Dynasty (1368–1644)
Purchase: the George H. and Elizabeth O. Davis Fund [F82-32/1,2]

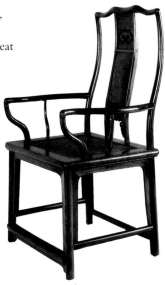

High-Back Armchair (one of a pair),
late 16th century
Huang-hua-li wood; woven fiber seat
44½ x 25½ x 23½ inches
(113.0 x 64.8 x 59.7 cm)
Ming Dynasty (1368–1644)
Bequest of Mrs. George H.
Bunting, Jr. [81-27/40 a]

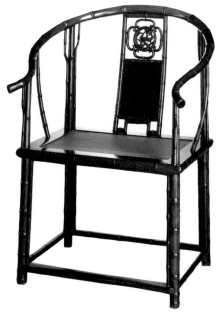

Armchair (from set of four), mid 16th/early 17th century
Huang-hua-li and *hua-mu* wood; woven fiber seat
39⅜ x 27¼ x 20 inches (100.0 x 69.2 x 50.8 cm)
Ming Dynasty (1368–1644)
Purchase: Nelson Trust [46-78/1]

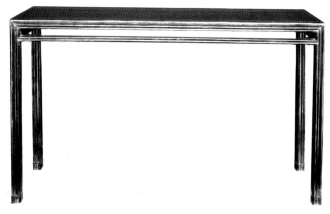

Side Table (one of a pair), late 16th/early 17th century
Black reed with lacquered wood panel top; bronze feet
33⅛ x 57 x 15¾ inches (84.1 x 144.8 x 40.0 cm)
Ming Dynasty (1368–1644)
Purchase: the Kenneth A. and Helen F. Spencer
Foundation Acquisition Fund [F72-53/1]

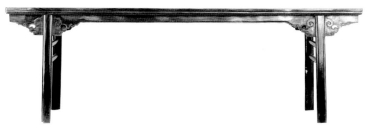

Library Table, late 16th/early 17th century
Huang-hua-li wood
33 x 105¾ x 40¼ inches (83.8 x 268.6 x 102.2 cm)
Ming Dynasty (1368–1644)
Purchase: Nelson Trust [46-71]

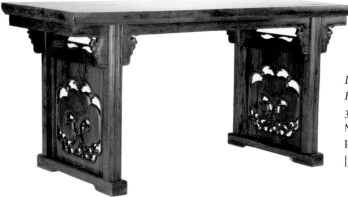

Library Table, 16th/early 17th century
Huang-hua-li wood
33¾ x 71 x 30 inches (85.7 x 180.3 x 76.2 cm)
Ming Dynasty (1368–1644)
Purchase: Nelson Trust [64-4/5]
[*See colorplate, p. 69*]

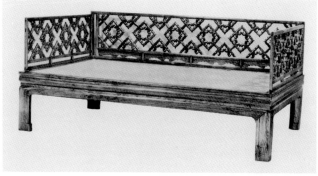

K'ang Couch, late 16th/early 17th century
Huang-hua-li wood
38¼ x 82¼ x 49⅝ inches (97.2 x 208.9 x 126.0 cm)
Ming Dynasty (1368–1644)
Purchase: Nelson Trust [46-70]

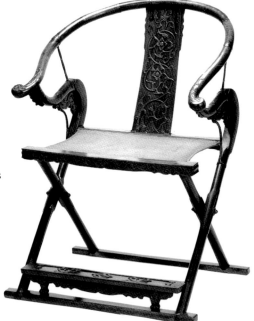

Folding Armchair, c. 1600
Hua-li wood; iron reinforcements
with silver inlay; canvas seat
40 x 27 x 17¹¹⁄₁₆ inches
(101.6 x 68.6 x 44.9 cm)
Ming Dynasty (1368–1644)
Purchase: Nelson Trust [68-1]

Tabouret, late 16th/early 17th century
Hua-li wood
33⅞ x 16³⁄₁₆ x 16³⁄₁₆ inches (86.1 x 41.1 x 41.1 cm)
Ming Dynasty (1368–1644)
Purchase: Nelson Trust [46-74]

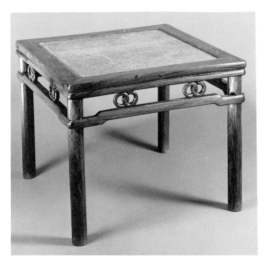

Stool (one of a pair), early 17th century
Huang-hua-li wood; woven fiber seat
20¼ x 24¾ x 24¾ inches
(51.4 x 62.9 x 62.9 cm)
Ming Dynasty (1368–1644)
Purchase: Nelson Trust [64-4/9 a]

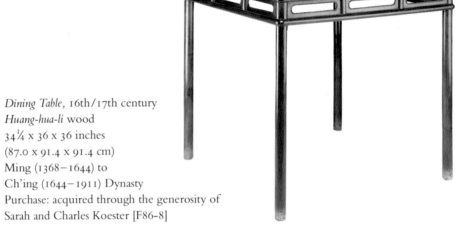

Dining Table, 16th/17th century
Huang-hua-li wood
34¼ x 36 x 36 inches
(87.0 x 91.4 x 91.4 cm)
Ming (1368–1644) to
Ch'ing (1644–1911) Dynasty
Purchase: acquired through the generosity of
Sarah and Charles Koester [F86-8]

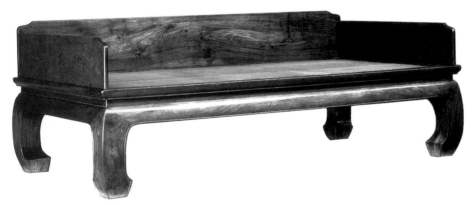

K'ang Couch, early 17th century
Huang-hua-li wood
29¾ x 83 x 44⅛ inches (75.6 x 210.8 x 112.1 cm)
Ming Dynasty (1368–1644)
Purchase: the Kenneth A. and Helen F. Spencer
Foundation Acquisition Fund [F72-51]
[*See colorplate, p. 69*]

High-Back Armchair (one of a pair),
early 17th century
Huang-hua-li wood; woven fiber seat
47½ x 23 x 17½ inches
(120.7 x 58.4 x 44.5 cm)
Ming Dynasty (1368–1644)
Purchase: Nelson Trust [64-4/13 a]

Pair of Tabourets, 17th century
Huang-hua-li wood
31⅝ x 15³⁄₁₆ x 20¼ inches
(80.3 x 38.6 x 51.4 cm), each
Ming Dynasty (1368–1644)
Bequest of Mr. Laurence Sickman [F88-40/53,54]

Pair of Chairs, 18th century
Lacquered wood with painted and incised decoration
31 x 21½ x 13⅝ inches (78.7 x 54.6 x 34.6 cm), each
Ch'ing Dynasty (1644–1911)
Gift of Mrs. George H. Bunting, Jr. [66-53/1,2]

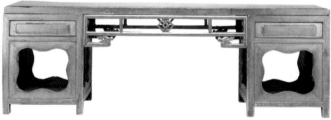

K'ang Table, 17th/18th century
Nan-mu wood
17½ x 54 x 13½ inches (44.5 x 137.2 x 34.3 cm)
Ming (1368–1644) to Ch'ing (1644–1911) Dynasty
Bequest of Mr. Laurence Sickman [F88-40/56]

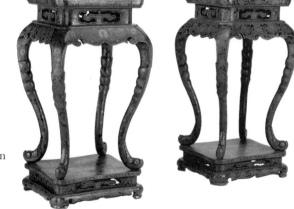

Pair of Tabourets, mid/late 18th century
Lacquered wood with painted and incised decoration
37⅛ x 21 x 21 inches (94.3 x 53.3 x 53.3 cm), each
Ch'ing Dynasty (1644–1911)
Purchase: Nelson Trust [32-51/1,2]

Ceramics

Square Dish
Shino ware (glazed earthenware)
6¼ x 6¼ inches (15.9 x 15.9 cm)
Momoyama period (1568–1614)
Purchase: Nelson Trust [62-17]

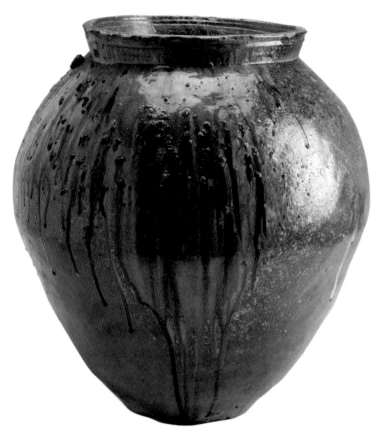

Echizen Water Jar, 16th century
Glazed stoneware
Height: 28½ inches (72.4 cm)
Muromachi period (1392–1568)
Purchase: the Edith Ehrman Memorial Fund [F92-32]

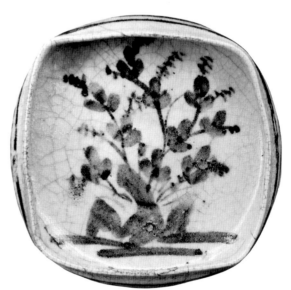

Square Dish
Shino ware (glazed earthenware)
6½ x 6¾ inches (16.5 x 17.2 cm)
Momoyama period (1568–1614)
Gift of Mrs. George H. Bunting, Jr. [67-45/1]

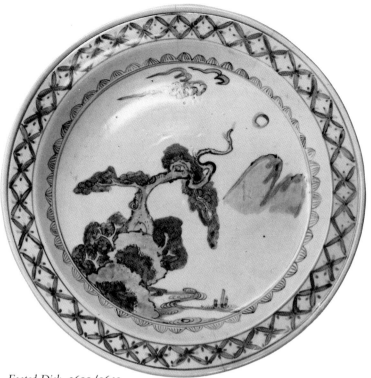

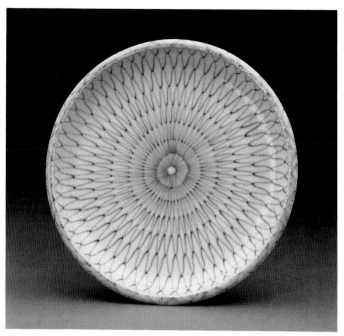

Footed Dish, 1600/1650
Hizen ware (porcelain with underglaze blue decoration)
Diameter: 15½ inches (39.4 cm)
Edo period (1615–1867)
Gift of Mrs. George H. Bunting, Jr. [69-34/2]

Dish, 1650/1700
Arita ware; *Imari* type (porcelain with underglaze blue decoration)
Diameter: 8⁹⁄₁₆ inches (21.7 cm)
Edo period (1615–1867)
Bequest of Mrs. George H. Bunting, Jr. [81-27/1]

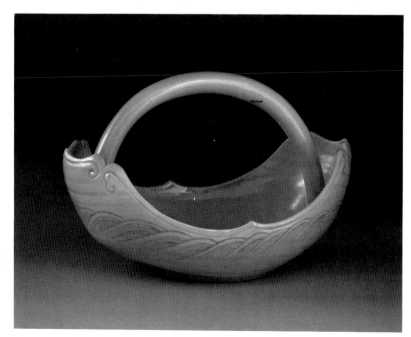

Cake Plate, mid/late 17th century
Kyoto ware (earthenware with underglaze blue decoration)
Height: 9¾ inches (24.7 cm)
Attributed to Kita Rihei, died 1678
Edo period (1615–1867)
Gift of the Harry Packard Foundation [F88-7]

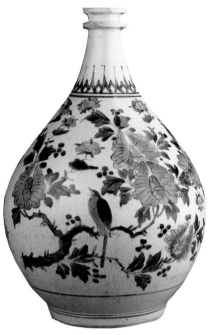

Apothecary's Bottle, 1670/80
Arita ware (porcelain with underglaze blue decoration)
Height: 15⅛ inches (38.4 cm)
Edo period (1615–1867)
Gift of Mrs. George H. Bunting, Jr. [78-39]

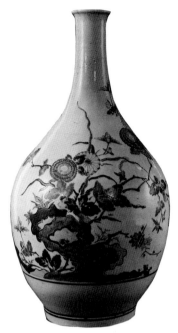

Bottle, 1680/90
Kakiemon ware (porcelain with overglaze enamel decoration)
Height: 14½ inches (36.8 cm)
Edo period (1615–1867)
Gift of Mrs. George H. Bunting, Jr. [76-37]

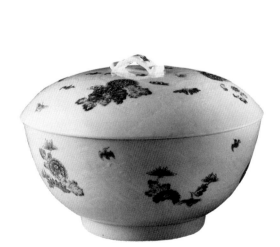

Covered Footed Bowl, c. 1690
Kakiemon ware (porcelain with molded and overglaze enamel decoration)
Diameter: 8⅜ inches (21.3 cm)
Edo period (1615–1867)
Bequest of Mr. John S. Thacher [F85-14/6 a,b]

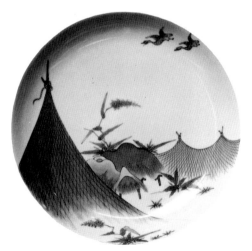

Footed Dish, c. 1730
Kakiemon ware (porcelain with underglaze blue decoration)
Diameter: 8⅜ inches (21.3 cm)
Edo period (1615–1867)
Gift of Mrs. George H. Bunting, Jr. [80-39/4]

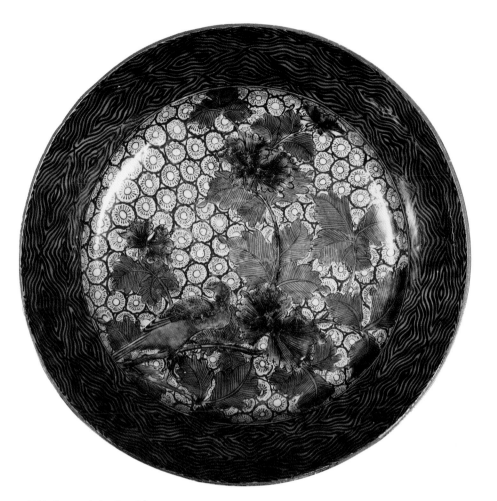

Square Plate
Kyoto pottery ware (earthenware with
underglaze iron-oxide decoration)
7⁹⁄₁₆ x 7⁹⁄₁₆ inches (19.2 x 19.2 cm)
Attributed to Ogata Kenzan, 1663–1743
Edo period (1615–1867)
Gift of Mrs. George H. Bunting, Jr. [67-45/2]

Dish, late 17th/early 18th century
Kutani ware (porcelain with enamel glazes)
Diameter: 17⅞ inches (45.5 cm)
Edo period (1615–1867)
Purchase: Nelson Trust [64-28]
[*See colorplate, p. 72*]

Pair of Covered Bowls (from set of five)
Kyoto pottery ware (earthenware with underglaze
iron-oxide and enamel decoration)
Diameter: 5½ inches (14.0 cm), each
Attributed to Ogata Kenzan, 1663–1743
Edo period (1615–1867)
Gift of Mrs. George H. Bunting, Jr. [71-33/1,2]

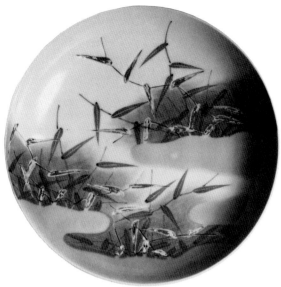

Footed Dish, early 18th century
Nabeshima ware (porcelain with underglaze
blue and overglaze enamel decoration)
Diameter: 7⅞ inches (20.0 cm)
Edo period (1615–1867)
Purchase: Nelson Trust [63-11]

Footed Dish, early 18th century
Nabeshima ware (porcelain with underglaze
blue and overglaze enamel decoration)
Diameter: 7⅞ inches (20.0 cm)
Edo period (1615–1867)
Purchase: Nelson Trust [63-6]

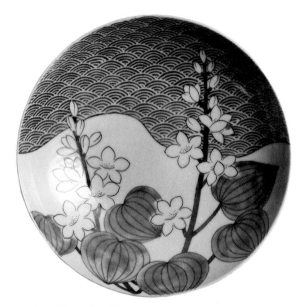

Footed Dish, early 18th century
Nabeshima ware (porcelain with underglaze
blue and overglaze enamel decoration)
Diameter: 5⅞ inches (14.9 cm)
Edo period (1615–1867)
Bequest of Mrs. George H. Bunting, Jr. [81-27/5]

Footed Dish, early 18th century
Nabeshima ware (porcelain with underglaze
blue decoration and celadon green glaze)
Diameter: 7⅞ inches (20.0 cm)
Edo period (1615–1867)
Gift of Mrs. George H. Bunting, Jr. [68-49/4]

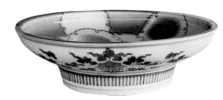

Plate, early 18th century
Arita ware (porcelain with underglaze blue decoration)
Diameter: 15⅜ inches (39.1 cm)
Edo period (1615–1867)
Purchase: Nelson Trust [63-4]

Footed Dish (interior and side), early 18th century
Nabeshima ware (porcelain with underglaze
blue decoration)
Diameter: 8 inches (20.3 cm)
Edo period (1615–1867)
Gift of Mrs. George H. Bunting, Jr. [80-39/6]

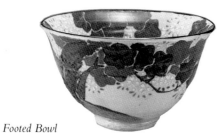

Footed Bowl
Kyoto ware (porcelaneous stoneware with underglaze
iron-oxide and overglaze enamel decoration)
Diameter: 6½ inches (16.5 cm)
By Nin'ami Dohachi, 1783–1855
Edo period (1615–1867)
Gift of Mr. W. M. Ittman, Jr., in honor of
Mrs. George H. Bunting, Jr. [69-21/1]

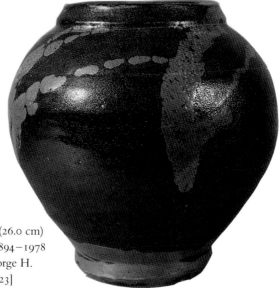

Jar, 1961/64
Glazed stoneware
Height: 10¼ inches (26.0 cm)
By Shoji Hamada, 1894–1978
Bequest of Mrs. George H.
Bunting, Jr. [81-27/23]

Sculpture

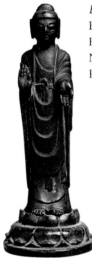

Buddha
Bronze with traces of gilding
Height: 9⅞ inches (25.1 cm)
Nara period (A.D. 645–794)
Purchase: Nelson Trust [58-49]

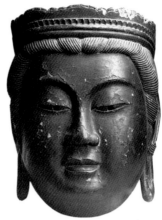

Ceremonial Mask of a Bosatsu
Painted wood
Height: 10 inches (25.4 cm)
Heian period (A.D. 794–1185)
Gift of Mr. John M. Crawford, Jr. [F75-19/1]

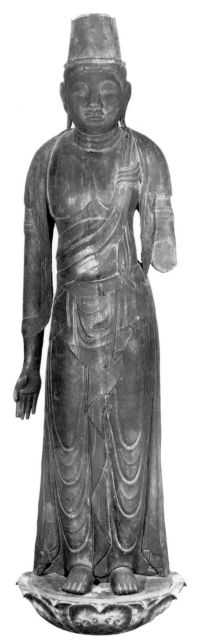

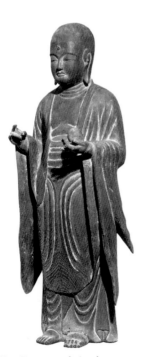

Jizō Bosatsu, 9th/10th century
Wood
Height: 39 inches (99.1 cm)
Heian period (A.D. 794–1185)
Purchase: Nelson Trust [31-141/2]

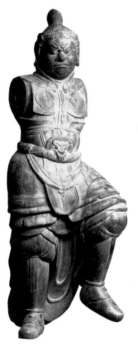

Guardian King, 9th century
Wood with traces of paint
Height: 36¼ inches (92.1 cm)
Heian period (A.D. 794–1185)
Purchase: Nelson Trust [77-16]

Kannon Bosatsu, 8th/9th century
Wood with traces of paint
Height: 64⅜ inches (163.5 cm)
Heian period (A.D. 794–1185)
Purchase: Nelson Trust [31-129]

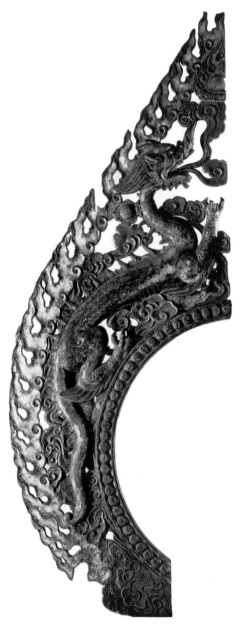

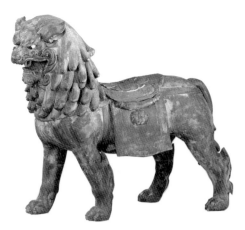

Striding Lion: Mount for the Buddhist Deity Monju, mid 13th century
Wood with traces of paint; crystal inlays
Length: 34 inches (86.3 cm)
Kamakura period (1185–1333)
Purchase: Nelson Trust [77-51]

Head of a Guardian King
Wood with traces of paint
Height: 49 inches (124.5 cm)
Kamakura period (1185–1333)
Purchase: Nelson Trust [33-1682]

Half of a Temple Drum Frame, 1150/1200
Wood with traces of lacquer, paint, and gilding
Height: 129¹⁵⁄₁₆ inches (330.0 cm)
Heian (A.D. 794–1185) or Kamakura (1185–1333) period
Purchase: the Edith Ehrman Memorial Fund [F81-16]

Ebisu, 17th/18th century
Wood with traces of paint
Height: 33⅜ inches (84.8 cm)
Edo period (1615–1867)
Purchase: Nelson Trust [33-1554]

Temple on a Hillside, from *Yuzu-nembutsu Engi*,
early 14th century
Handscroll section mounted as hanging scroll;
ink and color on paper
14 x 19¼ inches (35.6 x 48.9 cm)
Kamakura period (1185–1333)
Purchase: Nelson Trust [62-3]

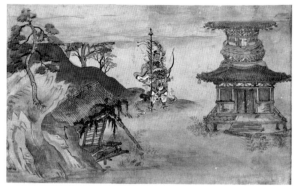

*The Korean Deity Hoshogongen at the Site of the Ruined
Temple Jin-o-ji*, from *Kōnin Shonin Eden*, mid 14th century
Handscroll section mounted as hanging scroll;
ink and color on paper
13¼ x 22 inches (33.7 x 55.9 cm)
Nambokuchō period (1333–92)
Purchase: Nelson Trust [60-14]

Kujaku-Myō-ō
Hanging scroll; ink, color, and gold-leaf strips (*kirikane*) on silk
46 x 28 inches (116.8 x 71.1 cm)
Kamakura period (1185–1333)
Purchase: Nelson Trust [31-100/77]

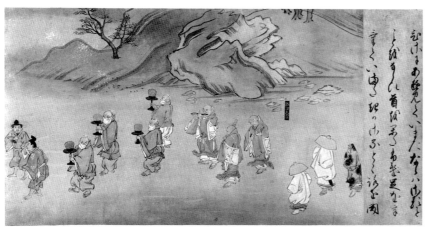

Procession of Priests with Offerings, from *Kōnin Shonin Eden,* mid 14th century
Handscroll section mounted as hanging scroll; ink and color on paper
12⅝ x 25⅜ inches (32.1 x 64.5 cm)
Nambokuchō period (1333–92)
Purchase: Nelson Trust [60-15]

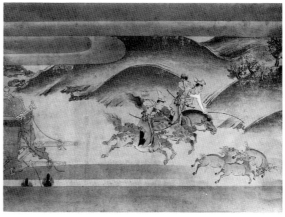

Prince Shōtoku's Injunction against Taking Life,
from *Shōtoku-taishi Eden,* mid 14th century
Handscroll section mounted as hanging scroll;
ink and color on paper
13⅜ x 18⁵⁄₁₆ inches (34.0 x 46.5 cm)
Nambokuchō period (1333–92)
Purchase: Nelson Trust [76-29/2]

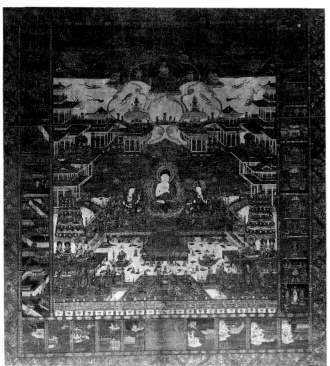

*The Mandala of the Western Paradise of
Amida Buddha (Taima Mandara),*
early 14th century
Hanging scroll; color, gold and silver
paint, and gold-leaf strips *(kirikane)* on silk
47¾ x 43 inches (121.3 x 109.2 cm)
Kamakura period (1185–1333)
Purchase: Nelson Trust [63-12]

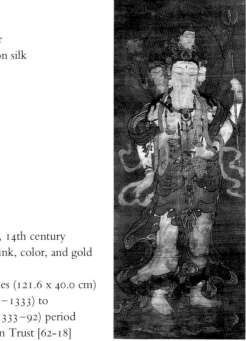

Bonten (Brahma), 14th century
Hanging scroll; ink, color, and gold
paint on silk
47⅞ x 15¾ inches (121.6 x 40.0 cm)
Kamakura (1185–1333) to
Nambokuchō (1333–92) period
Purchase: Nelson Trust [62-18]

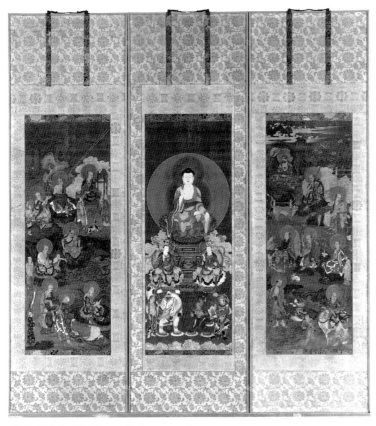

Formerly attributed to Kenkō Shōkei, active c. 1478–1506
Li Ao and Yueh-shan in Discourse
Pair of hanging scrolls; ink on paper
33⅝ x 16⅜⁄₁₆ inches (85.4 x 41.4 cm), each
Muromachi period (1392–1568)
Bequest of Mrs. George H. Bunting, Jr. [81-27/30 a,b]

Shaka Triad with Sixteen Rakan, 1400/1450
Fabric triptych; ink, color, and gold paint on silk
69 x 63¾ inches (175.3 x 161.9 cm)
Muromachi period (1392–1568)
Purchase: acquired through the Edith
Ehrman Memorial Fund and the generosity
of Mr. John W. Gruber [F86-27]
[*See colorplate, p. 71*]

Attributed to Kanō Motonobu, 1476–1559
Landscape
Hanging scroll; ink and light color on paper
20¹⁄₁₆ x 13½ inches (51.0 x 34.3 cm)
Muromachi period (1392–1568)
Gift of Mrs. George H. Bunting, Jr. [70-42]

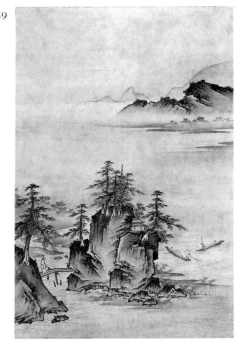

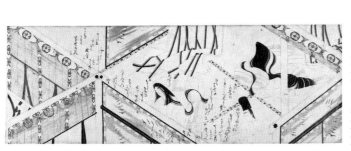

*Episode from "Pillow Book of Sei
Shonagon,"* 15th century
Handscroll section mounted as
hanging scroll; ink on paper
5¼ x 15⅞ inches (13.4 x 40.3 cm)
Muromachi period (1392–1568)
Bequest of Mrs. George H.
Bunting, Jr. [81-27/28]

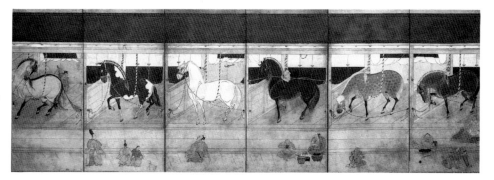

Horses and Attendants, 16th century
Six-fold screen; ink and color on paper
44 x 120 inches (111.8 x 304.8 cm)
Muromachi (1392–1568) to
Momoyama (1568–1614) period
Purchase: Nelson Trust [33-8/1]

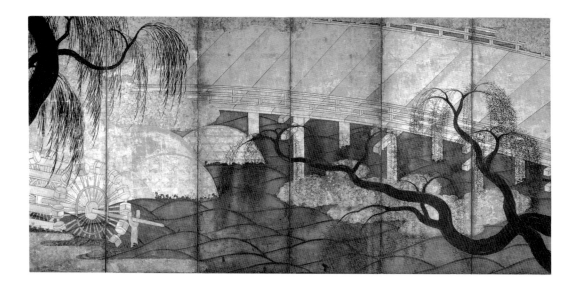

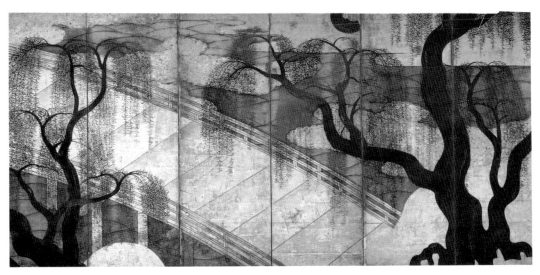

The River Bridge at Uji
Pair of six-fold screens; ink and color
over gold-foil ground on paper
67½ x 133¼ inches (171.4 x 338.5 cm), each
Momoyama period (1568–1614)
Purchase: Nelson Trust [58-53/1,2]
[*See colorplate, p. 73*]

Waters in Flood
Pair of six-fold screens; ink and color over gold-foil ground on paper
66¾ x 150 inches (169.6 x 381.0 cm), each
Momoyama period (1568–1614)
Purchase: Nelson Trust [69-20; 70-8]

Kaihō Yūshō, 1533–1615
Pine and Plum by Moonlight
Pair of six-fold screens; ink and slight color on paper
66½ x 139 inches (168.9 x 353.1 cm), each
Momoyama period (1568–1614)
Purchase: Nelson Trust [58-25/1,2]

Kaihō Yūshō, 1533–1615

The Four Scholarly Pastimes

Pair of six-fold screens; ink, color, and gold foil on paper

64 x 136¾ inches (162.6 x 347.3 cm), each

Momoyama period (1568–1614)

Purchase: Nelson Trust [60-13/1,2]

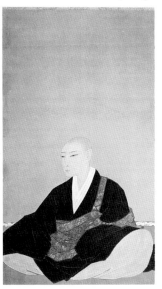

Tawaraya Sōtatsu, active c. 1600–1640
Illustration from "Tale of Ise," c. 1634
Album leaf mounted as hanging scroll;
ink, color, and gold paint on paper
9⅝ x 8¼ inches (24.4 x 21.0 cm)
Edo period (1615–1867)
Gift of Mrs. George H. Bunting, Jr. [74-37]

Kitagawa Sōsetsu, active mid
17th century
Chrysanthemums
Hanging scroll; ink, color, and gold
paint on paper
44⅝ x 17¼ inches (113.4 x 43.8 cm)
Edo period (1615–1867)
Gift of Mrs. George H. Bunting, Jr.
[68-49/1]

Tawaraya Sōtatsu,
active c. 1600–1640
Jittoku
Hanging scroll; ink on paper
37½ x 15¼ inches (95.3 x 38.7 cm)
Edo period (1615–1867)
Gift of Mrs. George H. Bunting, Jr.
[67-45/3]

Kanō Tanyū, 1602–1674
Dragon and Waves and *Tiger among Bamboo*
Pair of six-fold screens; ink on paper
61 x 141 inches (154.9 x 358.1 cm), each
Edo period (1615–1867)
Purchase: Nelson Trust [58-48/1,2]

Kaigetsudō Ando, 1671–1743
A Courtesan
Hanging scroll; ink and color on paper
40¼ x 17½ inches (102.3 x 44.5 cm)
Edo period (1615–1867)
Purchase: Nelson Trust [32-83/5]

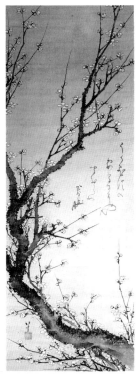

Katsushika Hokusai, 1760–1849
Flowering Plum, early 19th century
Hanging scroll; ink and color on
tinted silk
45�5/16 x 16⅜ inches (115.1 x 41.6 cm)
Edo period (1615–1867)
Purchase: Nelson Trust [32-83/7]

Mori Sosen, 1747–1821
*Shakyamuni Coming Down from the
Mountains (Shussan Shaka),* c. 1800
Hanging scroll; ink and light color on paper
42 x 21⅝ inches (106.7 x 54.9 cm)
Edo period (1615–1867)
Purchase: Nelson Trust [82-4]

Ike Taiga, 1723–1776
Impressive View of the Go River, 1769
Hanging scroll; ink on paper
51¹/16 x 22³/16 inches (129.7 x 56.3 cm)
Edo period (1615–1867)
Gift of Mr. William L. Evans, Jr. [79-6]

Katsushika Hokusai, 1760–1849
The Seven Gods of Good Fortune
Hanging scroll; ink and color on silk
16¼ x 25⅜ inches (41.3 x 64.4 cm)
Edo period (1615–1867)
Purchase: acquired through the generosity
of an anonymous donor [F74-33]

Maruyama Ōkyo, 1733–1795

Spring and Autumn with Children Playing on the Seashore, dated 1782

Pair of six-fold screens; ink, color, and gold paint on paper

67½ x 148½ inches (171.5 x 377.2 cm), each

Edo period (1615–1867)

Purchase: Nelson Trust [70-30/1,2]

Sakai Hōitsu, 1761–1828
The Thirty-six Master Poets
Two-fold screen; ink and color on paper
65 x 71 inches (165.1 x 180.3 cm)
Edo period (1615–1867)
Gift of Mrs. George H. Bunting, Jr. [77-50]

Tomioka Tessai, 1837–1924
Mountain and River Landscape, dated 1875
Pair of six-fold screens; ink on paper
67¾ x 147 inches (172.1 x 373.4 cm), each
Meiji period (1868–1912)
Gift of Mrs. George H. Bunting, Jr.
[75-31/1,2]

Yamamoto Baiitsu, 1783–1856
The Plum Blossom Studio, dated 1846
Hanging scroll; ink and light color on satin
52⅜ x 20¼ inches (133.0 x 51.4 cm)
Edo period (1615–1867)
Purchase: the Edith Ehrman
Memorial Fund [F79-13]

Tomioka Tessai, 1837–1924
Kanzan and Jittoku
Hanging scroll; ink on paper
53¾ x 19 inches (136.5 x 48.3 cm)
Meiji period (1868–1912)
Gift of I. Groupp and Julieann White
Groupp [73-48/1]

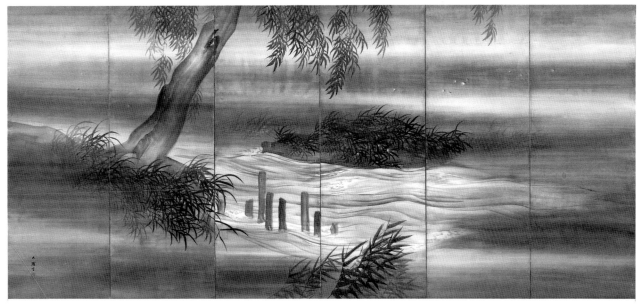

Shiokawa Bunrin, 1808–1877
River Landscape with Fireflies, dated 1874
Pair of six-fold screens; ink with slight color and gold paint on paper
68 x 148½ inches (172.7 x 377.2 cm), each
Meiji period (1868–1912)
Purchase: Nelson Trust [74-12/1,2]

Torii Kiyomasu I, active c. 1697–1720
*The Actors Ishikawa Danjūrō I and
Yamanaka Heikurō*, dated 1701
Hand-colored woodblock print
23¼ x 12¾ inches (59.1 x 32.4 cm)
Edo period (1615–1867)
Purchase: Nelson Trust [32-143/9]

Kitagawa Utamaro, 1754–1806
Two Women of the Lower Class, c. 1800
Color woodblock print
15¼ x 10⅛ inches (38.7 x 25.7 cm)
Edo period (1615–1867)
Purchase: Nelson Trust [32-143/146]

Katsushika Hokusai, 1760–1849
Kirifuri Waterfall at Mount Kurokami, c. 1831
Color woodblock print
14⅝ x 9⅝ inches (37.2 x 24.4 cm)
Edo period (1615–1867)
Purchase: Nelson Trust [32-143/183]
[*See colorplate, p. 75*]

Tōshūsai Sharaku, active 1794–1795
*The Actor Sawamura Sōjūrō III as
Ōtomo no Kuronushi*, c. 1794
Color woodblock print
11½ x 5¾ inches (29.2 x 14.6 cm)
Edo period (1615–1867)
Purchase: Nelson Trust [32-143/159]

Tsukioka Yoshitoshi, 1839–1892
The Fox Cry, dated 1886
Color woodblock print
12¹⁵⁄₁₆ x 8¾ inches (32.9 x 22.2 cm)
Meiji period (1868–1912)
Gift of Mr. and Mrs. Charles A.
Duboc [F89-7/1]

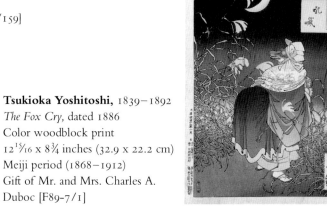

Decorative Arts

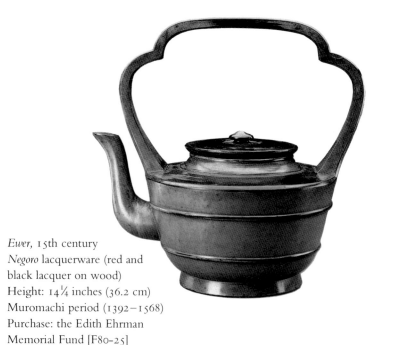

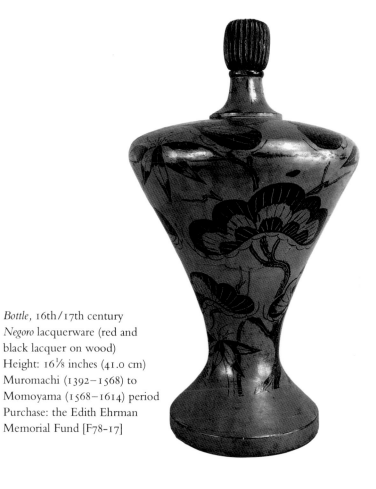

Ewer, 15th century
Negoro lacquerware (red and
black lacquer on wood)
Height: 14¼ inches (36.2 cm)
Muromachi period (1392–1568)
Purchase: the Edith Ehrman
Memorial Fund [F80-25]

Bottle, 16th/17th century
Negoro lacquerware (red and
black lacquer on wood)
Height: 16⅛ inches (41.0 cm)
Muromachi (1392–1568) to
Momoyama (1568–1614) period
Purchase: the Edith Ehrman
Memorial Fund [F78-17]

Sake Bottle, 16th century
Negoro lacquerware (red and black lacquer on wood)
Height: 7¼ inches (18.4 cm)
Muromachi (1392–1568) to Momoyama (1568–1614) period
Gift of Mr. W. M. Ittmann, Jr. [68-22]

Covered Container
Kamakura-bori lacquerware
(red and black lacquer on carved wood)
Diameter: 8¾ inches (22.3 cm)
Momoyama period (1568–1614)
Bequest of Mr. John S. Thacher [F85-14/7]

Suit of Armor (detail), c. 1600
Iron with lacquered metal plates,
chain mail, leather, brocaded silk,
silk tape, and gilt ornaments
Height: 61 inches (154.9 cm)
Momoyama period (1568–1614)
Purchase: Nelson Trust [32-202/27 a–i]

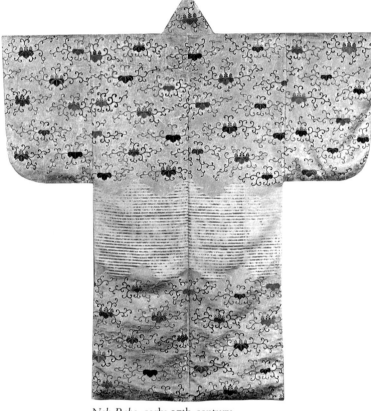

Noh Robe, early 17th century
Gold and silver foil with embroidery on silk
58 x 62 inches (147.3 x 157.5 cm)
Edo period (1615–1867)
Purchase: Nelson Trust [32-142/1]

Saddle, c. 1600
Lacquered wood
Length: 15¾ inches (40.0 cm)
By Motoyoshi, active early 17th century
Momoyama period (1568–1614)
Purchase: Nelson Trust [32-202/14]

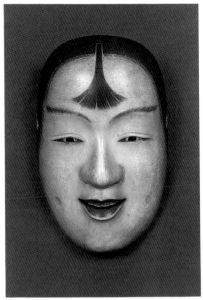

Noh Mask of a Youthful Attendant,
late 17th/early 18th century
Painted wood
Height: 8¼ inches (21.0 cm)
Edo period (1615–1867)
Gift of Lincoln Kirstein in memory
of Mrs. George H. Bunting, Jr. [81-63]

Cabinet, 18th century
Lacquered wood with metal
hinges and fittings
31⅛ x 24⁷⁄₁₆ x 9⁷⁄₁₆ inches
(79.0 x 62.1 x 24.0 cm)
Edo period (1615–1867)
Bequest of Mr. John S. Thacher
[F85-14/9]

Tiered Writing Box, c. 1775
Lacquered wood with gold and silver inlays
8½ x 13¾ x 8¼ inches
(21.5 x 35.0 x 21.0 cm)
By Izuka Tōyō, active c. 1760–1780
Edo period (1615–1867)
Purchase: the David T. Beals III Fund [F78-23]
[*See colorplate, p. 74*]

Writing Table and Utensil Box
Lacquered wood with gold flecks
(*maki-e*) and engraved bronze fittings
5¹¹⁄₁₆ x 25⅛ x 14⁵⁄₁₆ inches
(14.4 x 63.8 x 36.4 cm), table;
1¹³⁄₁₆ x 8¼ x 8⅞ inches
(4.7 x 21.0 x 22.6 cm), box
Meiji period (1868–1912)
Gift of Mrs. Jack Rieger in memory
of Mrs. Hortense P. Lorie [F76-30 a,b]

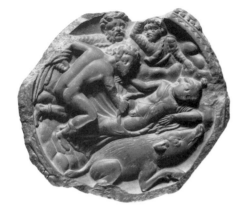

Patera or Cosmetic Tray, 1st century A.D.
Steatite (soapstone)
Diameter: 3 ⅞ inches (9.8 cm)
Taxila, Pakistan (Gandhara)
Indo-Parthian period
(1st century B.C.–1st century A.D.)
Purchase: Nelson Trust [49-8]

Head of a Buddha, late 2nd century
Gypsum rock
Height: 19¼ inches (48.9 cm)
Pakistan (Gandhara)
Kushana period (1st–4th century A.D.)
Purchase: Nelson Trust [33-350]

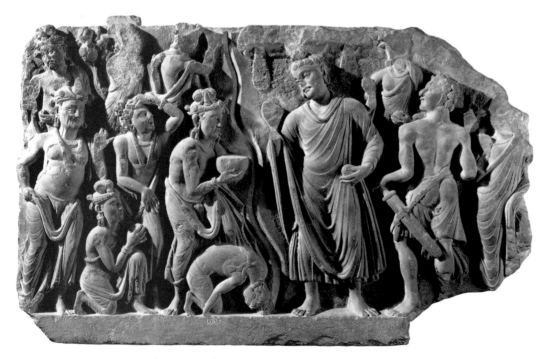

Scene from the Life of the Buddha, late 2nd century
Phyllite
22½ x 36 inches (57.2 x 91.4 cm), maximum dimensions
Pakistan (Gandhara)
Kushana period (1st–4th century A.D.)
Purchase: Nelson Trust [55-105]

The Bodhisattva Maitreya, early 3rd century
Phyllite with traces of paint
Height: 55 inches (139.7 cm)
Pakistan (Gandhara)
Kushana period (1st–4th century A.D.)
Purchase: Nelson Trust [35-32]

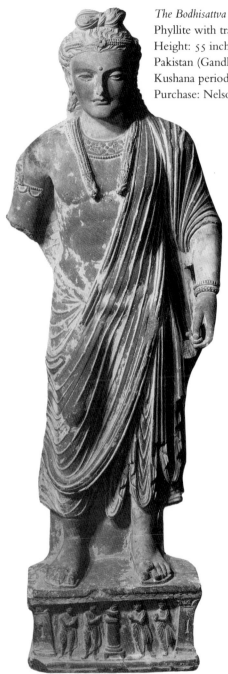

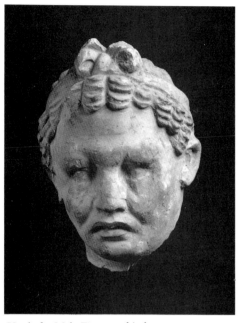

Head of a Male Figure, 3rd/5th century
Stucco
Height: 6⅝ inches (16.8 cm)
Taxila, Pakistan, or Hadda,
Afghanistan (Gandhara)
Kushana (1st–4th century A.D.) or
Later Kushana (4th–5th century A.D.) period
Purchase: Nelson Trust [31-64]

Head of a Buddha,
late 4th/5th century
Stucco with traces of paint
Height: 7 inches (17.8 cm)
Taxila, Pakistan, or Hadda,
Afghanistan (Gandhara)
Later Kushana period
(4th–5th century A.D.)
Purchase: Nelson Trust [61-46]

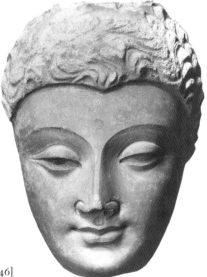

INDIA

Yakshi (Nature Spirit), 2nd century
Bronze
Height: 4½ inches (11.4 cm)
Mathura
Kushana period (1st–3rd century A.D.)
Purchase: Nelson Trust [53-52]

Yakshi (Nature Spirit), 2nd century
Sandstone
Height: 18¼ inches (46.4 cm)
Mathura
Kushana period (1st–3rd century A.D.)
Purchase: Nelson Trust [62-57]

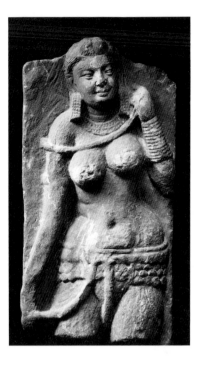

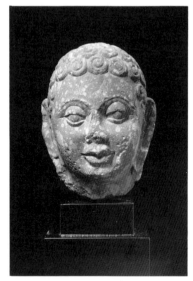

Head of a Jina, late 2nd/early 3rd century
Sandstone
Height: 5 inches (12.7 cm)
Mathura
Kushana period (1st–3rd century A.D.)
Purchase: Nelson Trust [35-305]

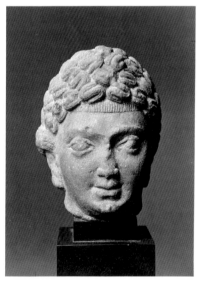

Male Head, 2nd century
Sandstone
Height: 5⅛ inches (13.0 cm)
Mathura
Kushana period (1st–3rd century A.D.)
Purchase: Nelson Trust [51-32]

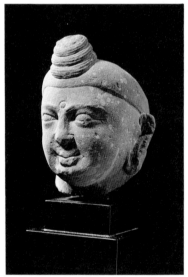

Head of a Buddha, late 1st/early 2nd century
Sandstone
Height: 5¼ inches (13.3 cm)
Mathura
Kushana period (1st–3rd century A.D.)
Purchase: Nelson Trust [35-306]

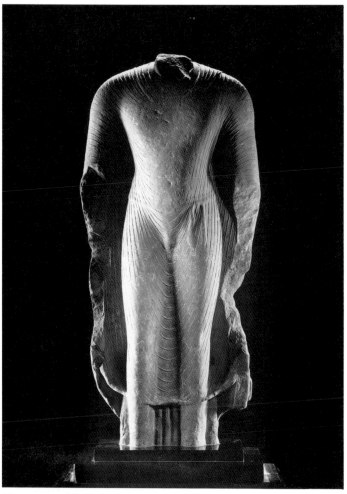

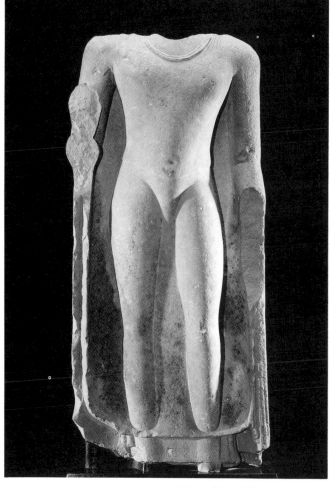

Torso of a Buddha, 5th century
Sandstone
Height: 45¼ inches (115.0 cm)
Mathura
Gupta period (A.D. 320–551)
Purchase: Nelson Trust [45-15]
[*See colorplate, p. 76*]

Torso of a Buddha, 5th century
Sandstone
Height: 34 inches (86.4 cm)
Sarnath
Gupta period (A.D. 320–551)
Purchase: Nelson Trust [39-19]

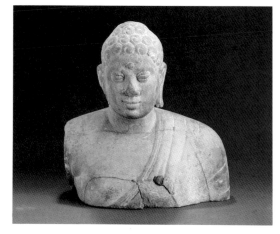

Bust of a Buddha, 3rd century
Limestone
Height: 12⅛ inches (30.8 cm)
Amaravati (Eastern Deccan)
Satavahana (1st century B.C.–mid 3rd century A.D.)
or Ikshvaku (mid–late 3rd century A.D.) period
Bequest of Mrs. George H. Bunting, Jr. [81-27/25]

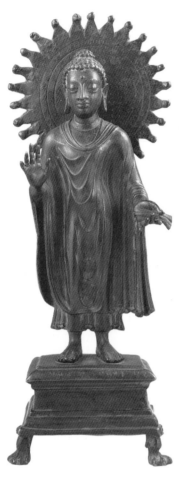

Standing Buddha, c. A.D. 400
Bronze
Height: 14⅝ inches (37.2 cm)
Dhanesar Khera (Uttar Pradesh)
Gupta period (A.D. 320–551)
Purchase: Nelson Trust [44-13]

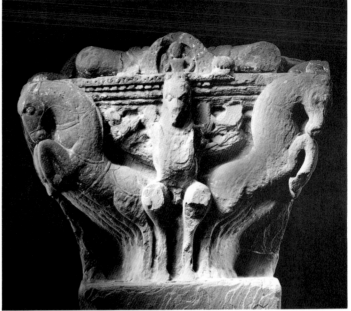

Base of a Surya Image
Sandstone
Height: 33½ inches (85.1 cm)
Mathura
Post-Gupta period (6th–7th century A.D.)
Purchase: Nelson Trust [48-19]

Head of Vishnu, mid 5th century
Sandstone
Height: 24½ inches (62.2 cm)
Mathura
Gupta period (A.D. 320–551)
Purchase: Nelson Trust [62-26]

Surya, the Sun God, c. A.D. 600
Bronze
Height: 6¾ inches (17.1 cm)
Uttar Pradesh
Post-Gupta period (6th–7th century A.D.)
Purchase: Nelson Trust [54-75]

A Makara, 5th century
Earthenware
9⁷⁄₁₆ x 14¹⁵⁄₁₆ inches (24.0 x 38.0 cm),
maximum dimensions
Mathura
Gupta period (A.D. 320–551)
Purchase: acquired through the generosity
of Mr. and Mrs. Earl D. Wilberg [F83-38]

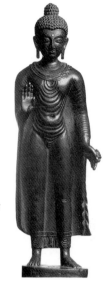

Standing Buddha, 10th/11th century
Bronze with silver inlay
Height: 10⅜ inches (26.4 cm)
Kashmir
Purchase: Nelson Trust [51-55]

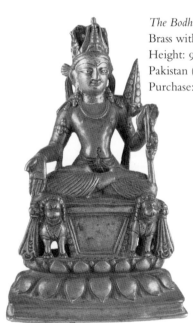

The Bodhisattva Maitreya, 8th century A.D.
Brass with silver inlay and traces of paint
Height: 9⅞ inches (25.1 cm)
Pakistan (Gilgit or Swat) or India (Kashmir)
Purchase: Nelson Trust [66-22]

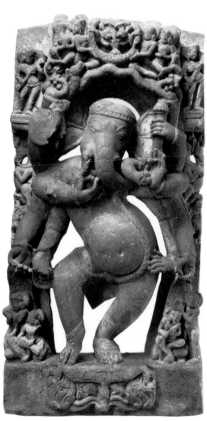

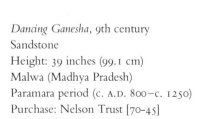

Dancing Ganesha, 9th century
Sandstone
Height: 39 inches (99.1 cm)
Malwa (Madhya Pradesh)
Paramara period (c. A.D. 800–c. 1250)
Purchase: Nelson Trust [70-45]

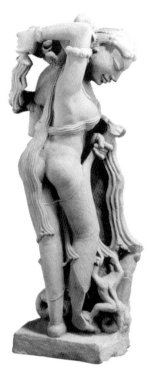

A Celestial Nymph, 10th century
Sandstone
Height: 23¾ inches (60.3 cm)
Khajuraho (Madhya Pradesh)
Chandella period (c. A.D. 825–1310)
Bequest of Mrs. George H. Bunting, Jr. [81-27/26]

Rishabhanatha, the First Jain Tirthankara, 10th/11th century
Sandstone
Height: 16½ inches (41.9 cm)
Madhya Pradesh
Probably Chandella period
(c. A.D. 825–1310)
Purchase: Nelson Trust [60-69]

Standing Shiva, early 11th century
Sandstone
Height: 31 inches (78.7 cm)
Khajuraho (Madhya Pradesh)
Chandella period (c. A.D. 825–1310)
Purchase: Nelson Trust [60-68]

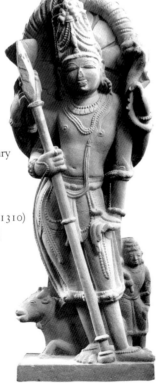

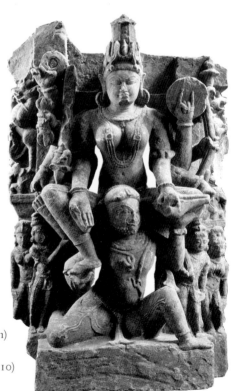

Chakreshvari, 11th century
Sandstone
31¾ x 20¼ inches (80.7 x 51.5 cm)
Khajuraho (Madhya Pradesh)
Chandella period (c. A.D. 825–1310)
Purchase: Nelson Trust [60-82]

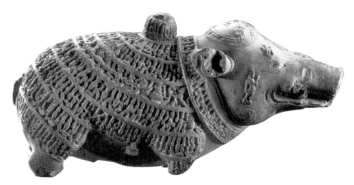

Dancing Bracket Figure, 12th century
Sandstone
Height: 24½ inches (62.2 cm)
Khajuraho (Madhya Pradesh)
Chandella period (c. A.D. 825–1310)
Purchase: Nelson Trust [40-18]

Vishnu as the Boar Varaha, 11th/13th century
Limestone
Length: 16¾ inches (42.6 cm)
Gujarat or Rajasthan
Solanki period (10th–13th century),
Maru-Gurjara style (11th–13th century)
Purchase: Nelson Trust [44-47]

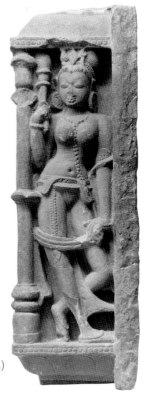

Shiva and Parvati on the Bull Nandi, c. A.D. 973
Sandstone
18 x 33¾ inches (45.7 x 85.7 cm), maximum dimensions
Sikar (Rajasthan)
Cahamana period (c. A.D. 973–1192),
Maha-Meru style (early 8th–mid 10th century A.D.)
Purchase: Nelson Trust [35-304]

Chauri Bearer, 8th/9th century
Sandstone
23 x 7¾ inches (58.4 x 19.7 cm)
Rajasthan or Madhya Pradesh
Gurjara-Pratihara period (7th–11th century A.D.)
Purchase: Nelson Trust [59-14]

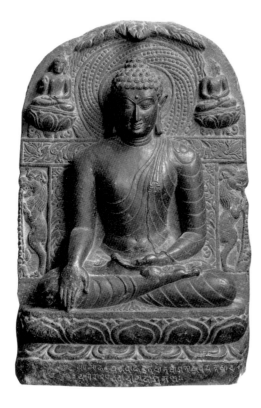

Seated Buddha, 9th century
Schist
21½ x 14½ inches (54.6 x 36.9 cm),
maximum dimensions
Bihar
Pala period (c. A.D. 756–c. 1170)
Purchase: Nelson Trust [31-63]

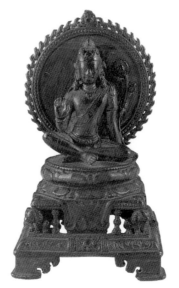

Padmapani Avalokiteshvara, 9th century
Bronze with traces of gilding
Height: 6¼ inches (15.9 cm)
Nalanda (Bihar)
Pala period (c. A.D. 756–c. 1170)
Purchase: Nelson Trust [54-73]

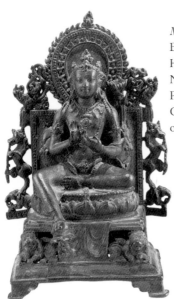

Manjuvara Vadiraj, early 9th century
Bronze
Height: 8⅛ inches (20.5 cm)
Nalanda (Bihar)
Pala period (c. A.D. 756–c. 1170)
Gift of Fred and Grace Kaler in honor
of Laurence Sickman [75-32/4]

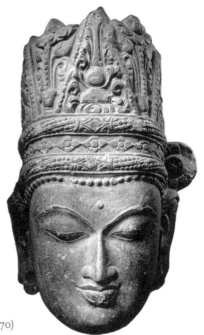

Head of a Crowned Buddha,
late 10th/early 11th century
Schist
Height: 15½ inches (39.4 cm)
Bihar
Pala period (c. A.D. 756–c. 1170)
Purchase: Nelson Trust [43-16]

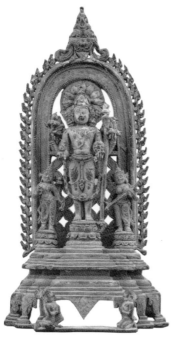

A Jina Seated in Meditation, 9th century
Bronze
Height: 8½ inches (21.6 cm)
Western Deccan
Western Ganga period (4th–10th century A.D.)
Purchase: Nelson Trust [62-49]

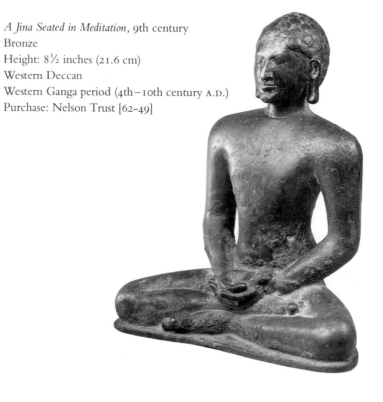

Vishnu with Lakshmi and Sarasvati,
c. 12th century
Bronze with traces of paint
Height: 7⁵⁄₁₆ inches (18.6 cm)
Bangladesh (Rangpur District)
Pala period (c. A.D. 756–c. 1170)
Purchase: Nelson Trust [63-3]

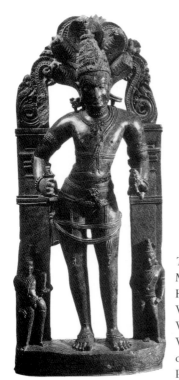

Shiva Vishapaharana, 9th/10th century
Bronze
Height: 18½ inches (47.0 cm)
Eastern Deccan
Eastern Chalukya period
(7th–11th century)
Purchase: Nelson Trust [50-17]

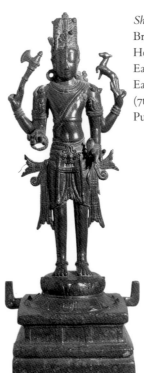

The Naga King Dharanendra, 10th century
Magnesian schist
Height: 23¾ inches (60.3 cm)
Western Deccan
Western Chalukya (10th–12th century),
Western Ganga (4th–10th century),
or Shantara (9th–11th century) period
Purchase: Nelson Trust [51-26]

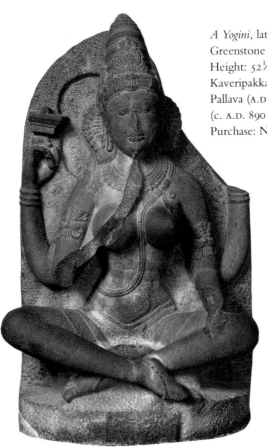

A Yogini, late 9th/early 10th century
Greenstone
Height: 52½ inches (133.4 cm)
Kaveripakkam (Tamilnadu)
Pallava (A.D. 550–890) to Chola
(c. A.D. 890–1279) period
Purchase: Nelson Trust [44-27]

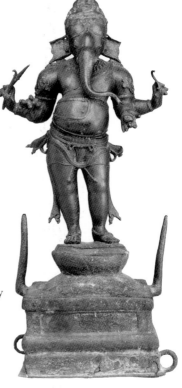

Ganesha, late 10th/early 11th century
Bronze
Height: 23¾ inches (60.3 cm)
Tamilnadu
Chola period (c. A.D. 890–1279)
Purchase: Nelson Trust [62-14]

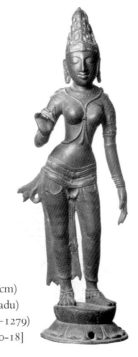

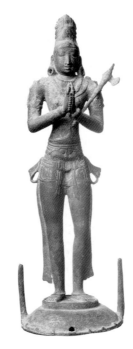

Parvati, 10th century
Bronze
Height: 20½ inches (52.1 cm)
Thanjavur region (Tamilnadu)
Chola period (c. A.D. 890–1279)
Purchase: Nelson Trust [50-18]

Chandikeshvara, 11th century
Bronze
Height: 16¼ inches (41.3 cm)
Thanjavur region (Tamilnadu)
Chola period (c. A.D. 890–1279)
Purchase: Nelson Trust [50-19]

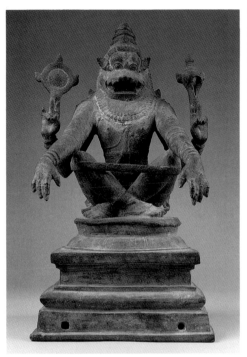

Yoga-Narashimha, 12th century
Bronze
Height: 19⅜ inches (49.2 cm)
Thanjavur region (Tamilnadu)
Chola period (c. A.D. 890–1279)
Purchase: Nelson Trust [63-2]

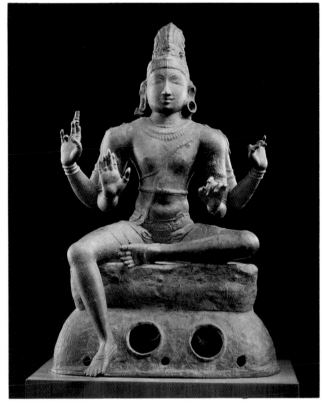

Shiva Seated at Ease, 12th century
Bronze
Height: 24½ inches (62.2 cm)
Tamilnadu
Chola period (c. A.D. 890–1279)
Purchase: Nelson Trust [61-7]

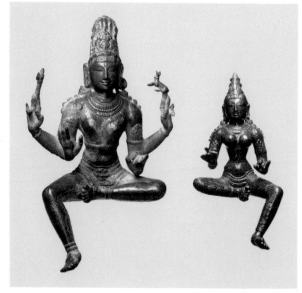

Shiva and *Parvati*, 12th century
Bronze
Height: 16 inches (40.6 cm); 11 inches (27.9 cm)
Tamilnadu
Chola period (c. A.D. 890–1279)
Purchase: Nelson Trust [34-8,9]

Shiva Nataraja, 13th century
Bronze
Height: 13³⁄₁₆ inches (33.5 cm)
Tamilnadu
Chola period (c. A.D. 890–1279)
Purchase: Nelson Trust [50-20]

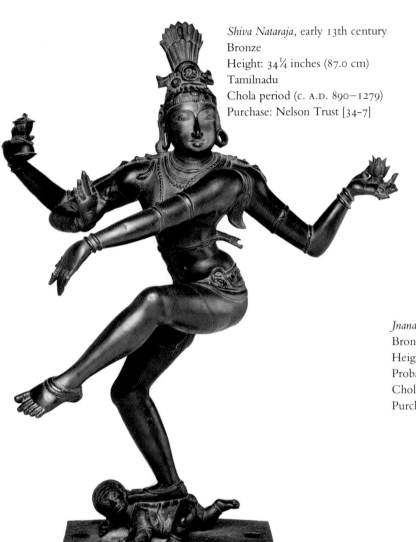

Shiva Nataraja, early 13th century
Bronze
Height: 34¼ inches (87.0 cm)
Tamilnadu
Chola period (c. A.D. 890–1279)
Purchase: Nelson Trust [34-7]

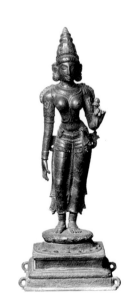

Jnanasambandar, a Shaiva Saint, 13th century
Bronze
Height: 26 inches (66.0 cm)
Probably Thanjavur region (Tamilnadu)
Chola period (c. A.D. 890–1279)
Purchase: Nelson Trust [34-5]

Vishnu and *Shridevi,* late 12th century
Bronze
Height: 21 inches (53.3 cm);
17¾ inches (45.1 cm)
Tirunelveli District (Tamilnadu)
Later Pandya period (12th–14th century)
Purchase: Nelson Trust [56-109,110]

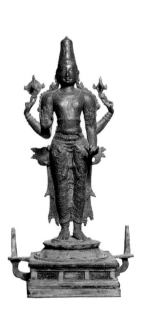

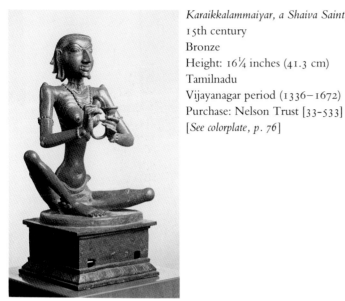

Karaikkalammaiyar, a Shaiva Saint,
15th century
Bronze
Height: 16¼ inches (41.3 cm)
Tamilnadu
Vijayanagar period (1336–1672)
Purchase: Nelson Trust [33-533]
[*See colorplate, p. 76*]

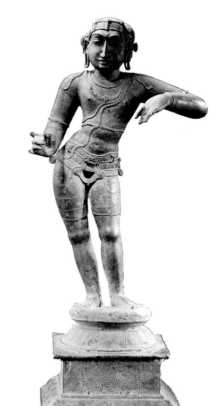

Sundaramurti, a Shaiva Saint,
15th/16th century
Bronze
Height: 26 inches (66.0 cm)
Tamilnadu
Vijayanagar period (1336–1672)
Purchase: Nelson Trust [45-18]

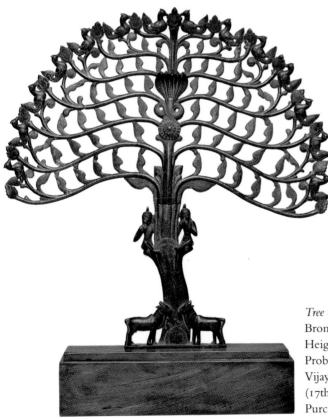

Tree of Life, late 16th/17th century
Bronze
Height: 24 inches (61.0 cm)
Probably Tamilnadu
Vijayanagar (1336–1672) or Nayaka
(17th–18th century) period
Purchase: Nelson Trust [41-35]

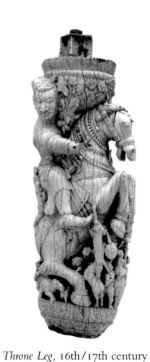

Throne Leg, 16th/17th century
Ivory
Height: 12 inches (30.5 cm)
Orissa
Mughal period (16th–19th century)
Purchase: Nelson Trust [64-1]

Illustration from Kalpa Sutra (detail), 15th century
Watercolor and gold paint on paper
4⁵⁄₁₆ x 10¼ inches (10.9 x 26.0 cm), overall
Gujarat
Early Western Indian style, Jain art (11th–16th century)
Purchase: Nelson Trust [35-176]

Illustration from Khamsa of Amir Khusrau Dihlavi, 1450/1500
Watercolor and ink on paper
4½ x 8¼ inches (11.4 x 21.0 cm)
Delhi or Jaunpur
Delhi Sultanate period (1173–1526)
Purchase: Nelson Trust [62-58]

Attributed to Lal, active c. 1590 or earlier–1605
The Poet and the Prince, page from a *Jahangiri* album, 1595/97
Watercolor and gold paint on paper
16⅝ x 10½ inches (42.3 x 26.7 cm), sheet;
8¾ x 4½ inches (22.2 x 11.4 cm), image
Agra or Allahabad (Mughal)
Akbar period (1556–1605)
Purchase: Nelson Trust [48-12/1]
[*See colorplate, p. 77*]

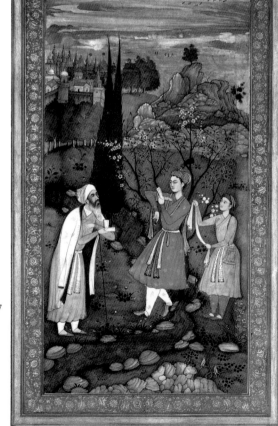

Attributed to Farrukh (Chela),
active c. 1585–c. 1604
A Buffalo Fighting a Lioness, page
from a *Jahangiri* album, late 16th century
Watercolor and gold paint on paper
16⅛ x 10⅜ inches (42.3 x 26.4 cm), sheet;
5¾ x 3⁵⁄₁₆ inches (14.6 x 8.4 cm), image
Agra or Allahabad (Mughal)
Akbar period (1556–1605)
Purchase: Nelson Trust [48-12/2]

Lovers in a Pavilion, page from a
Ragamala manuscript, 17th century
Watercolor on paper
8¾ x 6 inches (22.2 x 15.2 cm), image
Madhya Pradesh
Malwa school (c. 1620–1750)
Purchase: Nelson Trust [62-59]

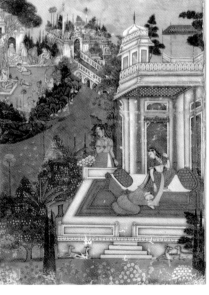

Dhanasri Ragini and *Ramakali Ragini,* pages from
a *Ragamala* manuscript, mid 18th century
Watercolor and gold paint on paper
12⅜ x 9⅛ inches (31.5 x 23.2 cm);
13 x 9⅜ inches (33.0 x 23.8 cm)
Hyderabad
Asifiya period (1724–1950)
Purchase: Nelson Trust [31-131/7,9]

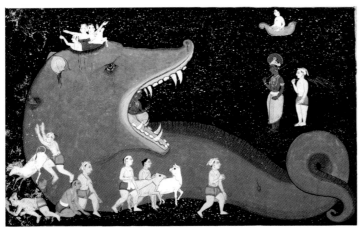

Krishna's Victory over Aghasura, early 18th century
Watercolor on paper
9¾ x 15⅝ inches (24.8 x 39.6 cm)
Rajasthan
Mewar school (c. 1600–1900)
Purchase: Nelson Trust [60-34]

Country Gathering about a Shrine, 1720/40
Ink and wash on paper
6⅝ x 8¼ inches (16.8 x 21.0 cm)
Pahari
Chamba school (c. 1660–1860)
Purchase: Nelson Trust [54-82]

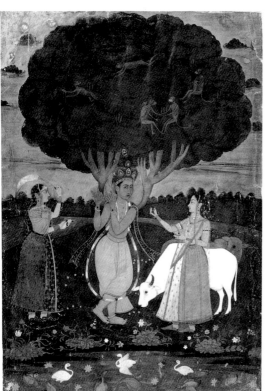

Krishna Playing the Flute, mid 18th century
Watercolor and gold paint on paper
11⅞ x 8⅜ inches (30.2 x 21.3 cm)
Rajasthan
Jaipur school (c. 1640–1850)
Purchase: Nelson Trust [31-131/8]

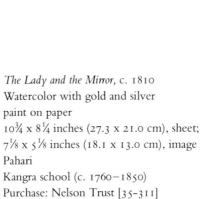

The Lady and the Mirror, c. 1810
Watercolor with gold and silver
paint on paper
10¾ x 8¼ inches (27.3 x 21.0 cm), sheet;
7⅛ x 5⅛ inches (18.1 x 13.0 cm), image
Pahari
Kangra school (c. 1760–1850)
Purchase: Nelson Trust [35-311]

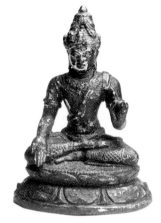

Avalokiteshvara, late 8th century
Bronze with traces of gilding
Height: 5¾ inches (14.6 cm)
Indonesia (Central Java)
Shailendra period (c. A.D. 750–c. 850)
Purchase: Nelson Trust [57-42]

*Stele with Scenes from the Life of the
Buddha*, 11th century
Stone with traces of color and gilding
5½ x 3⅜ inches (14.0 x 9.2 cm),
maximum dimensions
Burma
Pagan period (mid 9th century–1320)
Purchase: acquired through the generosity of
members of the Asia Society, New York [F72-12]

The Bodhisattva Padmapani, 8th/9th century
Bronze
Height: 4¹⁵⁄₁₆ inches (12.5 cm)
Indonesia (Central Java)
Shailendra period (c. A.D. 750–c. 850)
Purchase: Nelson Trust [56-75]

*Lintel Fragment with Scene of Indra
on His Three-Headed Elephant*,
late 10th century
Sandstone
22½ x 16¼ inches (57.2 x 41.3 cm),
maximum dimensions
Cambodia
Banteay Srei style (A.D. 967–c. 1000)
Purchase: Nelson Trust [49-20]

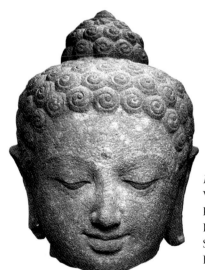

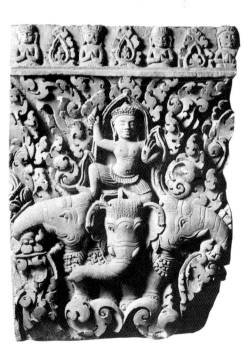

Head of a Buddha, c. A.D. 825
Volcanic stone
Height: 12¼ inches (31.1 cm)
Indonesia (Central Java)
Shailendra period (c. A.D. 750–c. 850)
Purchase: Nelson Trust [55-104]

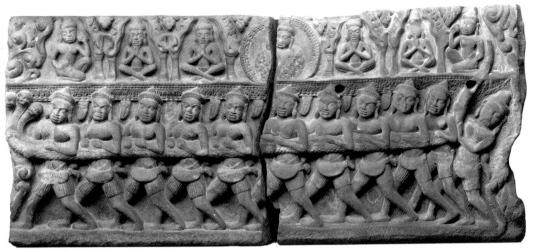

Lintel with Scene of Gods and Demons Carrying the Serpent Vasuki, 11th century
Sandstone
30 x 69 inches (76.2 x 175.3 cm), maximum dimensions
Cambodia
Baphuon style (c. 1010–c. 1080)
Purchase: Nelson Trust [48-18]

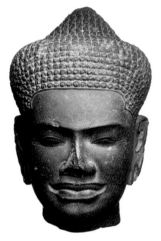

Head of a Buddha, 11th century
Gray stone
Height: 9⅝ inches (24.5 cm)
Cambodia
Baphuon style (c. 1010–c. 1080)
Purchase: Nelson Trust [56-87]

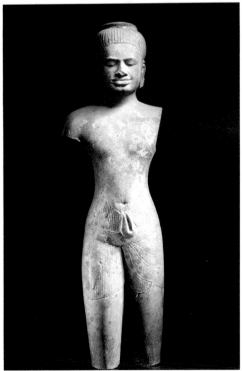

Standing Male Figure, 11th century
Sandstone with traces of gilding
Height: 28½ inches (72.4 cm)
Cambodia
Baphuon style (c. 1010–c. 1080)
Purchase: Nelson Trust [46-34]

Battle Standard Representing Garuda, late 11th century
Bronze
Height: 5½ inches (14.0 cm)
Cambodia
Baphuon style (c. 1010–c. 1080)
Purchase: Nelson Trust with the assistance of the
Hallmark Oriental Endowment Fund and the
exchange of the bequest of Joseph H. Heil [88-27]

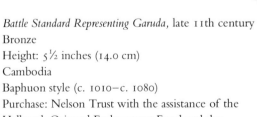

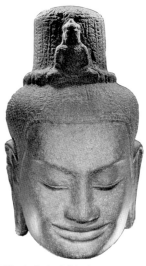

Head of Avalokiteshvara
Sandstone
Height: 11⅛ inches (28.2 cm)
Cambodia
Bayon style (late 12th–early 13th century)
Purchase: Nelson Trust [30-34]

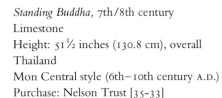

Standing Buddha, 7th/8th century
Limestone
Height: 51½ inches (130.8 cm), overall
Thailand
Mon Central style (6th–10th century A.D.)
Purchase: Nelson Trust [35-33]

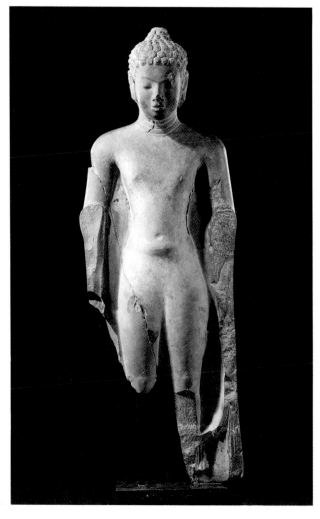

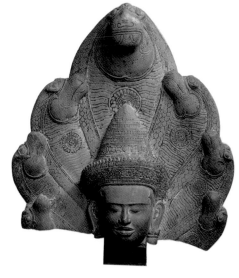

Buddha, 15th century
Bronze
Height: 23¾ inches (60.3 cm)
North Thailand
Thai Lan Na style (13th–19th century)
Purchase: Nelson Trust [59-16]

*Head of a Buddha Sheltered by the
Serpent King Muchalinda*, 14th century
Limestone with traces of paint
Height: 18 inches (45.7 cm)
Thailand
Khmer northeastern style,
Post-Bayon period (13th–14th century)
Gift of Mr. Earle Grant [60-78]

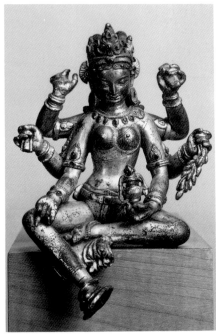

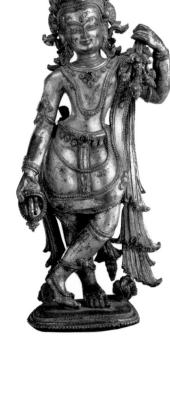

Chintamani-Lokeshvara, c. 1600
Gilt copper with semiprecious-stone inlay
Height: 9¹⁵⁄₁₆ inches (25.3 cm)
Nepal
Late Malla period (1482–1769)
Gift of Karen Ann Bunting and
Mr. and Mrs. O. G. Bunting [F86-44/1]

Vasudhara, the Goddess of Abundance, 14th century
Gilt copper with semiprecious-stone inlay
Height: 5½ inches (14.0 cm)
Nepal
Early Malla period (1200–1482)
Purchase: Nelson Trust [58-7]

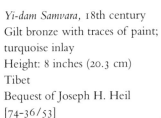

Mahasiddha, 16th/17th century
Silver with turquoise inlay
Height: 7⅝ inches (19.3 cm)
Central Tibet (Tsang)
Bequest of Joseph H. Heil
[74-36/48]

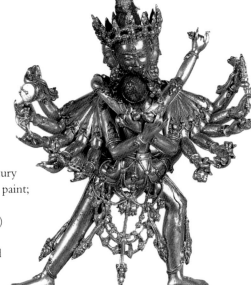

Yi-dam Samvara, 18th century
Gilt bronze with traces of paint;
turquoise inlay
Height: 8 inches (20.3 cm)
Tibet
Bequest of Joseph H. Heil
[74-36/53]

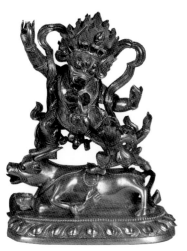

Dharmapala Yama with His Sister Yami, 17th century
Gilt bronze with traces of paint
Height: 7 inches (17.8 cm)
China, Tibeto-Chinese art
Ch'ing period (1644–1911)
Bequest of Joseph H. Heil [74-36/54]

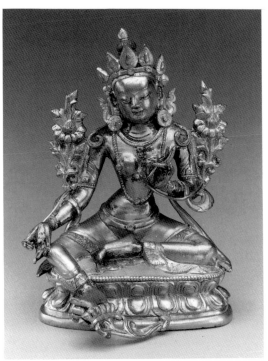

The Green Tara, 18th century
Gilt brass
Height: 4¼ inches (10.8 cm)
China, Tibeto-Chinese art
Ch'ing period (1644–1911)
Gift of Fred and Grace Kaler [F82-29/4]

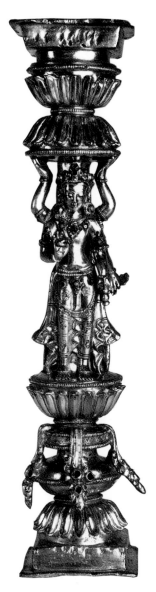

Section of a Pillar or Support, 18th/19th century
Gilt bronze with turquoise and
semiprecious-stone inlays
Height: 10¾ inches (27.3 cm)
Tibet
Gift of Mr. William L. Evans, Jr. [F78-22]

Padmasambhava on His Copper-Colored Mountain, 18th century
Thanka; colors on cotton, mounted on silk brocade
28¼ x 19⅝ inches (71.8 x 49.8 cm)
South Central Tibet
Probably Khyenri Serma style (17th–20th century)
Bequest of Joseph H. Heil [74-36/3]

Four Mandalas, 18th century
Thanka; colors on cotton, mounted on silk brocade
31¾ x 24 inches (80.7 x 61.0 cm)
Central Tibet
Menri Serma style (16th–20th century)
Bequest of Joseph H. Heil [74-36/16]

Darmapala Sitabrahma, 18th century
Thanka; colors on cotton, mounted on silk brocade
26 x 16¾ inches (66.0 x 42.6 cm)
China, Tibeto-Chinese art
Ch'ing period (1644–1911)
Purchase: Nelson Trust [34-256]

The White Mahakala, 18th century
Thanka; colors on cotton, mounted on silk brocade
30⅞ x 20¼ inches (78.5 x 51.4 cm)
China, Tibeto-Chinese art
Ch'ing period (1644–1911)
Gift of Mr. Laurence Sickman [78-29]

Platter with Kufic Inscription,
10th century
Earthenware with underglaze
slip-painted decoration
Diameter: 16½ inches (41.9 cm)
Soghd region
Purchase: Nelson Trust [54-80]

Bowl, 10th century
Earthenware with underglaze painted decoration
Diameter: 9⅞ inches (25.1 cm)
Soghd region
Purchase: Nelson Trust [54-79]

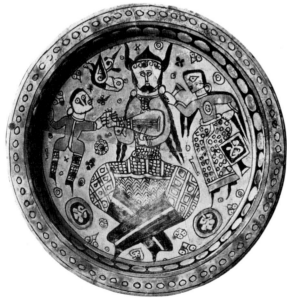

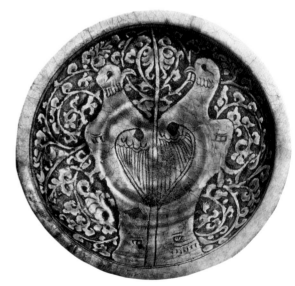

Footed Platter with Scene of Musician, 10th century
Earthenware with underglaze slip-painted decoration
Diameter: 13¼ inches (33.7 cm)
Soghd region
Purchase: Nelson Trust [53-10]

Bowl with Double-Headed Bird, 12th century
Glazed earthenware with relief decoration
Diameter: 14⅛ inches (35.9 cm)
Purchase: Nelson Trust [32-25]

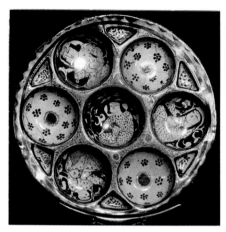

Sweetmeat Dish, late 12th century
Lusterware (earthenware with iridescent glaze
and underglaze painted decoration)
Diameter: 12⅞ inches (32.7 cm)
Kashan
Purchase: Nelson Trust [32-110]

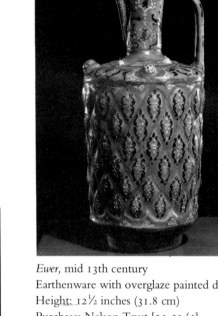

Ewer, mid 13th century
Earthenware with overglaze painted decoration
Height: 12½ inches (31.8 cm)
Purchase: Nelson Trust [35-31/5]

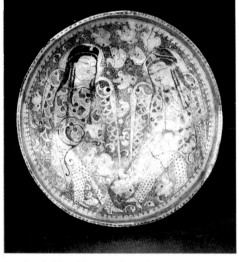

Bowl with Two Houri, early 13th century
Lusterware (earthenware with iridescent glaze
and underglaze painted decoration)
Diameter: 7¾ inches (19.7 cm)
Kashan
Purchase: Nelson Trust [32-120/5]

Bowl with Scene of Courtier and Attendants,
late 12th/early 13th century
Earthenware with overglaze painted decoration
Diameter: 7⅜ inches (19.4 cm)
Purchase: Nelson Trust [32-24]

Footed Bowl (interior), 13th century
Earthenware with underglaze painted decoration
Diameter: 8½ inches (21.6 cm)
Purchase: acquired through the generosity of
Mr. and Mrs. Milton McGreevy
through the Mission Fund [F72-32]

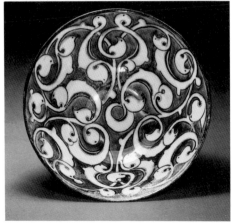

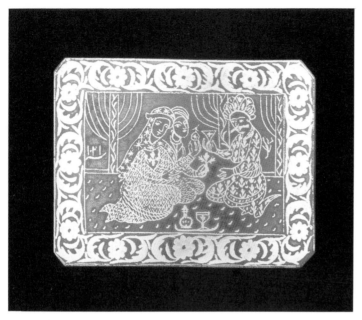

Buckle, late 19th century
Steel with gold inlay
2¾ x 3¾ inches (7.0 x 9.5 cm)
Purchase: Nelson Trust [34-223]

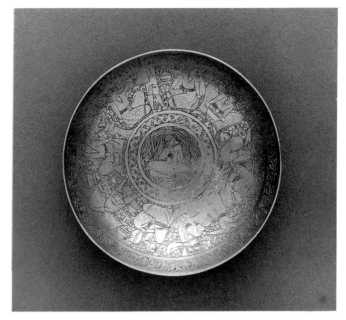

Drinking Bowl, late 19th century
Engraved and chased silver
Diameter: 3⅞ inches (10.0 cm)
Gift of Miss Emma Serl [56-127/3]

Candlestick, 13th century
Engraved brass with silver and gold inlays
Height: 9⅜ inches (23.8 cm)
Persia or Turkey
Purchase: Nelson Trust [51-6]
[*See colorplate, p. 78*]

Kettle, late 12th century
Cast, engraved, and hammered copper alloy
Height: 7⅞ inches (20.1 cm), excluding handle
Purchase: acquired through the generosity
of Mr. and Mrs. Milton McGreevy
through the Westport Fund [F70-15/8]

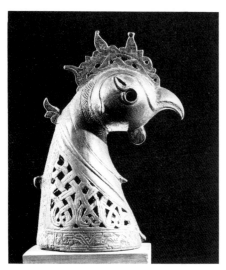

Incense Burner Top in the Form of a Griffin, 12th century
Copper alloy
Height: 6¾ inches (17.2 cm)
Possibly Khurasan region
Purchase: Nelson Trust [51-22]

Incense Burner in the Form of a Tiger, 12th century
Bronze
Height: 11⅝ inches (29.5 cm)
Possibly Khurasan region
Purchase: Nelson Trust [51-5]

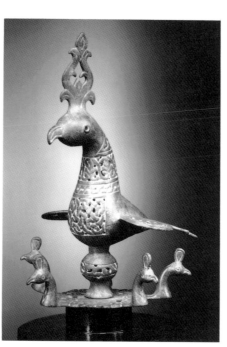

Finial in the Form of a Bird, 12th century
Cast copper alloy
Height: 8⅜ inches (21.3 cm)
Purchase: Nelson Trust [54-20]

Folio of Kufic Calligraphy from a Qur'an, 9th/10th century
Ink and gold leaf on vellum
8½ x 21 inches (21.6 x 53.3 cm)
Possibly Abbasid (A.D. 749–1258), Fatimid (A.D. 909–1171)
or Samanid (A.D. 819–1005) period
Purchase: Nelson Trust [44-40/2]

Stag, Serpent, and Herb, page from *De Materia Medica*
by Dioscorides, dated 1224
Watercolor on paper
12¾ x 9½ inches (32.4 x 24.1 cm)
Mesopotamian school, Seljuk period (1055–1258)
Purchase: Nelson Trust [44-40/1]

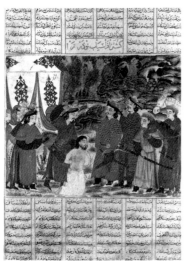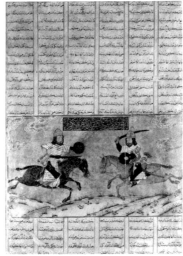

Afrasiyab Killing Naudar and *Rustam and Isfandiyar*,
2 pages from *Book of Kings*, c. 1335/36
Watercolor and ink with gold and silver leaf on paper
15⅞ x 11½ inches (40.4 x 29.2 cm), each sheet;
8¹⁵⁄₁₆ x 11⅜ inches (22.7 x 28.9 cm) and
6⅜ x 11⅜ inches (16.2 x 28.9 cm), images
Ilkhanid period (1256–1353)
Purchase: Nelson Trust [55-103; 33-60]

The Armenian Clergy, from
Compendium of Histories, 1425/35
Watercolor on paper
13⅛ x 9¼ inches (33.4 x 23.5 cm),
sheet; 10⁹⁄₁₆ x 8³⁄₁₆ inches
(26.8 x 20.8 cm), image
Herat
Timurid period (c. 1400–1510)
Purchase: Nelson Trust [46-40]

Couple Standing among Flowering Trees, c. 1480
Watercolor on paper
7 13/16 x 3 1/16 inches (19.8 x 7.7 cm), image
Tabriz
Turkman school (1419–c. 1510)
Gift of Mr. and Mrs. J. C. Nichols [49-85]

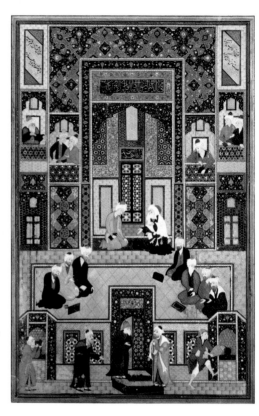

'Abd Allah Musawwir, active middle
of 16th century
The Meeting of the Theologians, 1540/50
Watercolor on paper
13 x 9 inches (33.0 x 22.9 cm), sheet;
11 3/8 x 7 1/2 inches (28.9 x 19.1 cm), image
Bukhara
Uzbek Shaybanid school (1500–1598)
Purchase: Nelson Trust [43-5]
[*See colorplate, p. 79*]

Attributed to Muhammad Siyah Qalam
Birds and Beasts in a Flowery Landscape, late 15th century
Ink on paper
6 1/2 x 9 3/4 inches (16.5 x 24.8 cm)
Tabriz
Turkman school (1419–c. 1510)
Purchase: Nelson Trust [43-6/2]

Hunting Scene, 1525/40
Watercolor on paper
7⅜ x 6⅛ inches (18.8 x 15.6 cm)
Tabriz
Safavid school (1501–48)
Purchase: Nelson Trust [43-6/3]

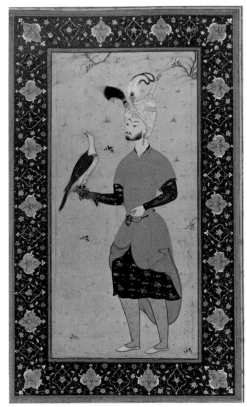

Attributed to Aqa Mirak, active 1539–1565
Young Man with a Falcon, 1540/50
Watercolor on paper
13 x 9 inches (33.0 x 22.9 cm), sheet;
9 x 5½ inches (22.9 x 14.0 cm), image
Tabriz
Safavid school (1501–48)
Purchase: Nelson Trust [43-6/1]

Opening Page from a Qur'an, 16th/17th century
Colors and gold leaf on vellum
14¼ x 8¾ inches (36.2 x 22.3 cm)
Isfahan
Safavid school (1501–48)
Purchase: Nelson Trust [34-221]

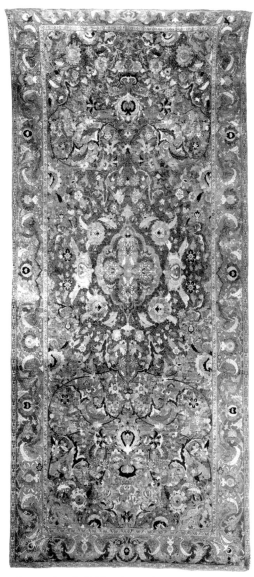

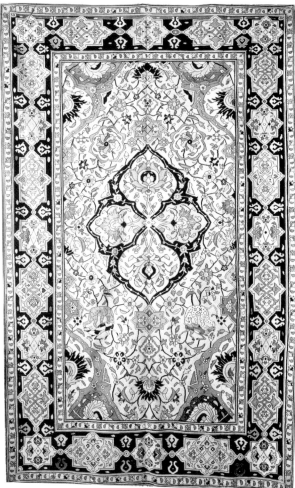

Carpet, So-called Polonaise, 17th century
Brocaded cotton and silk
143 x 72 inches (363.2 x 182.9 cm)
Kashan or Isfahan
Safavid school (1501–1722)
Purchase: Nelson Trust [33-460]

Tapestry-Woven Medallion Rug, 17th century
Silk with silver thread
95½ x 61½ inches (242.6 x 156.2 cm)
Kashan
Safavid school (1501–1722)
Purchase: Nelson Trust [32-70]
[*See colorplate, p. 80*]

UNABBREVIATED CREDIT LINES

An asterisk following the accession number of an illustrated object indicates that the unabbreviated credit line is too lengthy for inclusion in the caption. The full credit lines are given below, in alphabetical order by surname of the artist, or by common cultural designation.

African [87-7] — Purchase: Nelson Trust through the generosity of Donald J. and Adele C. Hall, Mr. and Mrs. Herman R. Sutherland, an anonymous donor, and the exchange of Nelson Gallery Foundation properties

Andre [37-1991/1] — The Patsy and Raymond Nasher Collection of the Nelson-Atkins Museum of Art, lent by the Hall Family Foundation

Bakst [F85-9 a,b] — Purchase: acquired through the generosity of the Leawood Women's Club, Richard Shields, and Felice Stampfle in memory of her uncle Arthur J. Suiter

Benton [F86-57] — Purchase: acquired through the Yellow Freight Foundation Art Acquisition Fund and the generosity of Mrs. Herbert O. Peet, Richard J. Stern, the Doris Jones Stein Foundation, the Jacob L. and Ella C. Loose Foundation, and Mr. and Mrs. Marvin Rich

Brancusi [37-1991/2] — The Patsy and Raymond Nasher Collection of the Nelson-Atkins Museum of Art, lent by the Hall Family Foundation

Caillebotte [89-35] — Purchase: Nelson Trust through the generosity of Mrs. George C. Reuland through the W. J. Brace Charitable Trust and through exchange of the bequests of Mr. and Mrs. William James Brace and Miss Frances Logan; the gifts of Harold Woodbury Parsons, Mr. and Mrs. Henry W. Bloch, and the Laura Nelson Kirkwood Residuary Trust; other Trust properties

Cesari [91-14] — Purchase: Nelson Trust through exchange of the bequests of Mrs. Jacob L. Loose, Mr. Paul Gardner, and Mr. Herbert V. Jones, Jr.; the gifts of Mr. and Mrs. Frederick Mont, Mrs. Carol L. Brewster, Mrs. Fred Wolferman, Mr. and Mrs. Arthur Wiesenberger, Mr. and Mrs. Louis S. Rothschild, Mrs. Virginia Jones Mullin, Charles S. Dewey, Edward M. Pflueger, Mrs. William H. Chapman, Mrs. Inez Grant Parker, Mrs. Justin L. Moody, and the Westport Garden Club; other Trust properties

Chinese [F83-8/1,3,7,9] — Purchase: acquired through the Joyce C. Hall Funds of the Community Foundation, the Joyce C. Hall Estate, the Donald J. Hall Designated Fund of the Community Foundation, the Barbara Hall Marshall Designated Fund, and the Elizabeth Ann Reid Donor Advisory Fund

Delacroix [89-16] — Purchase: Nelson Trust through exchange of gifts of the Friends of Art, Mr. and Mrs. Gerald Parker, and the Durand-Ruel Galleries, and the bequest of John K. Havemeyer

Ernst [37-1991/3]

The Patsy and Raymond Nasher Collection at the Nelson-Atkins Museum of Art, lent by the Hall Family Foundation

French [90-36]

Purchase: Nelson Trust through exchange of the bequests of Helen F. Spencer, Miriam Babbitt Simpson, Louise W. Withers, Mrs. Inez Grant Parker, John K. Havemeyer, and Linda S. Hall; gifts of the Airy S. Jones Fund, the Laura Nelson Kirkwood Residuary Trust, Mrs. Chauncey McCormick and Mrs. Richard Ely Danielson, Mrs. William H. Chapman, Bertha Hanicke in memory of Paul Willy Hanicke, Barton Hall in memory of his mother, Mrs. Charlotte E. Hall, Mrs. J. Eagles in memory of Jeanne Eagles, Winifrede Repp Railey, and Mrs. Logan Clendening; other Trust properties

Géricault [92-35]

Purchase: Nelson Trust through exchange of the gifts of Mrs. Raymond A. Barrows in memory of her husband, Mr. and Mrs. Milton McGreevy, Mr. and Mrs. B. Gerald Cantor, the Westport Garden Club, Mrs. Louis Sosland, Mrs. Elmo S. Fisher, Howard P. and Tertia F. Treadway, Mrs. Peter T. Bohan, Mr. William Averell Harriman, Mrs. Marion Mackie, Mrs. Carol Brewster, and Mr. Michael Hall; the bequests of Mr. Milton McGreevy, Mr. and Mrs. William J. Brace, and Helen Foresman Spencer; other Trust properties

Giacometti [37-1991/4]

The Patsy and Raymond Nasher Collection at the Nelson-Atkins Museum of Art, lent by the Hall Family Foundation

Kensett [86-10]

Purchase: Nelson Trust through the generosity of Mrs. George C. Reuland through the W. J. Brace Charitable Trust and the exchange of Trust properties

Marsh [F90-37]

Purchase: acquired through the Union Pacific Foundation Acquisition Fund, the generosity of Mrs. Herbert O. Peet, and exchange of the bequest of Thomas Hart Benton

Moore [20-1991]

The Patsy and Raymond Nasher Collection at the Nelson-Atkins Museum of Art, lent by the Hall Family Foundation

Native American [89-38]

Purchase: Nelson Trust through exchange of the gifts of Mr. William L. Evans, Jr., Mr. and Mrs. Robert Mann, Jr., and other Trust properties

Reinhardt [89-17]

Purchase: Nelson Trust through exchange of a gift of Mr. Paul Rosenberg, the Renee Clements Crowell Trust, and the Nelson Gallery Foundation

Ribera [88-9]

Purchase: Nelson Trust through the Katherine Kupper Mosher Fund and exchange of the gifts of Mrs. Virginia L. Coleman, Mrs. Vida M. Frick, Mr. and Mrs. Louis S. Rothschild, Mrs. Ruth A. Hirsch in memory of Mrs. Henry A. Auerbach, Mrs. Mary E. Evans and Mrs. John E. Wheeler in memory of Harry Martin Evans, Mrs. Sadie A. May, John Levy Galleries, Dr. and Mrs. Hanns Schaeffer, Mrs. Marion Mackie, Mr. Lincoln Kirstein, Newhouse Galleries, Mrs. Edwin Willis Shields in honor of Paul Gardner, and Mr. Paul Gardner; the bequests of Mrs. Jacob L. Loose, Howard P. and Tertia F. Treadway, Mrs. Raymond A. Barrows, Minnie Long Sloan, Content Aline Johnson in memory of Augusta Adelaide Johnson, Mr. Frank Ownby, and Mr. Lester T. Sunderland

Roman [87-21]

Purchase: Nelson Trust through the Katherine Kupper Mosher Fund, the generosity of the McGreevy Family through the Westport Fund, and the ex-

change of gifts of Hallmark Cards, Inc., Miss Alice Getty, an anonymous donor, Mr. T. Zoumpoulakis, Mrs. Jacob L. Loose, Mrs. Virginia Jones Mullin, Mrs. William Y. Boyd, Dr. F. A. Carmichael, Miss Lillian C. Ball, and Mrs. Allen Poteet, and other Trust properties

Vigée Le Brun
[86-20]

Purchase: Nelson Trust through exchange of the bequest of Helen F. Spencer and the generosity of Mrs. George C. Reuland through the W. J. Brace Charitable Trust, Mrs. Herbert O. Peet, Mary Barton Stripp Kemper and Rufus Crosby Kemper, Jr., in memory of Mary Jane Barton Stripp and Enid Jackson Kemper, and Mrs. Rex L. Diveley

PUBLICATIONS CONCERNING
THE PERMANENT COLLECTION

Handbook of the William Rockhill Nelson Gallery of Art. Kansas City, 1933.

The William Rockhill Nelson Collection. 2nd ed. Kansas City, 1941.

The William Rockhill Nelson Collection. 3rd ed. Kansas City, 1949.

Handbook of the Collections in the William Rockhill Nelson Gallery of Art and Mary Atkins Museum of Fine Arts. 4th ed. Kansas City, 1959.

Apollo Magazine, XCVI, no. 130 (December 1972): European art.

Apollo Magazine, XCVII, no. 133 (March 1973): Asian art.

Handbook of the Collections in the William Rockhill Nelson Gallery of Art and Mary Atkins Museum of Fine Arts. 5th ed. Vol. 1, *Art of the Occident.* Edited by Ross E. Taggart and George L. McKenna. Vol. 2, *Art of the Orient.* Edited by Ross E. Taggart, George L. McKenna, and Marc F. Wilson. Kansas City, 1973.

Eight Dynasties of Chinese Painting: The Collections of the Nelson-Atkins Museum, Kansas City, and the Cleveland Museum of Art, exh. cat. Essays by Wai-kam Ho, Sherman E. Lee, Laurence Sickman, and Marc F. Wilson. Cleveland: Cleveland Museum of Art, 1980.

Roger Ward with Eliot W. Rowlands. *A Bountiful Decade: Selected Acquisitions 1977–1987, The Nelson-Atkins Museum of Art,* exh. cat. Kansas City, 1987.

Ellen R. Goheen. *The Collections of the Nelson-Atkins Museum of Art.* New York: Harry N. Abrams, 1988.

Roger Ward and Mark S. Weil. *Master Drawings from the Nelson-Atkins Museum of Art,* exh. cat. Saint Louis: Washington University Gallery of Art, 1989.

Roger Ward. "Selected Acquisitions of European and American Paintings at the Nelson-Atkins Museum of Art, Kansas City, 1986–1990." *Burlington Magazine,* CXXXIII, no. 2 (February 1991): 153–60.

Henry Adams. *Handbook of American Paintings in the Nelson-Atkins Museum of Art.* Kansas City, 1991.

Henry Adams, Margaret Stenz, with Jan Marsh et al. *American Drawings and Watercolors from the Kansas City Region,* exh. cat. Kansas City, 1992.

INDEX OF ARTISTS